Fabrics

Fabrics

A GUIDE FOR

INTERIOR DESIGNERS

AND ARCHITECTS

MARYPAUL YATES

W. W. NORTON & COMPANY
New York • London

For information about permission to reproduce selections from this book, write to
Permissions, W. W. Norton & Company, Inc., 500 Fifth Avenue, New York, NY 10110

The text of this book is composed in Adobe Caslon
with the display set in Frutiger
Glossary drawings by Dawn Peterson,
reproduced by permission of Judy Juracek
Manufacturing by KHL Printing
Book design and composition by Gilda Hannah
Production manager: Leeann Graham

Library of Congress Cataloging-in-Publication Data
Yates, Marypaul
Fabrics : a guide for interior designers and architects / Marypaul Yates.
p. cm.
Includes bibliographical references and index.
ISBN 0-393-73062-X
1. Textile fabrics. 2. Interior decoration. I. Title.
TS1767 .Y38 2002
677—dc21
2001044549

W. W. Norton & Company, Inc., 500 Fifth Avenue, New York, NY 10110
www.wwnorton.com

W. W. Norton & Company Ltd., Castle House, 75/76 Wells Street, London W1T 3QT

4 6 8 0 9 7 5

For my three beloved Weisgals:
Benjamin, Bryan, and Leah,
and to the cherished memory of
Paul Yates, 1922–1999

Contents

Acknowledgments

The impetus for *Fabrics: A Guide for Interior Designers and Architects* came from the queries I have received over the years from interior designers, furniture manufacturers, friends, and students, who questioned me about using fabric and asked for a reference book on the subject. I thank all those who valued my opinion and asked questions, and I appreciate all the ideas that those inquiries gave me.

Many colleagues and friends encouraged my belief that such a work would be a valuable contribution to the field. I hope this short note of thanks can compensate them for their contributions of time and knowledge. All deserve credit for its success, and none is responsible for its shortcomings. In particular, Adrienne Concra, Margaret Dunford, Teri Figliuzzi, Harry Lonsdale III, Mark Pollack, Linda Thompson, Suzanne Tick, and Ray Wenzel shared their wealth of knowledge and were never too busy to help me split hairs or to advise me not to nitpick, as appropriate.

This book was begun so long ago that I cannot remember whose idea it was. Nancy Green is a likely suspect, whether it was her initiation or her prodding when I mentioned offhandedly that a demand existed for a contemporary volume on fabric use for interior designers. I extend to her my special thanks for all of her interest in my work, for her unending patience when life interfered, and especially for her vast accomplishments in publishing for the design profession.

Numerous talented designers, technicians, and experts in all facets of the textile industry commented on their areas of specialization and it gives me great pleasure to thank them. Margaret Walch and the Color Association of the United States provided extensive color and historic references. Thom Woller and Rob Jones offered countless suggestions and criticisms on all aspects of upholstery application. Alan Dean, Marty Gurian, Sal Messina, and David Ryan graciously helped on matters of testing, codes, and performance. Honore Buckley and Nat Harrison contributed substantially on floorcovering issues. Ron Sheridan's and P. C. Turczyn's acumen on print processes greatly enhanced those chapters. Various professionals, but especially Jennifer Eno, provided insight on interior designers' practical concerns. I am indebted to Sharon Clarke-Fodor and her colleagues at Koroseal, Charlie DiMotta, Lester Blumenthal, and Carol Novak for their expertise in wallcovering and wall systems.

One of the loveliest benefits of this project has been collaborating with Judy Juracek. Obtaining appropriate illustrations is a daunting task, and she not only contributed much of the photography here but also ran down any and every picture I contemplated. Working with someone of her intelligence and professionalism was truly a pleasure; if Nancy Green had not introduced us, I surely would never have completed this volume.

I am grateful to all those friends, designers, photographers, and companies that provided photographs and permitted their use in this book. James Anton Koch was especially generous and patient; I could never have done this book without his support. My particular thanks also go to Francine Allyn, Mary McKenna, and Kathryn Kimball of Rodolph Incorporated, Bruce Buursma and Linda Baron of Herman Miller, Susan Freedman of Clarence House, Regina Harrelson and David Gray of American Fibers and Yarns, Nat Harrison of Collins & Aikman, Deanne Moscowitz of BASF, Maryanne Solensky of Pollack & Associates, and Judy Straeten of Brunschwig & Fils, who, above what I could have asked, dug through many records and archives to find what I needed.

I efficiently used extensive travel time to write my first book—longhand, with paper and pencil, before laptops were common. Shellie Alper, Marty Sobin, Ben Tai, and Benjamin Weisgal probably wish I had done the same with this book, but I thank them for their twenty-four-hour availability keeping computers in working

order and accessible to me. Special thanks to Gary Handel, Emma Johnson, Robert Silarski, Zoe Tobier, Katie and Chrissy Vallianos, and Mrs. Wong for their various contributions of organizational and logistical support. My copyeditor, Casey Ruble, was astute, perceptive, and enormously helpful.

Glen Kaufman has been the most wonderful mentor anyone could want in a career, and he continues to provide guidance and encouragement for all my projects. Deborah Blum and Sandi Clarkson listened tirelessly to my fretting over the details of completing this book and constantly offered examples of a person's really squeezing extra hours into a day. My business partners, Harry Londsdale and Benjamin Weisgal, are my ongoing inspiration to keep inventing new fabrics that are fun to make.

Without the support of my family, I would never have managed this effort. Our children, Bryan and Leah, make the ongoing contribution of joy and happiness. My husband, Benjamin Weisgal, picked up more than his share of the slack at home and at work so that I could write. He deserves more of the credit than he will ever let me give him.

Introduction

Because fabric surrounds us—literally—nearly all the time, it seems logical that everyone surely would know more about fabric than almost anything else. And yet, many sensible, educated people express surprise when they are reminded of the complexity of the fabric-making process. Some are surprised that it is designed at all, assuming, we might suppose, that the nearly endless variety of fabrics available today occurred spontaneously.

Although designers often say that choosing fabrics is their favorite part of their job, it is also an unnerving source of problems for them. Available in a staggering range of choices, fabrics are perhaps the most versatile of furnishings, differentiating interior spaces by contributing color, texture, and pattern. But the discipline of fabric making and selection has become more complex with the development of new fibers, finishes, and constructions of products. The growing labyrinth of building codes and regulations that apply to fabric usage adds to the designers' task. Designers and architects are fully stretched to keep vast amounts of information on all interior and building products at their fingertips.

A wide range of references on the artistic, technological, and historical importance of fabrics is available. This book is intended to educate readers about the fabrication, sourcing, and selection of interior furnishing fabrics and to clarify the language of cloth as it is used by professional designers. In the field of fabric, where experience is a more prevalent career-training ground than academia, this is a particularly challenging task. Dialects speed through all living languages, and textile terminology is no exception.

This text traces cloth through the various stages of fabrication, touching on the distinctive characteristics of the most widely used materials and describing the many attributes and processes that give a fabric its finished appearance, including application for upholstery, drapery, wall-, floor- and window covering. An overview of the fabric industry outlines the path that cloth takes to reach the end-user. The designer's role with regard to sustainability and responsible selection of materials is considered throughout. The glossary defines terms, techniques, and materials in the context of interior-related concerns. All this information will help readers to make fabric choices that are informed and appropriate.

In spite of ongoing experimentation and exploration of new technology, those of us who develop new fabrics cherish the historical references that fabric reflects. In many cultures fabric is considered sacred or magical; at the very least it eloquently, beautifully, and portably represents the ritual, daily life and beliefs of our civilizations. Amazingly, fabric itself inherently commands enough respect to endure for generations, an unusual attribute for an everyday object and transitory product. I hope that this book will give readers increased respect for the exquisite fabrics of our era and thereby enable us all to most fully enjoy the beauty of this material.

Aesthetics

Many designers' favorite aspect of interior projects is selecting fabrics, probably because in most rooms fabric provides the predominant texture, pattern, and color. Fabric offers perhaps the greatest decorative potential of any material; compared with furniture or carpet, it is versatile, easy to manipulate, and low in cost. Vast ranges of fabric are readily available through trade and consumer sources. Easy to store and reuse, interior fabrics allow rooms to have a variety of design schemes (figure 1-1). Slipcovers and accessories are used seasonally in many residences; when a hospital needs a face-lift, window coverings or privacy curtains are often changed before more drastic renovation is undertaken.

For all these reasons, designers love to work with fabric; for the same reasons, fabric selection can be a complicated and nerve-wracking experience. Fortunately, all design problems have many solutions; the designer's primary goal should be to produce, within a reasonable time and budget, a space that the occupants enjoy. A few guidelines—and experience—can make the aesthetic considerations easier to anticipate.

Our access to a wealth of resources offering the broadest selection of fabrics in history makes selecting the "correct" few fabrics more difficult than it once was. If appropriate samples can be evaluated in the setting for which they are being considered, especially once lighting is established, making fabric decisions is relatively simple. But this adds considerably to implementation time, rendering such luxury in decision-making highly impractical. When it is impossible to judge the prospective fabric in the space where it is to be used, it should always be evaluated under the primary light conditions that will affect the room. The amount of fabrics being viewed should be proportionate to the amounts that will be used, and they should be placed on the same planes they will occupy in the final setting. For example, carpet, wallcovering, and seating fabric lined up in a row (figure 1-2) will have an effect quite different from that of carpet placed on a horizontal surface, next to a vertical wallcovering, accented with a smaller piece of seating fabric (figure 1-3).

Color

Fabric is usually chosen first and foremost for its color. Many excellent volumes address all aspects of color from scientific, psychological, and historical standpoints, and every academic design program includes courses on color theory. This book's brief discussion highlights only key color issues specific to fabric.

Because fabric is a composite of fibers and threads, its color never appears flat. This gives it the greatest potential of all man-made materials for achieving the complex character

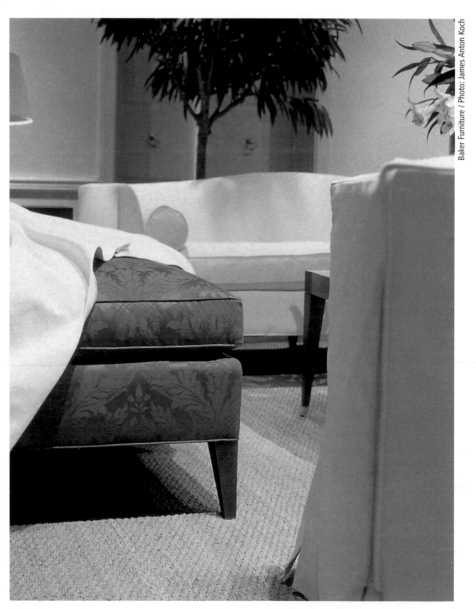

1-1 Because slipcovers are easy to change, they provide design variety in an interior.

Teri Figliuzzi / Photo: Judy Juracek

1-2 A designer's board shows various possible surface materials that will be used in a particular interior.

of color in nature. One inherent character of fiber is that it can be manipulated in ways that change its color effects. Consequently, the "same" color appears different in a lustrous silk, a woolen texture, or leather. Absolute color does not exist. Rather, a fabric's color depends on context: the fabric's texture and quantity, the materials surrounding it, and the room's light.

No matter how beautiful a fabric's pattern or how luxurious its feel, neither we nor our clients will want it if we do not find the color pleasing. In most cases the only rule for color is that the occupants like it. Even color

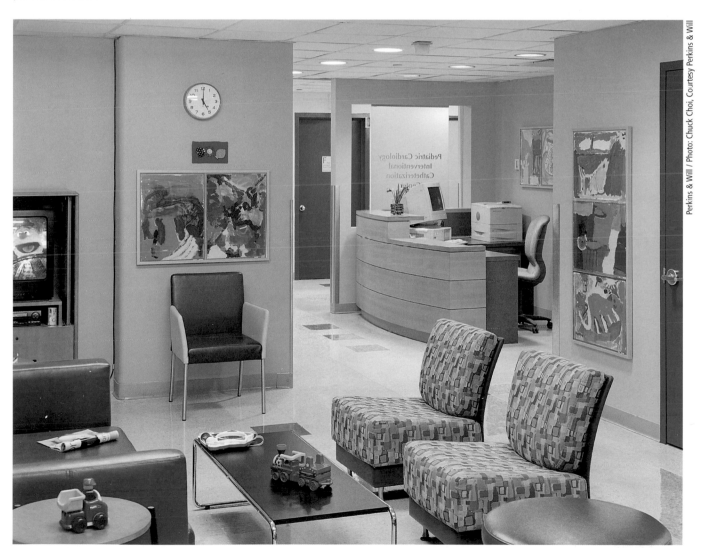

Perkins & Will / Photo: Chuck Choi, Courtesy Perkins & Will

1-3 Intense color and lively pattern activate a medical reception area.

1-4 A fabric's texture is determined by all facets of its makeup.

professionals are not immune to the whims of taste. When they say a color is "good," they may mean that it works within its context, or simply that they like it.

Many of the connotations we attach to color are culturally derived, not innate. Americans associate black with mourning; in other societies white, the traditional American bridal color, is the color of mourning. Chinese brides wear bright red. While one person may prefer a green bedroom because it is "relaxing," another might love lacquer red. In the post–World War II era, veterans held upper-management posts in most corporations. Any fabric with a hint of khaki or olive usually connoted an "army bunk" environment. Now, fifty years later, these colors are tremendously popular for office furnishings. Such connotations are often triggered by a color's appearance, but sometimes simply a color's name will provoke favorable or unfavorable prejudice. In either case, clients' and end-users' reactions to colors are equally important, because they will not choose to live with a color they do not like.

Many consumers—even design professionals—believe the safest approach to interior color is to use white or beige. Unfortunately, this strategy often backfires. White is not a noncolor; it is warm or cool and has a blue, gray, or yellow tint. It also tends to make "colored" items in the room visually jump, which is why it is chosen for gallery walls. Many people seek a "neutral" wall color and room furnishings that blend with the walls. This is a tricky endeavor, however, because when similar colors are viewed together, their differences seem more dramatic, making the casts and shades of the various neutrals highly critical.

Further, the more neutral an interior color scheme, the more noticeable all other details become. Quality of fabrication, upholstery tailoring, and architectural integrity become the hallmarks of a neutral interior. In addition, solid (and especially light) neutrals quickly show soiling and wear. In spite of the impeccable housekeeping that neutral interiors demand, such fabrics usually do not last as long as patterned or color-rich material.

Light and Lighting

Color is determined by light. Consequently, every fabric color must be considered under light conditions as similar as possible to those of the environment in which the fabric ultimately will be installed. Both the geographic region and the artificial interior lighting affect color and thus a material's appearance. If a color is chosen under one light condition and then used under another, the results will be unexpected and possibly undesirable. Color alternatives should be selected after they have been considered at all appropriate times of day, under all the light sources, and in the geographic region of the interior. Climate-controlled

buildings and an increasingly widespread availability of products have minimized regional color traditions. Nevertheless, some customs still remain. For example, bright colors are favored in the tropics because the blazing light washes out the colors of room surfaces, while the obscured sun of northern countries invites color subtlety.

Although changes in lighting seldom affect relationships between colors, they do cause dramatic variations in colors' casts and intensities. Fabrics designed for the candlelit interiors of past eras often look bright and harsh under incandescent or fluorescent lights. Dimming systems increase the yellow hue of light, making colors appear warmer. Fluorescent lights blacken the blue component of colors and make yellows appear brighter. Halogens can cause even the subtlest of colors to seem harsh, and large quantities of direct, natural light wash out the boldest colors.

Today consumers and end-users have sophisticated tastes and are aware of many aesthetic alternatives; those in the tropics may want subtle color in spite of local customs. There are no right or wrong answers; the designer simply must consider the ramifications that light will have on the material chosen, weigh the alternatives, and make an informed selection.

Texture

Texture is inseparable from fabric (figure 1-4); the word itself comes from the Latin textere, meaning "to weave." From the sleekest satin to the roughest burlap, texture is fabric's intrinsic defining characteristic. A fabric's texture is determined by all facets of its makeup: fiber content,

density, yarn configuration, weave, and surface finish, all of which are discussed in detail in later chapters.

Preference for rough or smooth texture seems to depend on cyclical market trends. When smooth, fine construction is popular, use of pattern generally heightens; conversely, rougher textures and coarse construction seem to promote interest in solid or heathery color.

Pattern

Motifs (the distinctive forms or figures in a design) and their arrangement on the cloth (whether applied to the fabric's surface or an integral part of its construction) constitute pattern, which is just one element of fabric design (figure 1-5). Pattern and design are terms often mistakenly used interchangeably. *Design* applies to all aspects of the cloth, including yarn size, combination, and color, yarn arrangement and density, and the finish of the cloth and its pattern.

Pattern is also often confused with *repeat*. A pattern is a configuration of elements that cover a surface and are arranged in a regular or formal manner; a repeat is one standard design unit (consisting of a specific arrangement of motifs) that is repeated at measured intervals across the width and length of a specific area. Clouds in the sky make a pattern. The clouds are scattered across a "surface" but no two are the same and certainly none occur at measured intervals.

Pattern is continuous. While composition in other design disciplines, such as painting, photography, and interior design, usually involves an arrangement of elements (motifs) that relates to the boundaries of the field, motifs in the language of pattern are designed only in relation to one another, as if no boundaries exist. Frames (of appropriate scale) randomly superimposed over different portions of a pattern would not contain identical parts of the design but would yield a similar spacing, scale, and effect. When isolated, any portion of a pattern should be consistent, though not identical, with other portions.

Though patterns without repeat

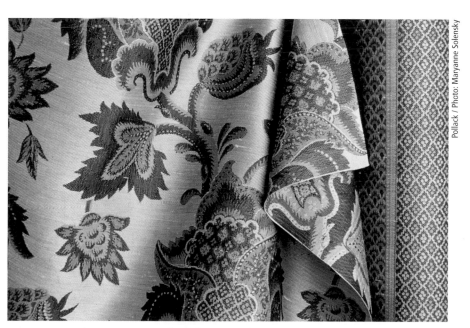

1-5 Pattern is the arrangement of motifs on a surface.

1-6 Even a "plain" fabric has a repeat, which in this case is the regular repetition of the thread interlacings of the weave itself.

1-7 Hand-produced fabrics such as this one may not have an exact repeat. The fabric is designed so that the same areas will occur at regular intervals, but because it is hand-painted it cannot be exactly the same at each interval.

occur frequently in nature (veins of stone, flowers in a field), rarely is a fabric produced without repeat. A repeat unit, which may be large or small, allows fabric to be produced efficiently. Even plain fabrics have a repeat, which simply may be the regular repetition of the thread interlacings in the woven fabric itself (figure 1-6). If the clouds-in-the-sky pattern, with no repeat, were somehow applied on cloth, no yard would be exactly like any other yard. This effect is sometimes laboriously undertaken by hand painting on fabric (figure 1-7). But to produce fabric efficiently, a fabric designer must develop a unit of the design that, when repeated, gives the appearance of clouds that are continuous and varied. In certain patterns the repeat unit is obvious, but any actual lines that occur where repeat units join are flaws (figure 1-8). Misaligned motifs that create an unintentional "edge" are called *line-ups*, while an *alleyway* or *hole* is formed by the design's negative space (figure 1-9). In complex masterly designs, the repeat unit itself is indiscernible and does not affect the viewer's overall impression of the fabric; for example, the motif and the scale of the fabric may be small, while the repeat is made large to increase variety (figure 1-10). The mechanics of a repeat do, however, dictate proper placement of the material on, for example, a piece of furniture or a drapery. Repeat placement is discussed further in chapter 8.

Pattern, however, is a visual effect. The flexibility of fabric makes it a superb medium for manipulating pattern within an interior. With pattern variety alone, spaces can be filled, broken, and enriched. Surface effects can be achieved; movement and flow created. It is a common device for activating large spaces devoid of furniture, such as a large floor expanse in a hotel lobby (figure 1-11). When patterned material is used to cover a wall, a chair, or a floor, the design takes on a new aspect: How the pattern relates to the shape and edges of the surface it covers and how it relates in scale and effect to other patterns in its environment change its impact (figure 1-12). The same pattern reads differently on a floor expanse, a sofa cushion, or a pleated drapery, for example (figure 1-13). Fabrics must be considered not only with the other fabrics but also with all other patterns in the

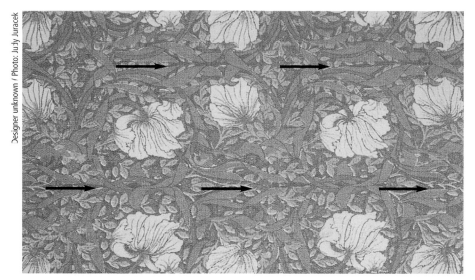

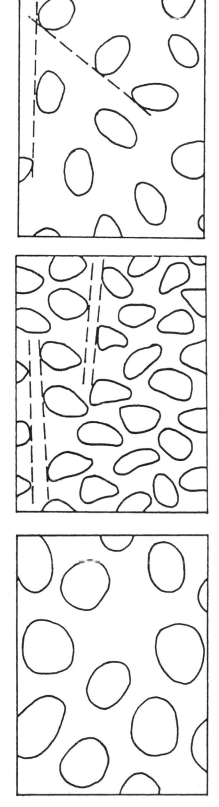

1-8 The heavy blue areas indicated with arrows are obvious joinings of the repeat units in this pattern.

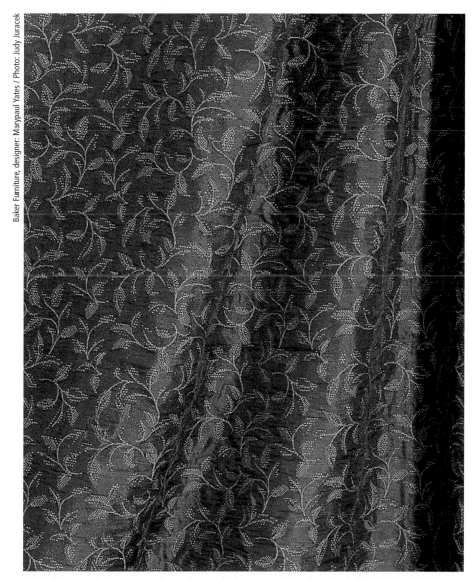

1-10 Small-scale patterns often utilize a large repeat in order to provide variety and interest.

1-9 The unintentional lines formed by the edges of certain motifs in the diagram on the top are line-ups, those formed by negative space in the center diagram are alleyways. The irregular space with no motif in the figure on the bottom is a hole.

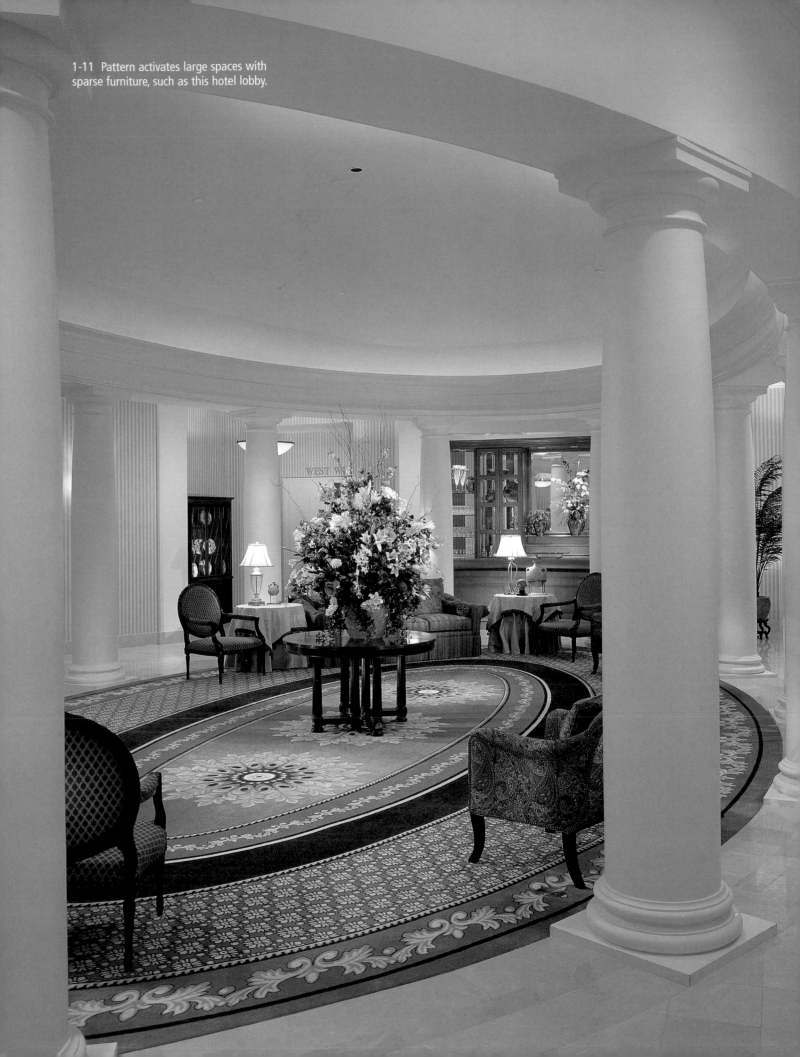

1-11 Pattern activates large spaces with sparse furniture, such as this hotel lobby.

environment, such as stone and wood grains, nonfabric wall- or floorcoverings, landscapes through the windows, and walls of books or artwork.

Market Appropriateness

While personal taste primarily dictates aesthetically appropriate choices for an interior, certain common-sense rules apply. The use of the room and the occupants' responses to the room are critical. For instance, most people work better in offices that are not too visually stimulating, i.e., light, bright, dark, or boldly patterned. Medium values, grayed hues, and harmonious combinations are pleasing office colorations. Small-scale patterns and textures disguise wear and soiling and are therefore popular for most nonresidential application (figure 1-14) and for areas in homes that receive heavy use, like children's and family rooms.

Because people do not spend much time in conference rooms or lobbies, these rooms can be dramatic, with intense color or bold pattern that would be tiresome in living spaces (figure 1-15, 1-16). For the same reason, lively pattern is interesting in residential powder rooms and entrance halls. Although a wide variety of fabrics and colors is used in hotel guest rooms to evoke atmospheres of different locations and eras, they are generally intended to be soothing, pleasant, and relaxing. Because hotel-room chairs may be treated roughly, bedspreads are laundered infrequently, and draperies are never laundered, the fabrics for these rooms are usually in a mid-color range and have patterns and textures that disguise soiling (figure 1-17).

Restaurants also host the spectrum of colors, depending on whether the atmosphere sought is calm or lively,

1-12 The same simple, geometric pattern creates a very different effect when featured on a small chair or a large drapery panel.

casual or formal. However, pinks are thought to increase appetite and blues to suppress a desire for food.

Healthcare application tends to have more practical aesthetic restrictions than other end-uses. This market is broad, including everything from pediatric areas and outpatient surgical facilities to drug rehabilitation centers, and some institutions are certainly more flexible than oth-

ers. In general, however, black, purple, and red are unpopular for healthcare interiors because they connote death and blood. Yellow is inappropriate because when reflected on a patient's skin it gives the appearance of jaundice. Calming patterns are sought (figure 1-18); those that would be jarring or unsettling to sick or medicated patients are not used. Like other healthcare

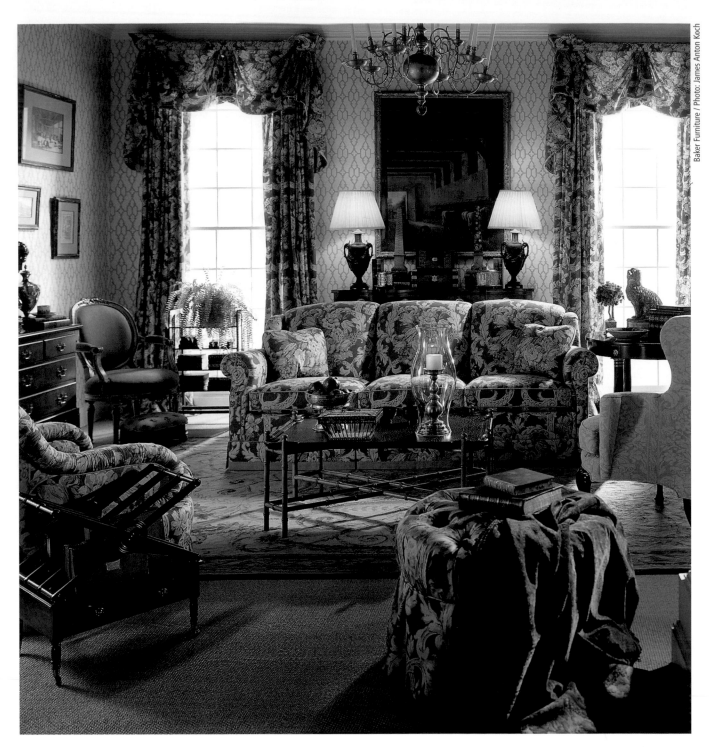

1-13 The same pattern appears to have a much larger scale when it is viewed on a flat surface (such as a sofa cushion) than it does when it is gathered (as in drapery).

OPPOSITE
1-14 Small patterns are popular in heavy-use areas, such as this medical office waiting area, because they help disguise wear.

1-15 Dramatic, intense colors that would be tiresome in everyday living spaces are appealing in areas that are used infrequently, such as this conference room.

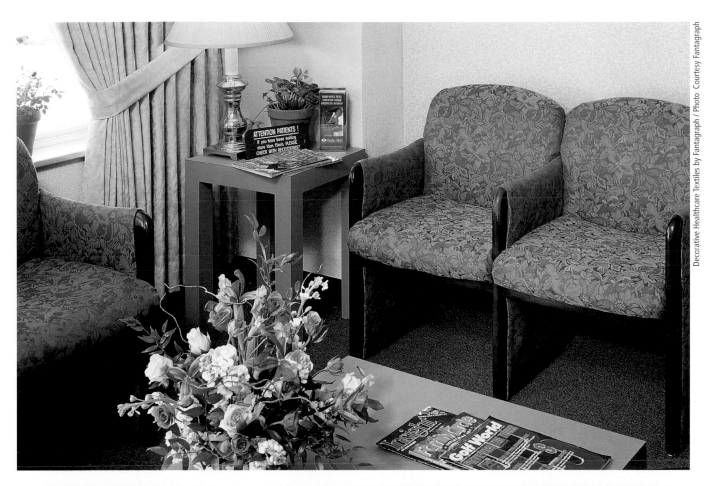

Decorative Healthcare Textiles by Fantagraph / Photo: Courtesy Fantagraph

Herman Miller / Photo: Hedrich Blessing- Nick Merrick Courtesy Herman Miller

1-16 Bold patterns create drama when used in a large expanse of drapery.

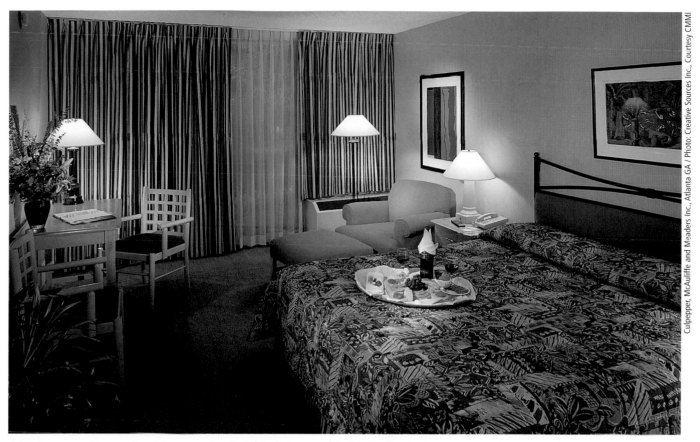

1-17 Pattern and texture in mid-range colors help hotel rooms maintain a fresh appearance.

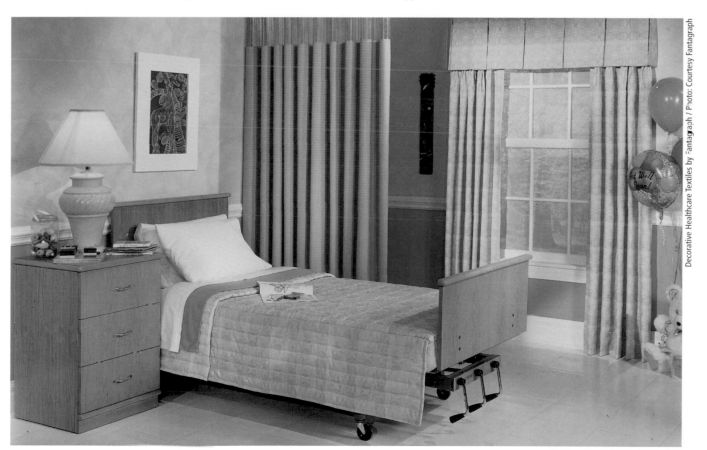

1-18 Calming patterns and colorations are sought for healthcare interiors.

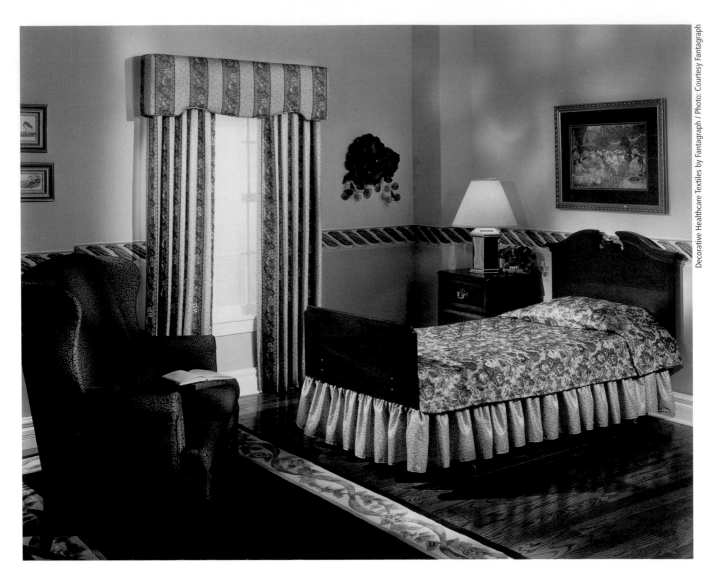

1-19 Long-term-care environments such as nursing homes are designed to achieve a homelike (or hotel-like) appearance.

facilities, long-term care environments such as nursing homes and rehabilitation centers require performance and cleanability of fabrics. However, these facilities are designed to achieve a homelike appearance; consequently, they often resemble hotel interiors more than hospitals (figure 1-19). In recent years, "home-like" has been translated in this context by the long-term-care industry as a "modified eighteenth-century European" style thought to be pleasing to most aging Americans. "Home" clearly has different mean-

ings to people of different generations, cultures, and ethnicities, and as our increasingly diverse population ages, these facilities surely will continue to reflect and respect differences in taste, culture, and background.

These guidelines for market appropriateness are commonly used starting points, but today's market is broad and varied. Different designers, end-users, and consumers may have widespread preferences. Almost every color or combination or colors is acceptable in some cases and for certain clients.

Sustainable Design

Designers' jobs have increased in complexity. Modern products need to be beautiful, hold to high design standards, and be suitable for their end-use and market. Today designers must also consider the environmental consequences of the manufacture and use of the products they specify. In fact, everyone who creates and uses materials should strive to understand their environmental impact. Designers may well drive the development of new techniques and processes that will enable furnishing materials to be made and used more safely.

Green Manufacturing

The U.S. textile industry can be proud of its environmental awareness and assumption of responsibility. In recent decades the industry has actively demonstrated its commitment to high standards and attention to new developments and discoveries. Fabric manufacturers strive to operate clean facilities that maintain and respect natural resources and, compared with other industries domestically and overseas, have achieved consistently high standards. Fiber companies and yarn spinners pursue and market a broadening range of recycled fibers and yarns that are woven or are otherwise processed into cloth. Known environmentally harmful chemicals for dyeing and aftertreatments have long been eliminated. Metals such as lead, cadmium, and chromium, which are disposed of by the tons in the electronics industry each year, were eliminated from fabric manufacture decades ago. The 3M Company, which manufactured the soil-release finish Scotchgard, voluntarily removed this tremendously successful product from the market due, reportedly, to concerns that a possibly harmful chemical produced in its manufacture remains in the body and the environment.

Green manufacturing processes can be very economical; when disposal is expensive, manufacturers prefer to reuse all that they can. Most fabric mills reuse and recycle materials such as yarn and fabric scraps, packing and storage materials, and machine oils (figure 2-3). Further, textile management programs educate employees on all of these issues to promote environmental awareness within their plants.

The American Textile Manufacturers' Institute (www.atmi.org) is the national trade association for the U.S. textile industry. A coordinating force that attempts to deal with problems and programs on an industry-wide basis, ATMI has established a volun-

2-1 Designers must consider the environmental consequences of their specifications.

tary rating system called Encouraging Environmental Excellence. E3, as it is known, was created in 1992 to advance the U.S. textile industry's already-strong environmental record. Textile factories can apply for the E3 rating and, if approved, be so classified. E3 requires that companies comply with all federal, state, and local environmental laws. In addition, companies must set their own environmental standards and then meet or exceed them.

The International Organization for Standardization (www.iso.ch), based in Switzerland, is a nongovernmental organization established in 1947 to promote the development of standardization and related activities in the world to facilitate world trade. ISO standards are developed through a consensus process carried out by technical committees formed of qualified representatives of industry, research institutes, government authorities, consumer bodies, and international organizations from all over the world. ISO has established a family of management system standards called 14000 that set requirements for what an organization must do to influence the impact of its activities on the environment. ISO standards must be met in order to achieve 14000 certification.

It should be noted that the extensive structure and accreditation process for ISO 14000 and E3 are appropriately oriented towards large companies. Small companies, which may or may not be more environmentally sensitive than large manufacturers, may not have the resources to complete the applications themselves. However, while the potential benefits of the ISO 14000 and the E3 system should not be underestimated, it is not enough to rely solely on simple rating systems.

2-2 Textile mill interior.

2-3 Copper shavings from engraved rollers set outside a print plant to be recycled.

European fabric manufacturers operate under standards as high or higher than those in the U.S., but many third-world countries have low standards and no governmental regulations on fabric production. When considering materials from the third world, designers must be especially vigilant about researching the manufacturing procedures of the companies producing those materials.

Fabric Use Issues

The best green reason for supporting good design in all products is this: When a product really works, its life will be long. Quality materials decrease the need for disposal and

2-4 The "Bounce" chair is easy to stack, ship, and reupholster.

therefore generate less garbage. It is incumbent upon interior designers and architects to use material with the longest useful life span possible. Next, reuse is the easiest, simplest way to recycle immediately. Interior furnishing products that can be reused, perhaps in less visible areas, have prolonged lives. Similarly, a product that can be refurbished mitigates negative environmental impact. While some furniture can be reupholstered relatively easily (figure 2-4), much furniture must be disposed of when the fabric is worn. This creates excessive waste and is an inefficient use of the furniture's other materials, which may have life spans far longer than that of the fabric cover.

Cleaning and caring for installed fabric are of paramount importance. If clothing is never cleaned or is cleaned incorrectly, it will not last long; the same is true for furnishing fabric. Upholstery, carpet, wallcoverings, and window coverings must be regularly vacuumed and professionally cleaned as needed. Fabric will not last if stains and spots are ignored.

The disposal of fabric is the other segment of the sustainability equation. On the positive side, most natural fiber materials are biodegradable, and some synthetics are recyclable. Further, compared to other materials that make up an interior, fabrics have only a minor impact: The space a chair occupies in a landfill is much greater than that needed for the fabric. Unfortunately, however, landfills and incinerators usually are the destination for fabric waste because actually retrieving installed fabric in order to recycle or reuse it is usually impractical.

Green design requires interior designers and architects to consider sustainable alternatives. Designing without regard for sustainability is simpler than evaluating which materials—from electrical and plumbing fixtures to office chairs—can be reused rather than replaced. Making arrangements to refurbish materials and to sort unusable materials so they can be recycled rather than dumped is time-consuming. Devel-

oping a flexible, long-lasting design requires additional effort. Although manufacturers continue to act on new information and improve green procedures, it is up to designers and end-users to make this large effort toward environmental conservation through reuse, refurbishing, and recycling.

Considerations for Specific Materials

While we may not have perfect solutions to environmental problems, we can act on the knowledge we have in order to make the most environmentally sensitive fabric selections. All aspects of the cloth must be considered and a decision made with the benefit of an informed, broad perspective. This checklist outlines the considerations for a fabric's life-cycle analysis:

• What impact do the cloth's fibers have on the environment? Are the fibers grown or made from replenishable materials? Can they be processed in ways that use the fewest chemicals possible? Plant fibers may seem to be environmentally friendly because they are natural materials and because organic agricultural production without synthetic chemicals is a concept familiar to most consumers. But synthetic fibers are often produced from recycled or recyclable fibers, for example, and may ultimately deplete fewer resources than the "natural" materials do. The negative environmental impact of nonorganic farming to raise cotton or even wool is arguably greater than that of a well-designed factory where synthetics are produced.

• How is the fiber processed into fabric, and how are color and finishes applied? Some natural fibers are cultivated to produce a limited color

palette that requires no addition of color to the raw material. The full-color palette achieved through addition of dyestuffs cannot be created this way; hence, the limited natural-fiber color palettes are narrower than the buying public desires. For example, sheep and alpaca naturally grow black, brown, and off-white hair, and hybrid strains of cotton produce various shades of brown fiber. These are beautiful natural colors, but they are not the reds, blues, teals, and sages that can only be achieved with dyes and that customers also want.

As with raw fiber, "natural" dyestuffs are not necessarily less harmful than their synthetic counterparts. People find many natural materials toxic, whether these materials touch our skin or enter our water supply. Dyestuffs (and finishes and treatments used by dye houses) that are known to be toxic or harmful have long been abandoned. Furthermore, so-called natural dyestuffs cannot be obtained in sufficient quantities and do not offer the lot-to-lot consistency or the colorfastness that users expect.

• How must the fabric be after-treated? Clearly, any treatment to a fabric adds chemicals that should be avoided when possible. However, in some cases the use of chemicals is necessary to impart characteristics of, for example, fire retardance or stain repellence to a product. Desired performance features of fabrics need to be weighed against their environmental costs. For instance, while stain-repellent treatment adds an "unnatural" material to the fabric, it also may considerably extend the useful life span of a piece of furniture.

• How will the fabric be attached to a different material? Adhesives are used in many fabric applications.

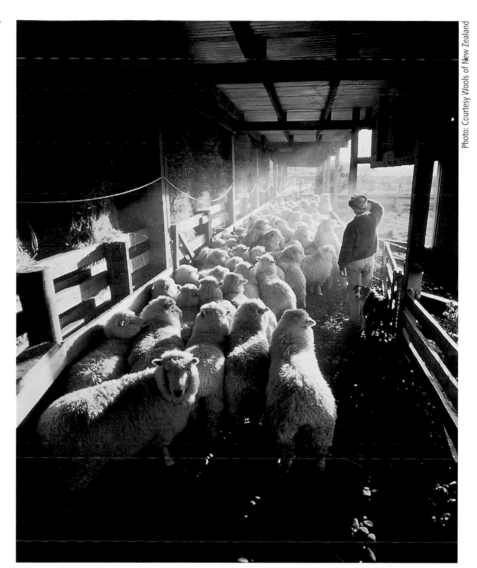

2-5 The fleece of these New Zealand sheep will become natural fabrics.

2-6 Recycled polyester is woven in a wide variety of fabrics.

The carpet and wallcovering industries continually develop water-based, nontoxic adhesives. Professional installers can recommend those that are nontoxic and that work best.

- How will the fabric be cleaned? Appropriate, routine care and cleaning dramatically extend the life of a material. Vacuuming, dry cleaning, and washing have different environmental ramifications, however. Vacuuming is critical but does not remove stains; dry cleaning imparts chemicals, but washing depletes water resources and fuel to pump, wash, and clean the water for reuse.

- Where is the fabric produced, and what are the environmental concerns of its makers? The U.S. has well-established voluntary and government-regulated standards for fabric manufacturing processes and facilities. Many beautiful fabrics imported to the U.S. are produced in countries with much less rigorous requirements or without requirements altogether. When we use (or otherwise encourage the production of) fabrics from areas without green concerns, we take a position on environmental issues.

- What transportation is necessary for moving the fabric from the region in which it is produced to the location in which it will be applied and installed? Generally, the farther it must travel, the more fossil fuels will be burned.

- Can the fabric be rolled, stored, packaged, and shipped with recycled and reusable materials and supplies? While this is not strictly a textile concern, it still relates to the overall impact of the chosen material.

- What will be the useful life span of the material and how will it ultimately be disposed of? It is important to remember that a fabric's life ends when the fabric looks bad—not when thread break (or any other failure) occurs. Most fabrics become unsightly from excessive soiling long before a hole is worn through them.

- Can reuses for the fabric be found? The longer the life the better, but eventually all fabrics wear out. Can the product be made into something else or used in a secondary location? If furniture or other fabrics cannot be reused in the interior for which they were chosen, many organizations—from charities to small local schools—may happily accept them.

- When the fabric on a piece of furniture becomes worn, can the piece be reupholstered or is it entirely useless?

- Is the material biodegradable, and if so can it realistically decompose? The biodegradable nature of an upholstery or wallcovering material becomes limited once it is attached to something else. For example, once a completely biodegradable upholstery fabric is glued to foam cushioning and assembled into a chair, it is difficult or impossible to separate it for decomposition.

- Is the material recyclable, and if so can it realistically be recycled? Carpet allows perhaps the greatest potential for actual recycling. Floor-covering is used in large quantities, is often of a single-fiber content, and the fiber can be removed from the base to which it is applied. These factors make it potentially economically viable to pick up old carpet before new carpet is installed. Carpet manufacturers, fiber companies, and installers are increasingly willing to take back carpet that has outlived its usefulness, as long as they receive the specification for the replacement carpet. Likewise, vinyl-wallcovering manufacturers and panel-fabric manufacturers have reclamation programs in place for some materials. Because most panel fabrics have a single-fiber content and are used in large quantities, they are easier to recycle.

Some manufacturers have aggressively assumed responsibility for recycling their own goods. Although most programs are not currently economically viable, the more they are used, the sooner they will become viable. In order to encourage manufacturers to continue taking increased responsibility for their products, it is imperative that the design community make a greater effort to utilize existing programs.

Our planet will be well served if all designers, clients, and manufacturers are aware of the environmental aspects of projects and of the choices that lead to sustainable solutions. Marketing labels do not mean a product is green or environmentally sound. We must consider the total project, whether big or small, high- or low-budget, and make the best choices we can.

Fibers and Yarns

The basic building blocks of all fabrics, fibers are components of different chemical makeup that are spun into the linear materials called yarns that are used in most fabric construction. Although the fiber makeup is important to the overall performance, appropriateness, and sustainability of a fabric, it should never be used as a sole criterion. No "perfect" fiber exists; each has unique properties, strengths, and weaknesses that make it more or less suitable for a particular use. Further, each fiber comes in many grades or qualities and can be well or poorly utilized in the yarn- or fabric-making process. Economics dictate appropriateness: The scarcity of a fiber, how difficult it is to harvest, and the number and complexity of manufacturing processes it must undergo raise its cost. The "nicest" forms of any fiber are always proportionately more expensive for these reasons.

Fabric structures are mentioned in this chapter only as they relate to specific yarns and fibers. They are discussed in more detail in chapter 4. Table 1 in the Appendix outlines the basic properties of common fibers, and the following short list of basic terms should be used as a guide for describing fibers and yarns.

- *Natural fibers* derive from fibrous materials that exist in plants, animal products, and minerals. Plant, or *cellulosic*, fibers include cotton and linen; *protein* fibers such as wool and silk come from animals. Glass fiber and asbestos are *mineral* fibers. Cellulosic and protein fibers are biodegradable.
- *Man-made fibers* are artificially created for use in fabric. Fibers can be man-made from natural materials (such as rayon from cellulosic material) or from synthetic materials.

3-1 The horizontal yarns in this drapery sheer have the typically even character of filament yarn.

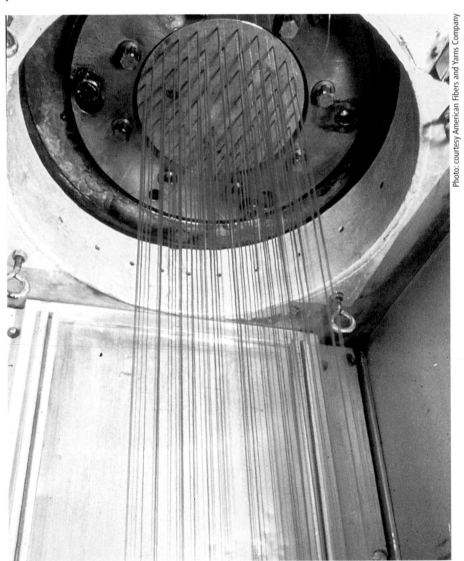

3-2 Polypropylene and other synthetics are produced as filaments and extruded through spinnerets.

• *Man-made synthetic fibers*, developed by scientists and manufactured in factories, are classified as generic or branded. Nylon, polyester, and acetate (like natural fibers) are generic categories that identify fibers of different chemical composition. Avora polyester (from Hoechst Celanese) and BASF nylon (from BASF) are branded versions of generic fibers produced in specific forms for performance or marketing reasons. Two different brands of polyester, for example, may perform slightly differently in spite of having identical chemical compositions.

• *Filament fibers* are produced in a continuous form, which results in a smooth character (figure 3-1). Filament yarn looks like dental floss. Silk is a naturally produced filament. All synthetics are produced as filaments; in its liquid state each fiber is extruded through tiny nozzles called *spinnerets* (figure 3-2). Continuous-filament synthetics are often subsequently processed into staple form that can be spun.

• *Staple fibers*, such as cotton, wool, and linen, are naturally produced not in a continuous form like silk, but in "cut" lengths that vary from plant to plant or animal to animal. (Cotton balls just off the plant and shorn sheep wool are typical of the staple-fiber character.) The length of the staple affects the material's quality, appearance, and performance, which are discussed in the sections on specific fibers. While a filament is inherently a thread or yarn, staple fibers must be made into a yarn through a spinning process. Synthetic filaments are frequently cut and processed in staple form so that they can be spun to look more like cotton or wool.

• *Spinning* is the mechanical process of making yarn from staple fiber (figure 3-4).

3-3 A selection of fabrics of different fibers: silk, wool, cotton, rayon, and polyester.

Baker Furniture, designer: Marypaul Yates / Photo: James Arton Koch

• *Texturized, air-texturized,* or *air-entangled* yarns are synthetic filaments that have a mechanically achieved rough surface (figure 3-5). The smooth filament effect of *continuous filament* yarn is disturbed in these yarns to simulate the "natural" appearance of spun yarns.

• A *plied* yarn consists of one or more strands of finished yarn *twisted* together.

• *Bulk* describes a yarn's (or fabric's) appearance of fullness with respect to its weight. For example, for the same weight of material, wool has greater bulk than silk. *Loft* refers to a yarn's springiness and resilience to its bulk when squeezed.

• *Thermoplastic* fibers soften (melt) when heated and reharden when cooled. Most synthetics are thermoplastic, which is considered a positive feature because they can be manufactured with different characteristics with heat. *Thermoset* fibers harden when heated and cannot be likewise manipulated.

• *Hydrophobic* fibers repel water; *hydrophilic* fibers readily absorb water.

3-4 Spinning includes different mechanical processes used to make yarns. Here yarns are being wound onto cones called packages.

3-5 Synthetic (polypropylene) filament yarns often have mechanically achieved rough surfaces that simulate the more natural appearance of spun yarns

• *Dimensional stability* refers to a material's ability to retain its shape and size after use or cleaning.

• For economic, performance, or aesthetic reasons, two or more fibers can be mixed together into a fiber *blend*. An *intimate blend* is a yarn or fabric in which the various fibers are spun together within one yarn. Two or more yarns that are each made up of individual fibers can be woven or knitted into a *mixture*.

• Color can be added to material at each manufacturing stage, and a fiber's ability to accept dye may be an important characteristic. Staple fiber that is dyed and then blended into a yarn is *stock-dyed*. Synthetic fiber that is dyed by the fiber manufacturer before the chemical is processed into yarn form is *solution-dyed*. Finished yarn that is dyed before it is made into fabric is *yarn-dyed* (figure 3-6), and fabric dyed after it is made is *piece-dyed*. These terms are thoroughly defined and discussed in chapter 6.

Natural Fibers

Cotton, wool, silk, and linen (and their close cousins) are commonly used natural fibers. These biodegradable fibers are considered a sustainable, environmentally responsible material choice, so long as no substance that negatively affects the environment has been added in the manufacturing process. Of course, biodegradability is of no value if interior furnishing materials are not disposed of properly.

CELLULOSIC FIBERS

COTTON. Cotton, the fruit of the cotton plant, is inherently a soft, comfortable fiber (figure 3-7). Its tendency to absorb water makes it feel cool to the touch and allows it to absorb rich, brilliant color easily. The cotton fiber is also relatively resistant to abrasion and sunlight, and it releases soil easily. These properties make it an ideal apparel fabric, evidenced by its worldwide popularity in garments—from saris to T-shirts and blue jeans. It grows easily in a wide range of climates. Machines can harvest the fiber and remove its seeds (ginning), making it a dominant crop and trade item around the world.

Cotton grows in staple form. The staple fiber can vary dramatically in length and in luster depending on the specific variety of the plant and on the manufacture and processing. This variety, along with cotton's willingness to blend with other fibers,

makes it extraordinarily versatile. Most widely available are the shortest staple grades, which yield a matte (or even dull) surface and a dry, sometimes fuzzy, *hand* (the way the material feels). Short-staple cotton is *carded*, a manufacturing process that smoothes the fibers and arranges them approximately parallel to each other before they are spun into yarn. Coarse sizes of carded cotton yarns are usually single-ply (called *singles yarn*), and finer sizes may be singles or two-ply. Long-staple cotton fibers may be carded or *combed*, a process that arranges the fibers more strictly parallel to create a smoother, softer, stronger, more lustrous, and more even yarn. Combed cotton fibers are always two-ply yarns. The extra-long-staple grades of cotton, such as Egyptian, pima, and sea island, are almost always combed. Cotton is also frequently *mercerized*, a permanent chemical process invented by John Mercer in 1844, in which the cotton is impregnated with a caustic soda solution. For furnishing fabric the process is most often done to yarns, but it can be applied to warp (the vertical yarns in the weaving process) or to cloth after it is woven. Mercerizing increases the strength, bulk, luster, and dye affinity of cotton. At its most luxurious, a high-grade mercerized cotton rivals the rich hand and color intensity of silk (figure 3-8).

LINEN AND BAST FIBERS. Linen and its relatives of the bast family are, along with cotton, the most prevalent cellulosic fibers (figure 3-9). Most bast fibers, including linen

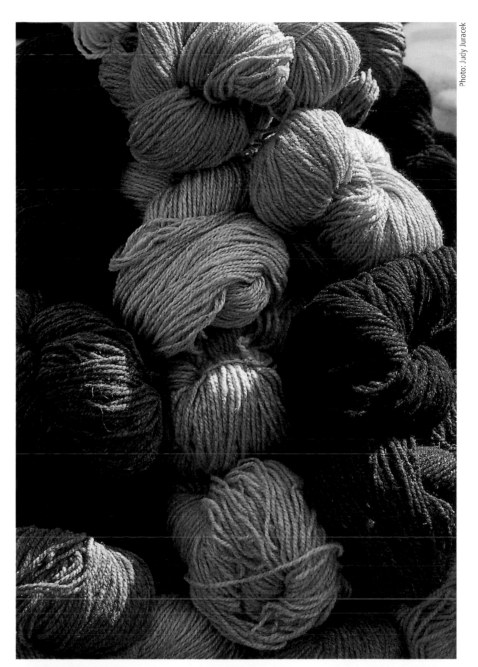

3-6 Finished yarn that is dyed before it is made into fabric is yarn-dyed.

3-7 Cotton fiber is the fruit of the cotton plant.

3-8 Mercerized cotton matelassé on sofa.

3-9 Linen fiber is from the stem of the flax plant.

(from flax), jute, hemp, and ramie, are removed from the plant's stem, or sometimes from its leafy parts (for sisal). Through a procedure known as retting, the unusable pulpy parts of the plant are literally rotted away and the stiff, parallel fibers are extracted. Linen feels smooth, crisp, hard, and cool, but its lack of resilience makes it brittle (and therefore vulnerable to upholstery abrasion) and wrinkle-prone (which can be minimized through special wrinkle-resistant finishes). In a dry envi-ronment its brittleness is intensified. It is excellent for wallcovering, where these limitations are inconsequential. Linen dyes beautifully in a dye bath, but when the fabric is printed, dye saturation is difficult to obtain because of the density of the fiber. For this reason, linen prints tradi-tionally are designed to look "worn" from the beginning, often with the undyed ground color being promi-nent. The patina of the prints shown in figures 5-1 and 5-55 are charac-teristic of linen grounds.

Linen yarns, like cotton, are man-ufactured through various processes that result in vastly different fabric appearances and performance char-acteristics. Linen is naturally a tan color called the *gray* (figure 3-10); partially bleached *boiled* linen is a lighter, pearly color; and *bleached* linen is a beautiful, clean white. While the following terms are not commonly used in the marketing of linen fabrics, it may be useful to know their meanings because they are occasionally labeled as such. *Line-linen* is linen of very long staple fibers (almost a yard [meter] long is not uncommon) that are usually combed and often mercerized, which yields a luxurious and durable fabric and yarn. *Tow-linen* refers to yarn made of very short staple. While tow-linen is quite suitable for wall-covering, it can be fuzzy and have low abrasion resistance. Linen fibers may also be characterized as *wet-spun*, which yields a smooth charac-ter, or *dry-spun*, which produces soft, lofty yarn.

The availability, soft hand, and silky luster of *ramie* make it popular for apparel and occasionally for drapery use. Its attributes are the result of its fine gauge, which makes its natural abrasion resistance low. For this reason it is unpopular for

upholstery,, though a small percentage of ramie is sometimes blended with a stronger fiber such as wool.

Although most bast fibers accept dye brilliantly, neither sisal nor jute is colorfast, and both quickly oxidize back to tan when bleached. Their inflexible but heavy, wiry fibers make them appropriate for carpet fabrication and even for industrial uses. Sisal is popular as a carpet face fiber. Jute is relatively inexpensive and its natural color is not particularly desirable; consequently, it has found a life in the unglamorous but hard-working category of textile fibers—as carpet backing and burlap wrappings, for example. These uses, however, are largely being usurped by less expensive and more easily produced synthetics, particularly polypropylene.

OTHER PLANT FIBERS. Other plants are woven into fabrics in many parts of the world. Some are used as wallcovering, but most are produced for floorcovering. Most do not absorb color readily and are not malleable, as is obvious from their appearance and from their sometimes centuries-old uses. Grass (woven as mats and wallcovering), sea grass (as tatami), piña, abaca, and raffia (as mats), and bamboo, rattan, and cane (as window blinds and screens) are examples of cellulosic materials (figures 3-11, 3-12).

PROTEIN FIBERS

Fibers processed from the cocoons of moths (silk) or from the hair or fur of certain animals (e.g., wool) are protein fibers. Like other classes of fiber, protein fibers are chemically similar and can therefore be dyed similarly. Although some types of protein fibers may be quite different from others—for example, silk's

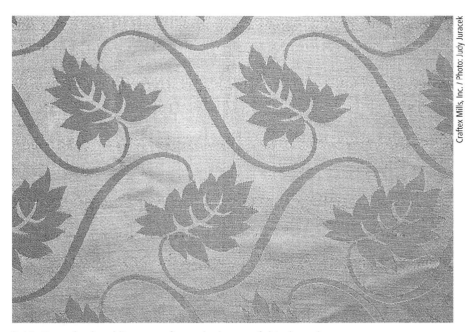

3-10 Natural-colored linen yarn forms the leaves of this damask pattern.

form and fabrication differ from that of the hair and fur fibers—all protein fibers tend to be lofty, lustrous, and resilient.

WOOL. *Wool*, the most prevalent protein fiber, is the fleece of sheep (figure 3-13). Various breeds are domesticated and bred for the qualities of their wool and their ability to thrive in specific geographic regions. (*Merino*, a well-known breed of sheep, is the only breed commonly used as a marketing label.) The natural *crimp*, or waviness, of the wool fiber, its roundness, and the scalelike quality of its outer layer make wool beautifully springy, lofty, and resilient. It naturally regains its shape, making it maintain any finish (for creases, pleats, or sheen) applied to it during manufacturing, but it does not accept wrinkles or creases created by normal use. This resiliency also makes it quite durable. Paradoxically, wool is both oily in character (imbued from its lanolin), making it soil-resistant and easily cleanable, and hydrophilic, giving it great dye affinity. Its unique ability

to absorb moisture without feeling wet makes it comfortable to the skin and appropriate for insulation. Compared with cloth of other fibers, appropriately processed and constructed wool cloth maintains a pleasing appearance for a long time.

Wool is harvested in staple form (figure 3-14) and, like all staple fibers, varies widely in staple length and fiber quality. Shorter-staple wool is carded and, when spun, is called *woolen*; longer-staple wool can yield a softer woolen grade, but it is most often combed after carding, spun on a different type of equipment, and then plied to yield *worsted* yarns. Tweed fabrics, flannel, and melton are typical woolen fabrics (figure 3-15). Suitings, gabardines, and sateens require the smooth character and sheen of worsted yarn (figure 3-16). (The fabrication of these cloths is further discussed in chapters 4, 6, and 7.)

Virgin wool is new fiber that has never been used in yarn or fabric. *Reprocessed* wool is the unused scrap fiber and fabric accumulated during the manufacturing processes. *Re-*

Juraku Co. / Photo: Judy Juracek

claimed, *recycled*, or *reused* wool is recycled from used wool fabrics. *Felt* is produced from wool fibers that are not woven (or even spun into yarn); rather, the matted fibers are wet out (so the scales expand and bind together) and then dried, flattened, and pressed into a uniform thickness. (*Felting* also refers to a stage of the finishing process for certain woolen cloths, such as flannels and meltons, in which they are given their fuzzy, napped face. This process is further discussed in chapter 7.)

OTHER ANIMAL FIBERS. Mohair, the fleece of the Angora goat, is long and lustrous. While it is considerably less versatile and more expensive than wool, its silky appearance, soft hand, durability, and springy resilience make it desirable for upholstery fabric. Especially popular for upholstery plush (a luxurious grade of velvet), mohair reflects environmental light, which enhances it aesthetically in the dense pile yarns (figure 3-17).

Alpaca fleece and *cashmere*, the fleece of the Kashmir goat, are seductively soft and fine, but their delicate fibers and high cost make them unusual in furnishing, except for an occasional wool blend or accent piece. Alpaca is most often used in its rich range of natural browns (figure 3-18), while cashmere is often dyed like wool. *Pashmina* is cashmere, but it is usually associated with a lightweight cloth of fine cashmere yarn, sometimes containing a blend of silk. Other animal fibers sometimes used in appar-

Rodolph Incorporated / Photo: Rodolph Incorporated

3-11 Paper is used as filling yarn in this mat

3-12 Synthetic yarn that simulates raffia forms the tufts in this fabric.

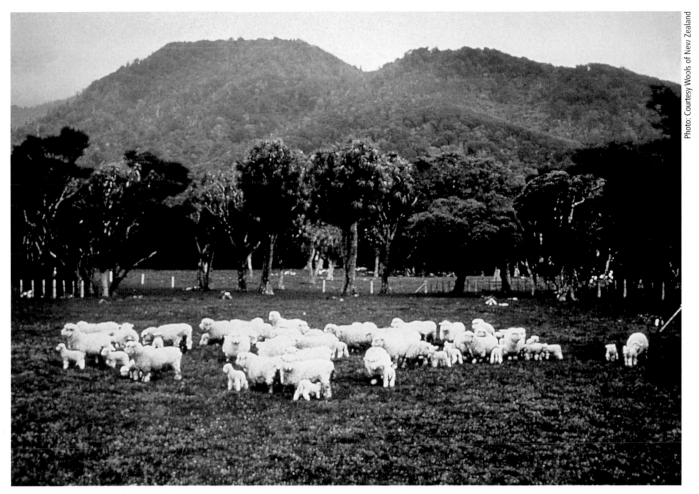

3-13 Wool is the fleece of sheep.

el have limitations similar to those of mohair, alpaca, and cashmere and consequently are used for furnishings only rarely. *Angora* (from rabbit fur), camel's hair, and vicuña are examples.

Horsehair, woven into luxury upholstery fabric, came into vogue in the late eighteenth century as a mark of elegance in aristocratic interiors (figure 3-19). It cannot be spun; actual hairs from horse tails are used as filling (horizontally woven) yarn and woven strand by strand into the fabric (usually on cotton warp). Thus, the width of the fabric can be no wider than the length of the horse's tail, which is roughly 23 inches (58 cm) for white horsehair and 25–27 inches (63–69 cm) for black hair. Its appearance is smooth and

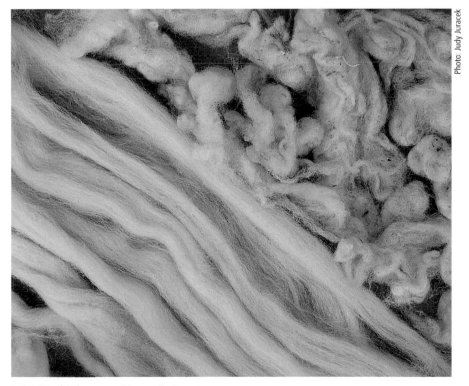

3-14 Wool is harvested in staple form.

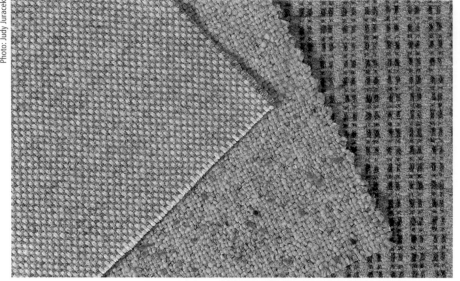

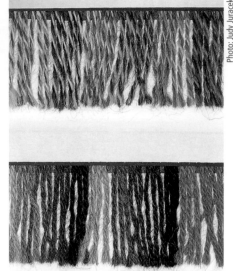

Photo: Judy Juracek

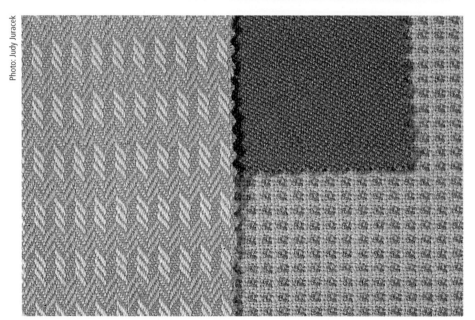

Photo: Judy Juracek

LEFT, TOP TO BOTTOM: 3-15 Tweeds, heathers, and flannel finishes are typical of woolen fabrics.

3-16 A smooth, crisp surface character is typical of worsted fabrics.

3-17 Mohair, the fleece of the Angora goat, is especially popular for luxurious upholstery.

ABOVE: 3-18 Alpaca is most often used in its rich range of natural browns. Two yarns are separately twisted together to create these two-ply yarns.

BELOW: 3-19 Horsehair, woven into luxury upholstery fabric, came into vogue over two hundred years ago as a mark of elegance in aristocratic interiors.

Photo: Judy Juracek

Brunschwig & Fils / Photo: Judy Juracek

lustrous, with a hard, durable hand. While rare and extremely expensive today, horsehair remains a niche staple of traditional upholstery fabric and is frequently simulated in synthetic fiber.

SILK. *Silk*, harvested from the cocoons of moths, has been prized for centuries because of its elegant sheen, rich luster, and vibrant colors when dyed. Each cocoon produces only about 1,000 yards (914 m) of fiber, which yield a mere few ounces (grams) of silk. Even the industrial revolution could not mechanize silk production, and today it remains an extraordinarily labor-intensive process.

The cocoons of various varieties of Asian moths are made of fine, continuous-filament fiber that is painstakingly harvested to yield silk (figure 3-20). Wild moths eat oak leaves and produce a brownish cocoon of *wild* silk, which is usually harvested after the moth has broken out of the cocoon and thereby broken the filament. Because it is broken, the fiber is treated as a staple and spun into yarn. The diet of mulberry leaves on which cultivated silkworms are raised makes their cocoons almost white. The filament fiber from these cocoons is reeled as a continuous strand (producing *reeled* silk) before the moth matures and evacuates (figure 3-21). Several strands of silk can be reeled together to create a heavier filament yarn called *tram* (figure 3-22).

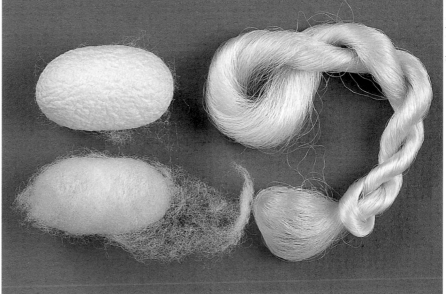

3-20 Silk yarn painstakingly harvested from the cocoons of silkworms is woven into fabric.

3-21 Filament silk fiber is reeled as a continuous strand from one or more cocoons.

Pollack / Photo: Maryanne Solensky

Photo: Judy Juracek

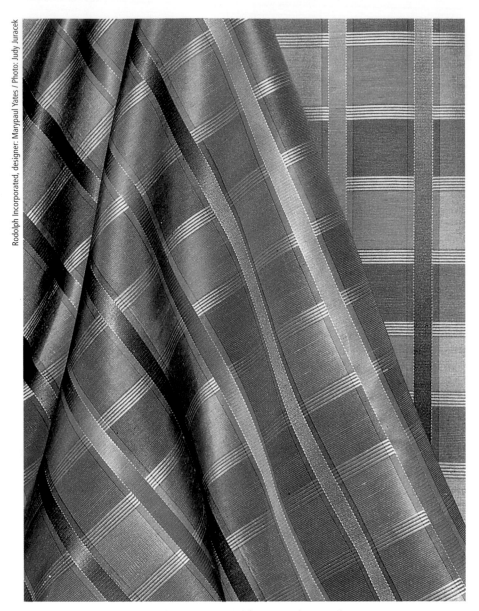

3-22 Smooth hand and high luster are typical features of tram silk.

When the silkworm produces the cocoon, the silk fiber is coated with a gum called *serecin*, which is used as a natural sizing (stiffener). Just as starch does for a cotton shirt or wax does for dental floss, the serecin makes the silk stiff, so that it is much easier to handle during reeling. After the silk is reeled, the gum is *boiled off*, sometimes as part of the dyeing process. Silk in which the gum has not yet been removed is called *raw silk*. *Spun* silk is spun from cocoon scraps that cannot be reeled and is often mislabeled as raw silk (figure 3-23). Wild silk, which is always spun, yields yarn called *tussah* (figure 3-24). Plain-woven fabric of tussah yarn is sometimes called *pongee*. Cultivated silk from pierced cocoons, used for white and dyed, textured silk, also must be spun. *Noil* is spun, cultivated silk waste (very short fibers) and has a fine but very nubby texture (figure 3-25). *Doupioni* silk is the double strand of fiber that "twin" worms produce when they join in one cocoon. The irregularities of the two strands match up to create larger-than-usual slubs (gradual shifts from thicker to thinner over long lengths). Plain fabrics woven of doupioni yarns are called *shantung* (figures 3-26, 3-27).

Silk also blends well with some synthetics. Filament polyester can become a vehicle for showing off the silk in blends. Long-staple rayon can be mixed with silk to produce a lower-cost fabric that retains silk's luster and brilliant color.

Although silk often is considered fragile, its high tensile strength made it the fiber of choice for parachutes before the advent of synthetics. Its smooth character makes it abrasion-resistant. It can be sensitive to fading and, if gum is left in the fiber, to degradation from light exposure. Above all, its high cost makes it inappropriate for uses involving heavy wear or harsh light.

Man-made Fibers

Most other fibers are man-made. Some fibers are man-made from "natural" materials into forms that can be used to make fabric, but most are man-made from synthetics, which are chemical compounds specifically developed and produced for use as fibers.

NATURAL MAN-MADE FIBERS

Fibers man-made from natural materials include glass fiber, extruded directly from glass, latex from rubber, asbestos from serpentine, and metal wires. Rayon and acetate are processed from wood pulp that has been manipulated into a liquid (viscose) state.

GLASS. Glass fiber is extruded from molten glass in filament form. (Fiberglas and Fiber Glass are not synonyms for glass fiber—they are registered trademarks for glass fiber

3-23 This chair is upholstered with spun silk, from cocoon scraps.

3-24 This distinctive brown color indicates tussah, or wild silk, which is always spun.

3-25 The nubby character of the fabric on the left is typical of noil silk. The smooth, multicolored fabric below it is tram silk.

and belong to Owens-Corning and PPG Industries, respectively.) Glass is used in some wallcoverings (see figures 8-92–8-95) and also has industrial applications, for example in the aerospace and electronic industries. Its current primary end-use in interiors is as a fireproof barrier, or interlining, between cushion and outside cover, for upholstered furniture and bedding that needs to pass certain flammability tests (discussed in chapter 9). Some fibers that are called "flame resistant" actually melt when exposed to heat or flame; because glass does not burn at

3-26 The slubby irregularities that occur when two strands of silk are reeled create doupioni silk, shown in plain shantung fabric.

3-27 Doupioni silk beautifully emphasizes the form that it envelops.

all, it is an excellent flame barrier. The foam and cushion materials in seats and mattresses are highly flammable and even combustible; the purpose of the barrier is to prevent flame from reaching them.

Because glass fiber is also stiff, undyeable, and its fibers can splinter off when the yarn is cut during fabrication, it is hard to believe that glass was once popular for drapery fabrics. It became obsolete for drapery use once flame-resistant synthetic fibers became popular.

LATEX. *Latex* is a dispersion of rubber in water. Rubber can be naturally obtained from trees, or it can be synthetically simulated. Material that stretches (is *elastomeric*) can be made into yarn from extrusions of latex fiber. Latex can also be used to coat fabrics as a finish and is popularly applied to the backs of many machine-made rugs. Latex does not blend well, so it is used in applications where its natural appearance is not a negative, such as in narrow strips of elastic for apparel.

RAYON. Rayon, the first man-made fiber developed, is processed from natural cellulosic material (wood pulp or cotton waste fiber) and is available in different forms (that try to achieve varying levels of performance) and brands (produced by various companies). Rayon was developed as a lower-cost alternative to cotton, but it currently costs about the same as comparable grades of cotton. Chemically, it performs almost identically to cotton. Rayon is notable for its high luster and ability to yield fine or coarse yarns. It is often used to create slub-yarn effects (figure 3-28).

Rayon is less dimensionally stable than cotton, however, especially when wet. Because it tends to

3-28 Rayon is notable for its high luster, used here in the gold yarn to contrast with the matte character of the cotton chenille yarns.

stretch, especially when it is wet, *high-wet-modulus* rayon (a *high-tenacity* version of rayon that is also called *polynosic* rayon) was developed. The fiber's physical structure is modified in the spinning process to yield greater dimensional stability.

Although there are actually three methods of producing rayon, the most popular type of rayon is *viscose*, so called because its cellulosic material has been processed into liquid and then extruded into filament. Any rayon that is not otherwise labeled is viscose rayon. *Cuprammonium* rayon is extruded in a copper

solution, and although it is produced in Europe, it is no longer manufactured in the U.S. because of the cost of cleaning the copper residue from the waste water. *Saponified* rayon is reverted from acetate through a chemical process so that the fiber looks like rayon but dyes like acetate. Rayon is most often used in a filament form or a long-staple spun form. With its high luster in these forms, rayon simulates silk. It lends luster and drape when blended with other fibers. Its features make it excellent as an accent yarn in fabrics of almost any end-use, from fabrics

3-29 The slubby character of spun rayon is a popular filling yarn in fabrics of almost any end-use.

3-30 The inherently smooth character of filament polyester is perfect for sheer drapery.

fiber has been manipulated to achieve specific characteristics, but all petrochemical synthetics are hydrophobic and thermoplastic. They tend to be nonallergenic, do not promote mildew growth, and do not appeal to moths or other pests. On the negative side, synthetics tend to collect static electricity, which makes pilling a problem. They are not biodegradable, although some are recyclable.

The chemically inherent smooth character of synthetic fibers is enhanced by the manufacturing process of extrusion, which forms a smooth, continuous-filament yarn. This characteristic is often desirable. For example, filament polyester is a popular yarn for sheer drapery (figure 3-30) and for the warps of many upholstery fabrics (figure 3-31). It is available in either a filament state with a sheen or in a texturized filament form with a more matte, toothy quality; both forms yield a fine, strong yarn that permits easy handling in the weaving process and allows for fine detailing in the fabric's design.

As the uses of synthetic fibers have broadened, manufacturers have developed staple forms from the continuous-filament fibers. These synthetic staples are now available in a variety of staple lengths and characters and can be spun into yarns that resemble spun yarns of natural fiber. *Microfibers* are popular forms of synthetics, particularly polyester and nylon. The thinnest yarns can be made from microfibers, which frequently are knitted or woven into very tight, dense, lightweight, soft fabrics that are often brushed after they are dyed. This cloth is sometimes called *moleskin*, which originally was made of fine cotton.

Synthetics are also modified in the fiber state for other reasons: to add

used as wallcoverings to drapery and upholstery fabrics with fill-effect yarns (figure 3-29). It should never be used as vertical yarn in a drapery because the fabric's weight will pull and make the panel sag unevenly.

ACETATE. To produce *acetate*, cellulosic fiber is extruded through an acetate solution. Acetate therefore chemically performs very differently from other cellulosic fibers, notably in that it requires a unique type of dye. Acetate has very poor abrasion resistance and cannot be made into a wide variety of yarn fabrications. It is, however, very low-cost, light-resistant, and dimensionally stable, making it excellent for use in drapery-lining fabric and for drapery-fabric warp yarns.

SYNTHETIC MAN-MADE FIBERS

Most man-made fibers that are not made from natural materials are classified as synthetic, and most are long-chain polymers derived from petrochemicals. Each generic class of

color (rather than dyeing the yarn or fabric), to decrease luster or static, or to enhance flame retardance. Fibers that have been modified still perform much like their basic fiber family, but with a certain performance feature added or enhanced.

Generic forms of synthetics (e.g., polyester, nylon, acrylic) are chemically distinct from one another. Companies that manufacture and sell synthetic fibers sometimes give their fiber a brand name (e.g., Trevira polyester, Cordura nylon, Orlon acrylic). Some brand-name fibers have unique features, but many are virtually identical to those offered by other companies. Generic fibers are sometimes called *unbranded* fiber.

POLYESTER. Perhaps the best all-around performing synthetic fiber, polyester is light-resistant, wrinkle-resistant, dimensionally stable, and available in a variety of forms. When properly processed and constructed, polyester fabrics have good abrasion resistance as well. Polyester is easy to clean, but some stains can be hard to remove. It also can be recycled. Its versatility makes it popular for upholstered furnishings (primarily in blends) and it is the preferred fiber for many vertical applications: as drapery, hospital-cubicle curtains, wallcoverings, and panel fabric.

In the interior furnishings market, most types of polyester are not marketed under brand names. The exception is flame-resistant polyester. When exposed to open flame, polyester melts and pulls away from the heat source. This property makes it perform well on flammability tests. Generic polyester fiber has been manipulated to perform even more favorably on such tests, and it has been marketed and promoted for that feature. The most popular flame-

3-31 Filament polyester is a popular warp yarn for jacquard fabrics with many different fill yarns.

3-32 Trevira polyester is well established in the contract market for many end-uses.

resistant polyester fiber has long been known as Trevira F.R. (for *Flame-Resistant* or *Flame-Retardant*), which is a brand name of the Hoechst Celanese Fiber Corporation. Hoechst Celanese renamed this product Avora, but the older product (labeled Trevira F.R.) is still in circulation. Non-flame-resistant versions of Trevira are also available. This polyester fiber is simply named Trevira.

Trevira C.S. (*Comfort* and *Safety*) is manufactured by the company's Eur-opean producers. It performs virtually identically to the F.R. version, but the two are currently available in some different fiber forms. For example, C.S. is available in a higher sheen, while F.R. is in a semi-dull form. C.S. can be spun into yarns and then woven into fabrics with a higher luster than is produced with the F.R. yarns (figure 3-32). Avora and Trevira F.R. and C.S. do not maintain their flame resistance when blended with other fibers and therefore must be

used in 100 percent form when flame resistance (to pass a particular code) is required.

Another popular flame-resistant polyester is Visa polyester from one of the largest fabric producers, Milliken. Visa is not actually modified in the fiber state; rather, the finished fabric is aftertreated. Because the treatment is added in the dyeing process under high heat and pressure and is precisely controlled, it is considered permanent, and polyester fabrics with this treatment are identified as Visa polyester. (Visa was developed as a soil-release treatment for polyester, and its flame resistance

was only subsequently recognized.) Because Visa is only available from Milliken, which is a weaving mill and not a fiber company, it exists only in the types of fabrics that Milliken chooses to weave and market. Fiber producers usually sell fiber to many spinners and weavers. Avora and Trevira, for example, are woven at many different mills into a broad variety of fabric types.

NYLON. Nylon is the definitive synthetic for carpet and at one time was the definitive synthetic for contract upholstery fabric. As the market has become more accepting of a broader

variety of fibers and fabric types, nylon has become less popular, maintaining only a small niche, mostly in high-volume, low-cost fabrics that need to withstand very heavy traffic (figure 3-33).

Nylon is offered in its filament (or air-textured) state. Its staple can be spun similarly to wool fiber on either woolen (carded) or worsted (carded and combed) spinning systems. It can be dyed in the fiber, yarn, or finished-fabric state (see figure 6-16). Its tensile strength makes it a popular choice for intimate blends with fibers more vulnerable to wear. It is commonly blended with wool for this

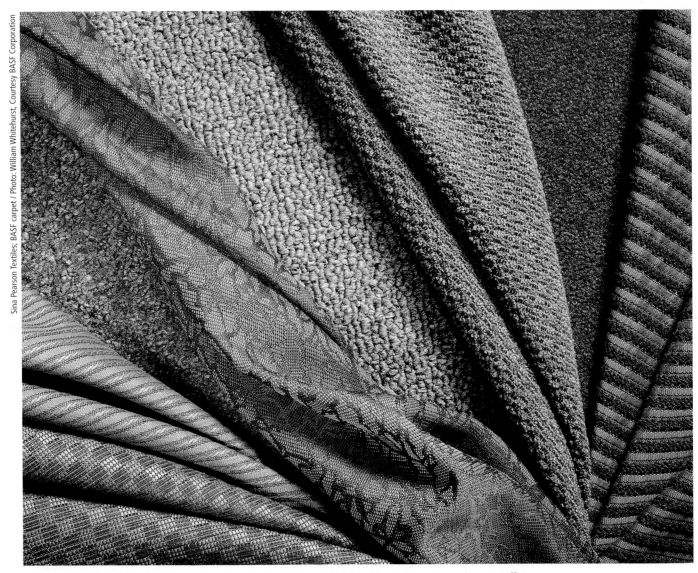

3-33 Nylon maintains a niche in high-volume, low-cost fabrics that need to withstand very heavy traffic.

purpose, though its supposed superiority to a suitable grade of wool fiber is questionable, and nylon's propensity to pill arguably generates an inferior performance to 100 percent wool in such blends. (Intimate blends of 90 percent worsted wool and 10 percent nylon are, nonetheless, the staple grade of fabrics for aircraft seating.) Furthermore, once wool is blended with nylon, it no longer maintains the biodegradable feature of wool or the potential recyclability of nylon. Nylon, like most synthetics, is vulnerable to stains, but it can be cleaned with routine methods.

Compared to those of other popular upholstery fibers, fabrics of spun nylon are the most vulnerable to *pilling* because of nylon's high static and tensile strength. The static emitted from the surfaces of these fabrics attracts free-floating particles in the air, and the tenacity of the fabric makes it hold onto those *pills*, or flecks on the surface of the fabric, while pills on softer fibers are gently rubbed away through use. Pilling is minimized by tightly spun yarns and tightly woven fabrics that allow only minimal strands of fiber to reach out of the fabric's bounds. Fabrics of filament nylon yarn (figure 3-34) are considered to be some of the most durable fabrics available; they do not pill because the continuous strand of filament leaves no short ends of the fiber on the fabric's face.

Nylon's poor *moisture regain*, or ability to regain its original size and shape after it has absorbed atmospheric moisture, makes it unsuitable for wallcovering, drapery, or other vertical uses. Even on a humid day, its own weight pulls it down into unsightly sags. Its poor moisture regain is not a problem in upholstery because the fabric does not hang

Upholstery nylon is occasionally

3-34 Fabrics of filament nylon are considered to be some of the most durable fabrics available because the continuous strands of filament do not allow short ends of fiber on the fabric's face.

marketed by brand names. Popular nylon brands (with producers) are Antron (DuPont), BASF (BASF), and Cordura (DuPont). BASF is available only in solution-dyed and air-textured filament form. Cordura exists only in a high-luster filament form.

Nylon is not considered flame-retardant, but it usually can be aftertreated or backed to pass most fire codes. Nomex (DuPont), considered a form of nylon, does not burn. However, it cannot be dyed and is very stiff, difficult to cut, and quite expensive. For these reasons its application is largely for industrial uses, such as firefighters' clothing. Like glass fiber, it is used in upholstery as a barrier that prevents flame from reaching the interior cushion material of the furniture.

ACRYLIC/MODACRYLIC. Because it is soft, bulky, nonallergenic, and warm, acrylic is a popular wool sub-

stitute in sweaters and blankets. However, it is not popular in furnishings for two reasons. First, its low abrasion resistance makes it unsuitable for upholstery. Second, it is one of the few fibers to which no aftertreatment for flame resistance can be added. This means that acrylic cannot pass the necessary tests for the difficult fire codes occasionally required for furnishings. Although the aftertreatments are not usually needed, fabric suppliers prefer to market fabrics that allow for the possibility of treatment as need arises.

Modacrylic (from "modified acrylic") was developed as an inherently flame-resistant version of acrylic fiber, and before the advent of Trevira F.R., it was the most prevalent flame-resistant fiber. Unlike Avora or Trevira F.R., modacrylic maintains its flame resistance in certain blends, making it possible to develop flame-resistant yarns and fabrics with a range of aesthetic characteris-

3-35 Modacrylic is blended with nylon in a popular upholstery construction.

tics. It is commonly blended with nylon in a popular upholstery yarn, and sometimes with polyester or other fibers for wall or panel application (figure 3-35). Because it requires dry cleaning, modacrylic's use for drapery has been largely eliminated since the appearance of the washable Trevira F.R., Avora, and Visa polyesters. A dry, matte fiber, modacrylic maintains a flat, almost brittle appearance, even in blends.

Orlon, from DuPont, is the most prevalent brand name of acrylic. SEF (for *Self-Extinguishing Fiber*), from

Solutia (formerly Monsanto), is the most widely used modacrylic brand. Kanekalon, from Kanekafuchi, is modacrylic that is available in a higher-luster form.

OLEFIN. Also called polypropylene, olefin is a lightweight, bulky, low-cost petrochemical fiber (see figure 3-5). These features, as well as its nonabsorbency and stain and mildew resistance, make it extremely popular for very heavy-use upholstery, adhered wallcoverings, and some carpets. It is a popular plastic

material in items like soda bottles that can be recycled into yarn. However, olefin can only be dyed in the fiber state, so its color flexibility is quite limited. The fiber companies determine the colors in which olefin will be available. Those colors can be blended as the yarn is formed, but the raw fiber color cannot be altered (figure 3-36). Partly because of its limitation in color, olefin tends to be used in high-volume and commercial markets.

Furthermore, although olefin passes common flammability requirements, it cannot be aftertreated for flame resistance to satisfy the most stringent tests. Herculon (made by Hercules and used primarily in residential fabrics), Nouvelle (Hercules's contract brand fiber), and American Fiber (formerly Amoco Fiber) are the prominent olefin fibers.

SPANDEX. Spandex is a generic fiber category that has elastomeric properties similar to those of latex (or rubber), but its flexibility, strength, and resistance to abrasion and to deterioration from exposure to oils (and perspiration) are better than those of rubber. Also unlike latex, spandex blends beautifully with other fibers and is almost always featured in a yarn that covers a core of spandex with fibers of polyester, cotton, or wool. For interior furnishings fabrics a small percentage of spandex is sometimes blended with other fibers to increase the material's recovery, especially when it needs to cover curvaceous, sculptural forms of seating. Lycra, owned by DuPont, is the best-known brand of spandex.

Yarn

Most yarns are either spun, using processes developed to most advan-

tageously utilize specific types of fiber (woolen, worsted, cotton, and linen spinning), or extruded and manipulated out of synthetic materials. A yarn is any linear material that is used in fabric-making.

FILAMENT YARNS

The simplest yarns are made of an individual strand of fiber, or monofilament. Mylar and Lurex, which are brand names of metallic-looking yarns that are actually finely cut strips of sheets of synthetic fiber (called slit film), are examples of monofilaments (see figure 3-47). A multifilament consists of several filaments used together as one yarn. Silk reeled from the cocoon is a multifilament, as are most synthetics extruded through the tiny openings in the spinneret. Because filament yarns are a continuous material without loose ends or rough edges, they resist pilling and have a high tensile strength. Continuous filament is the smoothest form of synthetic yarn just out of the extrusion process. Texturized, air-texturized, or air-entangled filament yarns look more natural because their surfaces are rougher (see figure 3-5).

SPUN YARNS

Most yarns are spun (which simply means they are manufactured through one of the systems that utilize spinning frame equipment) from either natural fiber or man-made fiber staple. Because spun yarn is made from staple fiber and not from a continuous filament, its characteristic feature is that loose lengths of fiber can be removed from the yarn if it is unwound and pulled apart.

YARN SIZE

Yarn is generally measured by its length per pound. A heavy yarn

3-36 Olefin (polypropylene) can only be dyed in the fiber state, and the raw fiber color cannot be subsequently altered. Synthetic fiber is stored in pellet form.

yields fewer yards per pound (meters per kilo) (although it will "fill up" a fabric more quickly) while a finer (thinner) yarn has a higher yield, or more yards per pound (meters per kilo). Harkening back centuries, different equipment and processes were invented to achieve varied spinning effects with cotton, wool, and linen. Yarn from each of these spinning systems was measured differently. We still use these different units, or yarn counts, today. Cotton yarn in bed sheets may be advertised as "fine, 60s cotton." Woolen yarn is called "1 run," "2 run," etc. These are sizes of yarn only and have nothing to do with quality or other features.

YARN TWIST

After yarns are spun, they are twisted to increase strength and abrasion resistance. The degree of twist can vary from none at all, called a roving yarn (figure 3-37), to so tight that the yarn doubles back on itself and has a bumpy, pebbly texture, called a crepe yarn. Most yarn is twisted

somewhere between the two extremes, and in a clockwise direction, called an *S twist*. Yarn twisted in the opposite direction is a *Z twist;* it is used for increased texture in some novelty effects, especially crepes.

YARN PLY

Twisted yarn is single-ply, called singles. Singles yarns best show the original character of the fiber and are used in many fabrics, like woolen tweeds or soft apparel cashmere, for example. However, two (or, rarely, three or four) singles yarns can be twisted together to form a stronger, smoother, more even yarn called a two-ply (or three-ply or four-ply). Worsted yarns, for which a smooth, even character is desirable, are almost always two-ply, and even yarns that are often used as singles, such as cashmere, can be two-plied for increased durability in interior use. Cotton's versatility allows it to be used in many forms. For shirting and sheets it may be promoted as carded or combed, singles or two-

3-37 A heavy yarn twisted very slightly is called roving.

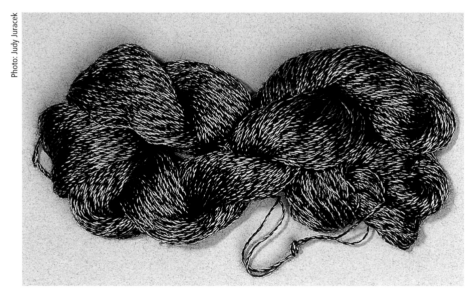

3-38 Marl or jaspé yarn is produced when two yarns of the same size but different colors are plied together.

ply, and fewer or more threads per inch; the latter in each case yields a smoother, softer, more luxurious, and more durable fabric.

When yarns of the same size but of two different colors are plied together, a barber pole–like effect called a *marl* or *jaspé* is produced (figure 3-38). When marl yarns are used in pile or carpet the all-over, random, marblelike effect is called *moresque* (figure 3-39).

SLUBS AND NUBS

A slub yarn gradually shifts from thicker to thinner over long lengths (figure 3-40). Slubs are an inherent feature of some fibers, such as linen and doupioni. Mechanical slubs can be added to some yarns in the spinning process by feeding more, less, and then more fiber into the machine. As with all things natural and synthetic, the natural slub is beautiful for its randomness while the mechanical slub is regular, appearing as a pattern over a large area, which is often unwanted.

A *nub* is a small knot of fiber that is fed into the staple during spinning. Wool tweeds with multicolor specks are examples of nub yarns in which the nubs are dyed a contrasting color before the yarn is spun (figure 3-41). Silk tweeds can be similarly created with contrasting color noils. Some nubs that naturally occur in fiber are picked out and eliminated before the yarn is spun; if they appear only occasionally, nubs may seem to be flaws, especially because they often do not dye evenly with the rest of the fiber.

NOVELTY YARNS

Novelty yarns are manufactured in a variety of methods. In novelty twisting, components of different sizes and characters are wrapped and twisted in varied and interesting ways. A bouclé (figure 3-42) twists a heavy ply roving back and forth in a loopy or curly pattern over a fine, threadlike core and then is held together with a fine wrap yarn. Variations of bouclé are *ratiné*, in which the effect yarn is less loopy and more zigzagged, and *seed yarn*, which is nearly smooth for great lengths and then shows bunches of the effect yarn in knots, or "seeds" (figure 3-43).

True *chenille* yarn (figure 3-44) is made by weaving a fabric with spaced warp yarns and then cutting the fabric into strips between the warp spaces, which exposes the cut end of the filling along a continuous band held together by the warp. The fuzzy surface of chenille is similar to a pipe cleaner or a caterpillar; in fact, "chenille" is French for caterpillar. Today, most chenille is made by novelty twisting, with the loose fiber fed into the twister, which binds the short cut fibers as the core is created.

(The actual yarn is made up of core binders, the long yarns that are not visible but hold the fuzzy, "cut" material together.) *Mock chenille* is a much less expensive process, and is most often made of a synthetic ratiné yarn that is cut or abraded to fray the fibers on the outside surface.

Even true chenille yarn can vary dramatically in quality, depending upon the actual quality of the fiber being used, the way it is twisted, how many binders hold it together, and the way the binders are formed. Chenille is available in an extraordinary variety of price points. Unfortunately, however, this confuses many consumers. While it can be difficult to compare how two fabrics are made and anticipate how well they will perform in their ultimate use, generally a less expensive chenille is not as densely fabricated and the loose ends will eventually pull out, making the fabric look "bald." Evaluating a sample of the fabric can help, and a good supplier should offer advice on how the fabric should be used.

Chenille is often used as a term to describe fabrics made primarily of chenille yarn (figure 3-45). The fabrics that are made into what are commonly called "chenille bedspreads" (or *candlewick* fabric) are another item altogether (figure 3-46). They may not contain chenille yarns at all, but rather are a kind of pile fabric (see chapter 4).

A yarn can be a continuous strand of braid or knit; a shoelace is an example. *Gimp* is a yarn with a completely covered core. Elastic yarns are often gimp of latex core with a predominant fiber covering; metallics are often gimp of a slit film wrapping a stronger continuous synthetic core (figures 3-47, 3-48).

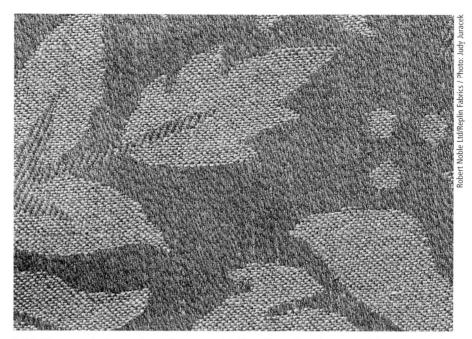

3-39 Moresque is the random, all-over, marblelike effect of marl yarns in fabric.

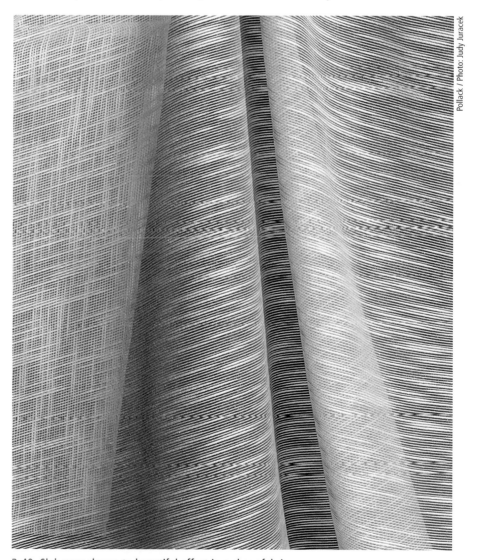

3-40 Slub yarn shown to beautiful effect in a sheer fabric.

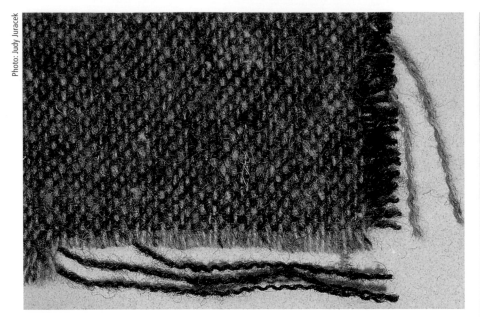

TOP LEFT
3-41 For this tweed fabric, nubs were dyed contrasting colors before the yarn was made.

TOP RIGHT
3-42 Bouclé yarn creates a relief surface in this upholstery fabric.

CENTER
3-43 Bouclé (loopy character, bottom), seed (bunches/knots, center), and ratiné (zigzagged, above) yarns.

BOTTOM
3-44 The fuzzy surface of two chenille yarns.

TOP LEFT
3-45 Any fabric made primarily of chenille yarn is called chenille fabric.

TOP RIGHT
3-46 Chenille bedspreads are made of candlewick, a kind of pile fabric.

CENTER
3-47 Metallic yarns are often gimp of slit film wrapping a stronger synthetic core.

RIGHT
3-48 Metallic yarn in jacquard fabric.

YARN COLOR EFFECTS

Many color effects can be created in spinning and twisting. As noted earlier, twisting yarns of different colors into a two-ply yarn creates a marl, or jaspé (see figure 3-38). Tweeds and heathers are created by blending contrasting colors of fiber into a single yarn (figure 3-49). Space-dye yarns are dipped, printed, or injected with contrasting colors at intervals along the length of finished yarn to create a "random" appearance of color (figure 3-50). Novelty twisted and chenille yarns can become multicolored if they are made up of components of different colors (figure 3-51). Synthetic filament yarns can be formed with contrasting color filaments that are extruded together or joined in a distressing process like air entangling, or they can be spun in a similar fashion to natural fiber staple.

3-49 Heather yarn is created by blending contrasting colors of fiber into a single yarn.

3-50 Space-dye yarns are dipped, printed, or injected with contrasting colors along a single length of yarn.

3-51 Chenille yarn is multicolored when it is made of individually colored components.

Fabric Structure

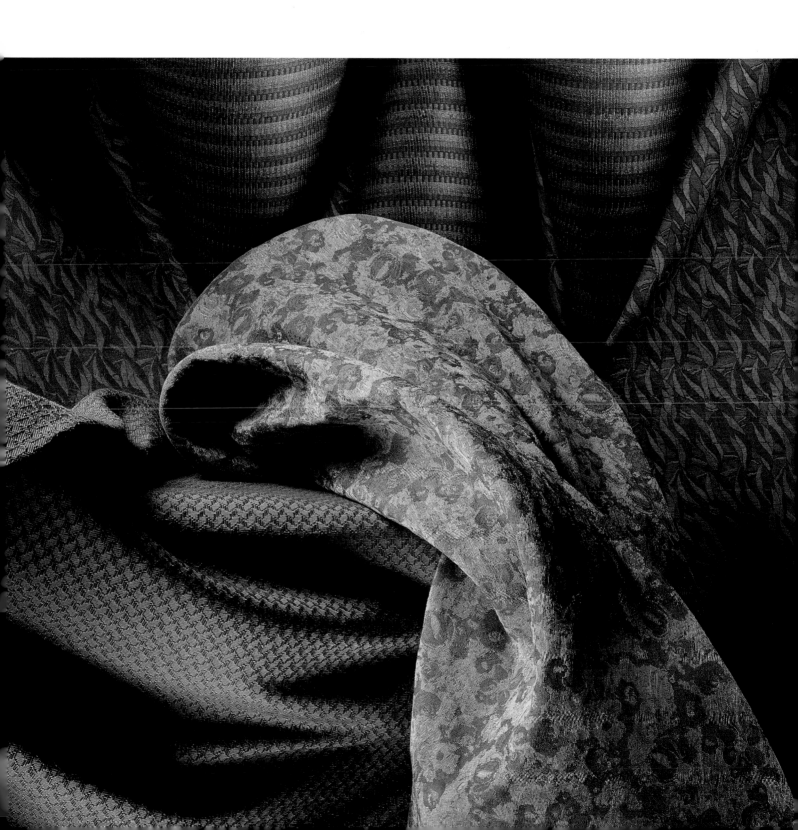

We are surrounded by fabrics almost all the time, so much so that we probably do not even realize how many words in our everyday parlance are actually technical terms for fabric. For example, "woolens" and "tweeds" are actually fiber- and yarn-spinning systems, while "floral" is a pattern and "chintz" is a finish. These terms, and many others, relate to various aspects of the character of fabrics.

Fabric *structure*, or the way the cloth is made, is one of the most common ways to identify material; the term refers to the way the yarns or fibers are interlaced, interlooped, or held together. *Structure* is not the same as *construction*, which refers to the sizes and density of yarns in a particular cloth. Fabrics that use the same size and content of yarn, number of threads per inch or centimeter, weight, and finish are said to be the same *construction*, or *quality*. *Quality* is used to compare fabrics to each other irrespective of their pattern or design. *Fabric* is an all-encompassing term that includes all types of cloth, whether woven, knit, tufted, nonwoven, felted, or even occurring in nature. *Textiles*, by definition, are fabrics that are woven; most interior furnishing fabrics are woven. Nonetheless, fabrics of all other fabrications are used in significant interior furnishing applications. The overall use of materials that are not

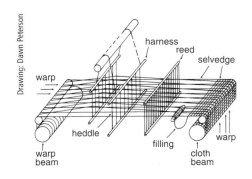

4-1 Loom diagram (front of loom at right).

woven continues to increase with the ongoing development of new fabrics and furniture, though their popularity may ebb and flow. It is helpful to have a basic overview of how popular furnishing fabrics are made and of how common fabric classifications relate to fabric's structure.

Wovens

Other than carpet (which is usually tufted) and vinyl (which is a film), by far the largest volume of fabric in an interior is woven. Despite great technological strides in many fields, woven fabrics basically are still produced as they have been for centuries. Although today we can weave more quickly, more efficiently, and with more consistent quality, the process has always entailed a set of parallel vertical threads (the warp) laid flat and run lengthwise through the loom, and a horizontal set (the fill, or weft) interlaced one thread at a time through the warp yarns (figure 4-1). Patterns can, of course, be added to the surface of a fabric through printing, but woven patterns depend upon whether the warp or the fill is over the yarn of opposing direction at each interlacing of the fabric. The vertical edges of the woven fabric are the selvedges, which are usually of a stronger yarn

4-2 The three basic weaves (left to right), twill, plain, and satin, are clearly illustrated as the subject matter of this piece by Carol Westfall.

than the rest of the fabric and are "bound" where the filling yarns wrap around the edges as they are woven.

Woven structures can be varied in three ways: by grouping yarns together in the weave, by varying the size and scale of yarns in a fabric, and by varying the density of the yarns within a specific area of cloth.

BASIC WEAVES

All woven patterns conform to one of the three basic weave structures: plain weave, twill weave, and satin weave (figure 4-2). Fabrics woven of these basic weaves are often called shaft woven, a shaft (or harness) being the part of the loom that holds the heddles (cords or wires) through which the warp ends are threaded.

In *plain weave* (figure 4-3), every individual warp thread, or end, interlaces alternately with every individual fill thread, or pick. Plain weave, or *taffeta*, is universal; it is used for a wide range of fabrics including the finest silk (figure 4-4), medical gauze, tweed, and ground cloth for cotton prints. The simplest variations on plain weave are *basket weaves* (figures 4-5–4-8), in which several yarns in each direction are grouped together and woven as one. Many wallcoverings, panel fabrics, draperies, and upholstery fabrics are simply a plain weave that showcases a particular

yarn. *Grosgrain*, *faille*, *rep* (figures 4-9, 4-10), and *ottoman* are all examples of plain weaves (or variations) in which a much denser warp is woven with a much heavier fill yarn (or a group of fill yarns handled as one yarn). This *cramming* of extra yarns in the warp direction forms a horizontal ribbed fabric (figure 4-11). Cramming weft yarns on a sparser warp is the common construction of flat-woven rugs, such as Navajo rugs and kilims (figures 4-12 – 4-14) but is not aesthetically or commercially practical for most other fabric uses. The hand technique of tapestry weaving also utilizes weft cramming (figure 4-15), in which *discontinuous wefts* (a weft woven back and forth between

4-3 Plain weave executed in vinyl-wrapped cord.

4-4 Silk taffeta's crisp hand makes it a beautiful drapery material.

TOP AND ABOVE
4-5, 4-6, 4-7 Basket weave variations. The third example shows the face (top) and back of the fabric.

CENTER RIGHT
4-8 Basket weave variation with chenille yarn.

BOTTOM RIGHT
4-9 Rep ground in jacquard upholstery fabric.

TOP LEFT
4-10 Pattern of broken rep effect.

TOP RIGHT
4-11 Cramming of extra yarns in the warp direction forms a horizontal ribbed fabric.

LEFT
4-12 Cramming weft yarns is a common construction of flat-woven rugs.

ABOVE
4-13 Plain weave in rug, fill face, detail of 4-12.

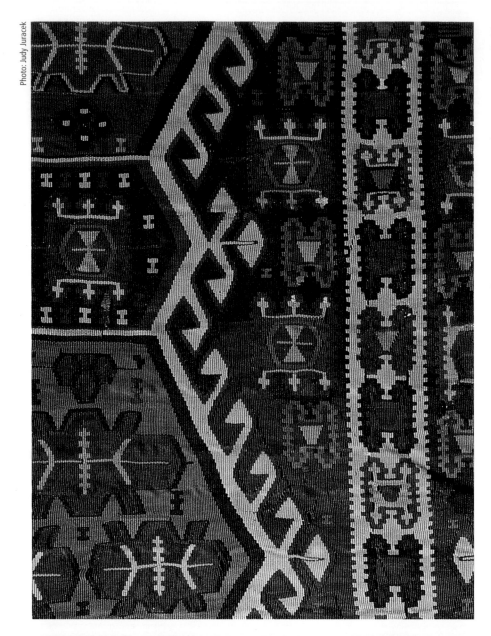

Photo: Judy Juracek

warp ends only in the area where it will appear on the fabric's face, rather than all the way across the goods from selvedge to selvedge) are woven in contiguous areas to produce areas of pure color. So-called tapestry-woven upholstery fabrics (figure 4-16) are jacquard-woven weft-faced fabrics, described later in this chapter.

In *twill*, the fill yarns (or filling) pass over one or more and under two or more warp yarns in successive off-set progression to create the appearance of diagonal lines (figure 4-17). The width, scale, and frequency of the diagonal change according to the arrangement of the interlacings, but each successive pick is woven in the same arrangement, offset by one end. Denim is a ubiquitous twill cloth. Other popular twills are serge, worsted gabardine, and cavalry. *Herringbone* is formed by bands of twill lines of alternating direction (figure 4-18).

Warp-faced twill shows more warp yarn on the face and fill-faced twill shows more filling on the face. Combinations of warp- and fill-face twills can be mixed in one fabric to create a pattern in a structure called *twill damask*. Twill lines lean either left or right, and when the two are combined a *reverse twill* fabric results (figure 4-19). *Broken twills*, in which twill lines of the same direction are interrupted and repeated in varying patterns, produce beautiful effects. Most dobby geometrics (see page 77) are based on twill variations.

In a *satin*, more warp yarns pass over the fill (a *warp-faced* weave) and are interlaced at widely spaced intervals to form a smooth, unbroken sur-

Photo: Judy Juracek

4-14 Plain weave in kilim rug, fill face.

4-15 Detail of hand technique of tapestry weaving is evident in kilim rugs.

TOP LEFT: 4-16 Traditional floral pattern in tapestry-woven upholstery fabric.

TOP RIGHT: 4-17 Twill weave is characterized by the overall diagonal effect of the woven surface.

CENTER LEFT: 4-18 Herringbone is formed by bands of twill lines of alternating direction.

CENTER RIGHT: 4-19 In reverse twill, twill lines of opposing direction are interrupted and repeated in varying patterns.

RIGHT: 4-20 Lustrous satin weave contrasts with the matte character of plain weave in this diamond matelassé pattern.

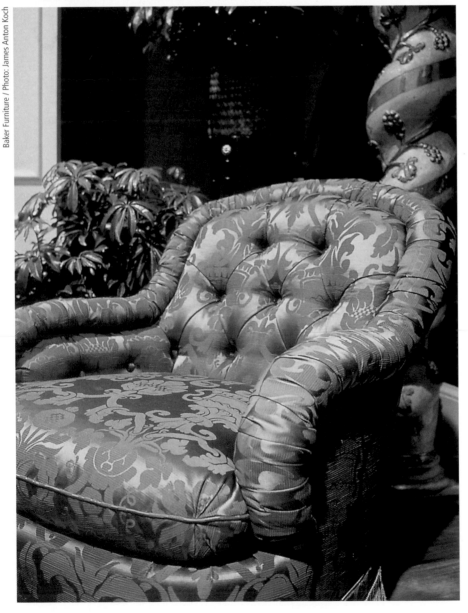

face (figure 4-20). A *sateen* is the opposite of a satin; it is a fill-faced fabric created in the same way (figure 4-21). Its surface is consistent but has a regular bump or slight tooth. To enhance the smooth surface, satin fabrics are usually woven on a dense warp of lustrous yarn. After satin is woven, it may be pressed with heat and steam to further enhance the polished appearance (called *calendering* for cottons and *decating* for worsted wools). Cotton satin ground cloth that is marketed in printed patterns or rich, solid colors is often called *warp sateen*, though that is technically an oxymoron. A beautifully finished, pressed, plain satin fabric of worsted wool is a *Venetian*. Antique satin is a popular drapery cloth made to simulate seventeenth- and eighteenth-century silks. It features a slub filling yarn in a satin weave fabric of lustrous fiber.

Tone-on-tone or positive/negative patterns created by using satin in certain areas and sateen in other areas are of *damask* structure (figures 4-22–4-26). Typical damask patterns are symmetrical and medallionlike, often with floral or leaf forms held in vases or urns (figures 4-27–4-29). These patterns are sometimes called *damasks*, *framed damasks*, or *frames*—even when they are actually executed in other structures (figures 4-30, 4-31). A jacquard loom is necessary to create such elaborate patterns, although simple geometric patterns can be achieved in damask structure on dobby or some shaft looms (figures 4-32, 4-33, 4-38).

Text continues on page 75

4-21 Sateen (gold) areas contrast beautifully with fill-faced broken cord-weave stripes.

4-22 Symetrical floral and leaf forms are typical of damask patterns.

ABOVE

4-23 Silk damask construction in small geometric pattern.

RIGHT

4-24 Contemporary geometric pattern in damask construction. Solid gray is satin, multicolor stripes are sateen.

BELOW

4-25 Traditional damask on loveseat and pillows.

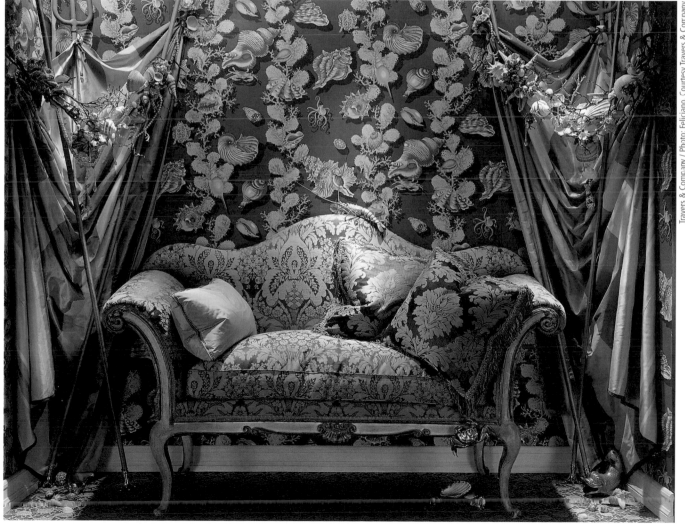

ABOVE
4-26 Damask of worsted wool satin (brown) and linen sateen (green).

RIGHT
4-27 Vases and urns are typically featured in framed damask patterns.

BELOW
4-28 Damask on sofa.

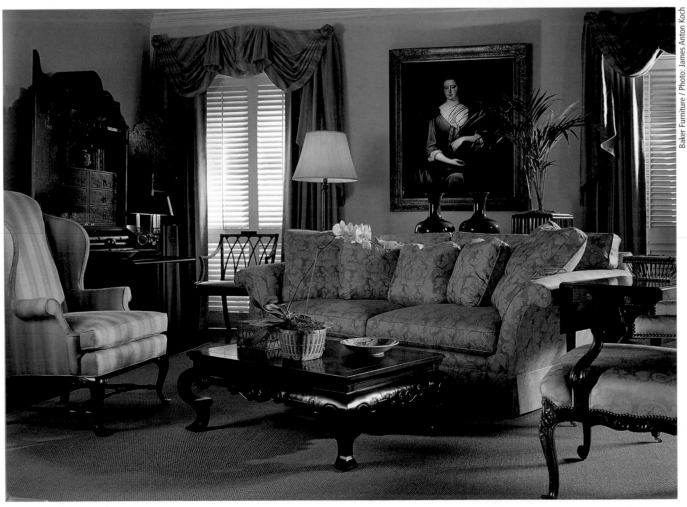

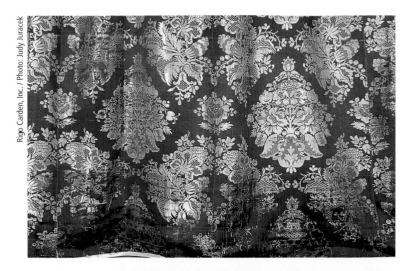

4-29 Traditional damask pattern with a patterned weave to replace the satin typically used in the ground of such fabrics.

4-30 The damask pattern on chair features a striaé warp and linen fill yarn, yielding an all-over textural effect.

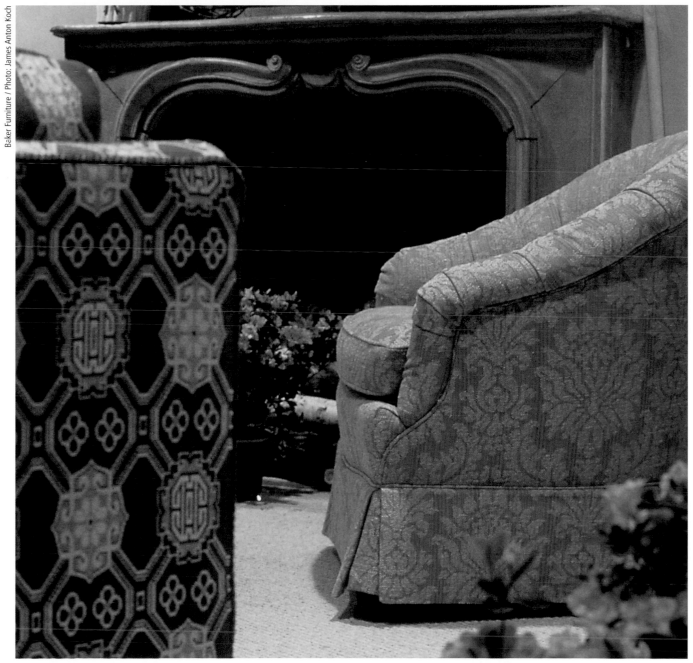

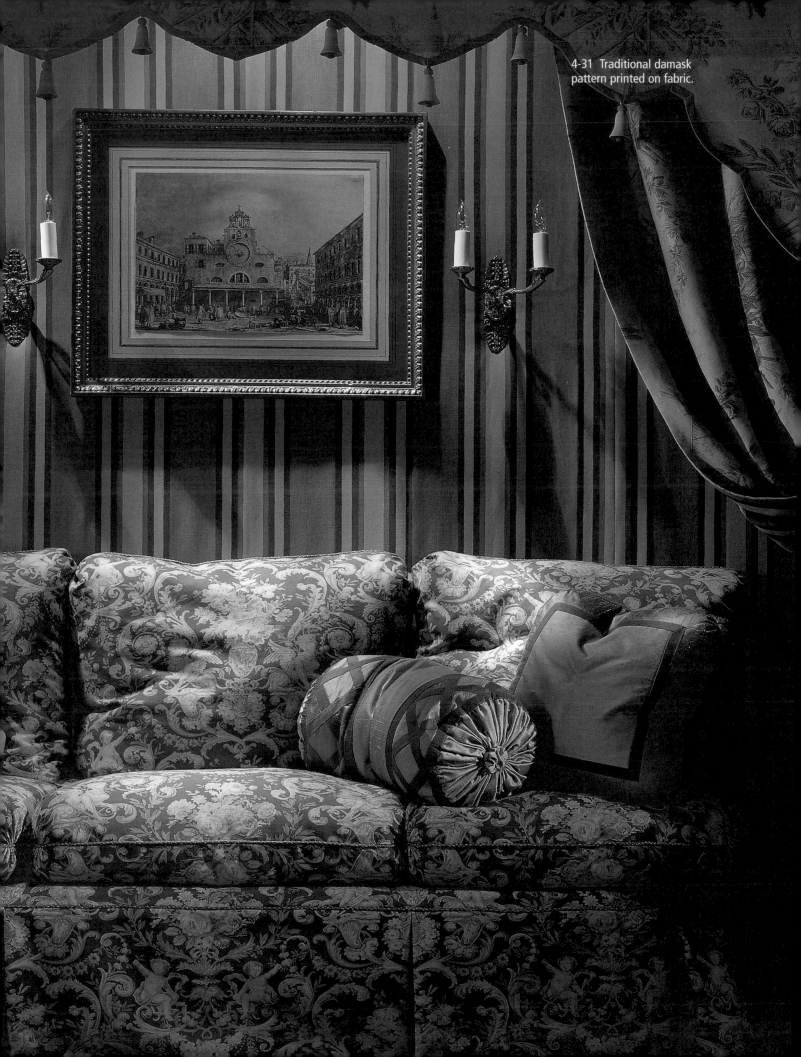

4-31 Traditional damask pattern printed on fabric.

Rodolph Incorporated, designer: Marypaul Yates / Photo: Judy Juracek

Rodolph Incorporated, designer: Marypaul Yates
Photo: Judy Juracek

Pollack / Photo: Judy Juracek

Pollack / Photo: Judy Juracek

Travers & Company / Photo: Feliciano, Courtesy Travers & Company

Robert Allen Contract / Photo: Judy Juracek

Robert Allen Contract / Photo: Judy Juracek

CLOCKWISE FROM ABOVE

4-32 Simple geometrics, stripes, and plaids can be achieved through dobby weaving in damask structures.

4-33 In this shaft-woven fabric, satin weave in stripes enhances luster against plain weave ground.

4-34 The face (pictured here) and back of true damask fabrics are exact opposites of positive and negative effects.

4-35 Back of fabric shown in figure 4-34.

4-36 This fabric uses many weaves, unlike a true damask of reverse satins, but follows the principle that the warp-effect face and fill-effect back are the positive and negative of the same image.

4-37 Back of fabric shown in figure 4-36.

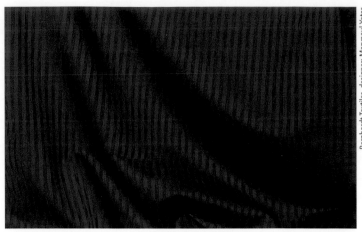

Bernhardt Textiles, designer: Marypaul Yates
Photo: Judy Juracek

4-38 The simple satin weave in stripes could be shaft or dobby woven, but the pattern is created by the undulating effect in ground areas, which requires jacquard capability.

4-39 Detail of the upholstery shown opposite.

OPPOSITE
4-40 Furniture upholstered with dramatically scaled chenille-ground damask pattern.

Baker Furniture / Photo: James Anton Koch

Baker Furniture / Photo: James Anton Koch

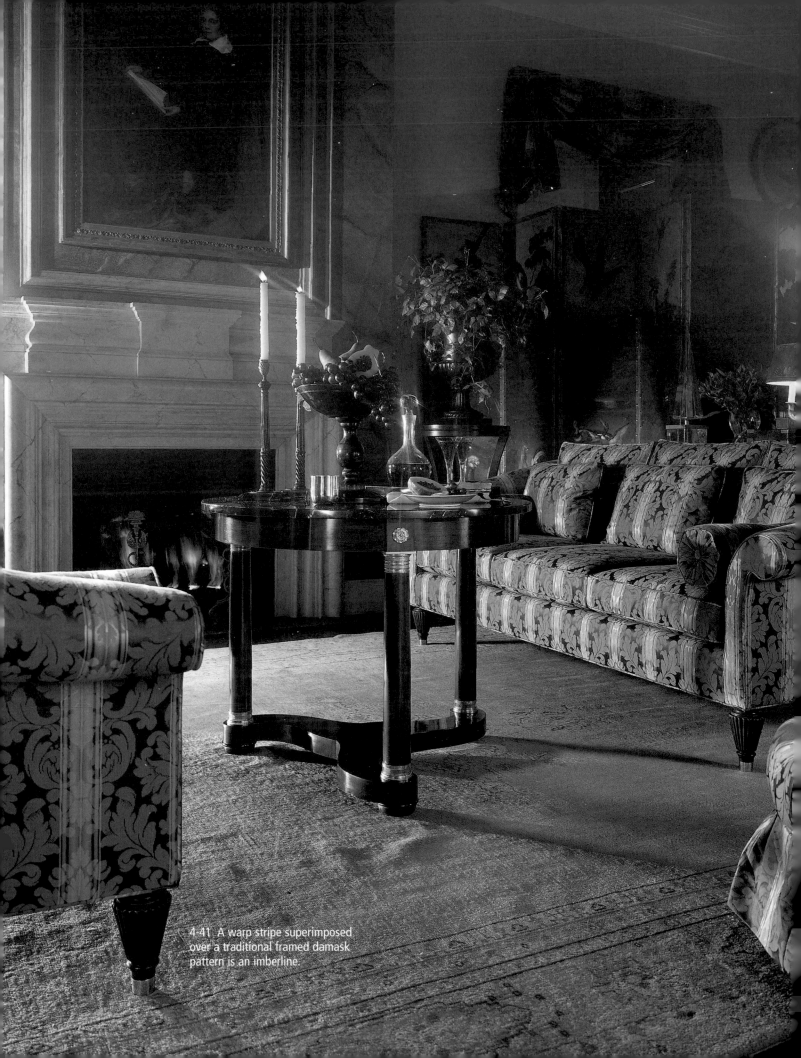

4-41 A warp stripe superimposed over a traditional framed damask pattern is an imberline.

A damask is a *single-fabric* structure, which means that each pick is either on the face or behind the warp (figures 4-34–4-40). No yarn can be "layered" or "hidden." In damask, filling colors cannot be isolated or separated from each other and woven only within certain areas of the pattern; rather, if more than one filling color is used, a horizontal stripe is created. Similarly, more than one warp color results in a vertical stripe. When a warp stripe is superimposed over a traditional framed damask pattern, the pattern is called an *imberline* or *imberline stripe* (figures 4-41–4-43).

In a *crepe weave* (figures 4-44, 4-45), which is a variation on twill or satin, each end and pick is tied down at intervals as irregular as possible, so that the surface of the fabric seems "randomly" uneven. The mechanics of the loom dictate that every weave repeat at a specified interval, but crepe weaves are often extended over many ends and picks to enhance the illusion of the randomness of the weave. The inherent stretch in a crepe-woven fabric makes it an ideal upholstery cloth. Its pebbly, irregular surface is intensified when it is woven in yarns that are twisted very tightly and in different directions. Such high-twist yarns are, therefore, known as *crepe yarns*, and fabrics employing an all-over crepe weave are simply *crepes*.

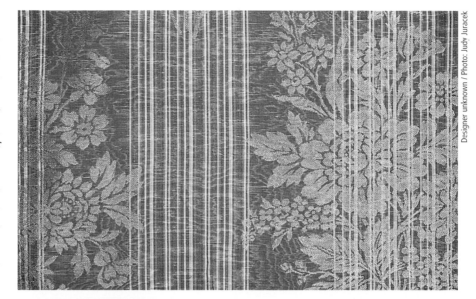

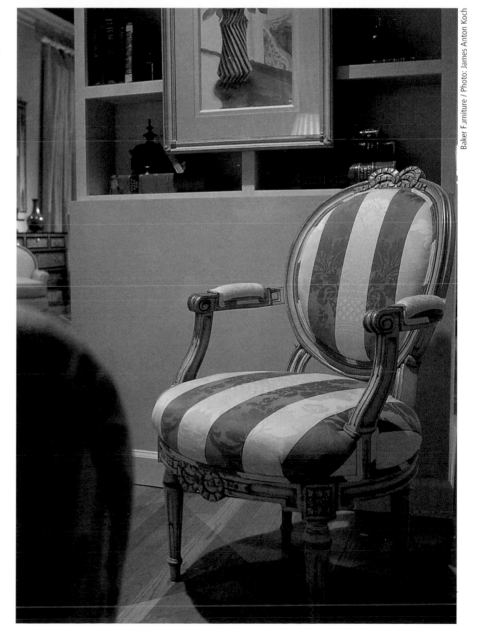

4-42 Imberline with multicolor striped warp and moiré finish.

4-43 The frame-damask pattern of this imberline appears quite subtle because the warp stripe is of such high contrast.

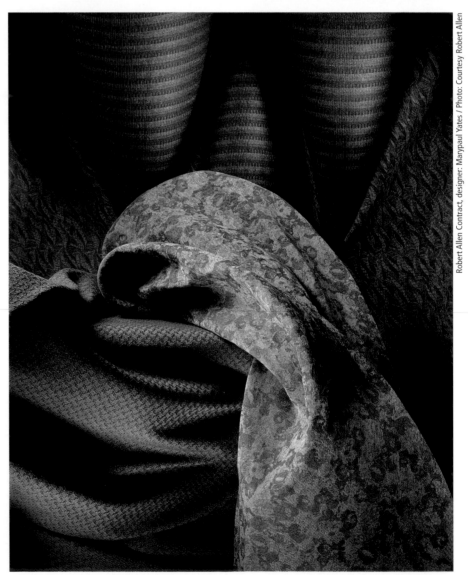

CLOCKWISE FROM TOP LEFT

4-44 In a crepe weave, all threads in the cloth are tied down at intervals that are as irregular as possible so that the surface seems pebbly and irregular.

4-45 Crepe weaves are used as the ground of many jacquard patterns such as this one.

4-46 In this coordinated upholstery fabric collection, the floral and abstract are jacquards. The geometrics (top and bottom) are dobby-woven.

4-47 Geometric dobby effect.

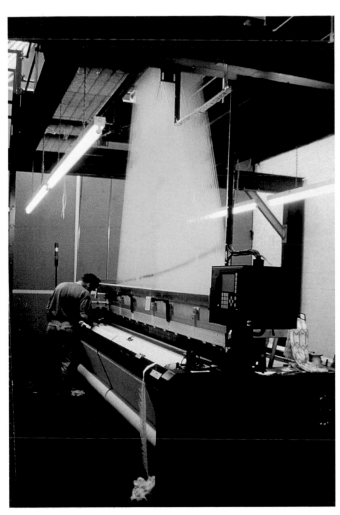

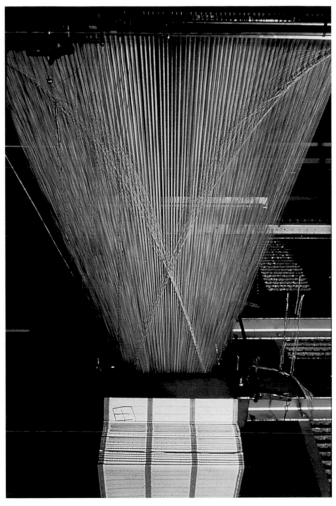

4-48 The yellow threads rising out of the loom are the heddles, which are controlled by the jacquard head above the gantry and lift the individual warp threads according to instructions that will achieve the fabric's pattern as it is woven.

4-49 Sitting above the gantry, the jacquard head obtains instructions by means of a punch-card system (though increasingly replaced by electronic devices) that directs the individual heddles to control the warp yarns.

DOBBY AND JACQUARD

Dobby and jacquard are not actually types of fabric structure. Rather, they are means of fabric manufacturing that allow different degrees of patterning within a variety of fabrics. As descriptive terms for woven fabric, a dobby refers to any small-scale geometric pattern and a jacquard to a large-scale pattern—whether geometric, floral, or abstract in motif (figure 4-46). Jacquard knits are warp knits that likewise feature large-scale pattern.

Dobby fabrics are very small geometric patterns woven by varying the arrangement of warp and fill interlacings (figure 4-47). Traditionally, dobby fabrics were created by (and named after) a special dobby mechanism that was attached to the loom and instructed the loom to weave such patterns. Today, most so-called dobby fabrics are actually woven on jacquard looms, and the name refers simply to the small-scale geometric motifs.

In a jacquard woven, a large number of the warp threads (usually half or a quarter of the total fabric width) are individually controlled by a loom pattern-control mechanism called the *jacquard head* (figures 4-48, 4-49). This allows for the largest possible pattern variation in a woven fabric. The jacquard mechanism, invented early in the nineteenth century by Joseph J. M. Jacquard, employed a punch-card system to replace a job that had been done by hand by "draw boys" who literally stood atop the loom and pulled up individual threads. The jacquard head has been considered the earliest precursor to the computer; today, most jacquard control is done by a computer that electronically controls the loom's thread-lifting instructions.

Although jacquard weaving allows for a great variety of patterns, it is limited in warp character and color flexibility. Because setting up jacquard warps is labor-intensive, every mill makes a commitment to the warps it

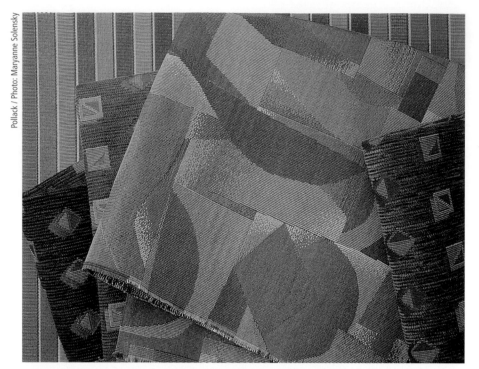

adopts and does not readily change this commitment. Once a mill adopts a yarn type and density of warp (or *sett*, which is the number of ends set per inch, or centimeter, of cloth), it equips certain looms to run on that construction. Changing to another sett is expensive and inefficient. Further, once a warp is established, most mills offer that construction in a range of specific colors. Custom jacquard warp colors are available, but not readily. Moreover, running a yarn with texture in a jacquard warp is extremely difficult, so jacquard fabrics nearly always feature a smooth warp.

Many popular furnishing fabrics are jacquard woven. *Tapestries* (figure 4-50) are designed with a rotating stripe of (usually) six different warp colors, with an individual end of each color following sequentially in repeating order (for instance, one end of red follows one of blue, which follows one of green, which follows one of gold, which follows one of purple, which follows one of black, which follows one of red again). The jacquard loom will be instructed to select all the red ends (which are every sixth end) to be lifted and woven with a particular filling to achieve a red area of the design. Blue ends, gold ends, and green ends are similarly selected in other areas. This warp-color arrangement, along with the weaves specified in each area, simulates the appearance of the true tapestry weave (in which fill-faced fabrics were hand-woven in plain weave with discontinuous weft) commonly used in past centuries for the large fabric murals in European cas-

4-50 Tapestry upholstery fabrics are jacquard woven.

4-51 Tapestry upholstery fabrics often feature period-style florals.

tles. Upholstery tapestry fabrics often feature period-style florals (figure 4-51) and scenes reminiscent of true tapestries, but this commercially produced tapestry technique can be used for anything multicolored and densely surfaced—from small geometrics to art deco–inspired abstractions (figures 4-52–4-54). Tapestry fabrics are extremely popular for upholstery; the multicolor effect makes them usable in many interiors and their heavy, dense construction is very durable (unless very fill-faced, heavy fill-yarn weaves are used). However, to run efficiently, an individual mill must limit its number of warp-color palettes. Because a tapestry requires several colors for each warp setup, most mills must limit the color flexibility for such constructions. Although the fill color influences the final fabric, these fabrics are warp-dominant. Therefore, when a particular mill uses green in the tapestry warp for tapestry-pattern leaves, any pattern woven on that warp will have almost the same green in its leaves. These patterns may reach the designer through various sources that all bought from the same mill (these distribution channels are discussed further in chapter 10).

BROCADE, LISÈRE, AND LAMPAS

Brocade (figures 4-55, 4-56) is a structure that uses a third element (a set of yarns all functioning similarly in a fabric) in addition to the warp and filling. This supplementary weft does

4-52 Art deco–inspired tapestry upholstery pattern (shown railroaded).

4-53 Harlequin (diamond motif) pattern in tapestery upholstery.

4-54 Tapestry upholstery with chenille yarn in geometric stripe.

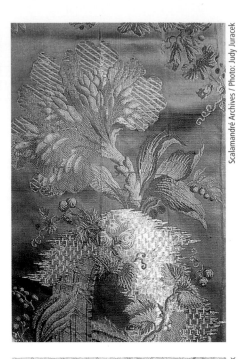

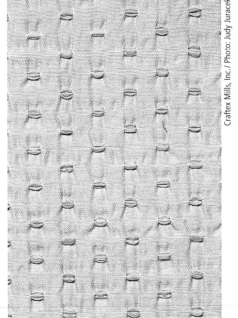

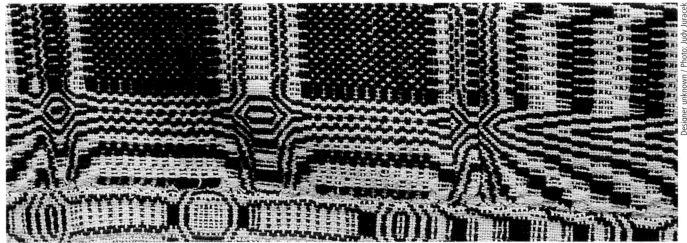

not create stability in the fabric or hold it together; rather, its decorative yarns are woven between the actual filling and usually float over large sections of the ground cloth between interlacings (figures 4-57, 4-58). The result is an embroidered effect created on the loom (figure 4-59). If supplementary yarns, whether weft or warp, were pulled out of the fabric, like stitches being removed, the "base fabric" would be of stable construction and only the figured pattern would be missing.

When the supplementary weft runs from selvedge to selvedge, surfacing only when needed to create the figure, it is called *continuous* (figure 4-60). On the back of the fabric the supplementary weft may create very long *floats* (yarn that passes over another yarn before it intersects again in the weave), shown in figure 4-61. In *cutwork* and *broché* these yarns are clipped away from the back

Rodolph Incorporated / Photo: Judy Juracek

Rodolph Incorporated / Photo: Judy Juracek

Rodolph Incorporated / Photo: Judy Juracek

OPPOSITE, CLOCKWISE FROM TOP LEFT
4-55 Brocade creates the clarity of the motif against the contrasting colored ground of the fabric on this chair.

4-56 Brocade utilizes a supplementary weft to create a motif that almost appears to sit on the surface of the fabric.

4-57 In this novelty-woven fabric, the supplementary weft is a ribbon yarn.

4-58 When brocade effect is woven in geometric dobby patterns, created by floating the supplementary fill over blocks of ground, the technique is called overshot.

RIGHT, TOP TO BOTTOM
4-59 Creating brocade on the loom is similar to applying embroidery stitches during the weaving process.

4-60 When the supplementary weft (metallic yarn in this fabric) in a brocade runs all the way across the fabric, surfacing only when needed to create the figure, it is continuous.

4-61 On the back of the fabric, continuous supplementary weft can create very long floats.

OPPOSITE, TOP ROW

4-62 In cutwork and broché, supplementary yarns are clipped away from the back in the areas where they do not surface. The face of the fabric is illustrated here.

4-63 Reverse side of fabric in figure 4-62.

BOTTOM ROW

4-64 Fillings are clipped away so that they do not show through the sheer areas of this fabric, creating a little "fringe" around remaining areas.

4-65 Dotted Swiss, originally produced with clip-spot technique, but now usually made by printing the dotted areas with adhesive and dusting with a fibrous powder.

THIS PAGE, CLOCKWISE FROM TOP LEFT

4-66, 4-67 Clip-spot efffect.

4-68 In madras gauze fillings are clipped away from sheer leno-woven areas and interlaced in others to create pattern with contrasting areas of varying density.

(figures 4-62, 4-63) This is especially necessary in sheer fabrics, in which changes in density intensify the pattern (figure 4-64); if the "waste" yarn on the back shows through, it will compete with the face pattern. The yarn can even be trimmed on the face, haloing the figure with a little fringe, which becomes part of the pattern. (Once the fill is clipped, it becomes *discontinuous*.) This trimming process is used for true dotted Swiss (figure 4-65), a fabric often commercially simulated through flocking, in which certain areas of the surface are printed with adhesive and then dusted with a fine, fibrous powder, for clip-spot fabric (figures 4-66, 4-67), and for madras gauze (figure 4-68).

A continuous-weft brocade effect that recurs only at spaced vertical intervals is often called *tissue* and the individual decorative threads, *tissue picks* (figure 4-69). A typical tissue effect would be an isolated spaced dot over a dobby ground; a contrasting-color small medallion over a damask is another example.

In certain high-priced, limited-

4-70 In warp brocade, supplementary vertical patterning yarns create the motif. (Contrast with figure 4-71.)

4-69 Tissue picks are the weft brocade effects of spaced dots or small motifs on a contrasting ground. The supplementary weft running on the back of the fabric creates a slight ridge on the face between motifs that is typical of tissue-pick effects.

silk industry (in Lyon, France), which caters to haute couture, and in traditional Japanese kimono and obi fabric weaving.

Warp brocades (figure 4-70) have vertical patterning yarns that work similarly to the weft-patterning yarns in weft brocade. Although faster and easier to weave, they are less popular than weft brocades (figure 4-71) because the fixed decorative warp makes color variation limited, as warps are more difficult to change than fills. *Lisère* is warp brocade, though the term usually refers to traditional decorative patterns created in the technique rather than to all fabrics of warp-brocade construction.

Lampas allows contrasting filling colors to surface in contiguous areas of the pattern (as in brocade), but none of the fillings is supplementary. Rather, lampas fabric is designed so that each fill color is rotated (alternating either two or three fills), and the weaves bring each fill (or a blend of more than one fill) to the surface

production fabrics, weft brocade may be woven in a manner that allows for the brocade yarns to be discontinuous. For example, suppose an expensive silk were being used as the brocade-effect yarn for a fabric in which the figure appeared only in certain areas across the goods. If a continuous brocade-effect yarn were

used, all the hidden silk floated on the back between motifs would be wasted. In order to avoid such waste, and to keep the fabric from becoming overly stiff and heavy, the brocade is woven only in the areas where the figure appears. This technique is popular only in specific silk-weaving production, such as the Lyonnaise

only in specific pattern areas. When the filling is not required on the face, it is woven inconspicuously on the back of the fabric. Lampas was traditionally a "poor man's brocade" that allowed more color variety than the single-filling damask construction, but it cannot achieve the clarity and density of the brocade-effect pattern. All areas of lampas, whether figure or ground, have equal color density and texture (figure 4-72).

In current commercial use, *lampas* refers to patterns woven in this way that simulate traditional brocade patterns (figure 4-73) but are not true brocades. Technically, fabrics woven in lampas technique but without the traditional lampas pattern are more often called *pick-and-pick* (two alternating colors) or *tri-pick* (three alternating colors). (The term *pick-and-pick* also sometimes refers to a type of coloration in which two contrasting fill colors are alternated every pick, even in a damask, or single-pick, construction.)

DOUBLE CLOTH, MATELASSÉ, AND BROCATELLE

In double cloth, every other end is woven as one fabric, and the alternate ends as another layer, so that the compound fabric is literally woven in two layers that intersect and switch from face to back in order to create pattern. Because the two layers are separate cloths, clear color from one layer can be surrounded by a different clear color from the other layer, almost as if they were sewn or glued together (figure 4-74). Double cloths are sometimes called "pocket weaves" because an opening (or "pocket") sometimes exists between the two layers, which may be tied together inconspicuously at spaced intervals. Because layered fabrics are particularly vulnerable to wear, tie-downs (extra

4-71 In weft brocade, supplementary horizontal patterning yarns create the motif. (Contrast with figure 4-70.)

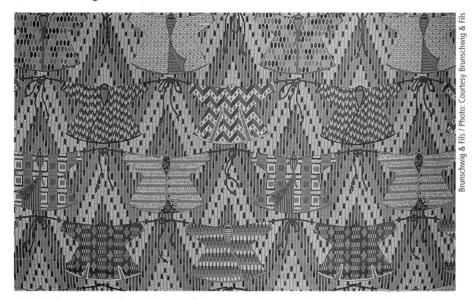

4-72 In lampas technique all areas of the pattern have equal color density, whether figure or ground.

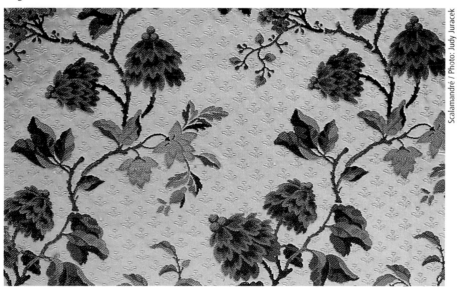

4-73 Lampas most often refers to patterns that simulate traditional brocade patterns in lampas technique.

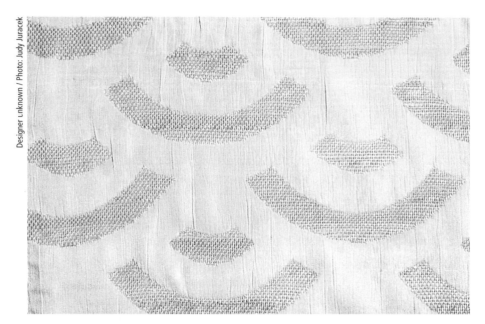

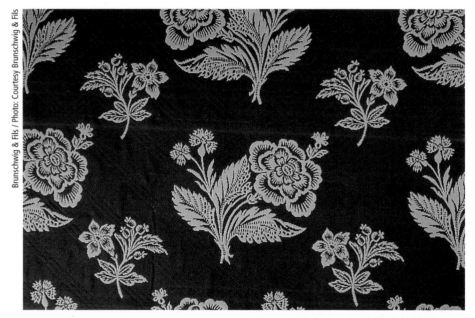

interlacings between the layers), which reduce the pocket size and therefore increase durability, are commonly used in upholstery fabrics.

Double cloths can be of any weave; a simple geometric pattern of double plain weave, for example, can be woven on a dobby loom. Jacquard weaving allows more complex patterning and more combinations of weaves in the two layers. The bright, simple, bicolor motifs typical of Provençal designs are often woven as double cloths (figure 4-75).

In *matelassé* fabrics (figures 4-76, 4-77), areas of single and double cloth are combined in one cloth. The double areas usually are "stuffed" on the back with a bulky yarn that never shows on the face (*stuffer picks*), producing a quilted effect. Satin-faced areas are usually contrasted with more tightly bound plain weave. Because both satin and plain weaves are warp-dominant in the densely sett warp needed for matelassé, these fabrics are nearly the color of the warp itself, which is usually solid. Small, geometric patterns in matelassé are usually called *piqué;* when the design is a vertical cord, it is called *bedford cord.*

Similar to a matelassé, a *brocatelle* (figure 4-78) features high-relief patterns created by a stuffer pick, traditionally a coarse, stiff linen yarn. However, in a brocatelle, the motif is created with a supplementary warp

4-74 Double cloth shows the clear contrast of the lighter and darker areas in this design.

4-75 Typical bright, simple, bicolor Provençal designs are often woven as double cloths.

4-76 In matelassé, areas of the design are "stuffed" on the back with a bulky fill yarn that never shows on the face.

so its color contrasts with the ground of the fabric. Brocatelle patterns are often similar to framed damask, but the coarser construction allows less detail in the patterning. Traditional brocatelle designs are crude, simple, sixteenth century–style motifs.

PILE FABRICS

Like brocade, woven pile fabrics (figure 4-79) incorporate an additional element woven in and between the warp and weft that form the ground cloth. The pile, however, which is brought to the face and held up in long loops, is so densely packed that it becomes a raised surface. In most pile fabrics, the ground is visible only from the back.

Many pile fabrics produced today are warp-knit pile fabrics, which are discussed in this chapter's section on knits. Although the variety of pile fabrics achieved through knitting is more limited than those possible through weaving, fabric of this structure is commonly used in high volume. Most of the fabric in American cars is warp pile knit, and similar fabric is popular in low-cost furniture.

Terry cloth is produced by allowing the extra warp to remain slack as loops in the weaving process. *Frisé* and *epinglé* (figure 4-80) are woven on a wire loom in which metal rods called *round wires* are inserted across the loom pick-by-pick (between ground picks) to hold up the loops and then are pulled out from the side to keep the loops round and of con-

sistent size. Velvet looms (and warp knitting machines) have *cut wires*; the metal rods contain sharp blades that create a plush surface by cutting the loops as each pick is woven. When only certain areas are cut and others are left as loops, a *ciselé* fabric is produced (figure 4-81). This manufacturing capability, which utilizes round wires and cut wires on a single fabric line, is becoming increasingly rare. *Epinglé* usually refers to an all-over, plain fabric. *Friezé* and *friezette* are antiquated terms. Loop-pile fabrics are sometimes called *gros-point* because they resemble coarse needle-point embroidery.

The fabric pile height can vary (both within a single fabric and from fabric to fabric) and is determined by the size of the loom's metal rod. *Velvets* have a short, even pile, while *velours* have a longer, plusher pile. Some velvets and velours undergo special finishing processes to be crushed, embossed, or *panné* finished (i.e., calendered so that the pile is pressed flat in one direction, resulting in increased luster and directional color contrast) (figure 4-82). The softness of long-pile velours is sometimes simulated in knitted pile fabrics, also called velour, especially for apparel.

4-77 An unusual combination of matelassé and multicolored yarns achieves an interesting plaid.

4-78 Brocatelle features high-relief motifs that contrast in color with the fabric ground and are usually simple, sixteenth century–style motifs.

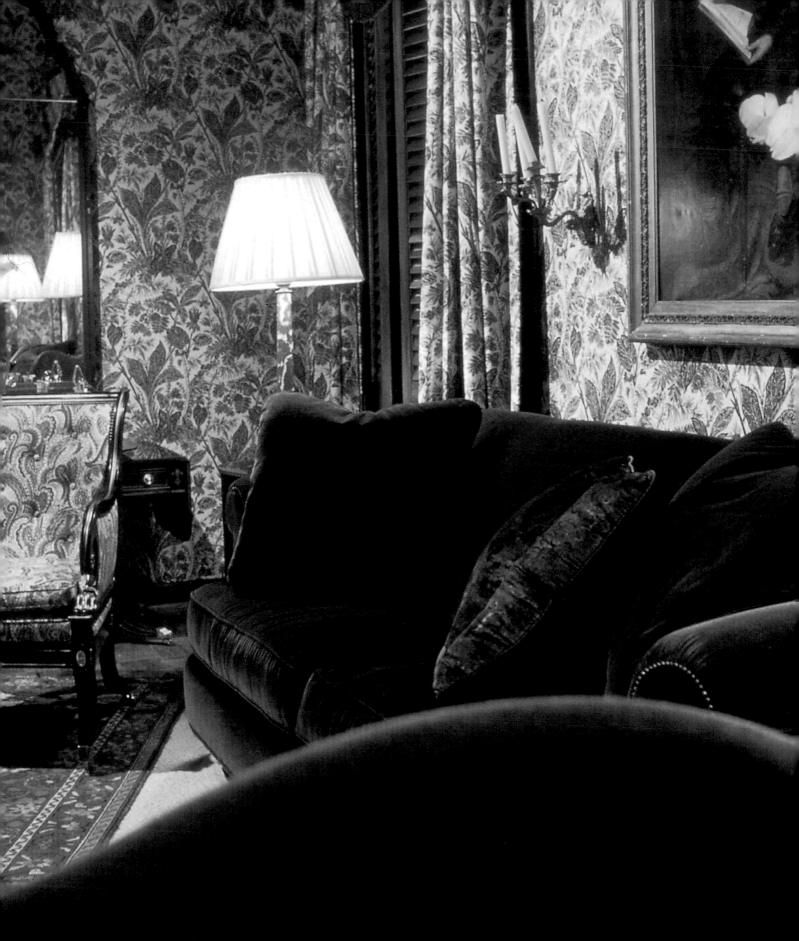

4-79 The pile yarns in velvet upholstery are so
densely packed that they form a raised surface.

TOP LEFT

4-80 A frisé features an all-over surface texture created by pile loops.

TOP RIGHT

4-81 Multicolored, yarn-dyed ciselé fabric in which cut and uncut loops create areas of textural contrast.

BOTTOM LEFT

4-82 In panné or crushed velvet the pile is pressed flat, producing increased luster and directional color contrast.

BOTTOM RIGHT

4-83 The longest pile height plush fabrics beautifully showcase the luster and translucense of mohair fiber.

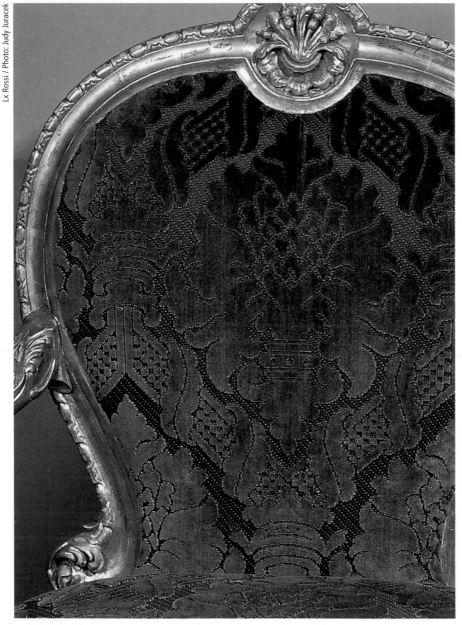

The longest pile height usually is associated with mohair pile fabrics (or sometimes wool) called *plush* (figure 4-83). Oddly, at the opposite extreme, inexpensive knit pile fabrics are also often called *plush*, in the automotive market, for instance. Figured, or *voided*, velvets were originally created by burning away portions of cloth with acid, but today they are woven with pile in certain areas only, so that the motif contrasts against the bare ground cloth. Such figured cloths may also be achieved in frisé or any combination of cut pile and exposed ground (figures 4-84, 4-85).

Plain-surface cut-pile fabrics are usually woven (or knit) face-to-face, so that two layers of ground cloth are simultaneously woven and the pile yarns are woven back and forth through both layers. A fine blade on the loom cuts the pile down the middle, so that the two fabrics can be "peeled" apart and wound onto separate beams afterwards. *Beams* are like large spools that hold the full width of the warp yarns behind the loom before the cloth is woven; the woven cloth is wound onto a beam at the front of the loom (see figure 4-1).

In velvets of *V-weave* (or *V-construction*), each pile end is caught under every single pick of ground filling, whereas a *W-weave* (also known as *W-construction*) catches a pile yarn under two consecutive ground picks (figure 4-86). Each weave is named for the letter that the individual pile yarn resembles in cross section. V-weave allows the pile to be more densely packed but is more suscepti-

4-84 Areas of multicolor ground show on the face of this frisé fabric.

4-85 Voided velvets contrast pile motifs against bare ground cloth.

ble to wear at the ground. W-construction is necessary for particularly slippery pile yarn. Preferred pile furnishing fabrics are often V-weave (because it allows the densest possible face), with a light acrylic layer added to the back of the fabric for upholstery use. The acrylic layer acts like an adhesive, holding the pile yarn in place from the back.

Corduroy and *velveteen* are weft-pile fabrics usually woven of cotton. In corduroy, the weft floats form vertical ridges and are cut to yield ribs, or *wales*. Velveteen has an all-over, short-cropped pile cut from weft floats.

Candlewick fabric, used in "chenille" bedspreads, only contains chenille yarn sometimes (see figure 3-46). Rather, it is a pile fabric in which a heavy yarn woven into a tighter ground is brought to the surface in loops that may be cut or uncut. The pile areas may be so sparse that they do not cover the ground; in fact, the ground and figure areas together form the intended pattern.

Any fabric woven of chenille yarn is called a chenille fabric (figure 4-87). Because chenille yarn itself has a pile, the fabric woven from it has a pile surface and adopts the yarn's inherent directional character. However, chenille fabric is not woven in a pile-fabric construction.

All pile fabric, including fabric woven of chenille yarn, should be considered *directional*: Depending upon how the pile yarns are interlaced with the ground and how the fabrics are finished after weaving, the pile lies slightly or significantly in one direction across and along the entire fabric. Light reflects differently when it hits the pile fiber in the "up" or "down" direction; therefore, when a fabric is cut into pieces for a

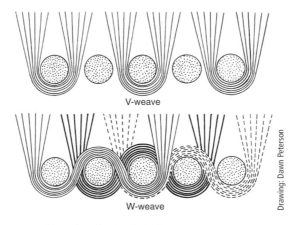

4-86 V-weave (top) and W-weave, cross sections.

V-weave

W-weave

4-87 Fabric woven of chenille yarn is called chenille fabric.

specific application, all pieces needed should be cut from the bolt in the same direction and installed in the same direction. For example, if two panels of drapery are cut so that one has the pile running up and the other has the pile running down, they will appear to be different shades of the same color. Directional pile should not be upholstered so that the warp of the fabric runs parallel to the floor, or *railroaded*, because the color appears different when viewed from each side. Some people prefer the softer feel of pile running down (standard for upholstery), while others prefer the increased depth of color when it runs up; in either case,

the direction must be consistent within the environment. If a pile fabric for an installation is being sent to different furniture manufacturers or drapery fabricators, all suppliers need to be informed of the preferred direction for use.

Pile fabrics have a peculiar reputation for durability; even experienced professionals often refer to any pile fabric as a nearly invincible, hard-wearing material. In particular, mohair plush is commonly referred to as an ideal fabric for high-traffic areas. However, pile fabrics are just like all other fabrics—when well constructed, they do their job very well, but if poorly constructed, they cannot

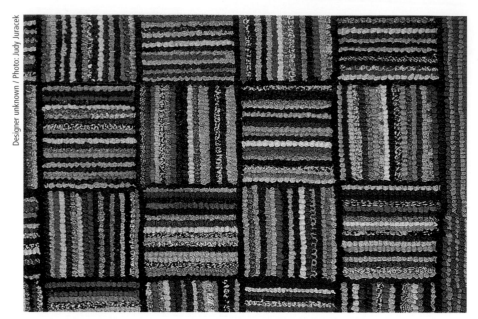

4-88 A tufted fabric is created when an effect yarn is inserted through a ground cloth, making loops that stand out on the fabric surface.

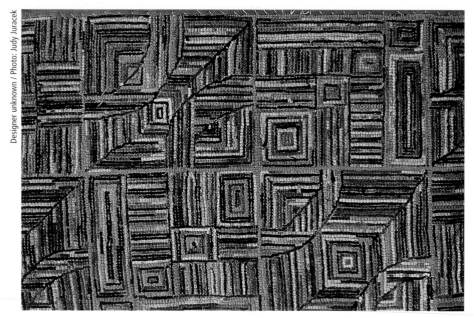

4-89 On the back of a tufted fabric the ground cloth shows between the rows of the effect yarn.

and not viewed as part of a class of fabrics that share the same characteristics and attributes. All of these concerns and considerations also apply to chenille fabrics.

TUFTED FABRICS

An effect yarn inserted through an open-mesh ground cloth causes tufted fabrics to simulate woven pile fabrics (figure 4-88, 4-89). The effect yarn is looped through at regular intervals and then may be sheared so that the loops become protruding cut ends of the yarn. Some wallcovering fabric and most carpet is tufted. Tufted fabrics are sometimes made in two layers tufted face-to-face like the filling on a sandwich. Once the "sandwich" of fabric is completed, a fine blade cuts the two layers apart from each other to make two bolts of carpet, as plain-surface cut-pile wovens and knits are fabricated. (See figure G-12.)

Knits

In knitted fabrics, one set of yarns loop around themselves or other yarns in the set to form an interlocking plane. A *single-knit* fabric, like jersey knit, is created with one continuous strand that is manipulated by a needle or needles. Single knits are ubiquitous (cotton T-shirts and most sweaters) but are not popular in interior furnishings. In a *complex* or *warp knit*, a large number of threads (similar to those that make up the warp on a loom) are fed in a parallel arrangement and another yarn (like a weft) is similarly manipulated by a row of needles. Tricot is a fine-gauge warp knit popular in lingerie; the infamous "leisure suits" of the 1970s were warp-knit polyester. Knits are produced on knitting machines permanently set to handle yarns of a

withstand heavy wear. Especially when pile fabrics are at peak popularity, many less expensive versions are marketed, and because evaluating the quality of a plain material is difficult, the inferior versions find their way into many inappropriate uses. Furthermore, the longer and softer the pile, the more easily it becomes pressed down, which appears as a worn "bald" spot. As is true with

most upholstery, if pile upholstery is not properly padded, the fabric will wear through from the back. Soft-fiber pile materials such as cotton and silk often show every fingerprint, and some cannot be handled easily during the sewing and upholstery process without *bruising*, or leaving permanent marks where the cloth is touched. Every pile fabric should be considered individually

4-90 The stretch and flexibility of warp knits make them popular for niche uses, for example, in ergonomic office seating.

4-91 Warp knits are appropriate for casements because they are stable even when fabricated with openings between the stitches.

specific size and limited to producing fabric of a certain weight and gauge. Knit patterns are produced by the selection of the loop direction on the plane of the fabric; the loops are brought either to the back or to the face, which creates, respectively, a smooth or bumpy surface. Since knits do not have ends and picks, their construction is counted by gauge, which is the number of courses and wales (horizontal and vertical stitches, respectively) per inch or centimeter in the fabric.

Although warp knit's inherent design limitations have hindered its growth potential in interior application, knits have established a significant role in three areas. First, the stretch and flexibility of dense warp knits make them popular for niche uses, such as in ergonomic office seating and other furniture with contemporary, curvaceous styling (figure 4-90). Second, warp knits are stable even when fabricated with openings

between the stitches, which makes them popular as window-covering fabrics or *casements*, a type of window-covering fabric in which the yarns are spaced far enough apart to allow light to pass through (figure 4-91). Technically considered casements, nearly all *laces* made today are warp knits. (Casements and laces are further discussed later in this chapter and in chapter 8.) Third, most pile fabric is manufactured by warp pile knitting, which yields fabrics that look very similar to the woven velvets described earlier. Design flexibility in knit pile fabrics is more limited than in wovens, but knitting is less costly. This makes knitting ideal for producing fabrics for automobile seats and for other high-volume, low-cost goods needing high durability, such as for inexpensive furniture for family room use. Polartec, the popular apparel fabric, which is occasionally used for upholstery or interior accessories, is a knit.

Embroideries

Embroidered fabric has been embellished after its manufacture with needleworked accessory stitches (figure 4-92) or with decorative elements like sequins, bangles, or feathers. An inexpensive, plain fabric is usually used for the ground cloth, making the embellishment much more costly than the original material. Embroidery stitching can be done by hand or machine, and decorative elements can be sewn or glued to the fabric. In *raised* embroidery, satin stitch needlework covers a padding to create the pattern.

Crewel embroideries (figure 4-93), very popular in furnishings, are wool yarn embroidered onto coarse cotton ground. A traditional hand technique in many cultures, crewel is now machine-produced in India (see figure 10-4). A stitched pattern on a net ground is a popular sheer fabric called *tambour*. *Schiffli* embroidery is produced on a schiffli machine, which

TOP LEFT: 4-92 Cross-stitch embroidery on linen ground.

TOP RIGHT: 4-93 Crewel is wool yarn embroidery, usually on a coarse cotton or linen ground.

BOTTOM LEFT: 4-94 Schiffli embroidery is often produced on fine, sheer ground material.

BOTTOM RIGHT: 4-95 In an unusual eyelet effect, the sewn areas do not outline the cut areas; rather, the stitching pattern intersects the cut areas.

handles fine, sheer fabric popular for window covering (figure 4-94). Both schiffli and crewel are necessarily produced in short lengths because the fabric is fed into the machine sideways (selvedge first) and stitched by thousands of needles simultaneously.

In *appliqué* technique, an additional layer of cloth is stitched onto the ground during the embroidery process and then cut away in specific areas. In addition to the stitching, the contrast of multiple layers of fabric in some areas with a single layer in other areas offers additional de-

sign possibilities. Likewise, some areas of fabric can be cut away between embroidered areas for eyelet (figure 4-95) and lacelike effects.

Quilted Fabrics

Quilting stitches two layers of fabric (called two-ply) together with a loose

4-96 Quilting stitches two layers together with a loose fiber layer in between. The quilted material has been upholstered.

4-97 Machine-made quilts are popular bedding in both homes and hotels.

fiber layer in between (figure 4-96). Because the layering adds softness and warmth, quilts have been popular for centuries as bedding material. Today, mass-produced machine-made quilts are very popular in both homes and hotels (figure 4-97), and new, handmade quilts from around the world are widely available. Fabric is quilted for bedspreads and other uses; when it is produced in a 110-inch (2.8-m) width, no seams are necessary. Quilting stitches on the fabric face may be very obvious or almost invisible. Machine- or hand-stitched patchwork is often quilted and closely associated with quilting technique, though the two need not be done together (figure 4-98).

Quilted fabrics are not only used for bedding. Many furniture manufacturers offer machine quilting of various fabrics before they are upholstered. These fabrics are usually *outline quilted*, that is, the stitching follows the outline of the motifs in a printed fabric (figure 4-99). An alternative to outlining motifs is to se-

4-98 Patchwork fabrics need not be quilted.

lect a quilting pattern unrelated to the motifs. An example of such a pattern is *vermicelli*, a popular all-over, squiggly pattern (see figure 5-31). (Printed or woven patterns that look like vermicelli stitch patterns are also often called vermicelli.) In *trapunto*, only certain portions of a

design are stuffed in order to isolate specific areas against a lower-relief ground.

Bonded Fabrics

Glue, adhesive, and heat can be used instead of stitching to attach layers (called ply) of fabric to a single cloth,

TOP LEFT
4-99 Outline quilting: the stitching follows the outline of the printed motifs.

LEFT
4-100 Warp laminates, yarns that are laid vertically and laminated to a paper substrate, are popular for wallcovering.

ABOVE
4-101 Leno effect is characterized by warp threads that are twisted over and around each other, with filling yarns holding them in the twisted position.

creating a bonded fabric. For furnishings, these fabrics are usually a face cloth and a backing that has some performance feature (see chapter 7), but bonded fabrics are also used for aesthetic reasons. For example, an open-weave or eyelet embroidery can be bonded to an opaque fabric and then used for light upholstery.

Warp laminates (figure 4-100) are used for wallcoverings; parallel vertical yarns are laminated, or bonded, to a paper substrate. Fine or heavy yarns of any effect can be used; yarns of different colors can be arranged to yield stripes. Because these fabrics

are not woven and contain only vertical threads, they are less expensive than a comparable woven fabric with paper backing.

Casements and Laces

Casements (discussed above) are frequently warp knits, especially if they have an overall, even character. Casements can be woven and sometimes use *leno* technique, in which warp threads are intentionally lifted up and twisted over one another so that they cross back and forth between each insertion of filling yarn (figure 4-101). Leno technique stabilizes yarns in a loose construction, but

many open-weave fabrics are stable enough for drapery use without leno. The fabric seat of the popular Aeron chair is a leno fabric (figure 4-102). *Madras gauze* is a finely woven leno ground fabric in which a supplementary weft is woven only in the motif areas of the pattern and is clipped away from the ground areas. The final fabric has a heightened opacity in the motif and a fine, sheer ground (figure 4-103 and see figure 4-68).

Laces are a type of casement, but because they are commonly recognized they usually are simply called "laces" (figure 4-104). *Laces* are open-work fabrics produced by

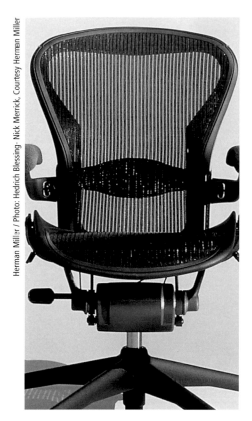

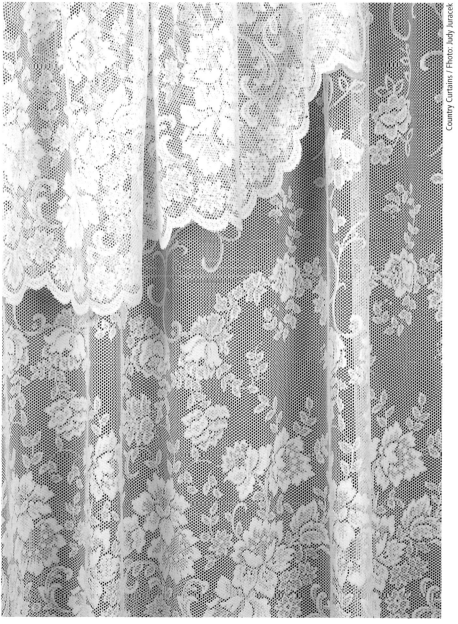

twisting and knotting together a network of threads to form patterns. They differ from embroidery in that they have no ground fabric. Most laces available today are made on special *lace machines* that offer a broad range of patterning capabilities.

Nonwovens

Many fabrics are made by processes other than weaving and are therefore "not woven." The term *nonwovens*, however, specifically refers to fabrics made directly from the raw fibrous

ABOVE
4-102 The fabric seat of the popular Aeron chair is a leno fabric.

RIGHT
4-103 Madras gauze features a finely woven leno ground fabric with supplementary weft woven in motif areas, creating heightened opacity in the motif and a fine, sheer ground.

4-104 Lace is popular as a casement window covering.

material—in other words, fabrics in which no yarn-making step is necessary (figure 4-105). Felt, the best-known nonwoven, is made of wool. As noted earlier, felt is made by wetting, heating, agitating, and pressing loose fiber into a solid mat. The scaly individual wool fibers hold the fabric together after it has dried.

Fibers other than wool can be manipulated through a similar process. One of the oldest-known fabrics is bark cloth. It is derived from tree bark that is soaked and then beaten into a coarse fabric (figure 4-106). In the *wet-process* method (used to make paper from cellulosic material), the fibers are suspended in water and deposited on a fine, sievelike screen. In the *dry-process*, or *bonded-web*, method the loose fiber is heated and an adhesive material is added. Disposable fabrics for tablecloths, diapers, and airline pillow covers are examples of nonwovens.

Nonwovens also are used as carpet backing and as pads placed under rugs and carpet. Nonwovens have found their way into wallcovering and drapery application, notably as readymade honeycomb blinds, for example. In these cases, the bonded fabric is often overstitched to increase strength (creating a *malimo*, figure 4-107) or *needlepunched* to add bulk and loft to the surface (figure 4-108). The basic structure of nonwovens is rigid, and the rigidity results in poor recovery when the fabric is distorted. For these reasons, nonwovens have not been adapted for upholstery application to date.

Films and Vinyl

Films are nonfibrous, synthetic materials that are formed into a thin layer of fabric. Their smooth surfaces and materials, which inherently lend themselves to being made into films,

4-105 A nonwoven is made by pressing and bonding raw fibrous material into a cloth.

4-106 Bark cloth is derived from tree bark that is soaked and then beaten into a coarse fabric. Color is added afterward.

4-107 Malimo, a bonded nonwoven is overstitched to increase strength.

4-108 Nonwovens can be needlepunched to add bulk and loft to the surface.

4-109 Cork is a natural material that can be used in a filmlike form.

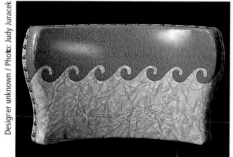

4-110 Because vinyl is completely water-proof it is frequently used for seating in areas that are likely to become wet or need to be wet cleaned.

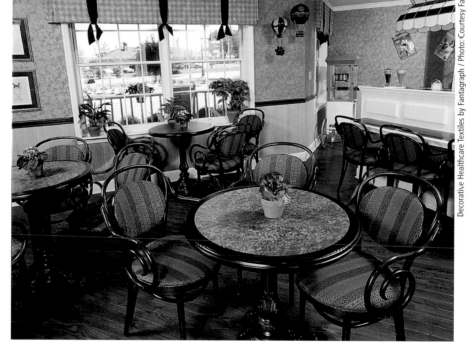

4-111 Vinyl wallcovering is often used in restaurants because it is soil-resistant and easy to clean.

make them waterproof and easy to clean but unbreathable and synthetic and "plastic" in appearance. Films can be used alone or laminated over or under fabric. The natural equivalents of films are cork (figure 4-109) and leather.

Vinyl is a film of plastic (polyvinyl chloride) that is usually bonded to another fabric or paper for stability and ease of application. Although designers often speak negatively about its plastic character, it is a useful interior product for several reasons. Because it is completely waterproof it can be wet cleaned. Consequently, it is frequently used for seating in areas that are likely to become wet, such as fast-food restaurants and hospital rooms (figure 4-110). It is the most popular "fabric" for wallcoverings, especially for large expanses of wall space in public corridors and other high-traffic areas (figure 4-111) (see chapter 8 for more information on wallcoverings). Diverse and beautiful colors and surfaces are available in today's vinyl products; while vinyl's surface may be more easily disturbed than that of many wovens, it is usually easier to maintain than painted wall surfaces. Because very different qualities of vinyl—like velvet, leather, and other "plain" materials—can appear similar, it is important to evaluate the appropriateness of individual vinyl products for the desired application and obtain performance expectations from suppliers.

Fabric Designs

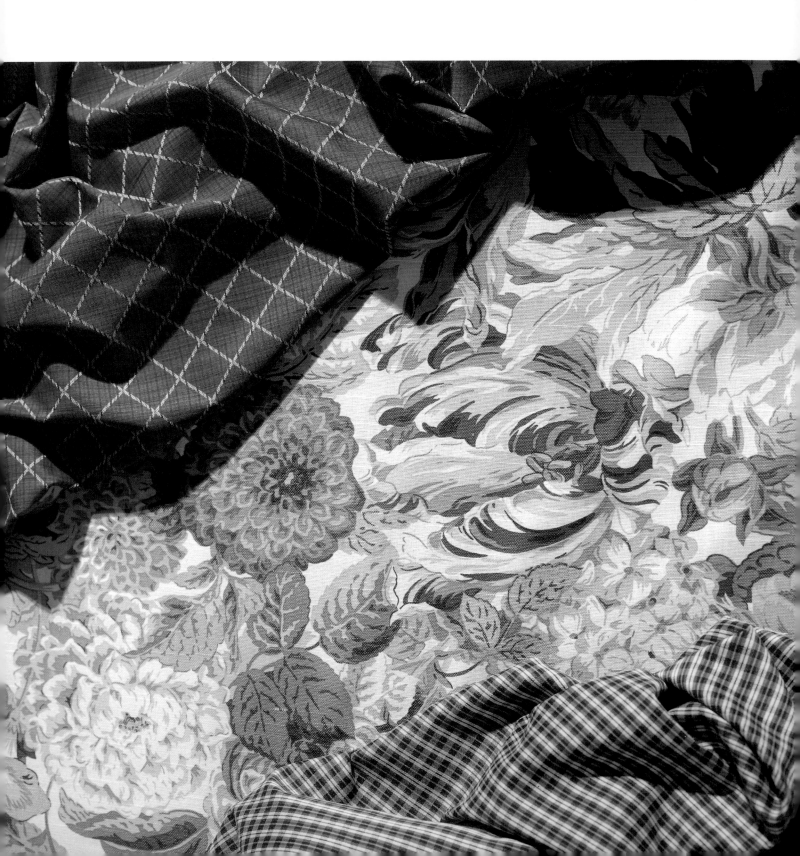

When designers select fabrics to use in an interior, or when suppliers organize their lines within showrooms and sample books, they are not likely to search for or organize them according to what yarns compose the fabrics or even according to the fabrics' structures. Instead, fabrics usually are given broad labels that relate to their appearance.

Knowledge of the basic properties of fibers, yarns, and structures helps designers and end-users understand what makes a fabric look the way it does or perform in a specific way. Furthermore, many popular names are derived from historical textile styles. Although familiarity with the origins and history of fabric decoration fosters an understanding of the framework within which contemporary designers work, designers cannot rely on such information alone. This chapter elucidates the common lingo that fabric users and suppliers use when speaking to each other. This lingo is often less precise than that used among the professionals who create the fabrics. Likewise, this chapter focuses on the characteristics of fabric styles as used in interior design—not on the detailed historical derivation of the styles or on museum curators' labeling. Numerous volumes written on nearly every historical period categorize fabric, often differently from both interior designers and textile professionals.

Fabrics are labeled according to how they are produced (their structure and construction) and according to their pattern. Pattern includes the *motifs* (the subject matter depicted), which range from stripes to landscape scenes, the *style* in which the motifs are rendered (including their geographic or historical origin and general appearance), and the *layout*

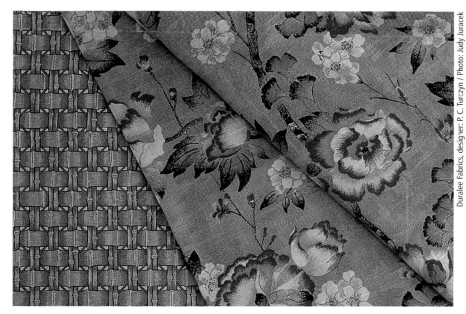

5-1 Fabric professionals distinguish fabrics as "prints," such as these, or "wovens" before categorizing them by any specific feature of the design.

(arrangement) of the motifs. These elements, combined with the overall color effect that the pattern imparts, are the essentials that together contribute to the general appearance of a fabric's design.

Designers and fabric professionals distinguish fabrics as "prints" or "wovens" before categorizing them by motif, color effect, or historical style (figures 5-1, 5-2). Although prints traditionally have been considered feature fabrics in an interior, this is not always the case, and "wovens" include everything from the plainest solid to elaborately figured velvets. Nevertheless, prints and wovens usually are segregated in trade showrooms; although some sampling formats pair prints and wovens as coordinates, this is just supplementary guidance for the customer. Fabrics also are identified as prints, plains (solid or nearly solid), dobbies (small woven geometric effects), jacquards (large patterns achieved through weaving rather than printing), and stripes and plaids; these categories trump other, more detailed descriptions (figures 5-3).

Within print and woven categories, materials of like fibers, or even those that simulate fiber and yarn types, are often grouped together. Sateens, worsteds, tweeds, linens, cotton ducks, and crepes are considered categories of material worthy of distinction.

Another major area of categorization is a fabric or collection's intended end-use. Many fabrics are marketed as appropriate for seating, window covering, and perhaps outer-bedcovering or certain wallcovering applications. Fabrics intended for general interior use receive no special labeling in a fabric line. Others are labeled as ideal for casements, wallcoverings, or trims.

Motifs and Effects

Almost every imaginable motif has been featured in fabric designs. Animals, pictorial scenes, people, everyday objects, geometric shapes, and abstract, imaginary objects are all frequently used motifs.

Florals (figure 5-4) have been the most common and best-selling

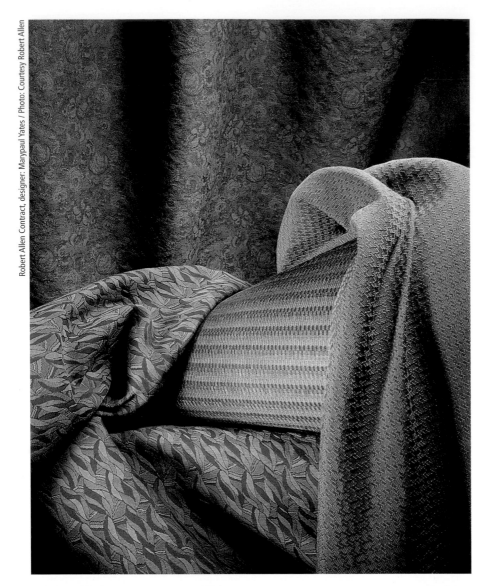

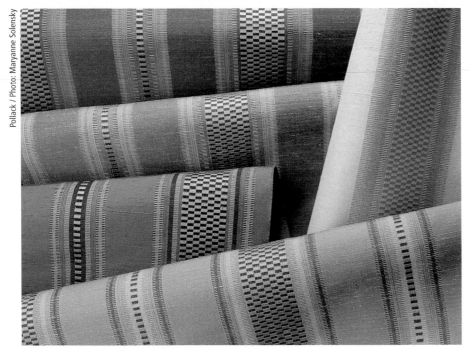

printed and jaquard-woven fabrics in apparel and interior textiles for several hundred years. The variety of pattern that can be derived from one flower makes it easy to understand why plant forms are such a popular motif. The structural way that a flower grows, the complex organic shapes of which it is made, and the surprising color combinations that naturally occur keep the motifs from being monotonous. Equally important, flowers rarely have negative connotations, unlike some animals, for example. Regardless of trends in styles, some interpretation of plant forms, whether abstract, stylized, or realistic, will always be prevalent.

Florals can be endlessly subcategorized, by types of flowers, scale, arrangement of motifs (bouquets, stripes), style (Provençal, Indienne, Jacobean), historical origin, or by combinations of these features. With regard to historical origin, it should be noted that France and England were early printing centers for florals, and even professional curators have difficulty describing stylistic differences between the two countries' prints. Nevertheless, florals are often labeled as English or French when their actual origin can be cited.

Today, a *chintz* is usually thought of as a home furnishing–scale floral pattern with a glazed or polished finish. A typical example is shown in figure 5-5. The colors of the motifs are usually strong and vibrant, often in striking contrast to a very light, very dark, or very rich *blotch* (printed background) color. Ivory, navy, black, burgundy, and lacquer red are popular

5-2 This collection of woven fabrics includes small textures, florals, geometrics, and abstracts.

5-3 Fabrics are often categorized by broad descriptions such as "stripes."

blotch colors in chintzes. The glazed or polished finish that is usually applied to these cotton fabrics after they are printed is also sometimes applied to fabrics that are dyed a solid color (figure 5-6). These fabrics are also often referred to as *chintz*. The existence of the term *chintz*, from the Hindu word *chint* (meaning colored or variegated), was recorded as early as 400 B.C. Throughout the centuries of development of dyed and printed fabric in India, the term has been used to describe many types of pattern.

Winding, unending bouquets that profusely cover the design surface and sometimes utilize symmetrical motifs typify the florals created by William Morris in the late 1800s. Morris was a prolific designer, craftsman, poet, and social reformer. His work spanned several decades and his designs for fabrics varied in style as his career progressed. Figure 5-7 shows an example of the carefully drawn floral forms that richly embellish the surfaces of Morris's fabrics. His work features subtle colors and penlike lines that provide an etched quality. Typically categorized as *Arts and Crafts*–inspired, patterns resembling the designs of Morris and his pupils are constantly reinterpreted (figure 5-8), although many of his original designs are still produced and sold today exactly as they were during his lifetime.

In a *botanical*, entire plant forms (including roots) are realistically rendered as if the viewer were seeing each part of the form at eye level. These motifs may be repeated in the pattern as completely separate ele-

5-4 Florals have been the most popular fabric design motif for centuries.

5-5 A chintz is a home furnishing–scale floral with a polished finish.

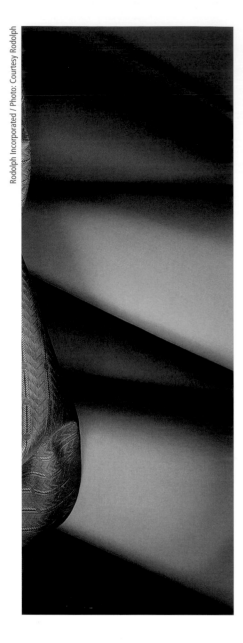

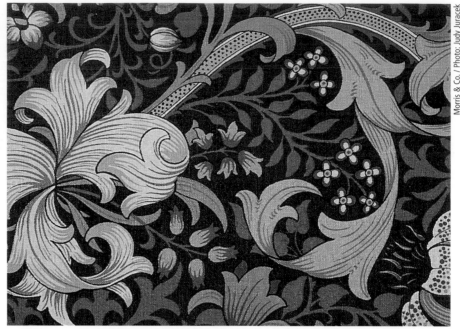

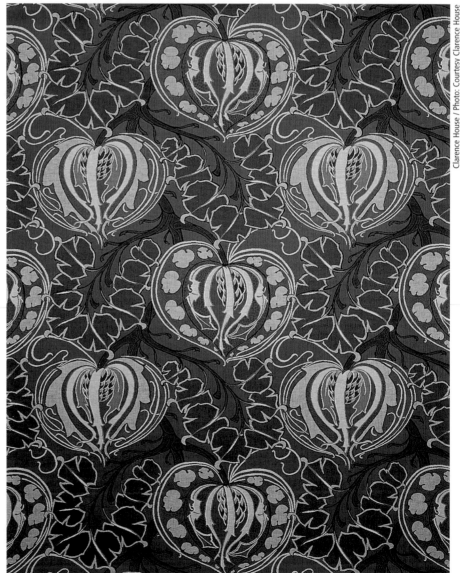

CLOCKWISE FROM ABOVE LEFT

5-6 Solid-colored cottons that are glazed or polished are frequently labeled "solid chintz."

5-7 Carefuly drawn floral, leaf, and vine forms that embellish the surface are typical of William Morris's fabrics.

5-8 Arts and Crafts–inspired patterns are constantly reinterpreted. The pomegranate is a popular motif in Arts and Crafts designs.

ments or sometimes even boxed off from one another. The plant species may be labeled as a part of the design. Figure 5-9 shows a traditional botanical, while figure 5-10 illustrates more stylized motifs in a botanical layout.

Popular throughout the history of printed fabric, *tropical* florals have been rendered in a wide range of styles. As the name implies, the motifs and colors feature imagery from the tropics, and the layouts are usually equally bold (figure 5-11).

The deeply colored floral on a light ground shown in figure 5-12 is a printed *Jacobean* design, derived from popular embroidered furnishing fabrics of the late-Elizabethan and Jacobean eras. Characterized by heavy ornament of German and Flemish origin, these patterns are usually made up of branches and other arborescent forms accented by floral motifs in meander layouts that feature leaves growing off of vines.

Indiennes were French interpretations of early Indian prints. These designs resemble Jacobean designs because of their layout, but they feature more exotic motifs rendered in a finer, lighter style (figure 5-13). *Portuguese* designs are similarly composed but were block-printed in England for export to Portugal and are brightly colored designs in figured stripes that sometimes feature vases and vignettes (figure 5-14).

Popular today in both apparel and home furnishings, *Provençal*, or country- French, designs are small-scale floral patterns that originated during the eighteenth century in Provence. Originally woodblock patterns, the slightly off-register color placement in these designs is part of their charm. Rich colors such as Wedgwood blue, yellow ochre, and poppy red are used together in vi-

Clarence House / Photo: Courtesy Clarence House

5-9 A traditional botanical print features entire plant forms realistically rendered and viewed at eye level.

Doblin / Photo: Judy Juracek

5-10 Stylized plant forms in a jacquard-woven botanical design.

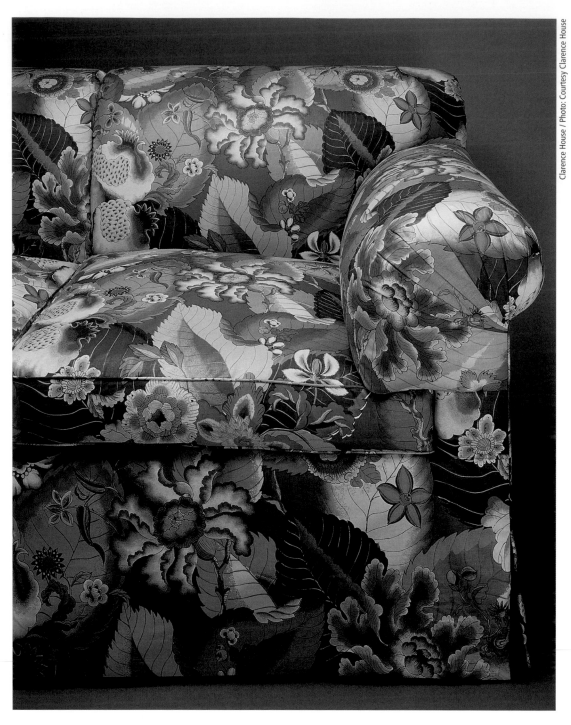

5-11 Tropical florals feature motifs and colors from the tropics.

brant combinations. The small floral motifs typical of these designs are very regularly spaced and may be designed as coordinating borders and stripes. They are usually printed but sometimes are woven in a double-cloth jacquard for upholstery (figure 5-15).

Paisley (figures 5-16, 5-17), the traditional Asian pattern of a tear-drop shape, originated in India on painted and printed fabric and appeared in woven cashmere shawls. Imitations of these oriental shawls were first woven in Paisley, Scotland, where the motif became more elaborately rendered.

Other natural forms, such as animals (figures 5-18, 5-19), animal skins (figure 5-20), shells, stones, waves, and landscapes, are also traditionally popular textile motifs. Many fabrics depict historical landscape or scenic patterns; some of the earliest in printed form originated in the mid-1700s at the famous print works in Jouy, France, and are therefore called *toile de Jouy*, "cloth from Jouy." Usually printed in one color on a natural ground, these designs (figures 5-19, 5-21) used complete pastoral or figurative "pictures" as motifs in simple repeats. Toiles also

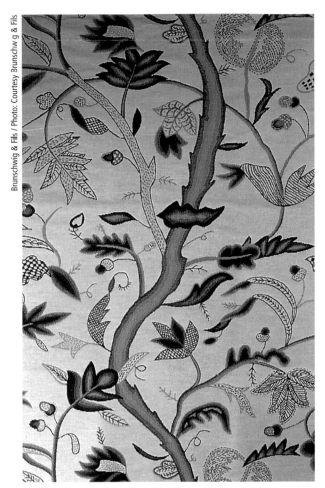

5-12 Jacobean floral prints are sometimes called mock-crewels because the effects simulate embroidered furnishing fabrics of the late-Elizabethan and Jacobean eras.

5-13 Indiennes were French interpretations of early Indian prints and resemble Jacobean designs but feature more exotic motifs rendered in a finer, lighter style.

5-14 Portuguese designs are similar to Indiennes but are brightly colored figured stripes and often feature vases and vignettes.

RIGHT

5-15 Provençal floral designs are small-scale, simply drawn, and boldly colored. They were originally woodblock-printed but are often simulated in double-cloth jacquard.

BELOW

5-16, 5-17 Paisley, the traditional Asian teardrop shape, is combined and reinterpreted in countless patterns.

5-18 Contemporary rendering of animals executed in metallic brocade on crepe ground fabric.

5-19 Traditional toile pattern featuring animal motifs.

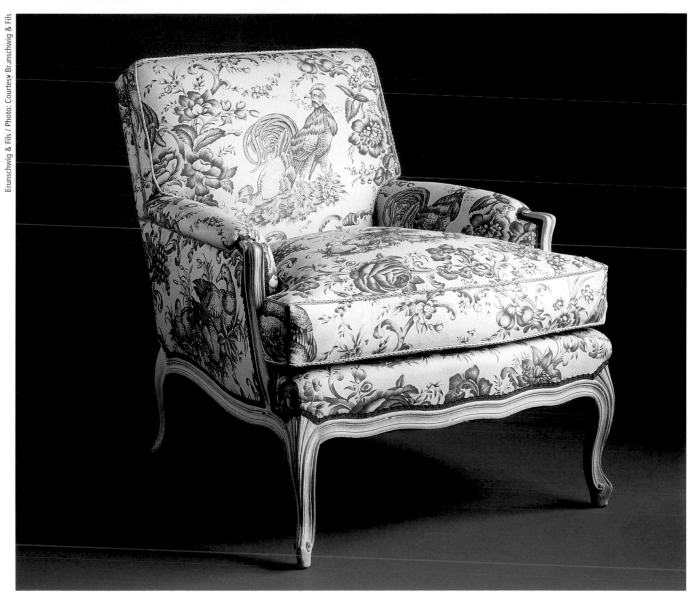

Pollack / Photo: David Arky, Courtesy Pollack & Associates

commonly include one-color florals, which feature vine-traversed layouts with large exposed areas of the natural ground cloth. The less common *toile de Nantes* designs originated in Nantes, the print center that rivaled Juoy in the eighteenth century. They are more crudely rendered and are usually stripe layouts and floral motifs rather than scenic designs (figures 5-22, 5-23).

Today, *chinoiserie* refers to any western interpretation of oriental design. This influence may be revealed by the style of floral rendering, but more often a chinoiserie contains figurative clues: Chinese architectural elements (such as the pagoda in figure 5-24), Chinese vases or ornaments, or stereotypical Chinese plant forms (such as the bamboo trellis in figure 5-25) often accent floral or figurative motifs in these designs. Because these motifs were popular in the eighteenth century, many toiles are chinoiserie. According to the fabric's visual elements, chinoiserie may be more specifically identified as Chinese or Japanese.

Designs in which the pattern is composed of pictures of recognizable objects are called *figuratives* (figures 5-26, 5-27), which feature more formal content or rendering, or *conversationals* (figure 5-28), in which motifs can range from crayons to teacups or seashells. Patterns designed specifically for children's products are called *juveniles*. These

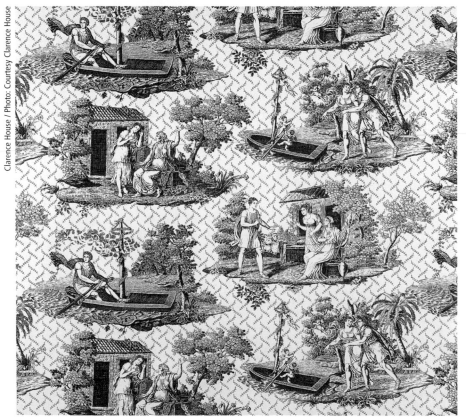

Clarence House / Photo: Courtesy Clarence House

5-20 Animal skin motifs in jacquard wovens.

5-21 Toile de Jouy designs are usually printed in one color on a natural ground and use complete pastoral or figurative pictures as motifs.

designs are often conversationals that feature boldly drawn and brightly colored popular motifs such as cars, animals, balloons, and clowns.

Geometrics, derived from any geometric shape, are the most prevalent type of design after florals. Some geometrics simply feature lines arranged on a single ground color, while others are much more elaborate (figure 5-29). *Abstracts* are softened geometrics and amorphous all-over patterns (figure 5-30). *Vermicelli* is a traditional abstract pattern that features wormlike squiggles that cover the pattern's surface (figure 5-31). Even though they are "geometric," straightforward stripes and plaids are generally considered separate categories.

Contemporary is a term used to classify designs with simple, extremely stylized motifs (figure 5-32). Calligraphic brushstrokes are a typical contemporary motif, as are simple abstract and geometric figures.

Transitional designs are almost contemporary, but the stylized motifs are not as starkly simple and may be recognizably naturalistic. Whereas a contemporary pattern is a specific, simple style, a transitional upholstery pattern might feature a loose interpretation of traditional motifs, making it appropriate for most styles of furniture. Florals, especially leaf forms, rendered in a painterly fashion are typical of transitional designs,

Manuel Canovas / Photo: Courtesy Manuel Canovas

Baker Furniture / Photo: James Anton Koch

5-22 Toile de Nantes designs (on bed) are more crudely rendered than toile de Jouy and are usually stripe layouts and floral motifs.

5-23 Toile de Nantes on sofa.

LEFT
5-24 Chinoiserie designs often feature Asian architectural elements such as pagodas.

BELOW LEFT
5-25 Stereotypical Asian plant forms, such as the bamboo trellis in this design, are often found in chinoiserie.

BELOW RIGHT
5-26 Staffordshire ceramics motifs.

OPPOSITE
5-27 Staffordshire ceramics are popular motifs in traditional figurative prints.

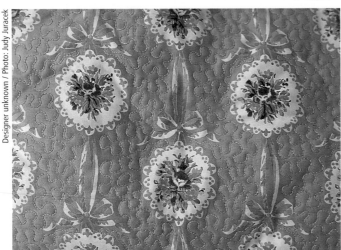

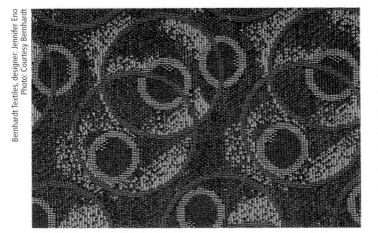

TOP LEFT: 5-28 "Conversational" usually refers to less serious motifs and objects such as these books.

TOP RIGHT: 5-29 Geometrics range from the simplest diamond to complex, elaborate patterns.

CENTER RIGHT: 5-30 Abstracts are softened geometrics and amorphic all-over patterns.

CENTER LEFT: 5-31 Vermicelli designs feature an overall pattern of narrow, undulating, wiggly lines.

LEFT: 5-32 A contemporary pattern has simple, extremely stylized motifs.

which sit comfortably between the realistic and the completely nonfigurative (figures 5-33, 5-34). *Transitional* is also a catchall term for interior-textile patterns that do not represent any particular historical style and can, in theory, be used in any setting or on any style of furniture.

Trompe l'oeil literally means "fool the eye," and patterns so designated create such an effect. Trompe l'oeil designs, in which objects are carefully rendered in extremely fine detail and the illusion of tactile qualities is emphasized, often are used in interiors to simulate marble surfaces or to depict absent architectural features such as columns or arches or even other fabric (figure 5-35). *Pillar prints*, inspired by English tradition, feature juxtapositions of architectural and floral elements (figure 5-38).

Other effects that are actually weaving and structural techniques have become accepted labels for design types, regardless of whether the specific fabric is actually rendered according to its label, is realized through a modified effect, or even is printed to emulate the more expensive woven techniques. The many uses of the word *damask* are discussed in chapter 4; likewise, brocades, tapestries, kilim, and other rug constructions conjure specific images of design types. Lampas and liseré have become more associated with the pattern styles in which they were traditionally rendered than with their woven structure. Simpler woven techniques like stripes, plaids, twills,

5-33 Transitional designs sit comfortably between the realistic and the completely nonfigurative.

5-34 Leaf forms are popular motifs in transitional designs.

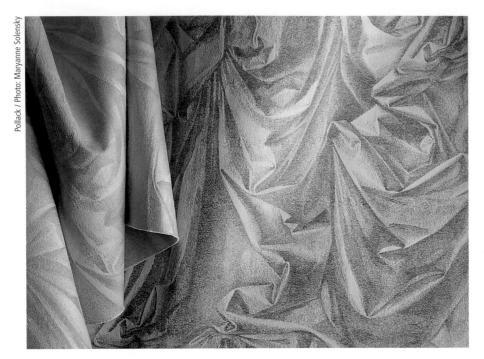

and herringbones are all used as design-type labels. These fabric structures and their typical appearances are discussed in detail in chapter 4.

Likewise, unique dyeing techniques characterize design styles: Chiné is usually French floral motifs achieved in a warp-print technique (figures 5-36, 5-37). Hand-painted, warp-resist-dyed, and wax-resist-dyed effects are techniques that typify designs. The warp-resist-dyed Japanese *kasuri* (figures 5-39, 5-41) and Indonesian *ikat* (figure 5-40), as well as the Japanese *shibori*, or tie-dye (figure 5-42), techniques are appealing and highly recognizable. Designs that were typically generated in these effects have become motifs in their own right. The floral patterns figured with "crackle" marks that are typical of the Indonesian wax-resist-dyed batik designs commonly are simulated in printed form (figure 5-43).

Early in the twentieth century Mariano Fortuny developed two fabric-embellishment techniques that are known by his name and, although frequently imitated, are still unique. *Fortuny pleated silk* was achieved through a finishing process that set fine but irregular pleats into the fabric (figure 5-44). *Fortuny prints* are reminiscent of traditional Italian brocades and damasks but are created by

5-35 In this trompe l'oeil draped fabric is rendered in fine detail in jacquard-woven fabric.

5-36 Chiné are French floral motifs achieved in a warp-print technique.

5-37 This chiné floral detail shows the blurry motif edges that are typical of warp printing.

OPPOSITE
5-38 Pillar prints feature juxtapositions of architectural and floral elements.

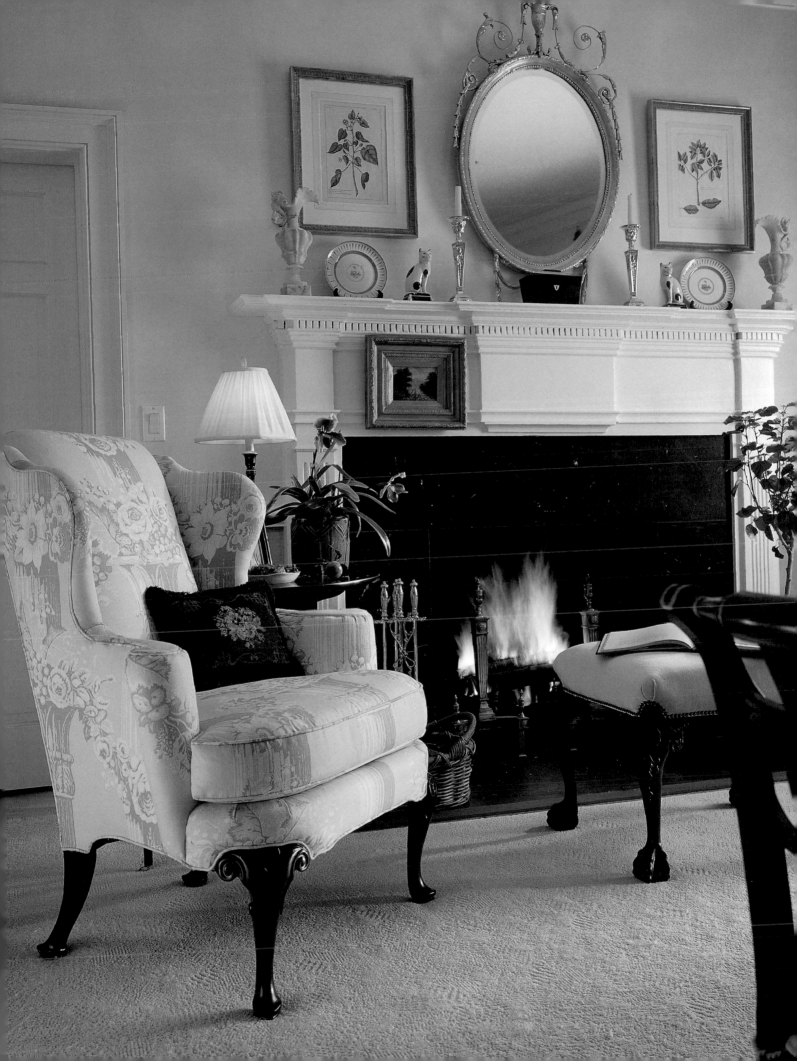

Designer unknown / Photo: Judy Juracek

Designer unknown / Photo: Judy Juracek

Sunbury / Photo: Judy Juracek

Charlene Page Kaufman Textile Study Collection, Lamar Dodd School of Art, University of Georgia / Photo: Glen Kaufman

Brunschwig & Fils / Photo: Courtesy Brunschwig & Fils

Producer unknown / Photo: Judy Juracek

TOP LEFT: 5-39 Kasuri-effect patterns often feature simple geometric shapes woven of warp- and fill-resist dyed yarns.

TOP RIGHT: 5-40 Ikats are Indonesian-derived designs woven of warp- and fill-resist dyed yarns.

CENTER LEFT: 5-41 Ikat and kasuri effects are often interpreted in jacquard-woven patterns.

CENTER RIGHT: 5-42 Japanese shibori patterns are appealing and recognizable for their unique effects.

BOTTOM LEFT: 5-43 Floral patterns figured with "crackle" marks typical of Indonesian batik designs are commonly simulated in printed fabrics.

BOTTOM RIGHT: 5-44 Fortuny pleated silk has fine but irregular pleats set into the fabric.

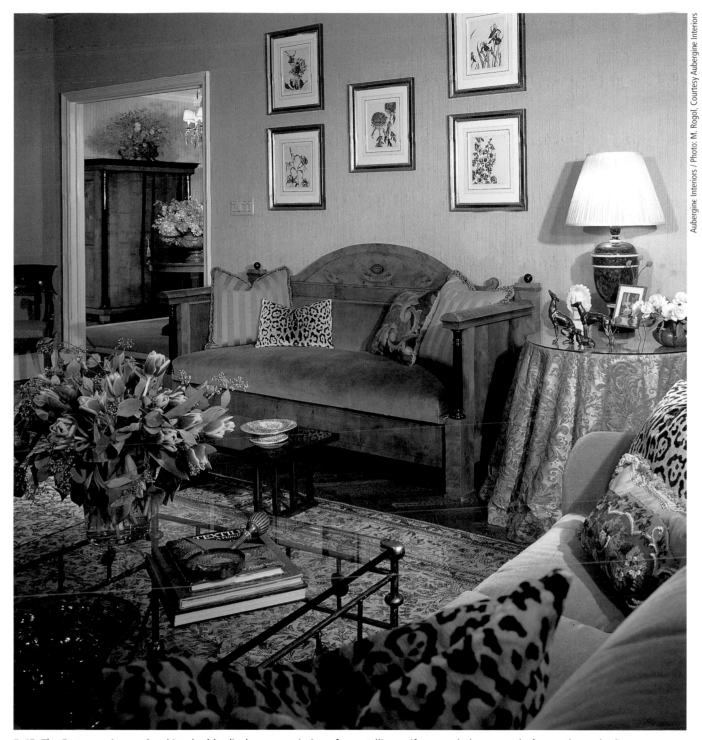

5-45 The Fortuny print on the skirted table displays overprinting of a metallic motif over a darker ground of amorphous shading.

overprinting a metallic or lighter opaque motif over a dark, batiklike ground area of amorphous shading (figure 5-45).

Textiles from different cultures can produce a type of design cross-pollination. Many cultures contribute motifs, patterns, and techniques that

become popular in various styles of design, producing fabrics of African inspiration (figure 5-46), early-American influence, and Chinese and Japanese influence (figure 5-47). Likewise, patterns from art or architectural movements from the Italian Renaissance to art deco work their

way into textiles (figures 5-48–5-52).

A *documentary* is a design derived from a specific style or even a certain fabric. A designer may take a group of fabrics from a museum and develop up-to-date patterns from the historic textiles. The new pattern may be a loose interpretation of the doc-

CLOCKWISE FROM TOP LEFT

5-46 The African-inspired pattern woven in chenille and novelty yarns reflects the textural inspiration of bark cloth.

5-47 This design features hand-painted vignettes adapted from a twelfth-century Japanese scroll known as the Lotus Sutra.

5-48 Italian Renaissance decorative effects influenced this tile design.

5-49 Elizabethan pictoral tapestry motifs are reinterpreted in this print.

5-50 This Georgian era–inspired dolphin motif is shown in a popular damask-woven design.

5-51 Art deco architectural forms inspired both this print and the decorative tassels that coordinate with it.

ument; however, if the new design is very close to the original, the original is given credit. Often a museum licenses the right to reproduce textiles from its collection, as well as to use the museum's name. The museum then oversees the development of those designs for commercial uses. Figure 5-53 shows an eighteenth-century hand-painted silk panel that was developed into the twentieth-century repeat pattern shown in figure 5-54.

Coordinates are designs developed to be used together. A geometric may be a coordinate to a floral, as illustrated in figures 5-55 and 5-56, or some of the motifs in a floral may be used at a different scale or in a different layout to make a coordinate. A stripe may go with a plaid or check, or one pattern may be rendered in two techniques to give a slightly dif-

5-52 Numerous twentieth-century artists designed fabrics;. some of them, such as this one by Gustav Klimt, are still produced today.

ferent look. A good coordinate pattern, however, can always stand on its own as a successful design. A group of designs developed and pre-

sented as a collection simplifies interior designers' and end-users' choices by providing readily accessible, useable coordinates.

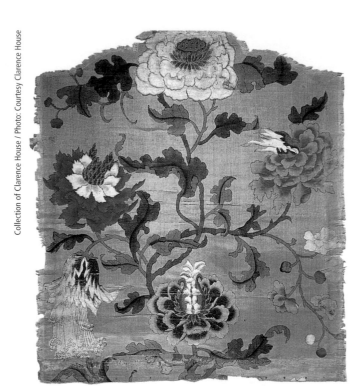

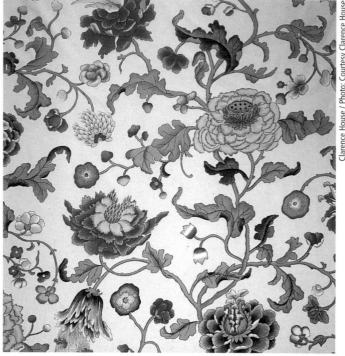

CLOCKWISE FROM TOP LEFT

5-53 This eighteenth-century hand-painted silk panel was the document used to develop the fabric in figure 5-54.

5-54 Twentieth-century repeat pattern developed from the original document shown in figure 5-53.

5-55 Checks are frequently coordinated to floral patterns.

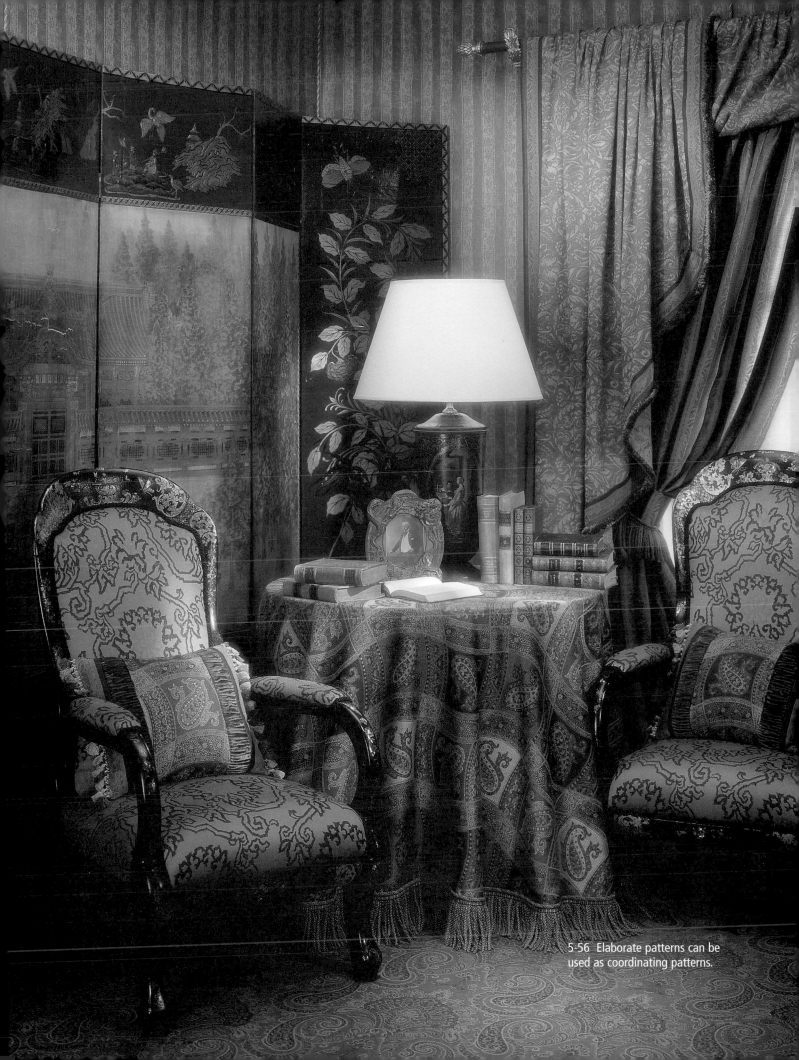

5-56 Elaborate patterns can be used as coordinating patterns.

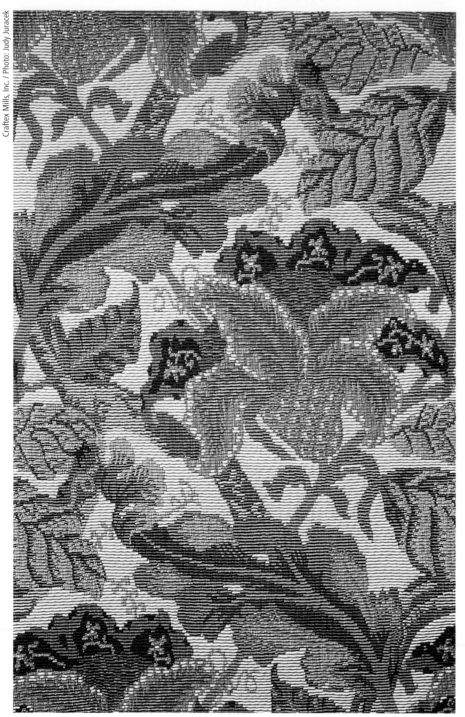

5-57 A tree-of-life pattern uses a meander to feature floral forms that seem to grow and wander across the surface.

Layouts

Textile design types may be categorized by layout as well as by motif or style of pattern. Fabric showrooms and sample books do not usually group fabrics by layout, but descriptions often include layout types. Furthermore, a designer may need or want a pattern of a particular character and should therefore be able to correctly convey that desire to a supplier.

A pattern composed of motifs that look randomly arranged is referred to as a *tossed* pattern. The elements may be *spaced* (with ground area between motifs, as in figure 5-10) or *packed* (so that motifs touch, as in figure 5-34, but may be separated by some ground area). Similarly, an all-over layout (also called a *meander*) has balanced motifs that recur irregularly within the repeat unit; the difference is that the motifs are connected in some way, forming a network that covers the entire design plane (see figures 5-8, 5-12). Typical of the Jacobean, Indienne, Portuguese, and Arts and Crafts styles, a *tree of life* (figure 5-57) is a type of all-over layout. These designs feature elaborate, embellished, floral-like motifs that seem to grow and wander across the design plane.

A pattern in which all motifs repeat directly under and directly across from one another at obvious, measured intervals is called a *set* or *tailored* pattern. Provençal designs (see figure 5-15) are often set patterns, as is the floral featured in figure 5-58. Polka dots are also a set pattern. Small patterns of this type are also called *foulards*, the French term for the silk or rayon fabrics for neckties and scarves often printed with these patterns.

Flowers or plants can be arranged in a *bouquet* layout, with identical or varying bouquets repeating at regular intervals (see figure 5-5). A *five-point bouquet* is a layout arranged so that when the fabric covers a sofa cushion, one bouquet is in the center and a quarter of a bouquet shows at each corner of the cushion (figure 5-59).

The *ogee* layout, which utilizes onion-shaped motifs, is common in wallpaper, traditional damask patterns, William Morris's designs, and Moroccan and Middle Eastern–based designs. The textile illustrated in figure 5-60 shows how the "points" of the onion shapes fit together to form the structure of the design.

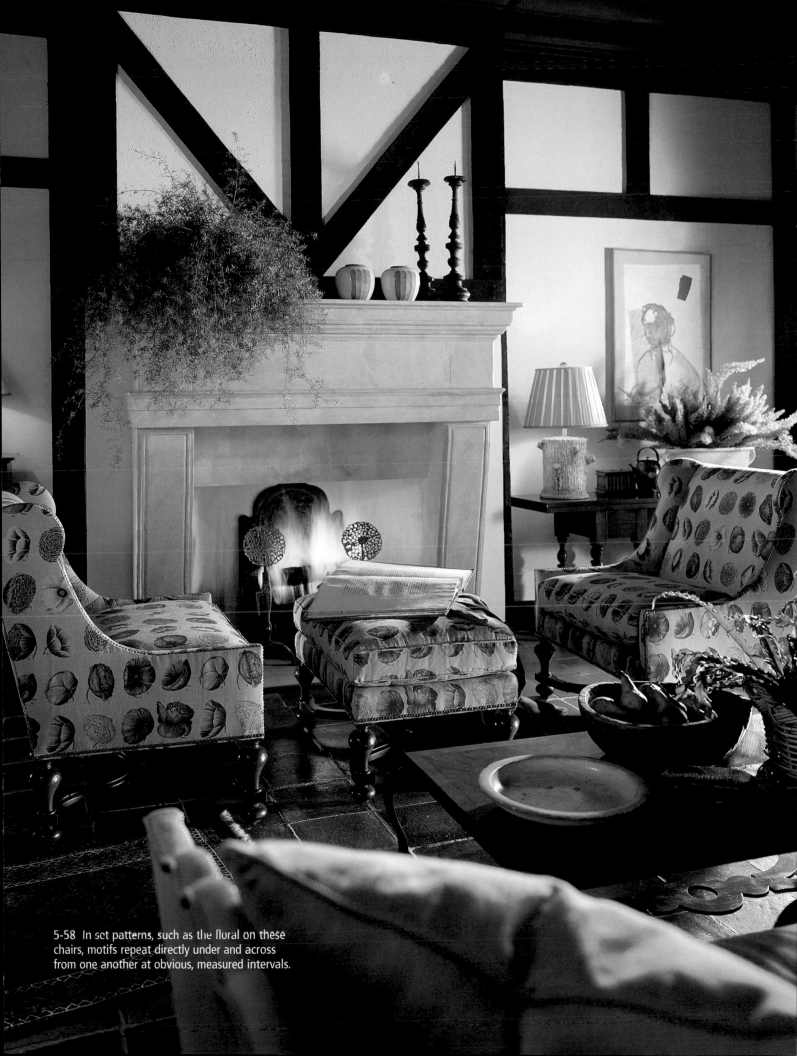

5-58 In set patterns, such as the floral on these chairs, motifs repeat directly under and across from one another at obvious, measured intervals.

5-59 A five-point bouquet layout is arranged so that when the fabric covers a sofa cushion, one bouquet is in the center and a quarter of a bouquet shows at each corner of the cushion. In this pattern, the bouquets are featured in vases.

Ogee layouts often incorporate floral forms in urns or vases as well as birds as motifs; damask and wallpaper designs in this layout are often of a single color on a contrasting ground.

A horizontal stripe layout is called a *bayadere*. As the design in figure 5-61 shows, this need not simply be a geometric stripe composed of straight lines; rather, it can feature any type of motif arranged in a horizontal format. Bayadere layouts usually feature strong, brilliant colors. Diagonal stripes, although not common, are almost always at a 45-degree angle, not only to facilitate the matching of the design at the seams, but also to allow the design to be used either horizontally or vertically. The diagonal usually runs from lower left to upper right.

A *border pattern* (figure 5-62) is placed along one selvedge, with a ground extending to the other selvedge. A border fabric is used for window covering or on upholstery skirts with a border around the hem;

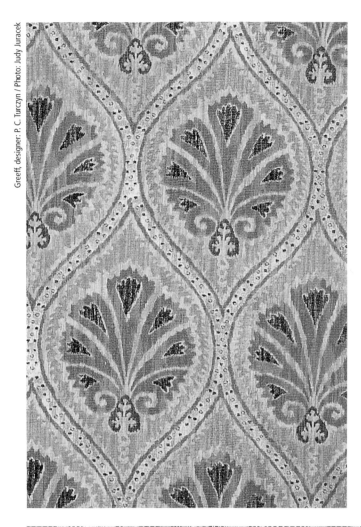

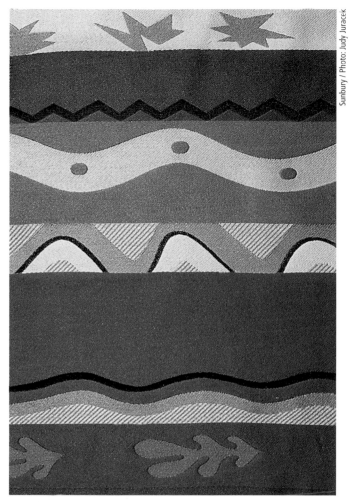

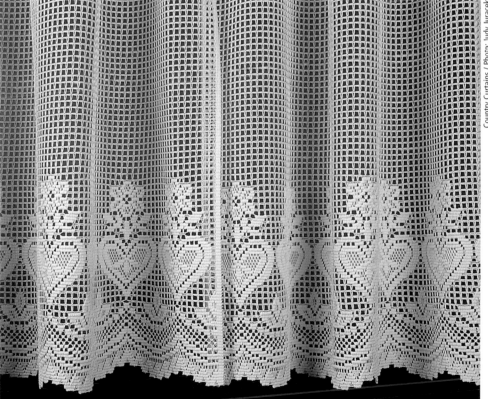

CLOCKWISE FROM TOP LEFT

5-60 Onion-shaped motifs positioned so that the "points" of the onion shapes fit together to form the structure of the design in an ogee layout.

5-61 A horizontal stripe layout, usually of bold colors and effect, forms a bayadere design.

5-62 In a border design such as this lace, the motifs are placed along one selvedge with a ground extending to the other selvedge

5-63 In a one-way pattern, all the motifs are oriented in the same direction.

5-64 In a two-way pattern, half the motifs are upright and half are upside-down, so that the pattern can be used in either vertical direction.

5-65 In a multidirectional pattern, motifs face all directions, making the fabric look "correct" from any angle.

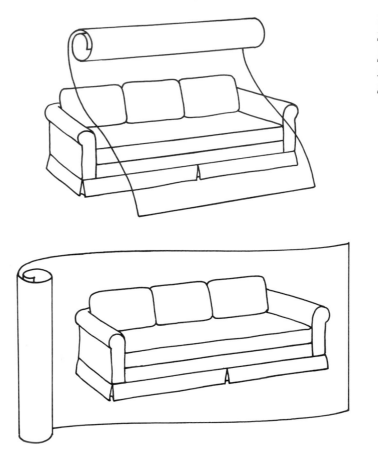

5-66 Fabric may be applied to furniture as it is woven, or so that the weft is parallel to the floor (top drawing), or so that the warp is parallel to the floor (bottom drawing), which is called railroaded.

therefore, if the fabric is expected to be hemmed, enough space must be allowed in the design for the hem of the article to be turned under without distorting the design.

Some home furnishings fabrics are designed so that there is a border along each selvedge with the ground in between; this forms, in essence, a double border. Such an *engineered* pattern is completely self-contained within specific edges. Designed almost like a drawing or painting, engineered patterns are striking for pillow covers, area rugs, and specialty upholstery.

In any type of layout, the direction of the motifs must be considered. In a *one-way pattern* (figure 5-63), all the motifs face upright in the same direction. In a *two-way pattern* (fig-

ure 5-64), half the motifs are upright and half are upside-down, so that the pattern can be used in either vertical direction. In a *multidirectional* pattern (figure 5-65), motifs face all directions, making the fabric look "correct" from any angle. Fabrics with one-way or two-way patterns must always be utilized in a consistent direction; that is, they must be cut with respect to the "top" and "bottom" of the pattern so that a piece of fabric showing upside-down motifs is not placed next to a piece showing right-side-up motifs. Because direction of motifs is a consideration in the utilization of these patterns, they are referred to as *directional*. Pieces of multidirectional-patterned fabric can be used together in any orientation, and therefore the

5-67 When used for upholstery fabric, horizontal patterns are usually railroaded, so that the stripe runs vertically on the furniture.

pattern is called *nondirectional*. Lower-end residential upholstery manufacturers most commonly use nondirectional patterns (as discussed in the seating section in chapter 8).

One-way patterns (either vertical or horizontal) are easily utilized for most interior-furnishing application and are therefore common. When used for upholstery fabric, horizontal patterns are usually *railroaded*—that is, the fabric is turned sideways so that the filling-oriented direction of the pattern runs vertically on the furniture (figures 5-66, 5-67). Vertical one-way or two-way patterns are convenient formats for drapery fabrics. Because most drapery fabricators are unwilling to spend the extra time and care required to line up horizontally positioned patterns at the seams (called *side-matching* the pattern), horizontal drapery patterns are uncommon in the American market, unless the shapes are vague enough that precise side matching is not required.

Color Application

Perhaps the single feature that most effects a person's reaction to a particular fabric is its color. If consumers or interior designers find a fabric's color unappealing, they will not even test its feel or evaluate its performance features.

Color can be imparted to fabric in two ways: through printing, in which coloring agents are applied to specific areas of the fabric's surface to create patterns or motifs; or through dyeing, in which fabric, yarn, or fiber is immersed in and saturated with a solution that completely colors the material. Partly because color can be added at various points of the manufacturing process, fabric can feature a broad range of color characteristics. It often is categorized into one of two groups: fabric with components that are colored before the fabric is produced (for example, yarn-dyed, stock-dyed, or solution-dyed fabrics) and fabric that is *in the greige* (natural, uncolored) and to which color is applied last (printed or piece-dyed). The process of coloring uncolored cloth is called *conversion*, and the companies that handle this process are called *converters*.

Colorfastness and Color Matching

Fabric color is never permanent, but relative color performance is important for some uses and is measured and compared in several ways. Lightfastness refers to a fabric's ability to maintain its original color when it is subjected to light up to a proscribed exposure level. Resistance or fastness to crocking (physical rubbing of the fabric's surface) is measured for both wet and dry conditions. Color that bleeds will run out of the fabric (and risk coloring other fabrics) in the washing process, although color loss

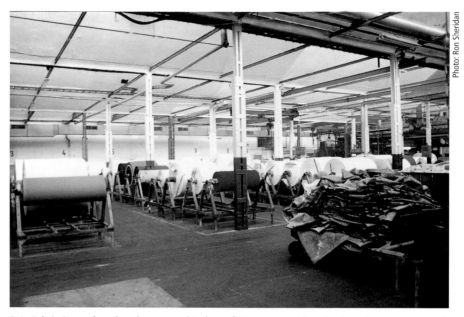

6-1 Fabric is produced and processed in lots of 50 to several hundred yards or meters, such as those shown stored in the factory in this picture. Once fabric is completely ready to be shipped to the customer, it is cut to more manageable lengths of 50- to 75-yard (-meter) pieces, which are rolled on individual tubes.

in the fabric itself may be imperceptible. Gas fading refers to a change of color because of impurities in the air.

A dye *lot* is the quantity of fabric that a given manufacturer can color in a single-production process in its factory. Depending on the weight of the cloth and the dyer's machinery, dye lots vary from 50 yards or meters to many thousands of yards or meters (figure 6-1). No two dye lots can produce exactly the same color. Regardless of how or at what point the dye is added to material, lot-to-lot color consistency and optimal performance of the finished product demand high quality control. A *commercial match* refers to a dye-lot variation that is considered acceptable in a production context—although it may not please the end-user! Acceptable variation from lot to lot is called *commercial tolerance*. A *master*, or *standard*, is an approved production sample to which all future lots of the same fabric are compared and matched; an *off shade lot* is too far from the standard to be

a commercial match. A *submit* is a small swatch of fabric that is sent in advance of the entire lot to show a potential user the exact color of that lot. A *lab dip* is a swatch made in a lab in order to establish an appropriate dye formula before a new color is dyed in a production lot; a *strike-off* is a first trial of a new print lot.

As noted earlier, color appears different under different light sources. Dye formulas must be established under stipulated lighting conditions (such as incandescent, halogen, daylight, etc.). Most dyers use cool-white fluorescent light, although customers may specify other light types to dyers. Dyers and weavers compare colors under a Macbeth SpectraLight, which is a small, isolated chamber into which material is placed so that it can be evaluated under a variety of specific lighting conditions that are within the apparatus (figure 6-2). *Metamerism* refers to a phenomenon in which two fabrics dyed with different dyestuffs match under one lighting condition (such as incandescent)

THESE SUBMISSIONS WERE MATCHED UNDER MACBETH SPECTRALIGHT. THE FIRST PRODUCTION DYEING OF EACH COLOR WILL BE MATCHED AS CLOSELY AS POSSIBLE TO THESE SUBMISSIONS, AND WILL BE THE STANDARD FOR FUTURE DYEINGS.

QUALITY: 10358
LAB DYE SAMPLES ARE NOT REPRESENTATIVE OF PRODUCTION FINISH.

Macbeth SpectraLight to control lighting conditions. Material is placed into this chamber, which measures about 30 inches (76 cm) in height, width, and depth. The light within it is set to a specified condition, such as fluorescent or incandescent.

6-3 Lab dips use the same fabric that will be dyed in production, but they are small swatches and their character may be different from the final product because no finishing can be applied to the lab samples.

but appear substantially different under another light source (such as daylight). A color that changes dramatically under different lighting conditions is said to *metamerize*. *Shading* refers to color gradation across or along the same piece of material.

When a textile designer requests a new color from a factory (whether yarn, solid fabric, or print) the designer submits a *target*, or swatch of the requested color, to the *color lab* at the factory. The dyer in the lab scans the target with a computer that is programmed to calculate various dye formulas that will approximate the color target. A color can be mixed many different ways, so the computer is programmed to consider factors such as dye cost, metamerism, and market expectations for color fastness and lighting conditions. The dyer chooses from the computer's recommendations and then makes a lab dip of the color (figure 6-3). Lab dips use the same fabric that will be dyed in production, but because they are dyed in the lab, their character may be quite different from that of the final product. Lab dips are usually a bit wrinkled or crumpled; finishing processes cannot be applied to such tiny samples.

Computers have greatly simplified the lab-dip process, but the eyes and knowledge of experienced dyers are crucial to the next step of comparing the lab dip to the target. After the dyers have made the necessary adjustments and subsequent lab dips, they submit the best lab dip to the fabric designer. Specifiers or interior designers who have requested a *custom color* are often asked to review the lab dip.

It is the dyer's job to match the color target, and most dyers can match a true color target superbly. If the target submitted is dissimilar in character to the material to be dyed, the dyer (or the computer) must decide what the target is. For example, inexperienced designers often submit a multicolor yarn, iridescent material, or velvet as a target for a solid fabric with the hope of achieving a more "complex" color result. When this is the case, the dyer is forced to choose which color to match, as the solid fabric cannot match the target provided. More knowledgable designers submit a "true" target that is similar in character to the material to be dyed. If that is impossible, they will clarify the goal, explaining, for instance, to "match the lightest portion" of a velvet. This allows the dyer to work efficiently, without having to read the designer's mind.

Dyeing

A dye is a soluble chemical that creates a specific color when it bonds with a particular material. Dyes vary in vulnerability to light exposure, washing, and other uses depending

on the dye's chemical makeup and on the material being colored. Nonetheless, dyeing is by definition a chemical reaction and a permanent process. Once the material and the dye bond, the color is a part of the material. Different chemicals must be used to color different materials: A dye *class* is composed of a group of dyes that work on a particular category of material. Fibers have affinity for certain dyestuffs; for example, cellulosic fibers take certain dye classes, protein fibers take others, and polyester still others. Dyes intended for one fiber may stain fibers of another group—or not affect them at all. Understanding exactly which dyes work for specific fibers is not germane to the work of interior designers; many textile professionals cannot name the dye classes that apply to specific fibers. This principle of chemical compatibility is, however, basic to understanding common references to types of dyeing.

YARN-DYEING

Yarn is commonly dyed after it is spun so that individual strands within the fabric are separately colored. Stripes and plaids are obviously yarn-dyed (figure 6-4), as are most jacquard and dobby-woven upholstery fabrics. Every mill runs a bank of standard yarn colors that it works with all the time, and some mills will produce custom yarn colors for a guaranteed order of anywhere from 50 to several thousand yards (meters).

In the past, and in some very small-scale limited production today, some yarn is *skein-* (or *hank-*) *dyed*. If it is kept loosely looped in skeins (figure 6-5), a chenille yarn, for example, can maintain maximum "fluffiness." Silk and very expensive novelty yarns are often skein-dyed. But because skein-

6 4 To produce stripes (and plaids), individual yarns are dyed prior to weaving the cloth.

6-5 Silk is often stored and dyed in loose bundles of yarn called skeins or hanks.

dyeing is so rare and most yarn is stored on special cones called *dye packages* (figure 6-6) that allow dye to travel most freely through the yarn in the dye bath, the term *yarn-dyeing* is used almost interchangeably with *package-dyeing*.

SOLUTION-DYEING

Fiber producers sometimes insert color when the fiber is in its liquid state, before it is extruded into its staple form. For packaging convenience, the liquid is often solidified into pellets (figure 6-9). Such solution- (or dope-) dyed color is inherent to the fiber; therefore, it is the most permanent and uniform of all dyes. However, the process is economical only in very large runs, and because the dye is added at the earliest stage of the manufacturing process, it is commercially viable in only the most universally acceptable colors (figure 6-10). Solution-dyed fibers can be blended through air entangling or spinning the staple form of the fiber to yield heather yarns, which allows for slightly more vari-

LEFT TOP TO BOTTOM

6-6 Yarn is stored on special spools called dye packages.

6-7 Each dye kettle in the dye house contains many packages of yarn. The dyeing processes are controlled by computer.

6-8 Yarn dye kettles.

BELOW

6-9 Synthetic fiber is often stored in solidified pellets.

ety. For example, the bulkiest yarn shown in figure 3-5 is not solid blue. Its heather effect has been achieved by air-entangling blue and white filament components together into one yarn. Carpets, outdoor fabrics, and some wallcoverings are made of solution-dyed fiber for maximum lightfastness and for economic reasons. Certain fibers (notably polypropylene) are dyeable only in solution form.

STOCK-DYEING

Natural fiber staple, or stock, can be dyed before the yarn is spun. While the quantities required for this process are far smaller than those for solution-dyeing, the raw material is more expensive. Stock-dyeing is commonly used to achieve woolen tweed and heather yarns in which various colors of stock are blended into a single strand of yarn (figure 6-11).

PIECE-DYEING

To create a solid-color fabric, gray goods are first scoured (to remove sizing that was added to make the yarn easier to handle during manufacture and soiling that was picked up along the way) (figure 6-12) and then immersed in a liquid dye bath for a specified length of time and under particular conditions (figure 6-13). Once dyed, the wet, colored goods are washed, dried, and pressed

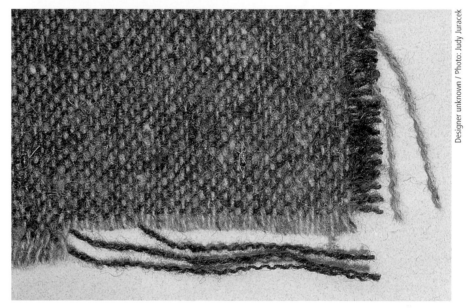

6-10 Because dye (stored in pellet form) is added at the earliest stage of the manufacturing process, solution-dyed fibers are commercially viable in only the most universally acceptable colors.

6-11 Stock-dyed fibers are blended into individual yarns and then woven to achieve the heather character of tweed fabric.

6-12 Greige fabric is scoured to remove soiling and sizing before it is printed.

6-13 Fabrics are placed in dye kettles for a specified length of time and under particular conditions.

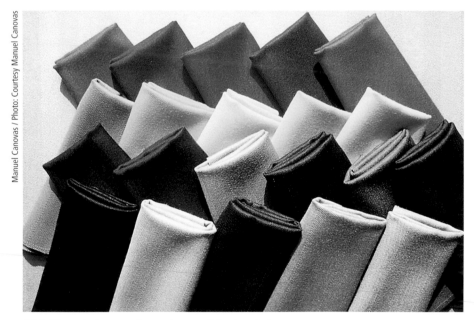

6-14 Piece-dyeing usually produces solid-color cloths.

turing—dyeing—after which the fabric can be shipped to the purchaser. Solution- and stock-dyeing are just the opposite: Color must be determined before the yarn is made. Lead-times (the time needed to produce fabric) are considered shortest for piece-dyeing because the illusion is that the fabric is "made" in the final, quick step of dyeing.

The main limitation of this method is obvious: Piece-dyeing usually yields only solid-color fabrics (figures 6-14, 6-15). In addition, piece-dyers are scarcer than ever and usually gear their facilities to meet the demands of large markets such as knits for sweatshirts and T-shirts, heavy wools for coating, plain cotton for sheets, and some denim. Piece-dyeing is less popular for interior-furnishing fabrics because solid-color fabrics are not commonly used in large quantities. (This could be a question of the chicken or the egg; tastes regarding all aesthetic products change, and as demand for solid-colored interior fabrics decreased, smaller dye houses disap-

(or otherwise appropriately finished). Fabrics are produced in a convenient manufacturing lot size called pieces, which are usually between 50 and 75 yards (meters) long. (Shorter pieces are convenient for very heavy fabrics and longer for very fine or lightweight fabrics.)

Piece-dyeing is the most efficient and economical coloring method

and allows for all the advantages of the conversion process. That is, manufacturers can inventory plenty of gray goods (without having to predict which colors will sell) and then dye pieces (or *assort*) according to which colors are in greatest demand. The converter needs only a week or two after the fabric is ordered to complete the last step of manufac-

peared, leaving only big dyers that are ill-equipped to service diverse and splintered markets like upholstery. Once the smaller dyers were gone, solid-color upholstery fabrics became scarce, so no dyers were "needed" to produce them.) However, flannel for upholstery or wallcoverings, solid velvets, some sheer and other types of drapery fabrics, and many panel fabrics are piece-dyed.

Many consumers, including designers and even some textile professionals, mistakenly believe piece-dyed fabrics are inherently less durable and have an inferior color application than other types of dyed fabrics. This is not true; the same dye is used regardless of whether it is added during the yarn, fiber, or fabric state. The dye is equally fast if properly applied in any phase of the fabric's production. Fabrics that are streaky or have not been completely permeated by the dye simply are not properly produced; this is not a characteristic feature of piece-dyed fabrics. No two dye lots are ever exactly the same, and while lot-to-lot consistency is not lower in piece-dyed fabrics than in yarn-dyed fabrics, human eyes are more forgiving when evaluating two lots of a multicolor fabric than two lots of a solid. Therefore, designers must take care to avoid mixing dye lots, particularly of solid fabrics.

UNION- AND CROSS-DYEING

In order to achieve a solid color, a cloth (or yarn) that is made of two fibers with affinity for two different dye classes must be union-dyed, or dyed twice—once with one dye class and once with another. For example, a solid navy-blue cloth of polyester and wool content has been dyed by one dye class for the wool fiber and by another class, perhaps in another dye bath, for the polyester fiber.

6-15 These jacquard-woven fabrics are dyed a single color, but contrasting weave areas reflect light differently, producing a tonal effect.

In fabrics of certain fiber blends, piece-dyeing can yield fabrics of two or more colors. *Cross-dyed* fabrics contain two different fibers that are separately colored as the cloth is immersed in two separate dye baths that each contain a different class of dye (figure 6-16). Cross-dyeing can be applied to distinctly different fibers, such as polyester and wool, that dye differently, or to certain synthetic fibers that have been chemically manipulated to be dyeable by two different dye classes. For example, specially formulated *cationic* nylon blended with standard nylon

yields a pure nylon cloth that can be cross-dyed.

Deep-dye forms of synthetic fibers will bond with the basic dye class for the fiber but result in a deeper shade of the same color for a monochromatic heathered effect. It is a variation on cross-dyeing because a cloth blended of regular and deep-dye polyester looks like a cross-dyed cloth but requires only the regular polyester dye class. Similarly, in *overdyeing* the fabric contains a predyed contrasting-color yarn or fiber that resists the dye stuff being used. All forms of cross-dyeing are less effi-

Robert Allen Contract, designer: Marypaul Yates / Photo: Courtesy Robert

cient and require more exact standards than the union-dye process. While commercially practical, cross-dyeing and its variations require special facilities, which are available but not common.

All of these processes can be applied to yarns rather than fabric; cross-dyed yarns are not common, but overdyed yarns made of a color and a black component are frequently used in yarn-dyed combinations (figure 6-17). Yarns are frequently union-dyed.

NATURAL AND UNDYED COLORS

In response partly to ecological concerns and partly to a new desire for a pared-down, clean aesthetic, natural materials in natural colors are extremely popular. While cotton has been genetically manipulated to grow in a range of "natural" colors, fibers in their natural state are usually some variation of off-white, brown, or gray (see figure 3-18).

Undyed natural materials do not fade, but they do change over time; materials that have been bleached undergo the most change and usually yellow and darken. Wool and other protein fibers also darken and yellow, cotton and cellulosics lighten, and linen and grass fibers darken. The changes are natural and usually give fabric a rich patina. However, if snow white is the desired color, an inert synthetic may be the best fiber choice.

Photo: Judy Juracek

6-16 Cross-dyed fabrics are dyed two different colors after they are woven. The process requires two different dye baths that each target a different fiber in the cloth.

6-17 Yarns that are black and white can be overdyed. The white takes the dye color, but the color does not show up on the black component.

PIGMENTS

Pigments arc not dyes; they are physically bound to the surface of a fabric with resins but do not chemically bind with the fiber. They are not used to color an entire cloth but rather are applied to fabric only through printing methods. Pigments have certain favorable features: They are inexpensive, easy to color-match lot-to-lot, and, though vulnerable to crocking, are very lightfast. Because pigments are opaque, appear to sit on top of the fabric, and are hard and stiff to touch, they are undesirable for sheets (although most domestically printed sheets are pigment-printed) but well-suited for sheer window coverings (figure 6-18) and wallcoverings (figure 6-19). Hotel draperies that are rarely touched but require a bold look and excellent lightfastness are often made with pigments. Printed metallics, like that pictured in figure 6-20, are pigments.

Printing

Printing allows color to be applied to specific areas of the fabric surface in order to create patterns and motifs that are not part of the fabric as it was manufactured. Several printing methods are currently used; each method has various design, performance, and manufacturing advantages and limitations.

6-18 Printed metallic pigment creates opaque areas on a sheer fabric.

6-19 Pigment color appears to sit on the fabric's surface when printed on a nonwoven (needlepunched) wallcovering fabric.

6-20 Printed metallic pigment on silk organdy.

6-21 In roller printing, cylindrical copper rollers are engraved to match the desired textile design.

6-22 Each roller is slightly wider than the fabric to be printed.

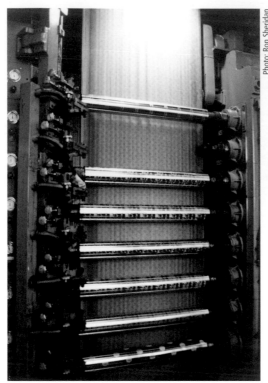

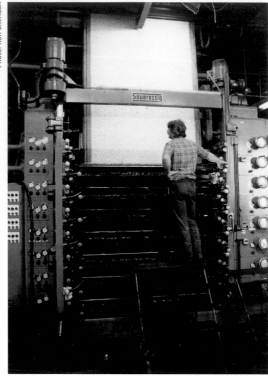

ROLLER PRINTING

In roller printing, a cylindrical copper roller is engraved to match the desired textile design (figure 6-21). The roller is slightly wider than the fabric to be printed (figure 6-22) and is a maximum of 16 inches (40 cm) in circumference, which dictates the repeat size of the pattern. Multicolored designs require an individual roller for each color. Once engraved, each roller is positioned against a large drum on the printing machine. The unprinted fabric is fed into the machine between the drum (sandwiched with a carrier pad, which acts as a conveyor to move the fabric) and the engraved rollers (figure 6-23). A color box containing one color of dye paste is located below each roller, and the color is delivered to the roller by an unengraved cylinder (similar to a house-painting roller) called a color furnisher (figure 6-24). Both the color furnisher and the engraved roller spin during printing.

Although very fine lines and subtle shading are best achieved

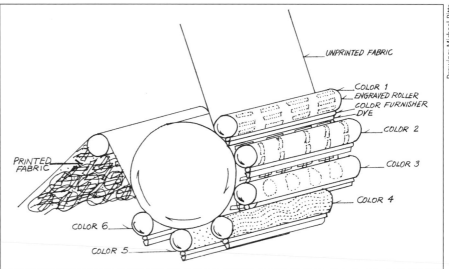

6-23. Each engraved roller is positioned against a large drum on the printing machine, and the fabric is fed between the drum and the roller.

through roller printing, the process has become uncommon because of the high cost of engraving rollers and the popularity of screen printing. These factors and the infrequent use of the process have made setting up the machinery a cumbersome enterprise. Roller printing is rarely used today for fewer than several thousand yards (meters) of a particular pattern. Runs of these large quanti-ties are rare for interior furnishing fabrics. Furthermore, roller-printer companies developed the roller-circumference sizes for apparel, their primary market. These standard circumferences dictate repeat sizes that are inappropriately small for use in interiors. Roller printing for interior fabrics is therefore limited and diminishing, although the effects achieved through roller printing are

simulated and referenced as such (figure 6-25).

ROTOGRAVURE PRINTING

Rotogravure, or *gravure*, printing is a modification of roller printing developed for noncloth materials that is becoming increasingly popular. It is the most popular method of printing on vinyl. The engraved cylinders are usually steel and have been designed to produce the large repeat sizes necessary for interior-furnishing patterns. Each cylinder delivers a color to the substrate at a separate station, and the material undergoes a drying process before the next color is applied. Most vinyl printers are equipped for four-color printing, although theoretically more colors are possible.

Gravure printing is also the preferred method for printing patterns on paper that are later transferred to fabric through *heat-transfer* printing. This process is used for synthetic fabrics and laminate substrates (see page 147). Gravure printing is the most economical method for long runs, and the technique allows for extremely fine, soft lines and subtle, almost photographic, gradation. Halftones, or shading of light to dark in a single color using only one roller, are best achieved with this technique (figure 6-26). However, large, open

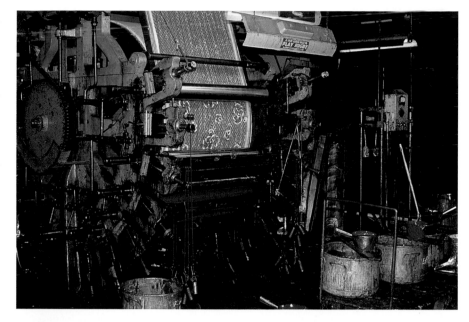

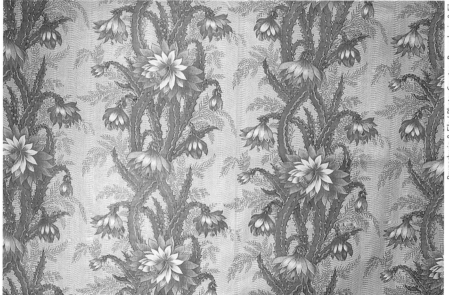

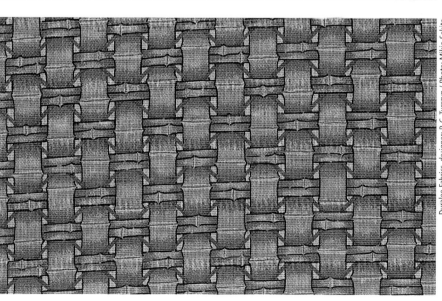

6-24 A color box, containing one color of dye paste, is located below each roller and is delivered to the roller by a color furnisher.

6-25 The fine lines in the ground of this fabric are typical of roller printing. The bold, solid areas of the floral motifs have been printed with a screen printing method.

6-26 Halftone effects yield shading of light to dark in a single color are sometimes achieved using only one roller.

Brunschwig & Fils / Photo: Courtesy Brunschwig & Fils

Duralee Fabrics, designer: P. C. Turczyn / Photo: Mikio Sekita

❖ 141 ❖

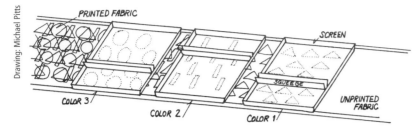

PRINTED FABRIC

SCREEN

COLOR 3

COLOR 2

COLOR 1

SQUEEGE

UNPRINTED FABRIC

6-27 In flatbed screen printing, frames stretched with a finely woven mesh are placed over the fabric to be printed. Blocked areas of the screens act as a resist and do not allow dye paste to pass through.

6-28 Flat screens stacked on end in storage.

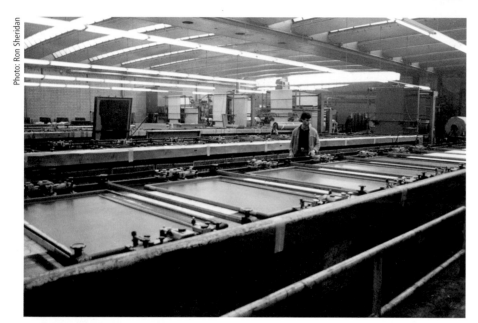

6-29 Flatbed screen print table.

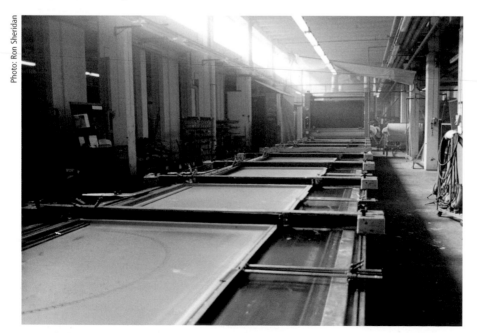

6-30 Flatbed screen print table.

areas of color are best achieved through screen printing, which produces a more even color.

SCREEN PRINTING

In *screen printing*, a finely woven open mesh fabric of silk, nylon, or metal is mounted over a frame (usually made of aluminum). Depending on the design, certain portions of the screen's surface are blocked out with an enamel-like covering, which essentially creates a stencil that is integrated into the screen. The frame is placed in contact with the fabric to be printed, and color is poured into the frame and carried back and forth across the screen with a squeegee (figure 6-27). The enameled areas of the screen act as a resist and do not allow the paste to pass through. The color is forced through the unblocked areas of the screen onto the fabric to create the printed design. As with roller printing, the complete design is created by the overprinting of several colors, each of which is delivered to the cloth by a separate screen.

Screen printing can be done in one of three methods. In *hand* and *automatic screen* printing, the fabric to be printed is laid flat over a carrier pad on a long table, and screens, rectangular frames that are of the same width as the goods across the table

(figure 6-28), are laid on top of the fabric. In automatic screen printing, the screens are lifted up after the color is delivered by automated squeegee, and a conveyor moves the fabric along. In hand printing, the squeegee is hand-operated and the screens and fabric also may be moved by hand. These two methods are called *flatbed screen printing* because the fabric and screens stretch out flat across the production table.

Flatbed screen printers (figures 6-29, 6-30) are almost exclusively European. Hand screen printing is rarely used in production but is used by certain custom and small specialty printers. Even automatic flatbed screen printing is slow and expensive. It is, however, frequently used for small runs of fabric and when very large repeat sizes are required.

Rotary screen printing is widely used. The fastest method of screen printing, it is efficient for large quantities (though usually not as large as those needed for roller printing). In rotary printing, as in automatic flatbed printing, the fabric moves along a table or conveyor. The screens are made of fine aluminum mesh and are cylindrical, with circumferences (and therefore repeat sizes) of up to 25 inches (64 cm) (figure 6-31). As the cylinder turns and the fabric moves along, dye is pushed from inside the cylinder through the unblocked areas of the cylinder's surface and applied onto the fabric (figures 6-32, 6-33). Again, each cylinder delivers one color to the fabric (figures 6-34–6-36). Rotary printing allows for larger repeat sizes than roller printing, and it produces prints with extremely accurate registration or *fit*, the alignment of the motifs with respect to one another (figure 6-37).

Screen print patterns are often of

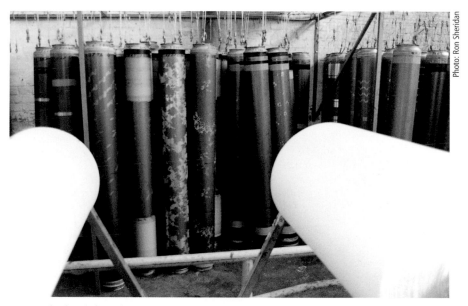

6-31 Cylindrical, fine aluminum mesh rotary screens are stored on end.

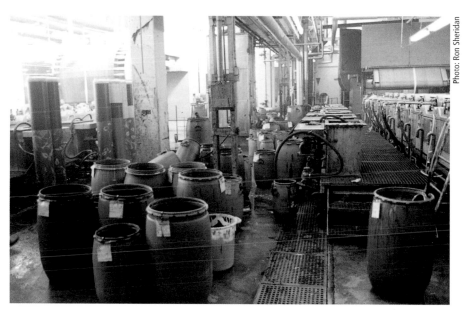

6-32 Dyes in vats being pumped into rotary screens on the printing table at right.

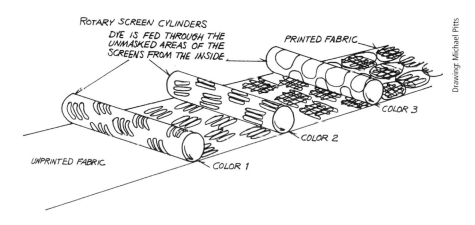

6-33 In rotary screen printing, dye is forced through the unmasked areas of the screens from the inside.

❖ 143 ❖

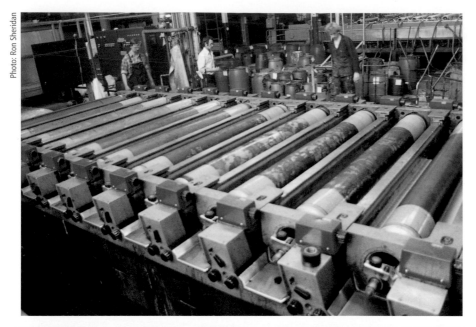

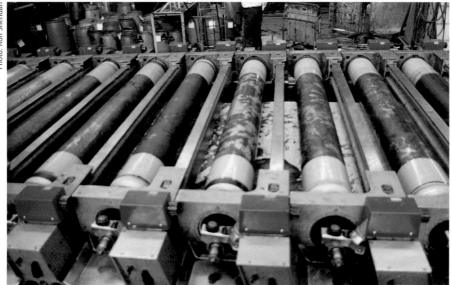

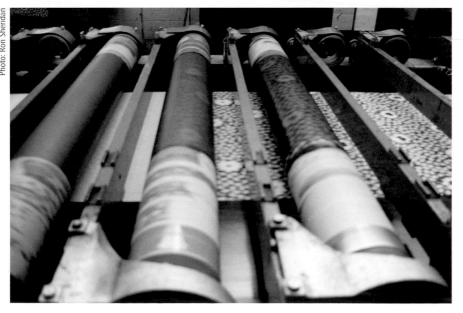

bold, simple, clear shapes. In flatbed printing, the dye dries slightly between each screen, producing a crisper, cleaner look and a finer line than in rotary printing, where each color does not have time to dry before the next color is applied to the cloth. True halftones are possible in screen printing only with *Galvanos* rotary screens. Galvanos screens are actually metal cylinders that are created through photoelectroplating, in which metal is added (or not added) to create the desired density of stencil. Galvanos screens are built up from nothing so that the spaces can be created in the exact microscopically small sizes desired. By contrast, other screens are made of fabric or mesh, which has a set construction of specific warp and fill yarns crossing at regular intervals. Its spaces, through which dye is forced, can only be the size, or multiples of the size, of the existing screen mesh. Nonetheless, because of their expense, limited availability, and environmental drawbacks (waste metals expelled in the process), Galvanos screens are becoming less popular; technological advances, however, make regular rotary screen printing capable of achieving increasingly finer detail.

WET AND DRY PRINTING

For both roller and screen processes, the use of dyes is *wet printing* (figure 6-38) and pigments is *dry printing*.

6-34 This rotary print machine is set up to print a design of eleven colors.

6-35 Each cylinder delivers one color and is engraved with a different segment of the pattern.

6-36 In screen printing, the pattern is clearly visible as the process is completed.

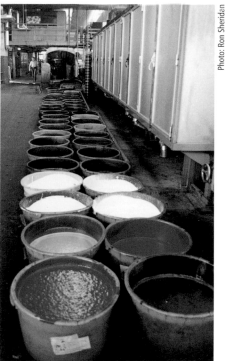

CLOCKWISE FROM TOP LEFT

6-37 The stems of these flowers and vines are intended to be orange, but because the "orange" screen was poorly registered, or lined up with the pattern, the white ground of the fabric shows through many stem areas.

6-38 Dye, ready to be printed, sits in vats.

6-39 Color applied in direct printing may be designed to leave portions of the cloth's surface undyed.

The ground cloth is usually damp for dye application and dry for pigment application, hence the names of the processes. As already noted, dyes react chemically with the fiber material, permanently altering the molecule composition. Pigment adheres to cloth with a resin binder and does not become part of the fiber.

DIRECT AND DISCHARGE PRINTING

In *direct printing*, color is applied directly onto a white cloth with any printing methods (figure 6-39). In *blotch printing* the background area is printed in the same manner as the motif; the printed background is called the *blotch* (figure 6-40). To avoid having to print the background, the entire cloth can be piece-dyed before the fabric is printed.

However, if the piece-dyed ground cloth is overprinted in a direct process, the applied colors will be influenced by the ground color (figures 6-41, 6-42). If the ground color is dark, the motif colors become darker and change hue as they combine with the ground color. In *discharge printing* (figure 6-43), the cloth is piece-dyed to the desired ground color, which is a medium-to-dark shade. A substance containing both a bleaching agent and a dye paste is applied to the cloth in the areas not comprising the background. The dark dye is thereby removed from those areas, which are immediately impregnated with the new desired dye color. Discharge printing is essentially a European process. Its

6-40 In blotch printing the background area is printed in the same manner as the motif. The yellow ground of this blotch-printed design is the blotch.

expense dictates its use in fine application in both furnishing and apparel fabrics. Discharge-printed cloths can be recognized by their solid ground color equally saturated on the front and back of the goods. The process is expensive and difficult to execute. The bleaching agent/dye paste looks like dirty bathwater as it is applied, so initial color trials (strike-offs) are essentially done blind; the true colors of the design emerge only after the fabric is printed, dried, and finished. In direct printing, by comparison, the color can be seen as it goes onto the cloth; it also dries rapidly, allowing changes

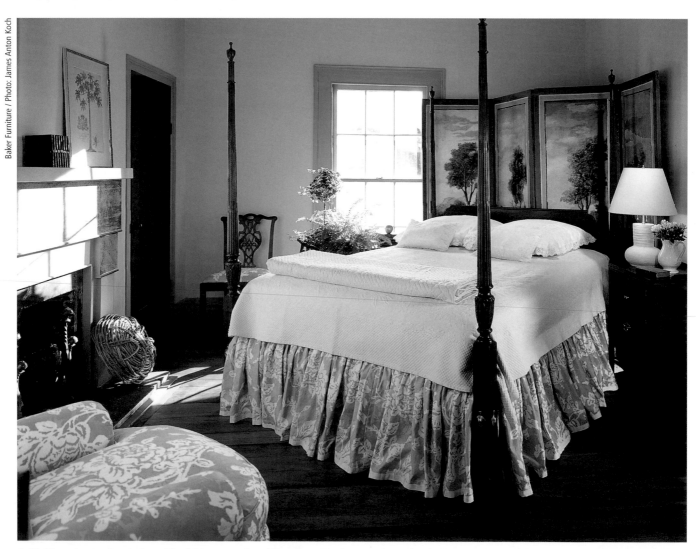

6-41 The print on the chair and bedskirt was printed in only one color on white. The design appears to be many tones of the two-color print because the ground fabric is a jacquard damask.

to be evaluated shortly after the strike-off is printed. (Most strike-offs are removed from the machine and evaluated under controlled lighting conditions before being approved or changed.)

Coordinating fabrics colored by different methods is always difficult, but discharge prints are particularly difficult to coordinate with other fabrics. The unpredictable results of the bleaching agent and the overall character of the fabric make discharge prints appear even more different from the cloths that are usually marketed as coordinates to prints.

HEAT-TRANSFER PRINTING

Heat-transfer printing is executed by first printing the design on paper (by the rotogravure method) with inks that contain *disperse dyes*, the class for which synthetics have an affinity. The face of the printed paper is then pressed against the fabric through a transfer machine. Under high temperatures and pressure, the dye *sublimates* (changes from a solid to a gas) and transfers onto the fabric (figure 6-44).

Transfer-paper printers require orders of large quantities, but print converters usually hold both the paper and the ground cloth in stock until the print is needed. The transfer process is very rapid, which allows for a quick delivery and small runs. In addition, converters usually stock several ground cloths and can transfer from the same paper onto any of the available cloths in the transfer process. This choice of ground cloth is considered an advantage of the heat-transfer process and permits maximum manufacturing flexibility. Also, heat transfer is economical and allows for design flexibility; fine lines, flat areas, photographic effects, and

6-42 When a piece-dyed ground cloth is overprinted in a direct process, the applied colors are influenced by the ground color.

6-43 Solid, dark ground colors that are equally saturated on the front and back of the goods are characteristic features of discharge prints.

6-44 In heat-transfer printing, the face of dye-printed paper is pressed against fabric under high temperatures and pressure. The dye transfers (sublimates) onto the fabric.

6-45 Natural fibers (in this case the lavender stripes of worsted wool) do not accept the heat-transfer print, which embellishes the alternate stripes of satin-weave polyester.

In apparel and high-end decorative markets, synthetics are undesirable, but today's fire codes heavily favor polyester for draperies and bedspreads in hotels, hospitals, and institutions. Therefore, most flame-resistant polyester prints used in the healthcare and hospitality markets are heat-transfer printed (see figures 1-17, 1-19).

Other Printing and Dyeing Techniques

By actually removing portions of the fabric itself, *burn-out printing* creates beautiful effects of sheer and opaque areas within a cloth. (The effect is similar to that of madras gauze, as illustrated in figures 4-68 and 4-103.) Traditionally, the fabric was passed over a flame so that the flammable cellulosic threads burned away, leaving the silk or wool animal fiber (which has a higher melting point). In production technique, however, burn-out printing is similar to discharge printing in that a bleaching agent (or acid) is applied to the cloth. Burn-out prints are ideal for sheer window coverings (figure 6-46). Print color can also be applied to the burned-out area so that it is perfectly registered in the sheer portion of the fabric. In *voided velvet*, a similar technique is used to remove sections of the pile yarns, leaving the ground weave visible in certain areas to define the pattern (figure 6-47).

Flock-printed fabrics are first printed with an adhesive in certain areas and then dusted with a fiber that is processed into fine powder that sticks to the adhesive. Flock prints are a less expensive alternative to figured velvets. They can be used for interesting effects, but they have limited abrasion resistance and thus are used most often for wallcoverings.

watercolor techniques are all possible. The heat-transfer process can also be environmentally friendly: In some instances, the paper can be used twice—the first pass gives a deep coloration and the second, a pastel *colorway* (alternate color choice in which the design is offered). The used paper can have a secondary market as wrapping paper.

Heat transfer's largest limitation is that it can only use the disperse dye class (except in rare specialty operations). This limits the method to use on synthetic cloths. Synthetic/natural blends are sometimes heat-transfer printed; interesting effects are created when the dye bonds with the synthetic portion of the fabric and is resisted by the natural fiber (figure 6-45).

In *resist-dyeing* and *-printing* processes, areas of a design are treated with a substance (such as wax or paste) that prevents the dye from being absorbed or fixed in certain places. *Batik* (figures 6-48, 6-49), which originated in Indonesia, is perhaps the best-known resist method. The areas to be masked are painted or printed with hot wax, and the waxed cloth is dyed, after which the wax is removed with heat or solvent. Batik is characterized by the fine streaks and crackle effect produced when dye has seeped through cracks in the wax. Batik dyeing is often simulated in machine printing, and the patterns are often Javanese in character.

Other resist techniques also originated in Indonesia. Two methods use string or thread to resist the dye: Areas of cloth are bound with string in *plangi* (tie-dye); in *tritik*, or stitch-resist, designs are stitched on the fabric and the stitches pulled tight enough to resist the dye. Batik, plangi, and tritik are often combined in individual designs.

Traditional Japanese resist-printing and -dyeing techniques also are often simulated (figure 6-50); they include *itajime*, *katazome*, *shibori*, and *roketsuzome*. *Itajime* (or clamp-resist) uses carved wood panels clamped together as the resist device (figure 6-51), and *katazome* uses starch paste as the resist. *Shibori* is a stitch- and string-bound dye-resist technique

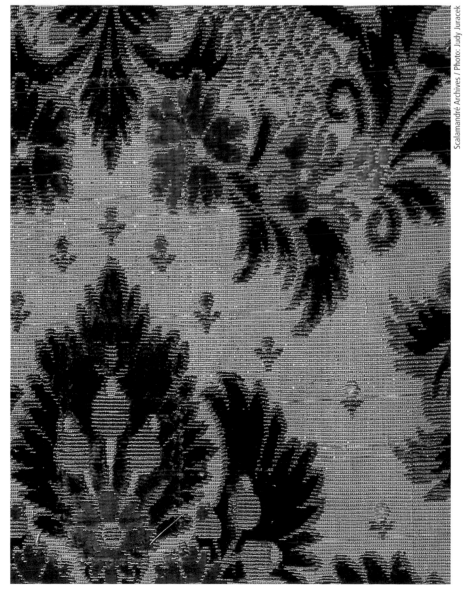

6-46 Burn-out prints are ideal for sheer window coverings.

6-47 In voided velvet, sections of the pile are removed, leaving the ground weave visible in certain areas to define the pattern.

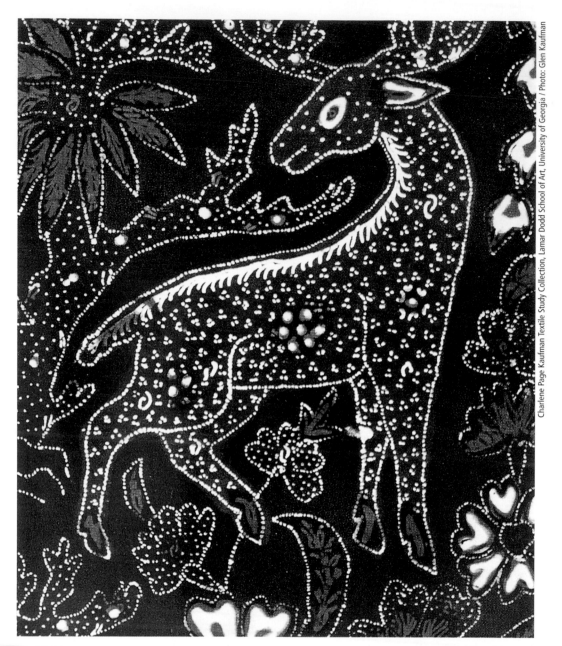

6-48 In batik, areas of the design are masked with hot wax, which resists dye and is removed after the cloth is dyed.

6-49 Batik is characterized by the fine streaks and crackle effect produced when dye has seeped through cracks in the wax.

(figure 6-52). *Roketsuzome*, a wax-resist technique, is a term less commonly used. All of these terms are used to refer to fabrics of these techniques or those that simulate the techniques and use Japanese imagery.

Resist dyeing or printing the warp (or filling) of fabric before it is woven has been used as a decorative technique in many cultures for centuries. When the fabric is woven, the already-patterned warp (or filling) yarns shift slightly, producing hazy, broken-edged motifs. This technique can be used in a variety of patterns, either abstract or figurative. *Kasuri* (from Japan) and *ikat* (from Indonesia) are achieved when the grouped warp (or filling) threads are tightly bound with ties to resist dye and then dyed and subsequently woven into cloth (figures 6-53–6-55). Today these terms are used both for the actual techniques and for simulated versions achieved through printing and jacquard weaving (figures 6-56, 6-57).

In *warp printing*, the warp is actually printed before the fabric is woven (figures 6-58, 6-59). Developed in France in the eighteenth century, the process was called *chiné*; this term is still used, usually for traditional French floral motifs (see figures 5-36, 5-37). Warp prints are still hand-produced in many parts of the world and are also created by heat-transfer printing the warp in commercial pro-

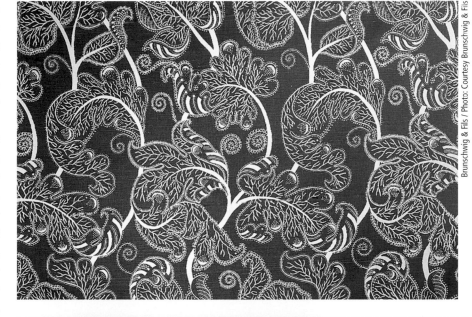

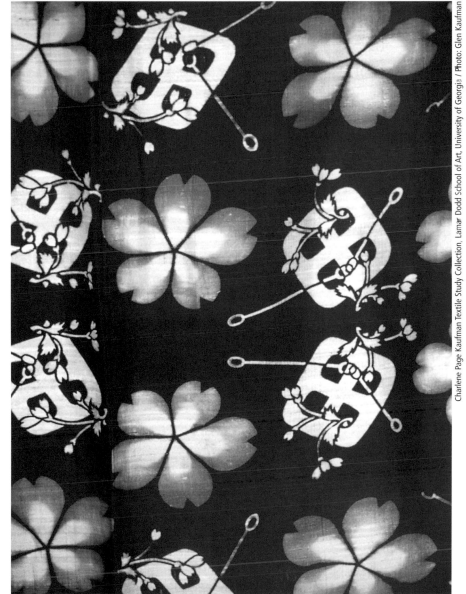

6-50 Traditional Japanese resist-printing and -dyeing techniques are often commerically simulated.

6-51 Itajime (clamp-resist) uses motif-carved wood panels clamped together as the resist device.

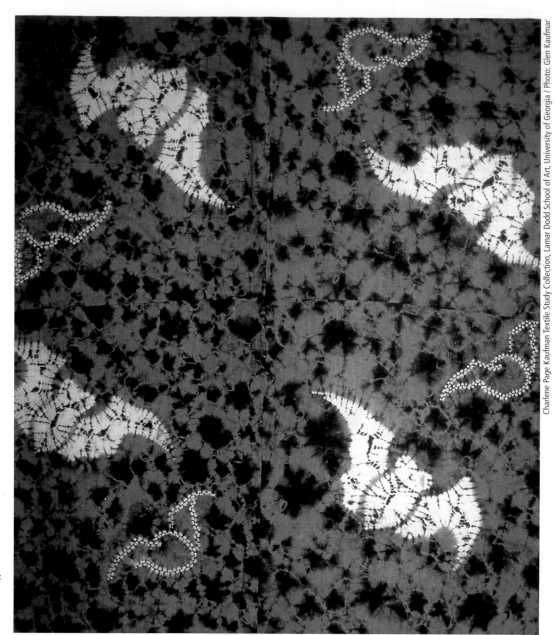

6-52 Stitch- and string-bound dye resist produces the many subtle textures of shibori, such as the ground and figures of this unusual design.

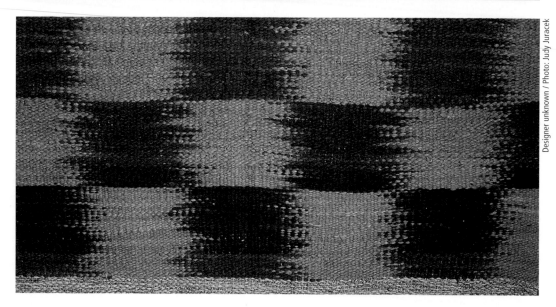

6-53 Grouped filling (or warp) threads are tightly bound with ties to resist dye and then dyed and subsequently woven into cloth in ikat and kasuri effects.

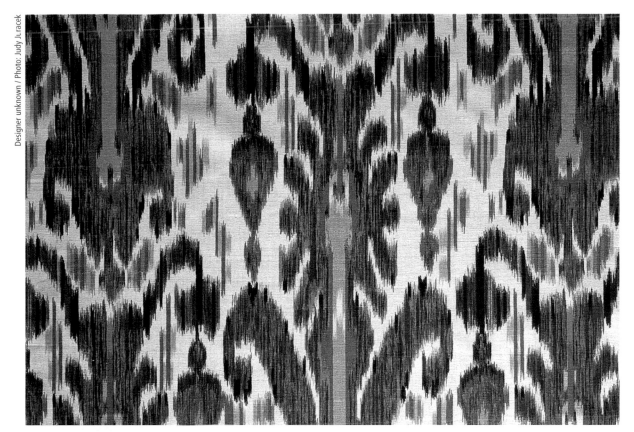

6-54 The hazy, broken-edged motifs typical of ikat occur when the already-patterned warp (or filling) yarns shift slightly in the weaving process.

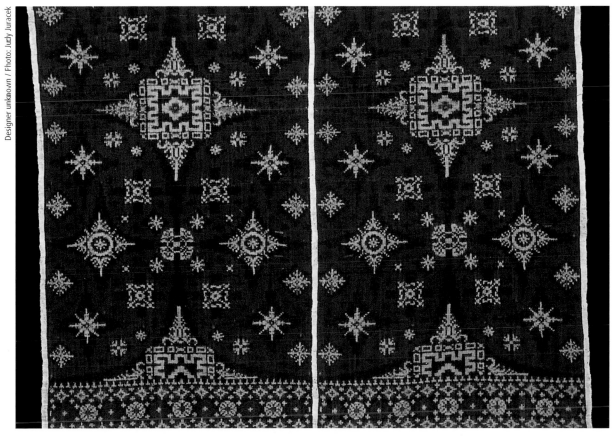

6-55 In double ikat, both warp and filling yarns are resist-dyed before they are woven.

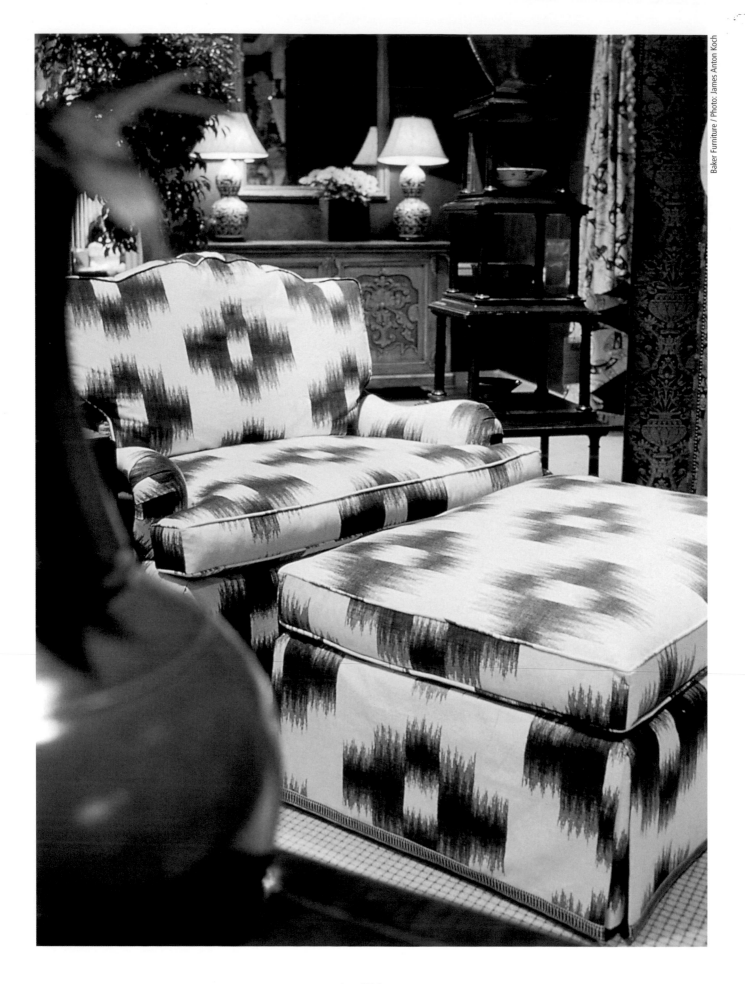

duction. Likewise, warp- print effects are sometimes simulated through heat-transfer printing a finished cloth; consequently, the term also sometimes describes lower-priced fabrics of warp-print appearance.

One of the earliest methods by which fabric was decorated was *block printing*. In this technique the design is carved on wood blocks, one for each color of the design. Dye paste is applied to the face of the block and then pressed against the fabric. This painstaking hand-printing method is no longer commercially practical, but designs featuring the simplified, solid-color motifs characteristic of block printing remain popular for furnishing fabrics (figures 6-60, 6-61).

In *ink-jet printing*, neither screens nor rollers are used. The dye is injected over the fabric by thousands of tiny jets that are controlled by a computer. Ink-jet printing is used for some carpet printing, and a variation of the technique in which portions of a synthetic finished fabric are air-textured with jets is used for drapery and panel fabrics. As the technology evolves, variations on this process probably will increase.

OPPOSITE
6-56 Kasuri effect simulated through printing.

RIGHT TOP TO BOTTOM
6-57 Ikat effect simulated in a jacquard woven.

6-58 Jacquard warp print double cloth.

6-59 In this jacquard matelassé, the warp was printed before the fabric was woven.

6-60 Solid-color motifs characteristic of block printing remain popular for furnishing fabrics.

6-61 Japanese block-print–inspired design.

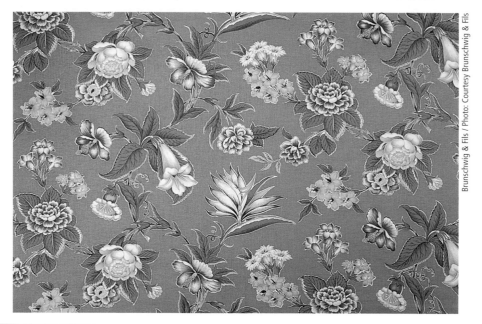

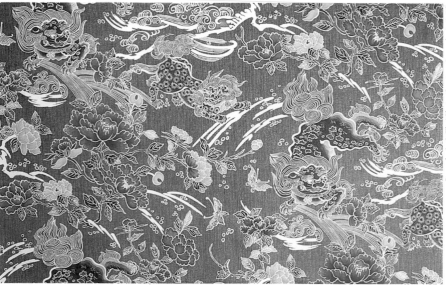

Finishing and Treatment

Many woven cloths are made with clean yarns (prescoured, bleached, and probably yarn-dyed) and go straight to the furniture manufacturer, where they are upholstered *loomstate*, or just as they came off the loom. Other fabrics, however, must undergo several finishing processes before they look and feel like the fabric that they are intended to be. Two pieces of the same loomstate goods can take on radically different characteristics depending on the postfabrication processes they undergo. *Finishing* is a broad term that includes everything that is done to fabric once it is produced. Finishes may make fabric cleaner, softer, stiffer, more durable, or even add a pattern. They can impart resistance to soil, light, or wear. Backings can be added to the fabric to make it opaque, easier to upholster, or suitable to adhere to walls. The variety of finishes is almost endless and is constantly evolving with new technology.

Standard Finishes

Old-school textile enthusiasts assert that no fabric is ready to be used until it is finished. Oils, resins, and sizings that are added to yarn and fiber to ease handling during the manufacturing process are removed in a standard finishing process. In finishing, a true fabric "washing" is called a *scour*; when the material is lightly washed it may be called *wet-out* or *sponged*. Many fabrics do not undergo even this basic finishing step, and consumers and end-users are pleased with the fabrics just the same. However, nearly all fabrics feel and look more beautiful when they are finished.

Standard finishes are also used to impart specific characteristics to the

fabric's appearance, transforming a cloth in the greige into a usable fabric. For example, prints need extensive cleaning to remove excess dye stuffs, oils, and sizings in the cloth. Figure 7-1 shows the entire *finishing range* (the vast equipment necessary to execute specific processes) for a

printed fabric. Once it is printed, the fabric in figure 7-1 enters the finishing process near the open doors in the distant background and is completely finished by the time it reaches the area in the foreground. Figure 7-2 shows the prepared fabric led through several rollers at the start of

7-1 Printed fabric is fed into this finishing range just inside the open doors at the far end of the photograph, and has completed the finishing cycle near the front of the machine at the far right of the photograph.

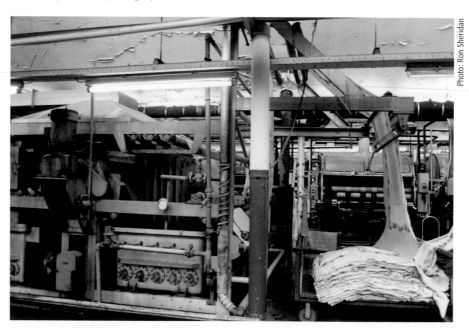

7-2 The prepared fabric is fed through several rollers at the start of the finishing range. The silver tub with red dials on it is the first wet bath in which this fabric is immersed.

the range. The silver tub with red dials on it is the first wet bath in which this fabric is immersed. Figure 7-3 shows the completely finished fabric leaving the machine. It is then pressed and, finally, neatly rolled.

Wool "flannel" is stiff, rough, and has an open weave when it comes off the loom (figure 7-4). Essentially, it is not yet a flannel! It becomes fuzzy only after it has been *carbonized* (acid-rinsed and dried to remove foreign sticks and grass in the wool), *scoured* (washed with soap), *fulled* (shrunk and bulked up), dyed, dried, *napped* (its surface brushed), *sheared* or *singed* (its loose surface fibers cut or burned to a relatively even height), and finally pressed or *decated* (pressed with steam). Each of these processes requires several hours and specific equipment. Most wool fabrics undergo some combination and variation of these finishing steps. Worsteds are usually *semi-* or *full-decated* (pressed lightly or heavily between heavy steel rollers and steam) to become a smooth, lustrous cloth. Woolens can be decated, pressed, or both.

Piece-dyed or printed cotton or linen must be washed and pressed. It is sometimes also *calendered*, which is essentially the same as decating though usually no steam is needed. (The term *calendered* is used for cottons and linens; *decating*, for wool fabrics.) These fibers may be *mercerized* (caustic soda added to increase luster and dye affinity—see figure 3-8) and preshrunk. Linen can undergo *beetling*, which is similar to calendering, to flatten the yarns in the cloth. Synthetics, especially fine constructions used for drapery application, are usually scoured and *heat-set* (pressed so the interlacing pattern of the synthetic yarns is set permanently). Seersucker is created by

7-3 The fabric that entered the finishing range in figure 7-2 is leaving the machine after undergoing all processes. Next it will be pressed and last, neatly rolled.

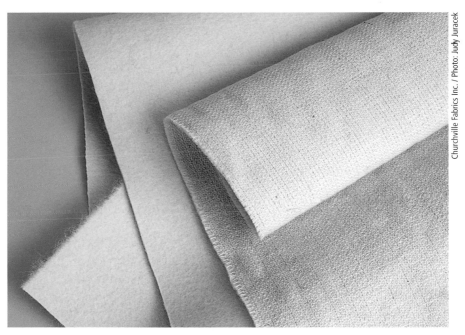

7-4 Woven wool felt fabric before and after finishing processes.

weaving one cloth of two different weaves and sometimes different fibers, usually in stripes. The finishing of the goods causes the different weaves and fibers to shrink in varying amounts, which creates a puckered effect (figure 7-5). Fabrics are sometimes immersed in water, or *wet-out*, and then dried so that the yarns become loftier. A *tenter* frame holds fabrics flat when they undergo

certain processes, and goods that have been finished may be tentered to pull them out to a consistent width by this framing process. Tiny holes in the fabric in lines along the selvedges are usually from pins that hold the cloth in place on the tenter frame.

A fabric truly can be created and designed through its finishing; many of these processes are done in a vari-

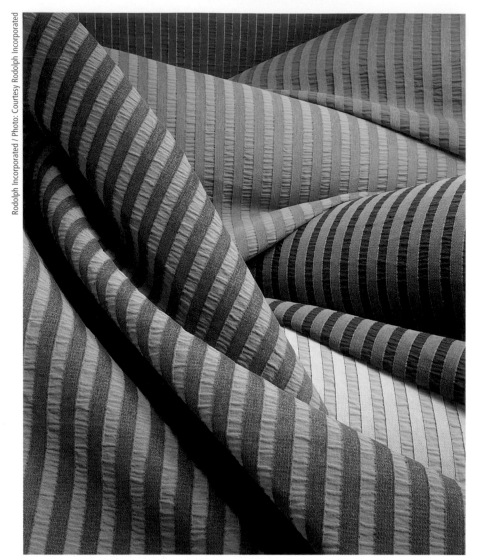

7-5 When seersucker upholstery fabric is woven and finished, the chenille stripe shrinks more than the plain-woven stripe, which becomes puckered.

7-6 Embossed leather.

ety of ways to achieve different levels of softness, stiffness, or sheen. In addition, the hand and appearance of the fabric depend on the tension under which the fabric is held and the speed at which it is allowed to relax during the various steps. Lot-to-lot consistency, therefore, is as critical in finishing as it is in color application.

Special Aesthetic Finishes

Other finishes simply embellish an already-usable fabric. Some fabrics and leather are *embossed* with a relief pattern (figure 7-6) through a press under heat and pressure. An engraved roller imparts the desired pattern to the fabric. Two rollers, a positive and a negative of the same pattern, are necessary to give a deeper embossing. Thermoplastic fibers can be embossed almost permanently (figure 7-7); the embossing can be so deep that it pleats the fabric and creates patterns through the varying shapes of the pleats (figure 7-8).

Moiré is created when two ribbed faille fabrics (a fine warp-faced rib weave) are pressed face-to-face. Commercially, the material is usually passed through steel rollers to heighten the effect. The yarns on the highest parts of the ribs naturally flatten and therefore appear different from the unpressed parts. The result is a grained, or watermarked, pattern (figures 7-9, 7-10) that is permanent in thermoplastic fibers. Moiré can be simulated through embossing, but the result is more even and crisp and therefore not as beautifully subtle. The appearance of moiré is also often simulated through printing (figure 7-11).

Glazing, *ciré*, and *chintz* are finishes that give fabrics a shiny, smooth

Nuno Corporation, Designer: Reiko Sudo / Photo: Courtesy Nuno Corporation, ©Sue McNab

7-7 Polyester keeps pleats indefinitely because it can be heat set.

7-8 The cotton velvet on the armchairs has been pleated and then laminated to a base fabric so that the pleats are permanently held in place.

Barbara Ross / Photo: Billy Cunningham, Courtesy Barbara Ross

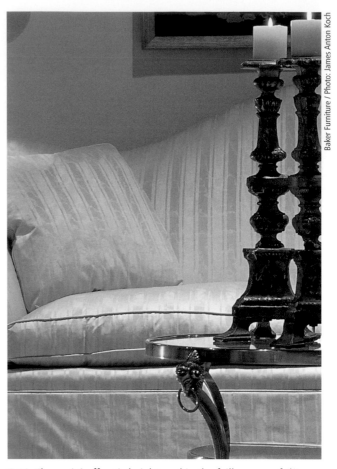

7-9 This watermarked effect is typical of moiré finish fabric.

7-10 The moiré effect is heightened in the faille areas of this stripe and minimized in the satin areas.

7-11 The appearance of a moiré effect is often simulated in printed fabrics.

7-12 The shiny, smooth appearance of this fabric's surface is enhanced by its glazed finish.

7-13 "Distressed" leather goes through various finishing processes to produce a worn, aged effect.

appearance by adding wax to the fabric's surface under heat and pressure (figure 7-12). Wax finishes are not permanent, and the patina that develops through use is considered characteristic of the cloth.

Napping brushes the loose fibers on a fabric's surface, raising their ends to create a soft, fuzzy finish. Brushed cotton, wool flannel, many blankets, and Polartec are examples of napped fabrics. Several finishing processes are necessary to impart the worn, aged appearance of distressed leather (figure 7-13), while suede is napped, brushed leather (figure 7-14).

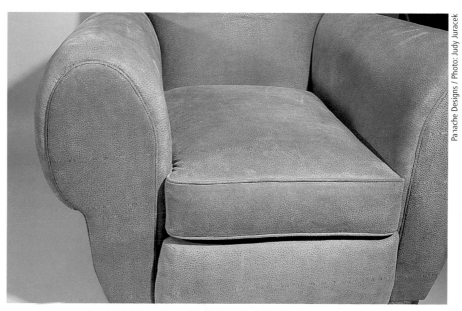

7-14 Suede is napped, brushed leather.

Functional Finishes

Certain finishes simply add a performance feature to fabrics. Textile purists call this "processing" rather than "finishing," but users of fabric (including wholesalers, distributors, and furniture manufacturers) do not distinguish the two. These finishes sometimes also are called "aftertreatments," since they are applied to fabrics that essentially have been completely manufactured and marketed already. Most functional finishes are achieved by immersing the fabric (or sometimes the yarn) in a chemical solution. (See chapter 2 for a discussion of the environmental impact of chemical finishes.)

Wrinkle resistance and permanent-press finishes are achieved by adding resins during a pressing process to fabrics of thermoplastic synthetic and cotton content so that they gain a "memory" for flatness. Unfortunately, these finishes lower the soil-release properties of the fabric. (Wools and most other animal fibers are inherently wrinkle-resistant due to their resiliency and excellent memory.)

Soil-repellent finishes, which are usually applied as the very last step in manufacturing (even once the fabric is on the furniture, though this is less durable), are useful and recommended for upholstery fabrics, particularly those of cellulosic or polyester content and those with a resin or permanent-press finish. These finishes are inappropriate for some fabrics: Wool is naturally soil- and water-repellent, and hydrophobic fibers such as poly-

7-15, 7-16 Crypton upholstery fabrics are water-repellent, stain-resistant, and breathable, and come in a variety of patterns, textures, and colors.

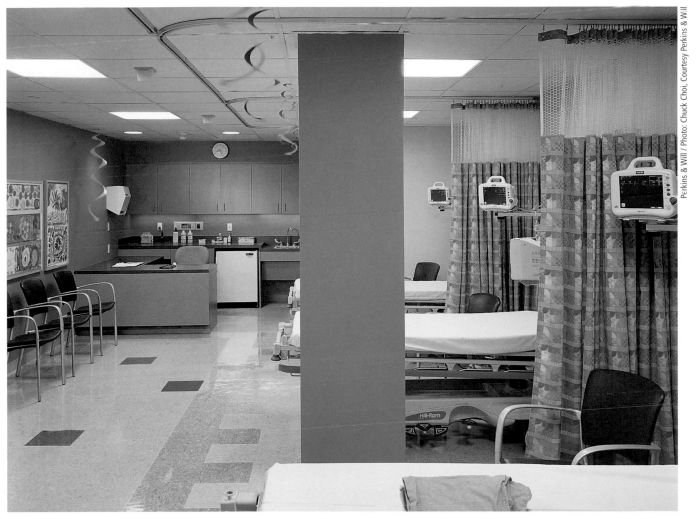

7-17 Hard surface flooring and wallcovering, vinyl upholstery, and draperies that can be washed at high temperatures are standard for healthcare applications.

propylene repel the finish itself. Silicone finishes repel water and water-based spills; fluorochemical-based finishes (like those of Scotchgard, Teflon, and Zepel) repel water- and oil-based stains. Soil-repellent finishes are not stainproof; they simply retard the stain and allow for a little extra time to remove a spill before it seeps into the material.

Crypton is a patented process (of Hi-Tex Inc.) that adds water-repellent and stain-resistant properties to fabric without sacrificing its "breathability." This makes Crypton an attractive alternative to vinyl for healthcare and hospitality seating. Crypton is a finish and backing combination, and it can be applied to various types of fabrics that are licensed by the manufacturer (figures 7-15, 7-16).

Antistatic finishes add moisture content and thereby diminish static electricity, which attracts soil. These finishes are usually quite temporary but are useful for high-static fabrics like nylons in contract applications. Carpets often are made with nylons built to have lower static. Antistatic (carbon) backings are occasionally applied to seating fabrics for areas in which computers are used.

Mothproof and other pest-resistant finishes can be added to fabric. Moths prefer wool and other animal fiber, so most materials are mothproofed in the yarn stage; if necessary, however, the goods can be aftertreated for this property.

Antimicrobial finishes can be added to inhibit growth of mildew and other microorganisms. They sometimes are recommended or required for hospital or institutional use, but they are not widely considered to be effective and therefore are not common. Materials that can be cleaned with bleach or washed at high temperatures are generally considered the safest antimicrobial fabrics. Hard surface flooring and wallcoverings, upholstery vinyls and fabrics with moisture barriers, and draperies that can be washed at high temperatures are standard for these applications (figure 7-17). Some

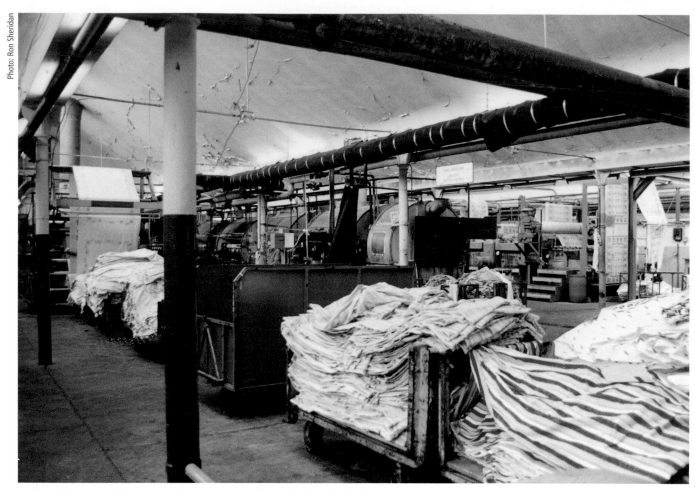

7-18 Fabric is placed in trolleys where it waits to be washed or finished.

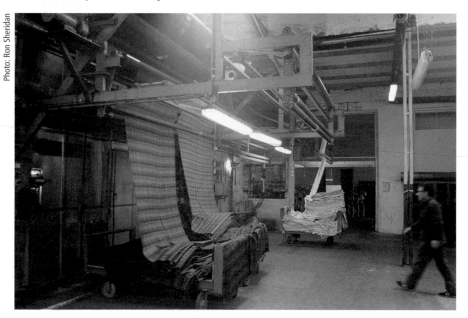

7-19 Fabric coming out of finishing range, before it is pressed and wound on bolts.

bedding and nylon for carpets are promoted as inherently antimicrobial, meaning that the chemical was added at the fiber stage.

Flame-retardant or *flame-resistant* (F.R.) finishes constitute perhaps the largest, most complex, and most common category of functional finishes. Neither *flame-retardant* nor *flame-resistant* means flameproof; only a few fibers like glass, Kevlar, and Nomex literally do not burn. Rather, when a fabric needs to be "F.R.," it actually means that it needs to pass a specific building code, which varies greatly according to end-use and the locale of the installation. Professional finishers and fabric suppliers can always recommend customary finishes and construction combinations to meet specific codes. (See chapter 10 for more information on meeting fire-code requirements.)

In general, F.R. finishes tend to change the fabric more than other types of finishes. In particular, it should be noted that cellulosic fibers that are colored with dyes of the fiber-reactive class cannot usually be

safely F.R. finished because serious discoloration can occur, sometimes even months after they have been treated. Although cottons and other cellulosics can be dyed with various dye classes, fiber-reactive dyes provide particular vibrancy and clarity. However, reliable manufacturers usually will refuse to apply treatments to fabrics that have fiber-reactive dyes. Manufacturers heavily involved in markets like hospitality that require F.R. aftertreatments may simply avoid carrying fiber-reactive dyed materials in their lines.

Durability of all aftertreatments, including F.R. treatments, varies greatly, depending on the fiber content and sometimes on the weight of the fabric itself. When requesting an aftertreatment, the specifier or user should ask about the expected life of the finish under normal use, including washing or dry cleaning.

Most functional finishes do not significantly change the hand, color, or appearance of the fabric, but a few finishes do, so it is a good idea to see a sample of the treated fabric (or do a trial if a sample is not available) before finishing an entire lot. Professional commission fabric finishers and suppliers are best equipped to handle questions about applying finishes or to run a trial if necessary. Further, the combination of and order in which multiple finishes should be applied for maximum synergy (such as a flame-retardant and a soil-resistant finish to an upholstery fabric) are best considered by these professionals, who are pleased to advise customers on these matters.

Backing and Lamination

Many of the functional features listed here can be imparted by adding a *backing* to the fabric instead of, or in addition to, a chemical immersion

7-20 Three different types of backing: (from left to right) laminated scrim, acrylic, and paper backing.

finish (figure 7-20). An *acrylic* (or *latex*) *backing* is a thin, plastic coating that, in liquid form, is sprayed or smeared onto the back of fabric to be used for upholstery or wallcovering. It can be almost imperceptible but makes the fabric feel stiffer and rougher. It adds dimensional stability and reduces seam slippage. In fabrics that are direct-glued to walls or to ergonomic seating cushions, the backing prevents the glue from seeping through to the face of the fabric, called *strike-through*. (Such a feature may require a special, heavier application of backing than is typical.) Backed, or *back-coated*, fabrics also ravel less, and some furniture manufacturers insist that some or even all the fabrics that they handle be acrylic-backed. Special acrylic backings also can impart flame-retardant features to specific fabrics.

Although acrylic backings are most common, fabric also can be bonded to a substrate of paper or another fabric. Paper backing is common for direct-glue wallcovering fabrics. Although it is usually pro-

duced as a standard by wallcovering manufacturers, it usually is not recommended as a custom finish—that is, a finish applied by a second-party finisher that did not produce the fabric itself—because if the fabric becomes distorted during the bonding process, the wrinkles or skewing will be permanent. Commission finishers are not well equipped to handle the strict quality control needed as a postproduction process.

Some fabrics are bonded to a knit or woven substrate. This is common for thin imported silks that are to be used as light upholstery and for pleated or embossed fabrics that need to be held in place and then upholstered. Fabrics used for upholstered wall application may be bonded to a foam backing for increased acoustical properties.

Fabrics that are *vinylized* or laminated with a clear vinyl film are durable and can be wiped or scrubbed clean (figures 7-21, 7-22). Although almost any fabric can be vinylized, Crypton fabrics have become more popular than vinylized fabrics be-

7-21 This fabric has been laminated in soft plastic (vinylized) to make it waterproof.

7-22 Vinylized fabric is waterproof but has a plastic appearance.

cause Crypton fabrics do not have the plasticky hand and appearance of their vinylized counterparts. Furthermore, vinyl is believed to negatively affect the environment whereas Crypton is not.

Barrier materials, used to impede spread of fire or moisture to the interior of a seat cushion, usually are completely separate from the face fabric and are separately applied as an underlining before the seat is upholstered. Sometimes the barrier can be bonded to the upholstery face fabric to eliminate the additional application process. Likewise, manufacturers or fabricators can back drapery fabrics with a black-out or flame-resistant material rather than fabricating the window treatment with separate lining materials to impart these characteristics.

All backings become a permanent part of the material and cannot be removed without damaging the face of the fabric. As with other finishes, the specifier or end-user should see a sample of the material before requesting that a large lot be specially backed.

Fabric Applications

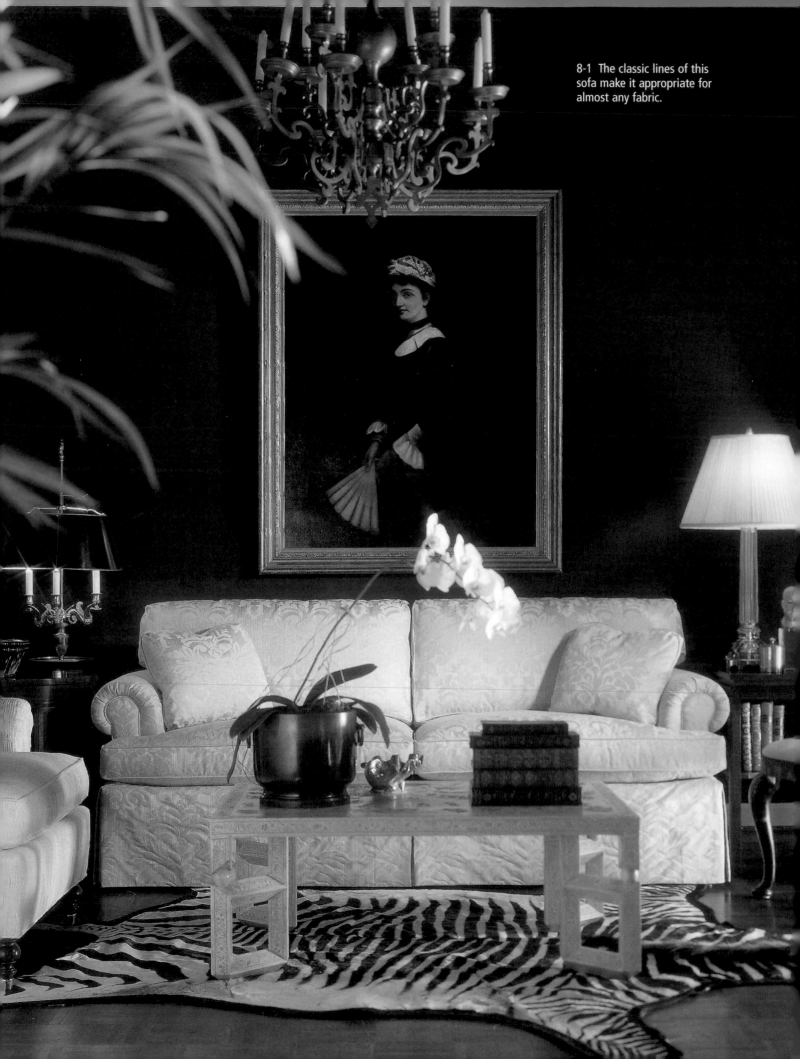

8-1 The classic lines of this sofa make it appropriate for almost any fabric.

Fabric is hardly ever used simply as fabric. It almost always becomes part of something else, whether used almost alone, as in a simple curtain, or as the final covering for a complex piece of furniture. Discussing fibers, weaves, and finishes on their own teaches us something about different materials' inherent features and characters. The next step is to understand materials' versatility and limitations in use. There are six major applications for interior fabrics: seating (or upholstery), window covering, wallcovering, panel systems, floorcovering, and fiber-based art. "Right" and "wrong" are rarely appropriate adjectives to describe specific uses in any application. However, an understanding of all facets of a material—its aesthetics, physical characteristics, and performance—is essential. Designers and clients must make appropriate choices and accept the trade-offs.

Seating

Most consumers think of upholstery or slipcovering for furniture as "the" fabric for interior use. (Residential professionals and most consumers use the term *upholstery* to refer to upholstered seating; members of the contract community are likely to use *seating*, as panel systems or walls, for example, also can be upholstered.) A homeowner usually focuses more attention on sofa selection than drapery; executives may evaluate prospective desk chairs but not the character of specified carpet. While seating may occupy a smaller area of space than window coverings or wall- or floorcoverings, it is surely the statement spot for most interiors. Today literally millions of fabrics are available for seating, but with more

8-2 Almost any fabric could be used on the simple forms of these chairs, while a strongly patterned fabric would probably clash with the dramatic lines of the chair shown in 8-3 (below).

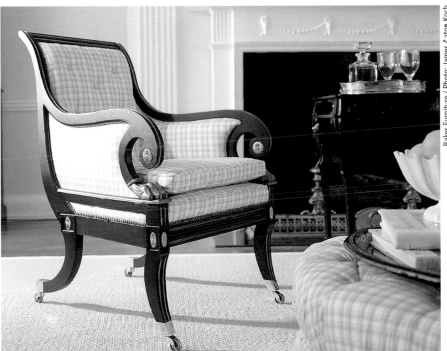

choice comes more complexity in application.

AESTHETICS

Selection of furniture-covering fabric involves evaluation of color, texture, and pattern preferences and an appropriate marriage of fabric to *frame*, the sculptural character of the furniture style. Some sofa frames are

so versatile that, when properly upholstered and expertly tailored, they look great in anything from a chintz floral to a plain velvet to a silk stripe (figure 8-1). The selection of appropriate fabrics may be more limited for a chair with strong lines and complex features (figures 8-2, 8-3). Furniture shape, or *silhouette*, is a sculptural form (figure 8-4). The sil-

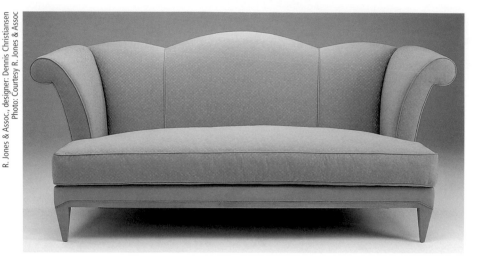

8-4 The sculptural form of upholstered furniture is its silhouette.

houette should be chosen to complement the desired fabric, or the fabric should be selected to enhance the furniture's line, not to disguise it.

Furniture manufacturers have guidelines about what kinds of fabrics will "work" on which frames, and they may bend the range of acceptable choices or rigidly adhere to their parameters. Manufacturers may insist that certain fabrics be acrylic- (or otherwise) backed; they may require seemingly exorbitant yardage allowances for certain frames or for matching certain patterns; they may refuse to use a very heavy fabric for certain finely detailed pieces such as *welting* (the fabric-covered cord used to accent seams or disguise the staples where fabric meets wood on a frame). A custom upholsterer can handle most, but not all effects, and a good upholsterer will advise the client in advance of inevitable pitfalls. Designers often want nonstandard application and are willing to accept the ramifications for a desired aesthetic. On the commercial upholstery level, economics dictate that each manufacturer maintain efficiency. This means that the handling of some materials may be simply too labor-intensive, beyond the skill level of the manufac-

turer's workers, or require tools not in the manufacturer's plant.

Most furniture manufacturers offer a range of "standard" fabrics that are available on their furniture. These standard fabrics are *graded* into the manufacturer's furniture line, which means that they are grouped by price range. For example, depending on the selected fabric, each specific frame the manufacturer offers is available at escalating prices from grade A (least expensive standard fabric choices) to as high as grade ZZ (several levels more expensive than grade A). The manufacturer considers both the actual cost per yard and the waste of the fabric to establish this range. Consumers who want more fabric choices than those available through this "one-stop" shopping system can order fabric from a fabric wholesaler, who sends the fabric to the manufacturer as a *COM*, or customer's own material (*COL* is customer's own leather). The manufacturer will equate the price of a frame in COM or COL with a particular grade level, or sometimes even price the frame above all available grades. (The sourcing of fabrics is discussed more extensively in chapter 10.)

Even within the manufacturer's standard line there may be restrictions on which fabrics are available for which frames, and COMs may or may not be appropriate for specific frames. To obtain the manufacturer's approval or to determine yardage requirements for a furniture order, a sample of the COM usually needs to be submitted, along with the fabric's width and repeat size specifications. For fabrics of large repeat size, the client is wise to submit an oversized memo of the fabric or even a full-width sample to the manufacturer before the fabric is ordered. Sometimes the placement of the motifs on the fabric necessitates additional yardage for matching, and additional yardage ordered later may not be from the same dye lot. Once it is determined that the fabric can be used on the frame selected, the manufacturer may give the customer a *sidemark* (a code number or acknowledgment number) that is to be actually marked on the package and all other pertinent paperwork when the fabric is sent to the factory for upholstering.

Residential upper-end manufacturers design their furniture to accept almost any fabric. As long as the fabric can be stapled to a frame and not damaged in handling, these manufacturers will use it. Only if a customer selects a completely inappropriate fabric such as a drapery sheer that will not hold up to the upholstery process will such a residential manufacturer suggest that the customer reconsider the fabric choice. More commercial (less expensive) residential manufacturers may refuse COMs altogether because their factories are set up for volume production and are not geared to handle single requests.

In the contract market, the guidelines for COMs are very different. Contract manufacturers insist upon

8-5 Ergonomic chairs are designed to be covered in a tight-fitting fabric that shows no wrinkles. Not all fabrics work on chairs of this type, because individual fabrics give differently and the shapes of the furniture also vary.

8-6 Chair with weltless seams.

evaluating and "preapproving" each COM before they will accept the order because many frames allow for only a narrow range of fabrics. For example, when fabric is tightly wrapped to closely fit the sculptural forms of so-called *ergonomic* (or *task*) seating (figure 8-5), manufacturers must often perform tests with a small piece of fabric to be sure they can properly apply it to the requested frame style. These manufacturers usually keep a log of previously approved COMs for specific frame styles within their line so that it is not necessary to test the same fabrics over and over and so that the approval process is not painfully slow and costly for the client.

TREATMENTS

Two pieces of fabric may be sewn together in a *plain seam* (figure 8-6), or the seam may be *topstitched* along one side. In a *double topstitched* seam (also called *baseball* or *saddle stitched*) paral-

lel topstitching outlines the seam on both sides (figure 8-7). Fabric may be attached to furniture with decorative nailheads (figure 8-8) or utilitarian fasteners may be covered with *gimp* (a narrow, flat-woven decorative braid) or with *welt* or *double welt*, the fabric-wrapped cord trim at seams and where fabric meets the wood frame of some chairs and sofas (figure 8-9). Any seam can be highlighted or emphasized by welt (or *flange welt*, which is like a welt without the cord inside). Welt may match the basic fabric or may contrast with it to accentuate the lines of the silhouette (figure 8-10). The strips of fabric used to make welting are cut on the bias (diagonal direction in relation to the cloth as woven) so that they have a slight stretch to fit neatly around the cord. The bias cut shows a pattern differently from the straight cut; for example, a stripe appears much wider when cut on the bias (figure 8-12). Seams may also be emphasized

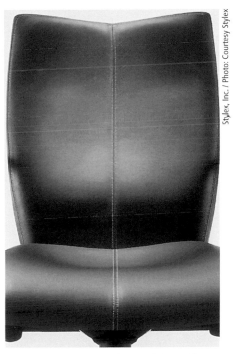

8-7 Double topstitched seam (also called baseball stitched or saddle stitched).

with brush fringe (figure 8-11) or cord used in place of welt (figures 8-13, 8-14).

Fabric is pulled through the entire seat back and attached to the frame

RIGHT

8-8 Decorative nailheads contrast with plain leather upholstery to emphasize the detail of the silhouette.

BELOW LEFT

8-9 A double welt looks like two lines of cord. It outlines the areas where fabric is attached to the furniture frame and hides the staples underneath.

CENTER

8-10 Contrast welt emphasizes the chair's silhouette.

BOTTOM RIGHT

8-11 The seams of this sofa are emphasized with brush fringe. (Bullion fringe is used for the skirt.)

OPPOSITE

8-12 A stripe appears to be wider when it is used as a welt, because the welt fabric is cut on the cloth's bias.

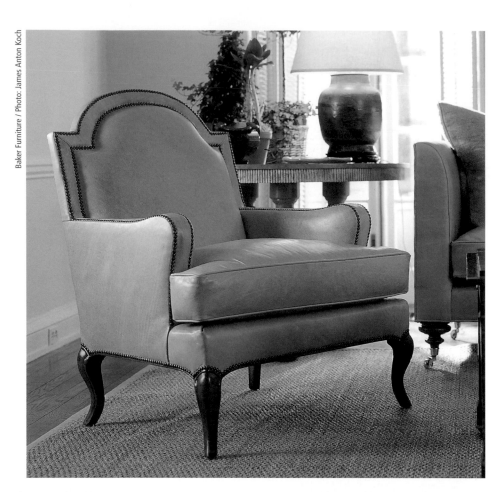

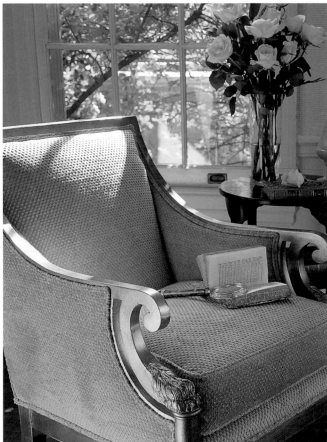

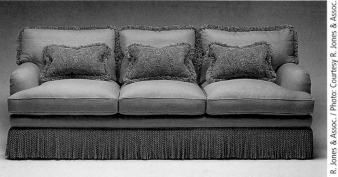

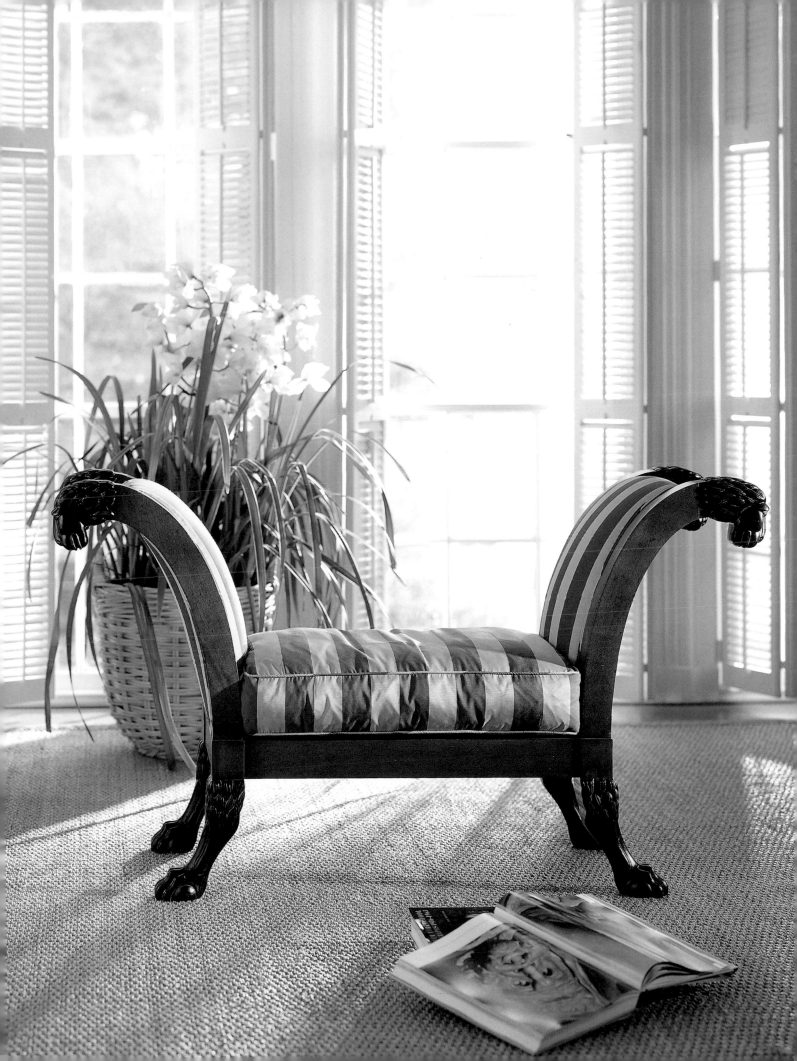

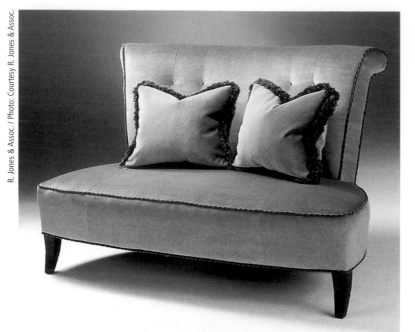

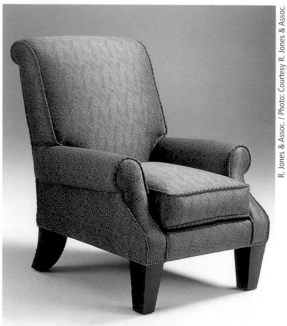

8-13 The striking silhouette of this loveseat is emphasized with plain velvet covering and contrasting cord at the seams. (Brush fringe is used on the accent throw pillows.)

8-14 The cord used on this armchair blends with the pattern fabric rather than creating a strong contrast.

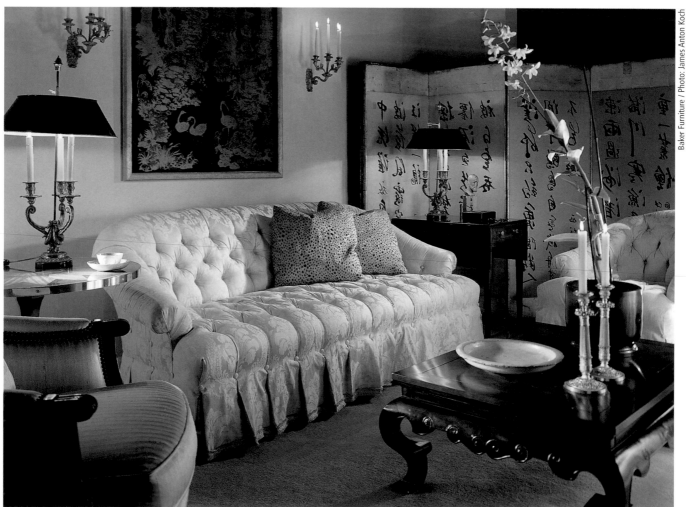

8-15 Diamond tufting used on a sofa.

in *tufting*. The tuft is held in place with buttons that are usually fabric-covered. The buttons may be arranged in square pattern (called *biscuit tufting*) or in diamonds (*diamond tufting*) (figure 8-15). When buttons are used as decorative accents on cushions but are not pulled through the actual upholstery, the treatment is called buttoning (figure 8-16). Buttoning does not create the deep-relief effect of tufting. In *channeling*, the fabric is pulled through the seat back and held in place with rows of stitching, creating a style called *channel back* (figure 8-17).

SPECIFICATION WRITING

When furniture is ordered, whether with COM or a manufacturer's standard offering, the designer or customer should specify on the purchase order all details of how the fabric is to be applied. At a minimum, this will include the identification name and number for the fabric to be used,

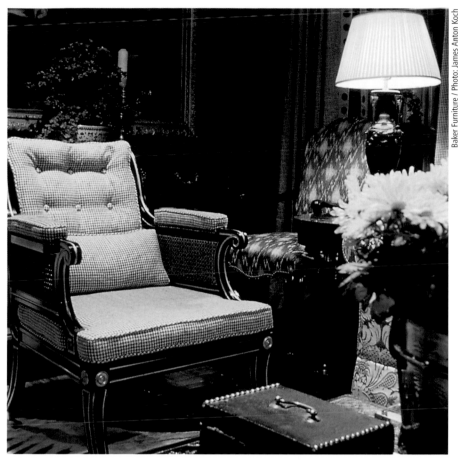

<div style="text-align: right"><small>Baker Furniture / Photo: James Anton Koch</small></div>

8-16 Buttoning attaches to fabric or goes through a pillow, whereas tufting (figure 8-15) is pulled through the structure of the upholstery.

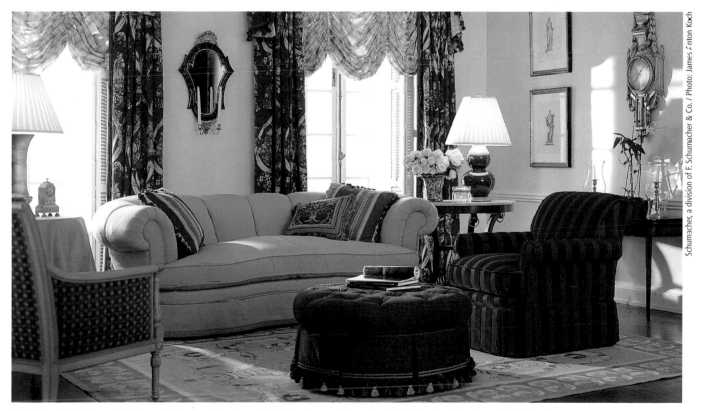

<div style="text-align: right"><small>Schumacher, a division of F. Schumacher & Co. / Photo: James Anton Koch</small></div>

8-17 The fabric is pulled through the seat back and held in place with rows of stitching in this channel-back sofa.

■ RJONES ■ COM IDENTIFICATION CARD

PLEASE COMPLETE AND RETURN TO R JONES. THIS CARD IS NECESSARY TO PROCESS YOUR ORDER.
To indicate "Apply at Manufacturer's Discretion", simply identify your COM, check box #1, and sign the card.

P.O. # _____ RJ Order # _____ Showroom _____

RJ Customer _____ Sidemark/Client _____

RJ Items Ordered _____

COM Source _____ COM Description _____

COM Product # _____ Color _____ Width _____ Repeat _____

↓ TOP OF FABRIC ↓ ↓ TOP OF FABRIC ↓ ↓ TOP OF FABRIC ↓ ↓ TOP OF FABRIC ↓

STAPLE HERE STAPLE HERE

Attach fabric swatch OVER THIS DRAWING to indicate THE CORRECT FABRIC DIRECTION . . .
. . . FACE SIDE OUT and TOP OF FABRIC UP.
Fabric swatch must be attached or order will not be processed.
The swatch side FACING OUT will indicate FACE SIDE for upholstery.

↑ BOTTOM OF FABRIC ↑ ↑ BOTTOM OF FABRIC ↑ ↑ BOTTOM OF FABRIC ↑

CHECK ONE
1. ☐ Apply COM at Manufacturer's Discretion
2. ☐ Apply COM as Described on This Card _____

RJones Office Use Only
Date Recvd. _____
Recvd. By _____
Notes _____

PLEASE SIGN BELOW

I authorize RJones to follow the COM application instructions described on this card.

Signature _____ Date _____

8-18 Some manufacturers require completion of a form such as this one, which clearly illustrates COM application details. Attaching such a sketch to any order is a good idea.

along with a swatch of the fabric and notation as to which way the fabric is to be run, which direction is up, and which side of the fabric is the face. Any preferences for pattern placement and seaming should be sketched and labeled. Pertinent trim details such as use of single or double welt, contrast trim, or nailhead must be specified. Where the balance of unused fabric should be sent must also be specified. Some manufacturers require completion of a form like the one shown in figure 8-18, which clearly illustrates the COM application details.

FABRIC DIRECTION. Fabric can be upholstered either *up the roll* (also called *as woven, top into bolt, top up the bolt, top right, right way,* or *standard*), so that the fabric is placed on the furniture in the same direction that it was woven, or it can be *railroaded,* so that the fabric is turned with the filling running vertically on the piece of furniture (see figure 5-66). Residential furniture manufacturers (especially those in the mass market) tend to railroad whenever possible; contract manufacturers usually upholster up the roll. Because they have designed their systems this way, it is most efficient for them to standardize their respective preferences accordingly. When choosing fabric to be used on furniture it is important to determine and specify which way the fabric will be run and what the ramifications will be (figure 8-19). Some stripes are woven horizontally and some vertically; if the furniture frame requires that fabric be railroaded and the stripes are woven vertically, the result of stripes running across the back of a sofa parallel to the seat may not be appealing. Stripes woven horizontally are almost always upholstered railroaded so that the stripes appear vertical on the sofa or chair (figure 8-20). If these stripes need to be upholstered up the roll, side-to-side matching at seams (figure 8-21) can be difficult or impossible because the exact dimensions of stripes woven across the fabric vary slightly along the length of the goods.

Whether applied railroaded or up the roll, many patterns are also designed with a correct "up" direction: Flowers run one direction; a damask design "grows" in one direction (figure 8-22). This means that some fabrics can be used only railroaded or only up the roll, and then with the motif "up." Direction also can simply be a personal preference. It should always be specified. In addition, it is important to remember that if the same fabric is being sent to different manufacturers or also to a drapery maker for use in the same installation, the fabric should be specified in the same direction to all upholsterers and workrooms.

In most cut-pile fabrics the pile

8-19 The damask on the front chair is upholstered as woven; the tapestry on the back chair has been railroaded. On a small scale chair, fabric can be applied either way without additional seaming, although different amounts of fabric may be needed for each.

8-20 The dramatic stripes on these chairs are woven horizontally but are usually railroaded so they appear vertical on the furniture.

8-21 Matching horizontal stripes on upholstery, as was done to produce the bold effect on these cushions, is labor-intensive and difficult.

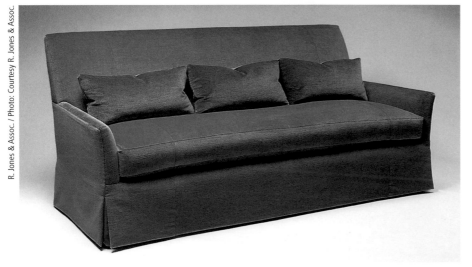

lies slightly in one direction and therefore the color appears to be different when it is viewed from a different direction. As a standard, pile is run slanting down on vertical surfaces and toward the front on horizontal surfaces. (When a person sits in a chair, the pile is pushed up; the pile pulls forward again when the person leaves the chair. Pile fabric installed in the opposite direction would leave a mark when the sitter left.) Weaves with floats in a particular direction (like satins) or ribs and ridges (like corduroy) are traditionally run with the floats, ribs, and ridges running vertically. This is arguably more comfortable, but many interesting and popular effects are achieved by upholstering fabrics in nontraditional directions or by contrasting directions within one piece of furniture. Even the direction of the distinct ribs of a simple ottoman weave or the plain (but directional) surface of a satin should be specified. For example, although most designers consider as woven to be the "correct" direction for satin and fabrics with horizontal ribs, manufacturers whose standard practice is to railroad would run the rib vertically and the satin sideways unless otherwise specified.

For a sofa design with a single seat cushion, a tight back (without loose back pillows), or a weltless front *rail* area (the front of the sofa under the seat and above the legs or skirt), any

8-22 The paisley motif on this sofa is centered on each cushion. The one-way design is correctly applied with points "up."

8-23 The plush fabric has been upholstered as woven on this sofa, so that seams are needed across the back and across the front rail. In a fabric that could appropriately be railroaded, the back and front rail area could be a continuous piece of fabric on the same sofa.

expanse that is longer than the width of the desired fabric will require seams if upholstered up the bolt (figure 8-23). If the fabric is railroaded, these seams are not needed, although the manufacturer may not necessarily eliminate the seams. Particularly as a cost-containment practice in the contract market and in competitively priced residential furniture lines, patterns are cut for a specific frame and are not recut. Therefore, seams in the original pattern will be present in subsequent renditions.

FACE. In trade practice, fabric is rolled on the bolt face-side in, and samples are ticketed with the company logo on the face. Designers sometimes prefer the back of the fabric and frequently ask if the back may be used as face (figure 8-24). Clearly, this will not work for fabrics that have an acrylic or some other functional backing. All fabrics undergo mending in the manufacturing process; this repairs minor flaws on the face but may also leave a knot or loose thread on the back. Thus, even with fabrics that are technically exactly the same on the back and face, the back will probably appear more flawed. If the back is to be upholstered as face, the upholsterer must make allowances for such flaws and extra yardage may be required. Similarly, any testing that has been done to the fabric pertains to the face and not to the back. If a designer is willing to pay for testing and allow time for the results, testing can be run for the back; the supplier may be willing to pay for the test or even have the cloth reinspected if the order is for a sufficiently large quantity.

PATTERN PLACEMENT. Standard upholstery practice is to center a particular motif on each pillow and

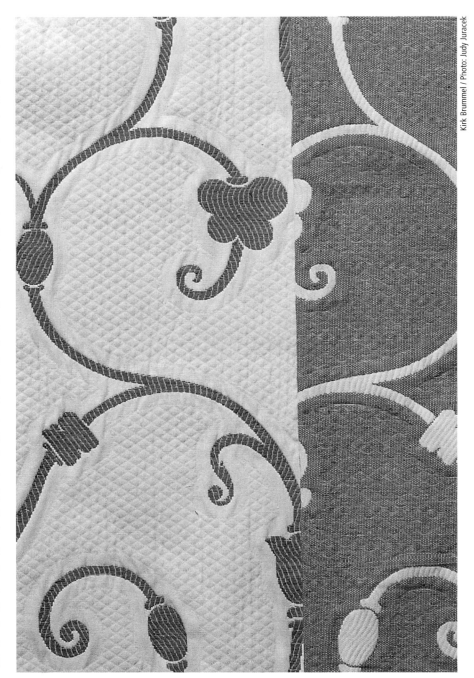

8-24 Designers often ask to use the back of the fabric as the face. A few are completely reversible, like this double cloth, but most fabrics are more durable on their face. In addition, more flaws may be noticeable on the back of the fabric.

cushion (figures 8-25, 8-26). A good upholsterer will make an effort to *match* all patterns (create a new, complete motif at all seams by aligning and joining the two portions of the motif) (figure 8-27). Mass-market upholsters match top-to-bottom but not side-to-side, whereas better manufacturers *four-way match*, or *flow match*, which means the pattern matches where each cushion ends and the next starts (figures 8-28, and see 4-31, 5-23). A quality upholsterer will match even all-over patterns that are designed to appear "repeatless."

Cushions (or pillows) are made in two styles. In *knife-edge* construction, two pieces of fabric of the same size are seamed together and the

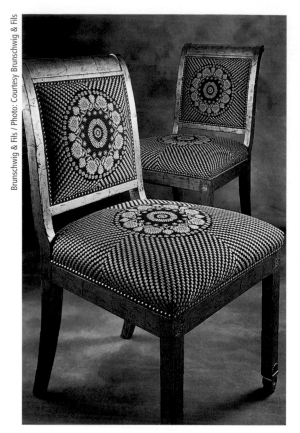

8-25 Some specialty fabrics, like this medallion design woven in horsehair, are engineered to fit specific chair styles.

8-26 The medallion pattern on this wing chair must be applied as woven (not railroaded) so that the figures in the medallion are oriented correctly. A medallion is usually centered on a cushion or chair back. The rest of the pattern is laid out to be matched from that point out. Note the matching on the front rail and cushion boxing.

cushion fills the pocket that is created. (If the knife-edge cushion is deep, pleats or gathers may be added at the corners.) In *boxed* construction, two pieces of fabric that form the top and bottom of the cushion are separated by a third piece of fabric that forms the "sides" of the cushion (figure 8-29). Pattern matching is particularly noticeable on boxed cushions, since the "side" (or *boxing*) is a flat, vertical surface.

Any preference for which motif should be centered or whether motifs may fall randomly should be specified to the upholsterer. Place-

ment of motifs also dictates seaming, again with variation from frame to frame. A common placement dilemma arises for patterns that have a 27-inch (70-cm) horizontal repeat and motifs centered 13 1/2 inches (35 cm) from each selvedge but no motif down the vertical middle of the goods. If such fabric is spread out on a table it appears to have an "alleyway" or empty area up the middle, which essentially makes it a 27-inch (70-cm) wide fabric. Usually it is preferable to have a motif in the center of a cushion, but even many chair cushions are wider than 27 inches

(70 cm). So, for a fabric of this layout to have a motif centered, for example on a T-seat cushion (a cushion shaped like a T) that is 34 inches (86 cm) wide across the front, seams will be needed on the crossbar of the T (figure 8-30). An alternative would be to center on the alleyway so that the full width of the fabric could be used, or to choose a frame that does not need more than a 27-inch (70-cm) expanse in any conspicuous spot.

Equally perplexing problems arise for designs that are a 27-inch (70-cm) half-drop layout, which results in a

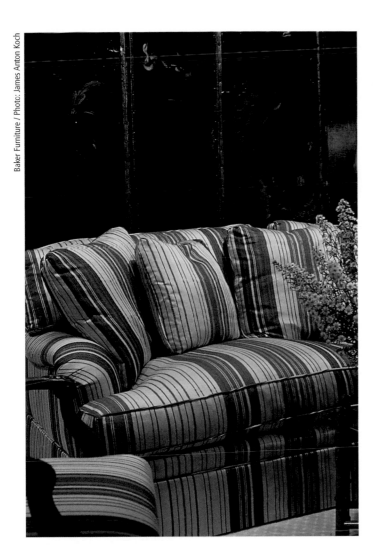

CLOCKWISE FROM TOP LEFT

8-27 In quality upholstery, the fabric is matched at each seam so that the pattern continues as designed on every furniture surface.

8-28 This plaid fabric is beautifully flow matched.

8-29 Two different styles of cushion: a boxed cushion on the seat and a knife-edge (with gathered corners) for the chair back.

8-30 A 27-inch horizontal repeat fabric must be seamed to be upholstered.

8-31 A 54-inch horizontal repeat fabric (27-inch half drop) must be seamed to be upholstered.

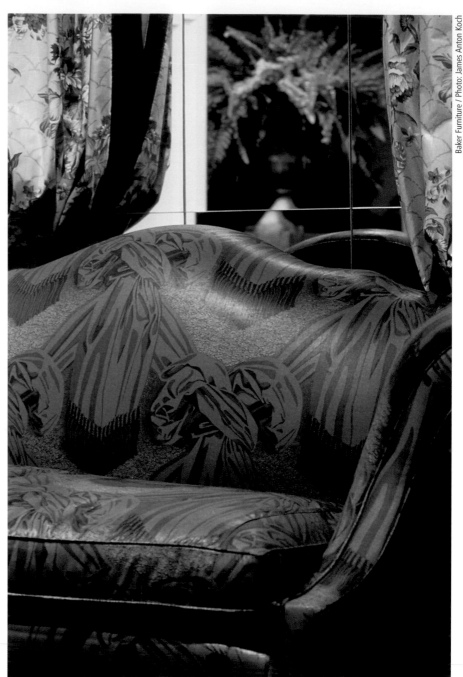

8-32 Dramatic, large-scale print on a tight-back sofa.

54-inch (140-cm) horizontal repeat. In such a layout the "left half" and the "right half" of the goods look exactly the same when laid out on a long table, except that on the right half the pattern appears shifted up. For use on many seating frames, such fabrics pose the same difficulties as 27-inch (70-cm) wide fabrics, because in order to center on either half, a seam will be necessary (figure 8-31).

SCALE

The scale of a selected fabric should obviously relate to the scale of the room in which it is used and to other decorative surfaces and patterns (including other fabrics) that will surround it in its setting. In addition, the scale of the fabric pattern must relate in a pleasing way to the cut sizes of fabric within the particular piece of furniture (figure 8-32). The

scale of the pattern and of the cloth itself can completely change the appearance of a seating piece. A very heavy, coarse weave can be inappropriate for a delicate silhouette, just as a very large-scale pattern can overpower a small frame.

It is also important to remember that furniture is designed with seams that allow the fabric to be shaped to the frame. As previously described, seams are often placed differently on the same frame for railroaded or up-the-roll application, or for fabric of different widths, or for particular repeat sizes, or for particular layout arrangements of the fabric itself. Any special concerns about seaming should be specified in writing to the manufacturer. When patterns are matched in sewing, many seams are hardly noticeable; the plainer the fabric, however, the more noticeable the seams.

TAUTNESS AND LOOSENESS

Whether fabric is pulled tight across the frame for a crisp, tailored appearance or cushioned in loose, unattached, or slipcovered forms should be considered in fabric selection (figure 8-33). For example, a stripe that remains static on a tight frame will appear wavier on a loose cushion. The same fabric will feel very different in a tight or loose application, and the appeal of the hand when the fabric is touched and sat upon should be considered. Fabric tightly constructed of very fine yarns, like a taffeta, may show pulls at stitch points in tight upholstery. Loose upholstery is more likely to show wear from pulls of loose threads in a coarse or open weave.

The aesthetic preference in contract seating is almost always a tight, smooth application (figure 8-34). Furniture is most likely to show wear

8-33 This taffeta looks and feels very different on the tight back and on the boxed seat cushion of a barrel-back chair.

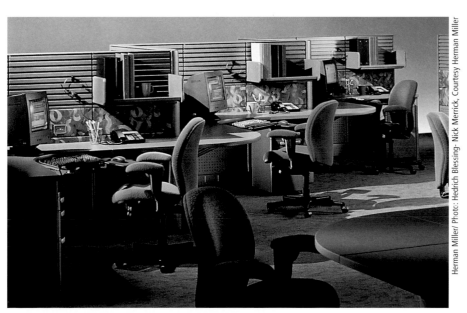

8-34 Contract seating usually requires tight, smooth fabric application, which results in a seat that would seem hard in a home setting.

8-35 The fabric on this barrel-back contract chair is smooth and shows no wrinkles but perhaps would seem hard and uncomfortable in a home.

at points where fabric is pulled tightly over a rigid frame section, especially if such an area is not properly padded between the frame and outer upholstery. These points are especially vulnerable if they strike an external object such as the edge of a table or desk.

COMFORT

Hand is a critical upholstery consideration, although taste varies widely on what is or is not comfortable to touch in various applications. However, whether fuzzy, smooth, or crisp, upholstery fabric hand should be considered in the context of application to a specific frame. When the fabric is tightly upholstered, its hand will be experienced only in terms of the fabric's surface. On loose cushions, the springiness, resiliency, and pliability also contribute to how inviting and comfortable the piece of furniture is.

An upholstery fabric's air and moisture porosity equally influences comfort. Natural fibers are more porous than synthetic fibers. Loose weaves are more porous than tight weaves. The composition of cushion stuffing and the tautness of the upholstery on the frame affect the dampness or dryness of the furniture. Completely moisture-repellent fabrics (those with plastic laminate coating or vinyl) are uncomfortable because the surface absorbs no moisture from the occupant's skin and allows no air to pass through. Such fabrics are inappropriate choices for lounge or office chairs that will be occupied for many hours at a stretch. For dining chairs in a fast-food restaurant or seats in a hospital room that are likely to receive many spills and will be occupied only for short spells, the comfort trade-off is not such a great loss.

WRINKLES

Although no one likes a poorly sewn or poorly tailored piece of upholstery, fabric does have characteristics that make wrinkles inevitable in certain applications. Pulling a very slippery fabric such as mohair plush or a very tight, flat taffeta weave around a corner almost certainly will create a wrinkle. Pulling a flat fabric so tightly around the inside of a barrel-back chair so that no wrinkles are present is appropriate for contract installation, but may make the chair back hard and uncomfortable by residential standards (figures 8-35, 8-36). Most fabrics wrinkle slightly with a few months of use; as long as the wrinkles look relaxed, even, and natural, they should not be considered a flaw. If a very smooth, wrinkle-free appearance is desired, a fabric with appropriate give, such as wool crepe, should be chosen. Any degree of sheen accentuates wrinkles.

DURABILITY

Designers and consumers frequently ask what upholstery fabrics are most durable. But durability is not that easily assessed; the fabric itself, the application, and the intended use all affect durability. We probably do not want all fabrics to be equally durable, or even the same "kind" of durable.

8-36 In a home, even a chair that requires tight upholstery like the barrel-back chair in the foreground is expected to have a soft feel.

Upholstery owners surely do not want fabric to last forever, because we tend to become tired of static surroundings. Perhaps the ideal fabric would look good for its intended use until the exact moment when its owner becomes weary of it!

INTENDED USE. Durability must be considered in the context of the fabric's intended use. A sofa in a family lounging area needs to be aesthetically pleasing, comfortable, and able to camouflage wear and withstand minor abuse. Dining chairs do not need to be highly abrasion-resistant, as they are used for only brief periods, or extremely light-resistant,

as they are usually under a table and protected from direct sun. Following are general descriptions of the factors that are critical in seating. (Laboratory tests and technical measurements of these characteristics are discussed more thoroughly in chapter 9.)

ABRASION. Many designers consider *abrasion*, or surface wear that leads to the breaking of the fabric's yarns, to be the primary durability factor, partly because the fabric industry performs laboratory tests that measure the abrasion point when a thread breaks. (The best-known methods are Wyzenbeek and Martindale.)

These tests are highly variable but are popular because thread break is easy to measure compared to "unacceptable" degrees of soiling or pilling. In use, however, pilling, fading, and soiling are far more significant in determining a piece of upholstered furniture's useful life span than thread break is.

The form and construction of furniture is as important to its durability as the amount and type of use or the yarn, fiber, and fabric construction. As mentioned above, an insufficiently padded sharp surface inside a sofa or chair is often a cause of abrasion, as is the frequent impact of a chair against a desk, table, or key-

❖ 187 ❖

board drawer. Upholstered arms and fabric welt that is raised above the cushion surface are inherently the weakest points on upholstered seating. Soft, resilient undercushioning takes the brunt of impact and thereby protects upholstery fabric. The harder the cushioning and the more tightly the fabric is pulled, the more vulnerable it becomes to abrasion.

The specific abrasion resistance of a fabric depends upon the type, resiliency, and quality of the fiber; the ply, twist, and size of the yarn; and the density and balance of the weave. Backings and finishings can also affect abrasion resistance. Hard, sturdy monofilament yarns are most difficult to break; a high twist and additional plies in the yarn further protect it from breaking.

PILLING. Loose fibers that work out of a fabric to the outside surface create *fuzzing;* abrasion rolls the fuzzing into little balls called *pills.* Pills are unsightly and contribute to increased surface soiling. Pilling causes fabrics in use to lose their appeal much more frequently than a thread break unravels the fabric. Fuzzing and pilling of wool fabric (and wool carpet) is common but diminishes over time as the loose fibers pill and then break away from the fabric surface. In synthetics, however, pilling is a much more serious problem because the fiber is so strong that it holds onto the pills and will not allow them to fall away naturally. Pilling or fuzzing often can be satisfactorily sheared with a hand razor—at the owner's risk, of course.

Pilling does not occur in fabrics of filament yarns, which are a continuous length and therefore have no short fibers. Not all spun yarns pill; the fiber tenacity, the fiber staple length, the spinning method used,

the fabric construction, and the fabric finishing all affect the tendency to pill. Spun synthetics are probably best avoided for use in very high traffic areas unless the specific fabric construction (though not necessarily the same pattern) has been in actual use in similar installations for an acceptable period of time.

MARKING. Any fabric with pile (including velvet or chenille) will show *marking,* or areas where the pile has been pushed down or pushed in a direction other than the original pile direction. Fabrics are touched in their normal use and must be handled to be sewn or upholstered. Over time, marking usually gives the fabric a patina that is not necessarily undesirable. However, if marking is of concern, samples should be evaluated before such a fabric is selected.

CROCKING. Loose dyestuff occasionally rubs off a fabric and onto some other surface. This fault, called *crocking,* can occur under either wet or dry conditions. *Dry crocking* is more common with leather and suede than with textiles and usually occurs only for a short while. *Wet crocking* is longer lasting when it occurs. Although not common, it is most prevalent in cotton fabrics, especially prints. Because it can be triggered by perspiration, precipitation, or wet clothing, a seat that is likely to be touched by these elements—for instance, in a beach house or the lobby of a gym—should be checked for wet crocking. Test data may be available from the supplier, or a damp white cloth can be rubbed across a sample of the fabric.

DIMENSIONAL STABILITY. The fabric on upholstered furniture is expected to look as though it "fits" the

frame without sagging or wrinkling. Fabrics that stretch out of shape or lack resilience are not desirable for seating, especially in loose application. Inferior cushion material that breaks down or shrinks can make the covering fabric look as though it has stretched or sagged.

Low fabric stability can be improved or enhanced in various ways. Sometimes backing helps—either coating or laminating may work for specific fabrics. Traditional application styles such as buttoning, tufting, quilting, and channeling hold fabric in place and thereby create stability.

In ergonomic seating, fabric is often fused directly to the cushion with heat and adhesive (called *direct-glue application*) (figure 8-37). Because the fabric must fit around rounded, sculptural forms, fabrics that are too rigid are difficult to upholster. Slight stretch is a benefit, and the glue eliminates post-application stretch. (The glue can, however, strike through and show on the face of thin or very open-weave fabrics.)

YARN AND SEAM SLIPPAGE. *Slippage* results when the parallel yarns in a cloth pull apart, giving the appearance of slits in the cloth. Slippage is particularly apparent in loose weaves of smooth yarns like medical gauze and is unusual in quality upholstery fabric because slippage makes a textile difficult to handle even for a fabric manufacturer . The fabric maker will generally modify the cloth in the weaving process by adding more picks (filling yarns) per inch (centimeter) to a fabric that appears to slip. Alternatively, acrylic backing can eliminate slippage. *Seam slippage,* in which yarn slippage occurs only where the fabric is flattened and pulled tightly at a seam, is a more common problem than gen-

eral yarn slippage. A prospective customer is wise to ask a manufacturer in advance if seam slippage will be a problem for any loose weave or for very tight, flat fabrics, especially if either is to be used on a tailored frame. Most residential and contract manufacturers test COM for seam slippage in advance and request that the fabric be backed if slippage is a concern. Even residential manufacturers will refuse to handle a very loose fabric unless it is backed or the customer signs a disclaimer.

TENSILE AND BREAK STRENGTH. Yarns are tested for their tensile and break strength by having their opposing ends pulled apart. Fabrics and yarns are tested for this property, but it is unusual for upholstery fabric to "wear" in this way. Except in case of sun rot, or when an aftertreatment (for flame retardancy, for example) weakens a fabric, upholstery fabric seldom rips or tears in use.

SNAGGING. Loose, loopy threads that are easily caught and pulled out of the fabric surface result in unsightly *snagging*. An occasional snag can be carefully pushed to the back of the fabric so that the snag is minimized. A fabric that snags all over with normal use should be considered inappropriate upholstery fabric. Testing a fabric by pulling at its surface with sharp tools is not appropriate and does not accurately predict normal wear; however, upholstery fabric that will be traversed by pets requires special selection.

CLEANING AND MAINTENANCE
Regular vacuuming and prompt attention to spots is the best maintenance for upholstery fabrics. When possible, cushions—and even chairs —that are identical should be rotat-

8-37 In contemporary ergonomic seating, fabric is often glued directly to the cushion. Fabric with a slight amount of stretch may be required in the fabric for certain frames.

ed so that the heaviest use spots do not receive all the wear and soiling.

Only the impermeable surfaces of vinyl, plastic laminate, Crypton, and similar finishes can be appropriately cleaned by wiping the fabric off with water. (Other fibers, such as polypropylene, or olefin, are not harmed by water, but the interior cushion may be damaged.) For any upholstery, wet spills should be blotted immediately. If a stain remains once the fabric is dry, it should be sent to a

professional cleaner as soon as possible. With time, stains may change the composition of the dyestuff so that even after cleaning a spot will remain.

Some spots on suede and leathers can be removed with a gum eraser or an emery board, and some smooth and grain leathers can be cleaned with a damp cloth and saddle soap. Amateur cleaning procedures are difficult to outline since the possible combinations of fiber, dyestuff, and

finish are almost endless, and an incorrect approach often sets the stain into the fiber. (Synthetic suedes are often very easy to clean; a Crypton synthetic suede is also available.)

Soil-repellent finishes, which are discussed in chapter 7, may be considered environmentally negative, but they retard some textiles' absorbency so that they can be blotted more easily. These finishes work best on hydrophilic fibers like cotton because they absorb more of the finish itself. The newer the finish, the more effectively it repels; its surface breaks down over time.

Windows

The swaying in the breeze of *soft* window treatments (window coverings made of fabric) adds a human element to a room that cannot be matched by even the most beautiful shutters, blinds, or shades (called *hard* treatments). In the same way that a special scarf or necktie adds a finishing touch to clothing, window coverings accent a room.

The dense weave of *sheer* fabrics makes them highly stable constructions, but because they are usually made of the *finest* (thinnest) possible yarns, the fabric is translucent or even transparent (figure 8-38). Sheer

8-38 Accents of slub yarns float between sheer layers in this double cloth. The accent stripes run horizontally across the bolt of fabric, but because the fabric is 118 inches (3 m) wide they will run vertically at the window if the fabric is railroaded.

8-39 Alternating bands of translucent and transparent effects are created by weaving different filling yarns across a fine filament warp.

8-40 The density of yarn and stitch arrangements create different degrees of privacy and light control in knit casement fabrics.

8-40 Knit casement fabric.

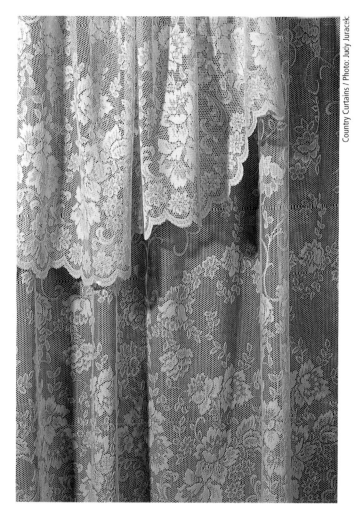

8-42 Lace curtain detail.

fabrics often contrast opaque and translucent areas for a beautiful effect (figure 8-39).

As noted earlier, a casement is any fabric in which the yarns are spaced far enough apart to allow light to pass through (figures 8-40, 8-41). In these open weaves the arrangement and frequency of openings between the yarns combines with the yarn colors to create interest in light control. Technically a kind of casement, laces can be used to similar effect (figure 8-42).

Window *treatment* refers to the way in which the covering is fabricated and installed in the room (whether it is fabric gathered on a rod or tacked as a panel to the wall) and extends to include wooden shut-

ters hinged and screwed to the wall (figure 8-43).

Drapery and *curtains* are both general terms that refer to any fabric window coverings. *Curtain* generally refers to unlined, lighter-weight fabrics with simple hardware such as that in figure 8-44 and may be more common in consumer language than among professionals. *Drapery* is a broader description of fabric window treatments with lining or multiple linings, more elaborate and substantial hardware, and sometimes trim (figure 8-45). These distinctions have not always existed but are current in American usage.

Cubicle curtains (further discussed later) specifically refer to the fabric panels that hang in hospital patient

rooms and other medical facilities to create privacy within a larger space.

Blinds and *shades* are fabrications that fit within the window frame or molding and are raised and lowered within the perimeter of their extended shape (figure 8-46). Blinds and shades may be made of a variety of materials, including wood, metal, plastic, and fabric. The most common fabric shades are *Roman*, *balloon*, and *Austrian* shades, which are all fabricated to pull up from the bottom on cords. Roman shades lie flat when extended and create accordion pleats when pulled up. Also called poufed or cloud shades, balloon shades (figures 8-47, 8-48), drawn up into soft, full scallops. Closely stitched vertical shirring or fabric of a

shirred appearance creates Austrian shades (see figure 8-17).

AESTHETICS, PERFORMANCE, AND FABRICATION

While the aesthetic properties of seating fabrics are evaluated according to the look and feel of the fabric's surface, window coverings are viewed more the way apparel would be. Like a beautiful scarf or dress, these fabrics are assessed according to how they feel when they are held vertically and loosely hung. Because any fabric that is not completely opaque appears very different when lit from the face versus from behind, draperies also must be evaluated under the light source that they will have in use (figures 8-49, 8-50).

In addition to provoking an emotional response, fabric at the window has many practical functions. Both the fabric and the treatment selected should respond to the desired level of privacy in the room. Drapery can eliminate an unsightly view, or it can serve as the perfect frame to highlight a beautiful view (figure 8-51). It can completely block or gently filter the outside light coming into the room, or regulate the light at certain times of day or over a portion of the

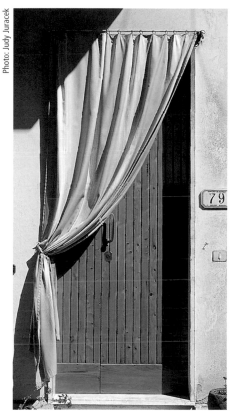

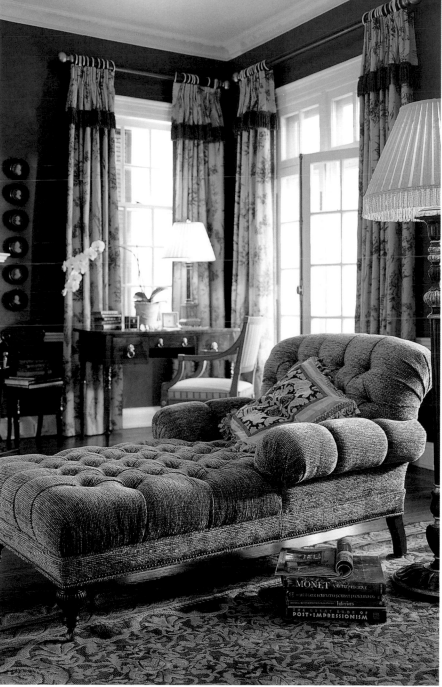

OPPOSITE
8-43 Window treatments include many fabrications, from fabric gathered on a rod to wooden shutters screwed to the wall.

ABOVE
8-44 A curtain is an unlined, lightweight fabric window covering with simple hardware.

RIGHT
8-45 Draperies are more elaborate window coverings with linings, substantial hardware, and sometimes trim.

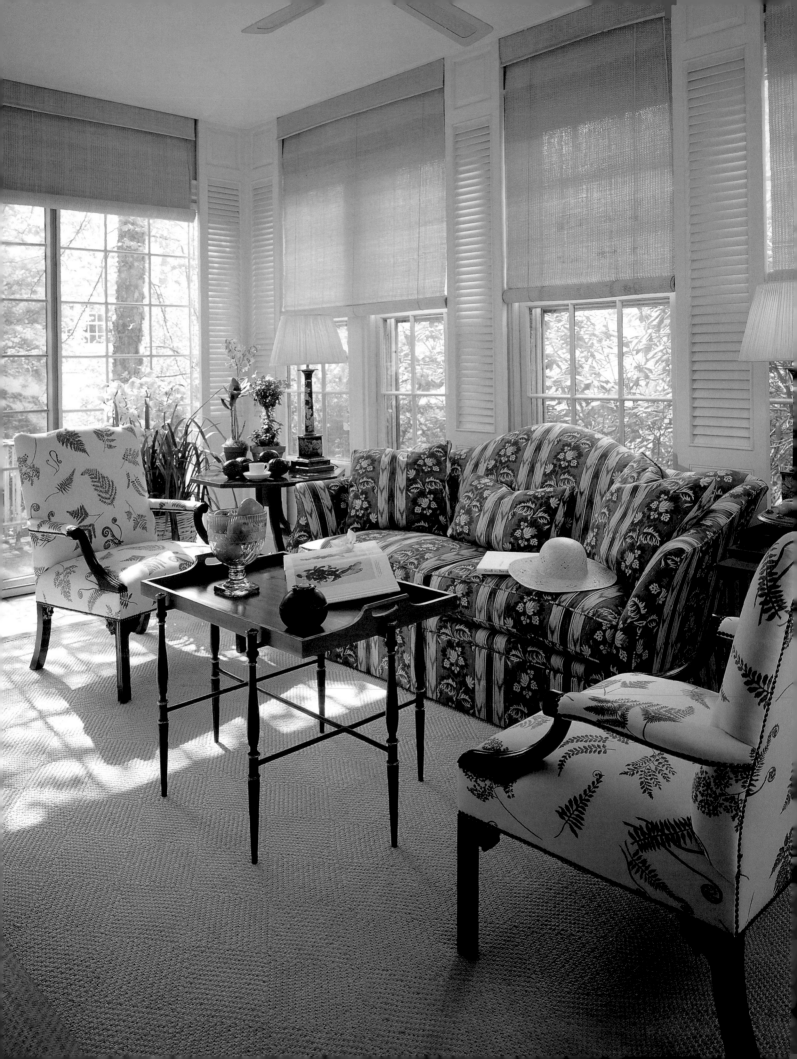

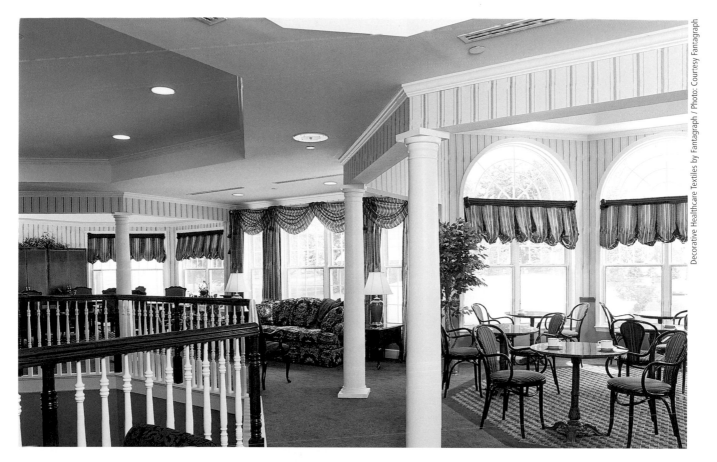

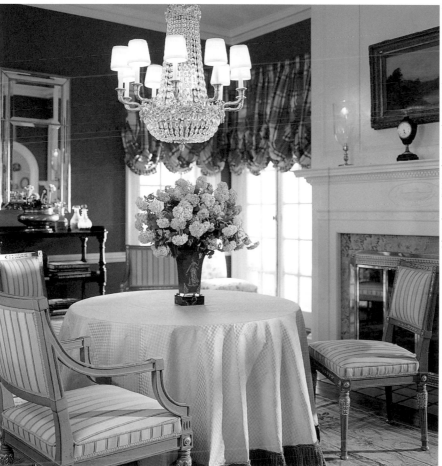

OPPOSITE
8-46 Woven linen roll-up shades.

ABOVE
8-47 Vertical striped balloon shades (left and right); valance over draperies on central windows.

LEFT
8-48 Balloon shades in a residential setting.

Decorative Healthcare Textiles by Fantagraph / Photo: Courtesy Fantagraph

Schumacher, a division of F. Schumacher & Co. / Photo: James Anton Koch

Interesting custom effects can be created using off-the-shelf components (including ready-made draperies) not only alone but also in combination. Layering of several fabrics at the window has been used for centuries, traditionally with sheers near the window and progressively heavier layers toward the inside of the room (figure 8-55). Any combination is possible, including multilayered sheers that create new patterns and gradual degrees of translucence.

Just as an upholstery fabric cannot be properly evaluated separately from the furniture that it will envelop, fabrics for the window are critically connected to all of the hardware used to create the treatment, the architecture within which it is integrated, and the sewing with which the treatment is executed (figures 8-56–8-59). Countless materials are available for rings, rods, and other attachment devices

LEFT

8-49 When lit from the front, the contrasting areas of matte and sheen in this fabric are highlighted. The fabric will appear much more solid when lit from behind; the lustrous areas will seem less so when no light is reflected off the surface.

8-50 The textural effect of this sheer is evident when lit from any direction, though more pronounced when lit from the front.

OPPOSITE TOP

8-51 The pillar print valance adds an architectural element in both construction and imagery. The overall window treatment frames the view and allows light into the room.

OPPOSITE BOTTOM

8-52 The scale of a pattern reads differently when viewed flat or gathered, a critical consideration when selecting fabric for window covering.

8-53 Covering every surface in a small space with this toile creates a cozy environment. Adding curtains of the same material enhances the softness.

room. The color of fabric at the window, along with the way it changes the room light, affects not only the overall colors of everything in the room, but also the atmosphere that the character of the light creates.

Drapery is often used to enhance the architecture and natural landscape outside the window by blocking unsightly elements—and it can do the same for interior features. For example, a fabric that is sheer over the window can be sewn to an opaque panel below to cover a radiator under the window.

Scale is as important in drapery as it is in all aspects of interior design (figure 8-52). Window treatments can make the room seem smaller and cozier or taller and more vast (figure 8-53).

Fabrics at the window can improve a room acoustically by filtering noise both coming in and going out. They also often reduce the level of draft and can add to thermal insulation. With the soundness of modern windows thermal benefit may be primarily psychological—but a room that "feels" warmer is still warmer (figure 8-54)!

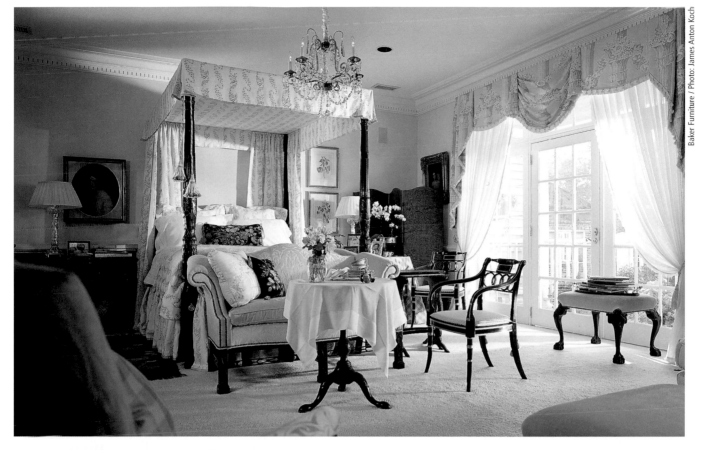

Baker Furniture / Photo: James Anton Koch

Kirk Brummel / Photo: Judy Juracek

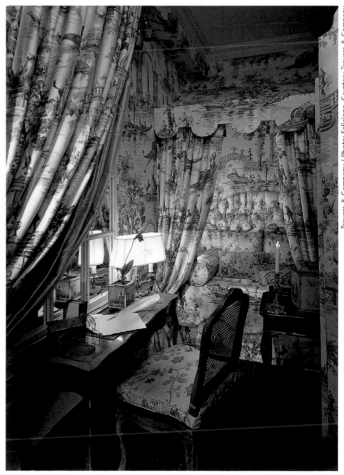

Travers & Company / Photo: Feliciano, Courtesy Travers & Company

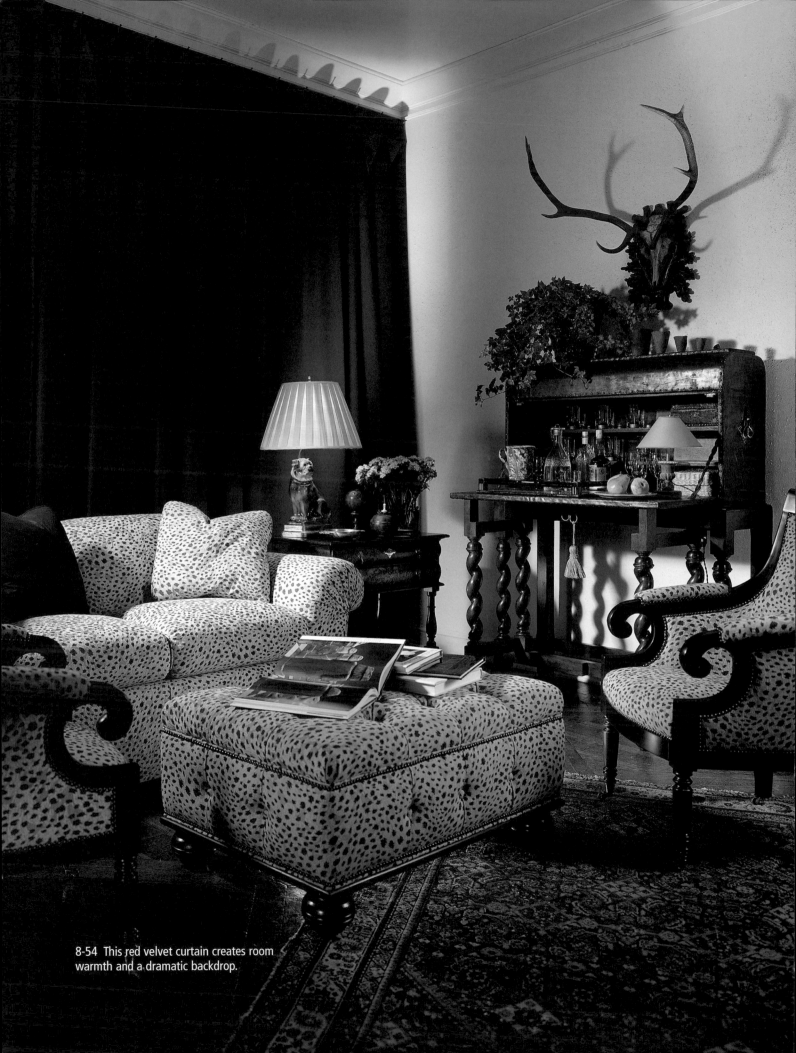

8-54 This red velvet curtain creates room warmth and a dramatic backdrop.

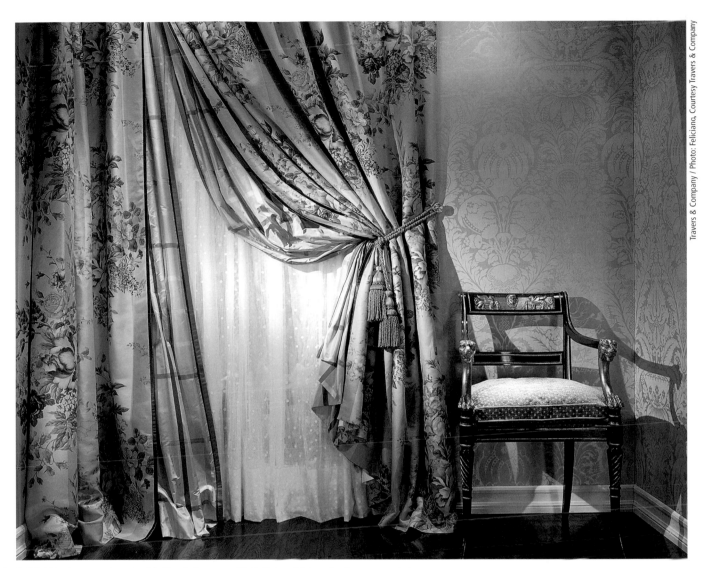

8-55 Window treatment with floral drapery, silk taffeta plaid underdrapery, and sheer.

that allow infinite possibilities—a far cry from the days when traverse rods and rings were the exclusive tools of the trade. Fabricators that specialize in making window treatments according to designers' specifications are called *workrooms*; conventional tailors are capable of achieving many straightforward treatments. The couture dressmaking and tailoring details that are well known to these professionals can be translated beautifully to expand the possibilities of fabric use in interiors.

DURABILITY

Almost any fabric can be used as a window covering. Quilts can be tacked to the window frame, as can rugs. The sheerest to the heaviest, the coarsest to the finest fabrics can be fabricated in some way. As in all environments, though, the light exposure, soiling, heat, and humidity that will affect fabrics' appearance and life span must be anticipated.

Naturally, external wear is not the culprit in vertical use that it is in upholstery, because draperies are not constantly touched during use. However, all fabrics do take some degree of abrasion. Window coverings are vulnerable at points where material is handled and where tension is created to open and close them. Pilling, crocking, and snagging may occur if a drapery is in a location that frequently is bumped with furniture or is brushed up against by people, especially if the fabric is vulnerable to these kinds of wear.

Light, sun, and soil are more common causes of drapery becoming unsightly. Silk reputedly is the most sensitive to light, and it indeed will not last forever at the window. This is a cruel fact because its drape and luster make it extremely seductive for this application (figure 8-60 and see figures 4-4, 8-55). Neither exposure to light nor lightfastness, however, are absolutes; the direct sun of east exposure is harsher on fabrics than the diffused light of north exposure.

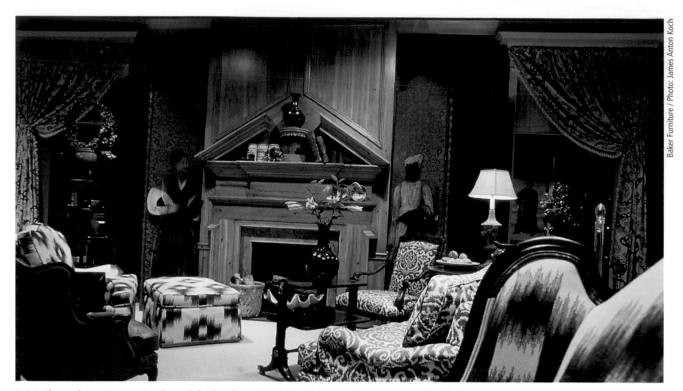

8-56 These draperies are simple and the hardware is hidden by a wooden cornice to highlight the architectural interest in the room.

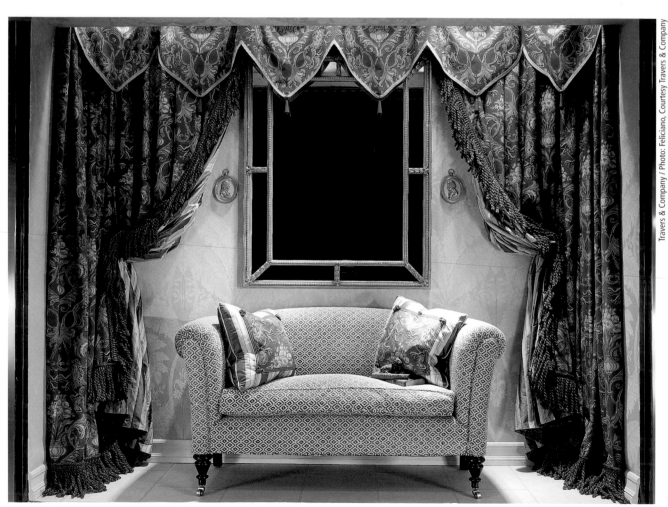

8-57 Drapery with contrasting lining and bullion fringe accent; valance with gimp and tassles.

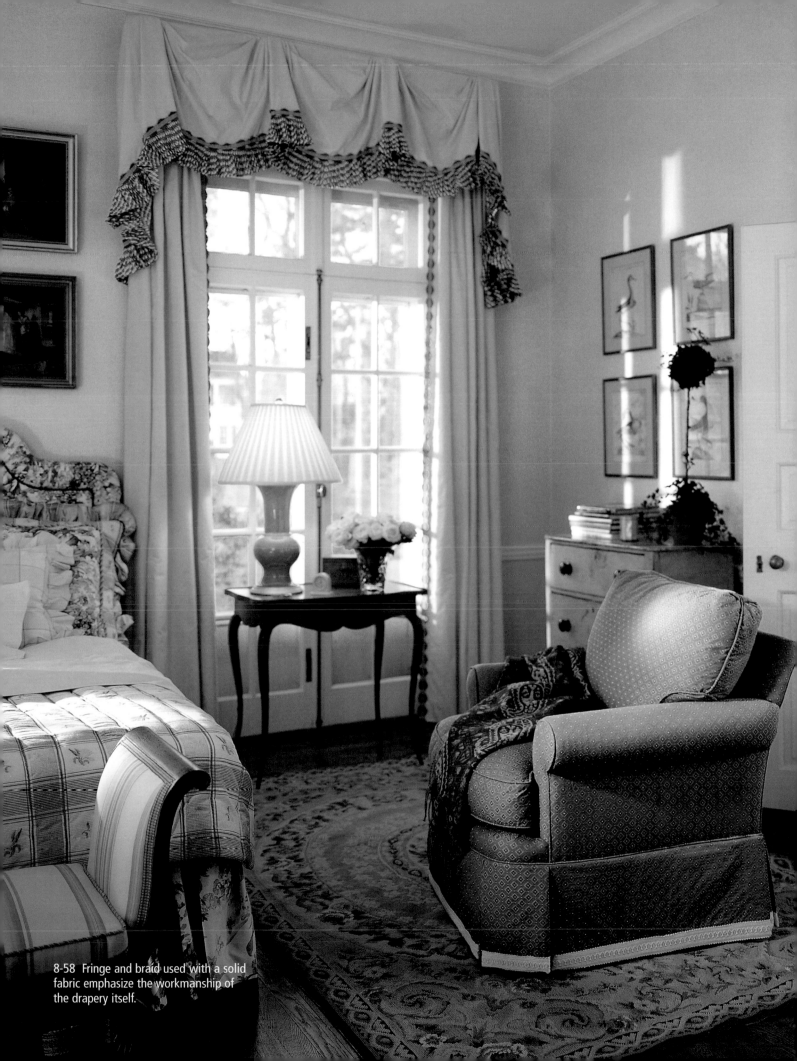

8-58 Fringe and braid used with a solid fabric emphasize the workmanship of the drapery itself.

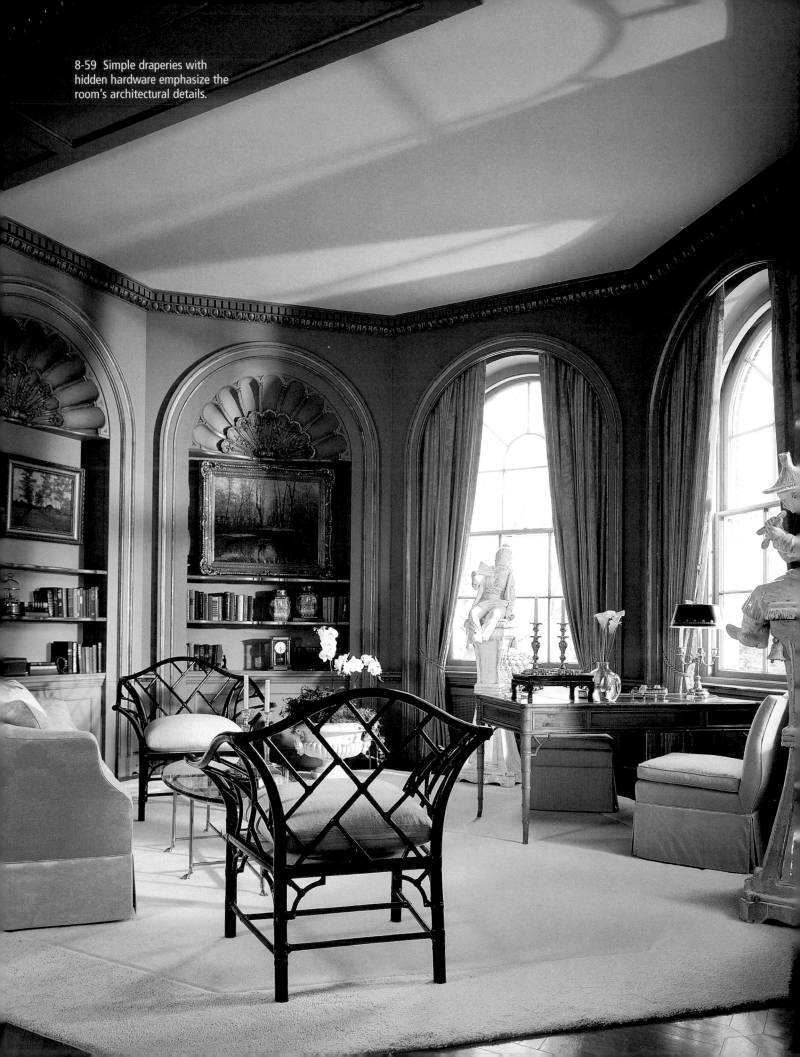

8-59 Simple draperies with hidden hardware emphasize the room's architectural details.

Direct light is stronger than light dissipated by outdoor foliage or by a feature of the window glass itself. Lined fabric is protected from exposure. The threads of the cloth that hang vertically closest to the window (usually the warp) receive more light exposure than the rest of the drapery.

Heat is equally abusive, especially to silk and wool, which become discolored and brittle when they are too dry. (Excess humidity leads to mold and mildew, which is less of a concern in today's climate-controlled buildings.) Fabric should be kept away from direct heat contact, and when baseboard heat units or radiators are directly under a window, special considerations must be made for the material and fabrication style, including length and lining material.

Dimensional instability can lead to unsightly treatments if it is not anticipated. Rayon is inherently stretchy. Thus, it generally should not run vertically at the window, although if the fabric "puddles" on the floor, the extra stretch probably is inconsequential. Wool shortens and lengthens with changes in humidity but always returns to its original length; with climate-controlled buildings, this usually is not a problem.

Unattractive seaming is often detrimental to beautiful drapery. *Wide-width* fabrics (108 inches [2.8 m] or more) are available (for both drapery and wallcovering application) so that the fabric can be railroaded from floor to 8½-foot (2.6-m) ceilings (or sometimes higher) and cover a large expanse without seaming. This is a wonderful installation benefit, but many fewer styles are available in wide width. More choices are available with wider-than-usual fabrics of 72 inches (180 cm) or more (usual for drapery is 48 or 54 inches [120 or 140 cm]); these

8-60 The drape and luster of silk make it a beautiful window covering, although it must be used with caution because of its sensitivity to light exposure.

fabrics require seams but fewer than standard sizes, often making them an appealing choice.

Some fabrication errors result in puckered or unsightly seaming. Seam or yarn slippage can also cause bad seams. It is always a good idea to ask a fabricator in advance for advice on any potential vulnerability that can be anticipated. A good sample of the fabric is, of course, necessary for any such evaluation.

Hemming should also be considered in installation. The customary deep hems may detract greatly from a beautiful sheer; a narrow "scarf" hem or other approach may be preferred. Fabrics that are patterned with opaque and sheer areas need to be hemmed so that the "like" areas line up, if possible. With advance consideration, good fabricators will offer excellent suggestions for these applications.

FLAME RETARDANCE

For commercial interiors, building codes require that vertically installed fabric that is freely suspended and not adhered to another surface pass

specific tests that measure the flammability of the material. Since open flame from any source would catch most easily to free-floating materials, and air circulation around them would fuel any such fire, drapery fabrics fall under closer scrutiny for these properties than fabrics for other applications. Testing for flammability is discussed in more detail in chapter 9, but the most commonly referred to tests for this market are called *NFPA 701 large-scale* and *small-scale tests*, which yield a pass/fail result. Building codes vary greatly from one municipality to another and owners of commercial buildings may have their own guidelines (frequently imposed by their insurance carriers) for fire codes. Consequently, in deciding which codes must be met, specifiers should rely on the client or facilities managers as well as their own code-compliance experts and knowledge and research. Fabric suppliers test many of their drapery fabrics for the most popular codes and can easily steer specifiers to fabrics within the required code category. Aftertreat-

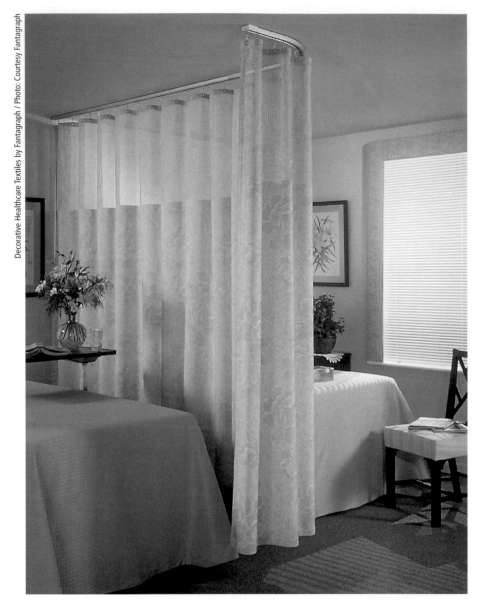

ments often enable particular fabrics to reach code compliance, but they may change the hand or appearance of the fabric and are considered an environmental negative because they require added chemicals.

HEALTHCARE

Cubicle curtains are considered a part of the window covering and drapery market although they do not actually cover windows at all (figure 8-61). These fabrics are hung from hooks housed in tracks along the ceiling and can run several yards (meters) in length. The body of the curtain does not extend to the tracks; either a mesh band (figure 8-62) or strips of fabric suspended between the track and the curtain are used to allow airflow in the room (and water

LEFT
8-61 Cubicle curtains are used to provide visually private areas within hospital rooms.

BELOW LEFT
8-62 The mesh fabric top band is sewn to the body of a cubicle curtain.

BELOW RIGHT
8-63 Fabrics designed to be used for cubicle curtains are attractive (though not necessarily identical) on both sides.

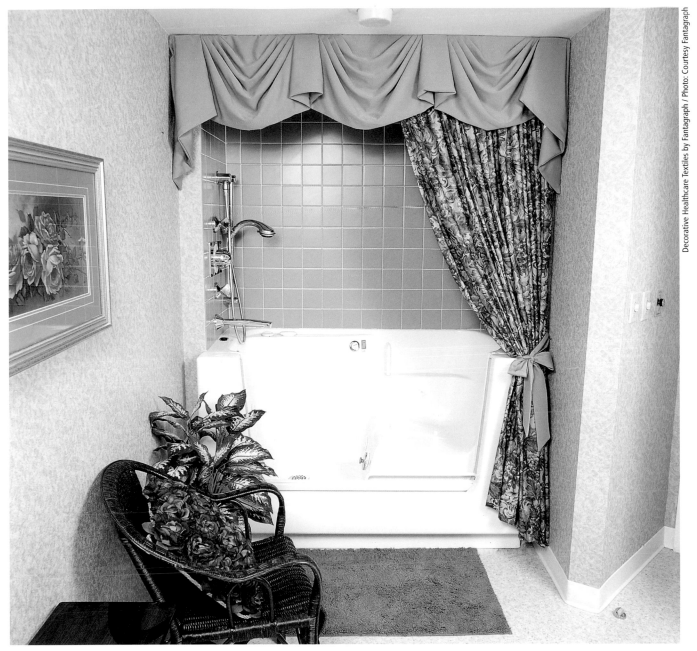

Decorative Healthcare Textiles by Fantagraph / Photo: Courtesy Fantagraph

8-64 Drapery treatments are often added to healthcare interiors for a more homelike, less sterile aesthetic.

from sprinklers in case of fire). The cloths usually are woven 72 inches (180 cm) wide so that no seaming is necessary when they are railroaded, although they are frequently fabricated the opposite way with vertical seams. Because they are installed in the middle of rooms and function as dividers, they are designed to be attractive on both sides, although the two sides are seldom identical (figure 8-63).

In addition to cubicle curtains, window covering and drapery treatments often are used to soften sterile healthcare interiors (figure 8-64). Almost all fabrics used for these purposes are Avora (formerly Trevira F.R.) polyester, often printed or piece-dyed and of lighter weight than required for the cubicle curtains themselves, which receive greater abuse.

For healthcare application all cur-

tain and drapery materials need to pass the stringent small-scale version of the 701 flammability test. The fabrics must also maintain both their flammability rating and colorfastness after repeated machine washings at the very high water temperatures required for hospital cleanliness. Fabrics woven of Avora, an inherently flame-resistant polyester, in specific constructions are generally considered the appropriate choice for cubi-

8-65, 8-66 Jacquard-woven fabrics designed for cubicle curtains offered in coordinating patterns for different areas of the same facility.

cle curtains. Because of the width, weight, and fiber requirements, and to meet the aesthetic preferences of the medical design community, fabrics that are engineered for cubicle use are marketed by their suppliers for this purpose (figures 8-65, 8-66).

LINING

A wide variety of linings are available to add one or more properties to a fabric at the window. The lining may add a desired aesthetic property like a different hand or stiffness. It may protect the fabric from light. *Black-out* lining blocks all exterior light from entering the room. Flame-resistant linings cannot make an outer fabric flame resistant; such a lining must be used with flame-resistant outer fabric so as not to lessen the properties of the fabric.

SPECIFICATION WRITING

As with seating (or any other use), all details regarding the direction, face, and centering of the fabric should be clearly detailed for the fabricator. Other details of seaming, hemming, and any other specifics should also be outlined. It is always a good idea to identify the fabric by giving the manufacturer's name and number and attaching a swatch of the material to the specification.

CLEANING AND MAINTENANCE

As with clothing or any fabric, more soiling and more dry cleaning or washing shorten the product's life span, and washing and dry cleaning leave chemicals in the fabric and in the environment. Protection from grime is desirable when possible. Window coverings, like most fabrics

in an interior, can best be maintained with regular vacuuming. When dirt remains apparent even after the fabric is vacuumed, most window-covering fabrics should be dry cleaned.

Certain drapery fabrics, notably cubicle curtains for hospitals, are made to be machine washable to temperatures high enough to kill staphylococcus germs. If a drapery or curtain needs to be machine washed, not only the fabric itself but also any materials used in the fabrication likewise must be machine washable.

Walls

Since the beginning of time, people have added decorative elements directly to walls. In many parts of the world during the Middle Ages, rug-like materials were hung on walls for

enhanced thermal protection and decoration. In the sixteenth century European artisans began painting murals on paper as a cheaper substitute for ornate tapestries. In the nineteenth century, with the advent of printing production, wallpapers featuring repeated patterns made their way into interiors.

The application of textured fabric directly onto walls is very recent. Although the vast majority of walls are covered with paint or other hard materials such as tile and wood, fabric wallcoverings have several attributes. Aesthetically, fabric gives a room a soft, warm atmosphere. Texture or pattern can relieve monotony of bland, bare walls, especially when architectural detailing is absent. Wallcoverings may also add performance features to a wall's surface, such as enhanced cleanability and durability. Although different wallcovering materials vary greatly in their performance and maintenance features, any pattern or texture (including paper or vinyl) applied to a surface disguises wear (figure 8-67).

This discussion of wallcoverings deals primarily with fabrics that are woven, backed, and applied to walls (figure 8-68). However, we include vinyl because fabric is most often compared to vinyl for use or consideration. Vinyl is, in the strict definition, a fabric film, but in professional terminology "vinyl" and "fabric" are considered separate categories of flexible wallcovering, and vinyl outsells other fabric wallcoverings many times over. (Wallpaper, which is paper printed with colored patterns, is considered purely decorative and is not included in the discussion, although some points noted here apply to any patterned or textural material applied to walls. Much "wallpaper" on the market today is actually paper coated with lightweight vinyl so that it can be cleaned with a damp cloth.)

Fabrics that are applied to *panel systems*, or freestanding movable walls that are made and upholstered

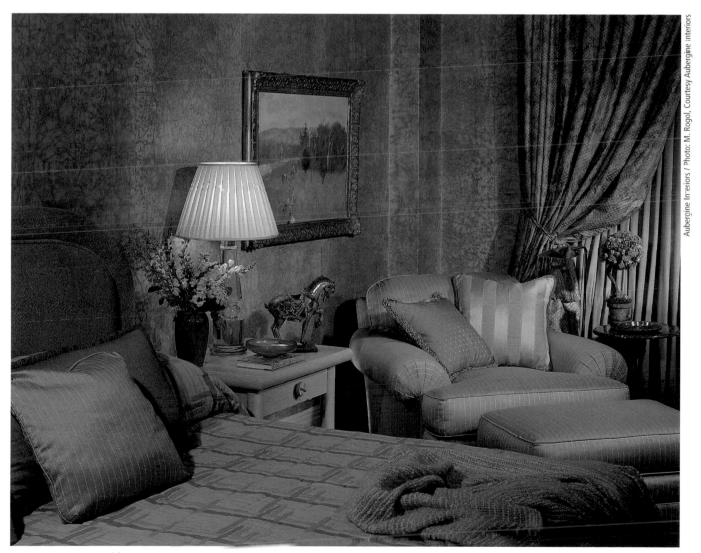

Aubergine Interiors / Photo: M. Rogol, Courtesy Aubergine interiors

8-67 Wallcovering adds interest to almost any room and also disguises wear.

8-68 Coordinated collection of woven fabric wallcovering.

8-69 Nonwoven needlepunched acoustical wallcovering.

by office-furniture manufacturers, are not wallcoverings. Although similar fabrics may be used for both purposes, their processing and application are quite different, and fabrics that are appropriate for walls are often unusable as panel fabrics. Panel fabrics are different from wallcovering and are thoroughly described in the next section.

FUNCTION

Painted walls mar and scuff from impact and show marks. Vinyl absorbs more wear and is easy to clean, but its surface can be damaged by sharp objects. Fabric can absorb and disguise many small marks so that less maintenance is required, especially in high-traffic areas. Fabric materials may "self-heal" to some degree so

that hanging artwork can be moved around without leaving nail holes that would be obvious on plaster (although any such wall surface must be kept clean so that the exposed surfaces do not discolor from soiling and contrast with the portion that has been covered). Walls must always be properly prepared, but fabric materials, including vinyl, can sometimes cover wall flaws—uneven, cracked, or rough areas—without the degree of extensive replastering and careful finishing that is required for a hard surface installation.

Walls with soft surfaces offer acoustical absorption, both by preventing sound transmission from one room to another and by reducing the volume level within the room. Nonwoven needlepunched fabrics produce a dimensional surface that is popular for its acoustical properties (figure 8-69). Fabric also can be laminated to foam to increase its acoustical properties. It is often applied over batting or acoustical board when maximum acoustical control is desired, for example in a conference room carved out of a busy office.

INSTALLATION METHODS

Fabric can be glued directly to walls, applied to panels that are attached to the wall, or stretched across the wall and attached along "tracks" on the wall.

DIRECT-GLUE. A glue paste can be used to adhere fabric with a nonporous (or nearly nonporous) backing directly to a wall. In the *direct-glue,* or *paste-up,* method, two lengths of the fabric are applied down the wall from ceiling to floor so that the vertical edges overlap slightly. The two thicknesses are then cut through with a utility knife, and the small overlapping strips are removed from

each length. The two cleanly cut edges then match perfectly. This splicing yields a smooth seam and is often called *double cut*.

Direct-glue is the simplest and least expensive wallcovering installation method. Vinyl is almost always direct-glued. It is not ideal for fabric wallcoverings, however; because the fabric is literally cut through, any long yarn floats, especially in the filling direction and particularly if the filling yarn is bulky, will become fuzzy and look loose and messy at the seam (figures 8-70, 8-71). Synthetics, such as polypropylene, probably are most prone to fraying. Many quality wallcovering fabrics are pretreated with an antifray coating that minimizes this problem.

If a fabric is of concern in this or any other regard, a wallcovering installer can apply a small test panel on a length of gypsum board so that the designer or end-user can decide whether its seams are unsightly. This test entails a small expense but avoids expensive mistakes on large installations.

The backing on any fabric that is to be direct-glued must be impervious to strike through. Fabrics that are paper-, knit-, or foam-backed literally have a second layer of material laminated to the face fabric and are ideal for direct-glue application (figure 8-72). Acrylic-backed fabrics

8-70 Woven fabric wallcoverings are pretested by the manufacturer to evaluate any potential seaming concerns.

8-71 Woven fabric grasscloth is a traditional effect, although its seams are noticeable. When heavier yarns are used in the fill direction, wallcovering seams are more noticeable than in a finer, tighter, more balanced woven fabric.

8-72 Paper backing (above) laminated to woven fabric wallcovering (below).

8-73 Acrylic backing (above) applied to polypropylene wallcovering (below).

8-74 Paper-backed grasscloth.

likewise can be direct-glued (figure 8-73). For wallcovering, a heavier acrylic backing than the common upholstery backing is frequently used, yielding a wallcovering that is sometimes called *double-coated* or *double-acrylic-backed*. Nonetheless, adhesive will not actually bleed through acrylic backing of any strength as long as the backing has been properly applied and the wallcovering properly installed.

Many installers prefer to work with paper-backed wallcovering because it is the most stable material. The paper substrate eliminates shifting of the fabric as it is applied to the wall. This material performs almost like wallpaper in application, and it is easy to *strip*, or remove from the wall, if necessary. Peelable crepe-paper backing leaves a layer of paper on the fabric and one on the wall when it is removed. Thus, the wall does not have to be reprepped, making the next installation easy to hang. Some installers, on the other hand, like the malleability of acrylic-backed wallcoverings because they can be adjusted slightly as they are applied.

Most, though not all, fabrics that are designed and marketed specifically for wallcovering application are paper-backed as they are manufactured (figures 8-74, 8-75). Many other fabrics that are marketed primarily for other end-uses—upholstery, panel fabric, or even drapery—are perfectly suitable for direct-glue application. If the fabric is not marketed with a paper backing, it must be sent to a textile finisher/processor for the addition of an appropriate backing, and the fabric supplier often offers such services as an accommodation to customers. The supplier and the processor are likely to recommend a particular backing for specific fabrics; acrylic backing is the

usual preferred aftertreatment, but a foam or knit backing is a better choice for thin fabrics. (Bumps or imperfections in the wall surface may *telegraph* through a thin fabric, so extra padding helps disguise these flaws.) Foam and knit lamination add stability to the fabric; these backings allow the face of the fabric to maintain "give" that may be useful in the application process. The foam or knit pad also adds additional sound absorption and makes the wall appear softly padded.

Warp-laminated fabrics are by definition paper-backed; in these materials, yarns of similar or varying colors and textures are arranged lengthwise as they would be in a warp (figure 8-76). Instead of weaving across the yarns with a filling, however, the "warp" is simply glued to a wallpaperlike substrate. Seams are easy to disguise in warp laminates because the vertical cuts do not need to break any threads.

Fabrics that are not marketed with paper backing rarely have it applied as an aftertreatment. If a fabric shifts even the tiniest amount as it is laminated to paper (or any other substrate) the shifts will be a permanent part of the material. If bowing or skewing occurs during the lamination process the fabric is forever bowed or skewed and therefore unsuitable for wall application. These errors cannot be corrected by the paperhanger. For this reason, fabric suppliers and processors usually do not assume the risk for this process and therefore do not recommend commission paper-backing. Wallcovering manufacturers who paperback vast amounts of fabric use complex, expensive equipment that maintains the straightness during the process; the processing quantity usually promotes consistency.

8-75 Palazzo has been a very popular woven wallcovering for many years and is available with a range of backings. It is a natural fiber blend, is available in many colors, and can be treated to pass most codes.

8-76 Yarns are arranged parallel and laminated to a paper substrate in warp laminates. The fabric on the left has been embossed to achieve the horizontal ribbing.

WRAPPED WALL PANELS. Fabric can be tightly wrapped around a panel of wood or fiber board and stapled to the panel's wrong side. Batting or padding can be wrapped underneath the fabric for a softer appearance, or an offset molding may be added to the edges of the panel to increase the depth of the panel reveal. The wrapped panels are mechanically attached to the wall, either flush with each other (and the ceiling and floor detailing) or with spaces between the panels. Fabric considerations for these *wall panels* are much less stringent and specific than those for the *panel systems* discussed in the next section.

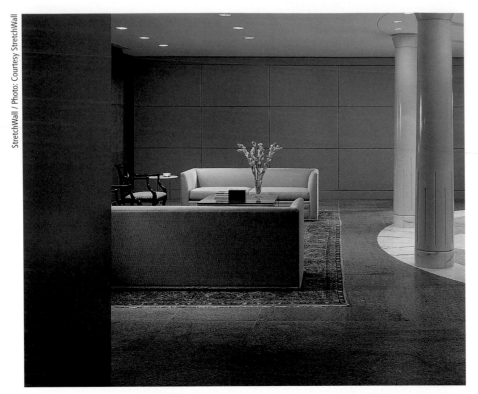

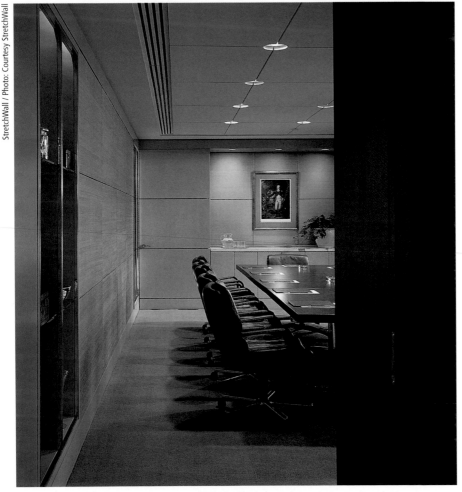

8-77, 8-78 Upholstered wall system (StretchWall) installation: (top) lounge seating in reception room, (bottom) conference room.

UPHOLSTERED WALLS. For more than a century fabric has been "upholstered" to walls. In the traditional installation method, wood laths are nailed to the wall at the room perimeters and at intervals as necessary to support the fabric. The fabric is then stapled tautly to the laths; lengths can be sewn together if a wider expanse of the fabric can be supported between laths. Raw edges stapled to the laths are usually covered with a decorative molding, welt, or braid. A thin batting or padding is usually applied between the fabric and the wall.

Various "upholstered wall systems" (which are not the same as panel systems) work similarly to this traditional wall-upholstering method, but the fabric is attached to the wall by a series of clips or tracks that hold the fabric tautly in place. Again, the tracks can be placed at intervals along the wall, or the fabric can be seamed and stretched across a wider expanse. These systems were designed and developed so that, unlike with the traditional method, no raw edges are exposed because they are folded into the clips or tracks. The lack of welting or trim covering the seams yields a more architectural, less decorative appearance (figures 8-77, 8-78). These track systems look much like wrapped panels, except that between the tracks the fabric is stretched over a padded surface rather than a firm panel. Complex system fabrications can be used to cover curved walls, vast expanses, and other novel installations such as in a concert hall or large auditorium (figure 8-79). StretchWall and Fabri-Trak are two of the best-known fabricators for wall-system applications.

An interlining fabric is sometimes necessary to upholster a fabric that is thin enough to telegraph or to show

actual interior materials through the surface. A variety of batting materials can achieve desired levels of acoustics and surfaces that can accept pushpins. Each wall system available is fabricated differently, so each manufacturer will evaluate the desired fabric for an installation, make recommendations for necessary processing, and often supply the appropriate support materials.

The tautness with which fabric is applied is critical to a successful installation. When evaluating these systems, the specifier or end-user should note the method used and how effectively it will hold fabric over time, as the material's weight and environmental changes increase its propensity to sag.

AESTHETICS

The most important consideration in the selection of a particular fabric for wallcovering use, as with any other use, is whether it is aesthetically pleasing. Wallcovering manufacturers go to great lengths to eliminate any potential problems with their product offerings, but wallcovering is perhaps the most technically problematic application. Whereas the folds of drapery or the cut-and-sew manipulations of upholstery fabrics can cover a multitude of fabrication mistakes, broad expanses of fabric laid flat on a wall make evident any flaw of pattern design, fabric production, or application. Particularly with fabrics not specifically marketed for wall application, it is wise to evaluate a large length of the fabric (or other material) rather than choosing it from only a small memo. This is especially important with patterned materials, as the human eye "sees" patterns differently in small pieces and in large expanses. One motif or color may appear prominent in a memo sample,

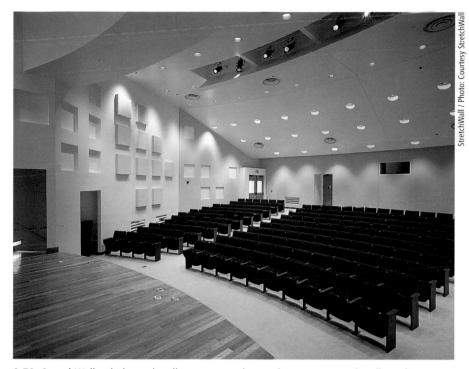

8-79 StretchWall upholstered wall systems can be used to cover curved walls and vast expanses in auditoriums.

while a different effect dominates a yardage length.

As with any end-use, fabric face and direction should be specified to the installer and processor. The scale of pattern must be considered both with regard to the room and to all other furnishings in it. Also, because the entire fabric will be viewed selvedge to selvedge, it is important to evaluate whether the pattern placement within the width of the fabric is pleasing—for example, whether the main motif runs so close to the selvedge that the seam will intersect it awkwardly.

Seaming concerns in direct-glue (double-cut) installation methods are discussed in that section, but any material that is to be double-cut should be critically reviewed to ensure that the seaming will not cause unsightly raveling. In wrapped-panel or upholstered wall installations no raw seam occurs, but wrapped edges butted together should be evaluated for negative effects. Even the most

subtle horizontal striping is usually unsuitable for direct-glue application, and it is problematic, at best, for other wall installations because the slightest bowing and skewing are unsightly on the wall, as is anything less than perfect side-matching.

DURABILITY

Although wallcoverings do not receive the continuous abrasion a piece of furniture does, they still must be considered for abrasion, pilling, crocking, and snagging, especially in areas that are likely to be bumped and pressed by people or furniture. Wallcoverings add dramatically to walls' resilience to both soiling and bruising from external sources. Fabric that is to be wall-upholstered or panel-wrapped needs to have adequate yarn and seam slippage and tensile and break strength to withstand the pulling and stretching needed to achieve a clean installation. The installer's opinion of a material's appropriateness is probably the best guideline. Because walls

are exposed to considerable direct light, wallcoverings also are usually tested for lightfastness, regardless of whether the manufacturer publishes the test results. These tests are discussed in chapter 9. It should be noted that the ACT standards for wallcoverings are not meant to apply to vinyl or wallpaper, and the standards (other than those related to flammability) may not apply to certain paper-backed materials.

DIMENSIONAL STABILITY

Because fabric expands and contracts with moisture changes in the environment, it is critical that fabrics that are upholstered or wrapped on panels be stretched in the maximum humidity that the room will experience. Even preshrunk cotton absorbs sufficient atmospheric moisture to sag after hanging, and wool can sag dramatically (although its recovery is excellent). Nylon absorbs so much moisture and its ability to regain its original shape is so poor that it should not be used as a wallcovering.

FLAME RETARDANCE

For commercial interiors, evaluating flame retardancy of wallcovering material may be necessary. In general, fire codes are different for fabrics that are attached to a substrate (like wallcovering) and those that are "free flowing" (like a drapery). In most cases, fabrics attached to substrates are subjected to the ASTM E 84 "tunnel test" and must make a particular rating (usually class A or B). Free-flowing fabrics must pass a so-called vertical test, usually the NFPA 701 (small- or large-scale), which is a more rigorous test. The tunnel test is most commonly executed in a form

8-80 – 8-82 Vinyl wallcovering.

in which material is attached to an asbestos board. Most materials pass this form of the test. It can also be run in the more stringent so-called loose-laid version, in which the test material is placed over an open mesh screen. Wallcoverings that are direct-glued usually are rated for the tunnel test—generally the "adhered" version. For upholstered walls or wrapped panels, some code-compliance experts assert that the entire assembly (i.e., the fabric wrapped on the panel) must be tunnel tested. Other experts believe that it is appropriate to test upholstered wall fabrics under the tougher loose-laid version of the tunnel test or under a vertical test, because although the fabric becomes a part of the interior structure by means of the attachment system, the fabric is not glued down to the substrate and air actually circulates around it. Codes are often more rigorous for areas like public corridors and lobbies than for private offices and conference rooms.

It is often noted that vinyl wallcovering (which is polyvinyl chloride) emits poisonous gas when it is burned. So do other materials, however, including wool. Although there are tests to measure toxicity, they are rarely required by code. A benefit of vinyl is its low flame-spread and smoke-developed ratings (parts of the tunnel test, discussed further in chapter 9). However, although test data compare the performances of specific materials, results are rarely black and white. Product selection criteria are best discussed with the manufacturer, who can make recommendations specific to the application.

Fire safety is a critical issue that must be carefully evaluated by all parties involved; the guidelines discussed here for code compliance are intended as a basic starting point, but

8-83 Vinyl wallcovering.

fire-safety requirements vary among municipalities, fire marshals, end-users, insurers, and specifiers.

VINYL

Vinyl, made of polyvinyl chloride, is a plastic film that is usually bonded to a paper or other fabric layer (figures 8-80–8-83). Vinyl is by far the most widely used fabric wallcovering. Its advantages are that it can be wet-cleaned, it can be very inexpensive, and it is easy to install. On the negative side, its seams are usually apparent and it cannot be repaired if its surface is gouged. (It usually is considered easier to maintain than a

painted surface, however.) Many beautiful and unusual surface and color effects are available in vinyl, but many designers eschew its "plastic" character.

Vinyl is the wallcovering of choice for healthcare interiors because of its cleanability. Coordinated patterns with border effects that also correlate with cubicle curtain fabrics are an established choice for that market (figure 8-84).

Vinyl is subject to certain performance classifications set forth by the General Services Administration and ASTM standards. At one time, the designations referred to material

weights, but currently they are performance measures only. The classifications specify that the lightest (type I) is intended for areas not subjected to abrasion, such as ceilings; type II is intended for general use in areas of average traffic; and type III is for areas of heavy traffic or rough abrasion. While the least expensive vinyls (type I) are far less expensive than fabric wallcoverings, many woven fabrics are good economic alternatives to the mid- and high-priced materials referred to as type II and III vinyl. Some consider polyvinyl chloride an environmentally negative material, although vinyl producers strive to curb its negative impact by limiting waste products and pursuing reclamation programs for used materials. In the future, vinyl may be easier to recycle than many other furnishing materials because it is of a single content and is used in large quantities.

DURABLE WOVEN MATERIALS

Woven fabrics of *polypropylene* (also called *olefin*) fiber were first introduced into the contract-furnishings market in the mid-1980s and are considered uniquely appropriate for wallcovering application (figure 8-85). The properties of the fiber include excellent lightfastness (because it is solution-dyed), cleanability (because it is extremely hydrophobic), and dimensional stability. These attributes dovetail nicely with its relatively low price, because budgets for wallcovering in large commercial areas are usually modest. While the interstices of this woven material certainly make it retain more soiling that is less easily removed than that of a film material, polypropylene is often touted as better performing than vinyl for walls because it does not mar as readily. Many beautiful

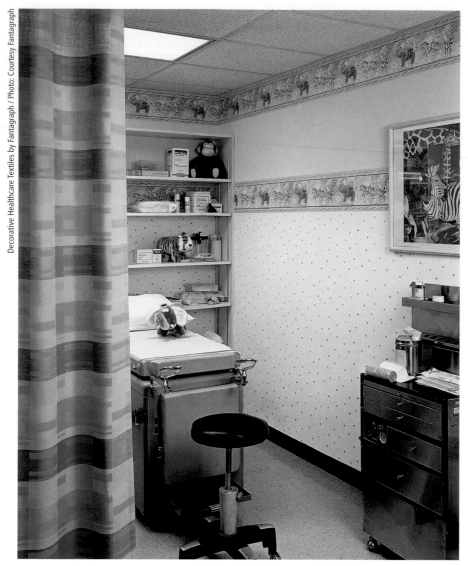

8-84 Coordinated vinyl patterns, including borders, define spaces and provide decorative elements in healthcare examining rooms.

8-85 A collection of durable polypropylene wallcovering.

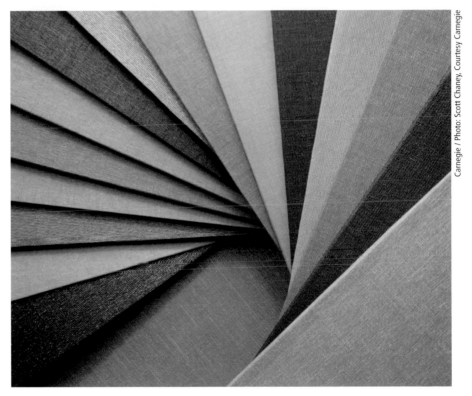

woven effects are available in poly-propylene wallcovering, and at sub-stantially lower prices than natural-fiber materials. Nonetheless, the bulkiness of the synthetic filling yarns produce more fraying at seams than finer materials, and many of the material's performance features are more theoretical than practical. The basis for polypropylene's widespread popularity is largely due to its overall appearance and attractive pricing.

A popular wallcovering fabric sim-ilar in performance to polypropylene is Xorel (a brand owned by Carnegie Fabrics), which is made of polyethyl-ene. It is known for its lustrous, wash-able, durable surface. Xorel is more expensive than most other synthetic wallcoverings but is nonetheless very popular (figures 8-86 – 8-89). Fabrics woven of vinyl-coated yarns, similar to those used in outdoor furniture, are another durable, cleanable wall material (figure 8-90). These surfaces have a plastic appearance but not a smooth, filmlike texture. Seams can be unsightly when these plastic yarns are cut.

8-86 – 8-89 Xorel is durable synthetic wallcovering.

In addition to the currently avail-able products, other materials surely will continue to be introduced into this category of materials.

OTHER MATERIALS

Natural fibers are also popular for woven fabric wallcoverings. Plain linen, silk fabrics, and various fiber blends are common. The exact fiber makeup generally is not critical in direct-glue application. Almost any fiber will perform well because the material cannot stretch or recover once it is laminated, and no specific fiber is needed to pass codes. Fabrics of natural fiber have limited applica-tion because they are generally more expensive than synthetics.

New materials are constantly devel-oped in an effort to find interesting aesthetic effects that can be installed with ease on walls. Moreover, natural materials that offer green alternatives

8-90 Vinyl-coated yarns are a cleanable material used in durable wallcoverings.

8-91 Fused and pressurized cellulosic fibers bonded with latex create a natural wallcovering material that offers a "green" alternative to vinyl.

8-92 Wallcovering of extruded quartz and gypsum is a durable natural surface material.

to vinyl wallcovering are evolving; these include pressed cellulosic materials (figures 8-91) and processed quartz and gypsum (figures 8-92–8-95) that can be embossed, printed, and otherwise embellished. *Washi*, or Japanese handmade paper, is available in many textural effects and is sealed with lacquer or varnish on the wall to increase its durability.

INSTALLATION CONCERNS

Wallcovering should be installed only by an accomplished hanger, and any processing done only by accomplished finishers and laminators. Errors in processing or fabrication can rarely be corrected, so it is critical that the utmost care be taken at all steps of fabrication. Fabrics that are to be upholstered in commercial installations probably need to pass fire codes that require a flame-retardant finish. The finish may change the fabric's color, hand, or moisture absorption. Fabric suppliers are equipped to recommend appropriate products for specific installations and should be consulted to assure the end-user's and specifier's satisfaction.

Most wallcovering complaints have to do with the character of

seams. A test panel should always be prepared to evaluate the seam's appearance before a wallcovering is selected.

CLEANING AND MAINTENANCE

All fabric wallcoverings should be vacuumed regularly. Vinyl can be wet-cleaned because it is a nonporous material. Polypropylene fiber is chemically inert and therefore can be washed even with strong solvents such as bleach. However, not all polypropylene fabrics can be cleaned in this aggressive manner; they may contain other fibers in the blend or a backing that cannot withstand the cleaners. Moreover, a specific yarn type may be too loose or a particular weave configuration too porous. Because of the ease in cleanability (and also because polypropylene itself is inexpensive relative to other fibers) these wallcovering fabrics and other durable woven materials are considered appropriate for high-traffic areas such as corridors and healthcare and institutional installations. Nonetheless, specific performance features should be discussed with the fabric supplier to avoid any misunderstandings.

Panel Systems

The freestanding, movable walls that connect to desks and other integrated office furniture are the main component of *office systems furniture* pertaining to fabric application (figure 8-96). Although many component configurations are possible, these moveble walls, or *panels*, were originally conceived to be 5 feet (1.5 m) tall (or shorter) so they could circumscribe semiprivate office areas (*cubicles*) within a large open-plan office interior (figure 8-97). (Although semiprivate office spaces are called

8-93–8-95 Extruded quartz and gypsum wallcoverings.

"cubicles," "cubicle fabrics" are hospital curtains, as noted earlier, and do not pertain to this use.) Fabric for panel upholstery is usually railroaded. Because it must yield a 5-foot (1.5-m) finished, usable width, the fabric is specially woven 66 inches (170 cm) wide (sometimes even 69 inches [175 cm]) with allowance for the waste needed to wrap it around the panels.

As with seating upholstery fabric, each panel-systems manufacturer offers a line of standard fabrics that can be purchased as a part of the furniture (figure 8-98). These usually are fabrics that upholster easily on all of the panels that the manufacturer produces and provide the best possible yield per yard or meter. Standard panel-fabric offerings number far fewer than upholstery fabrics, and many panel manufacturers run the same (or slight variations of the same) panel fabrics. Residential manufacturers rarely require preapproval for COM seating fabric selections, and contract manufacturers may require it. For panel application, however, COM approval is mandatory and often a painstaking or even futile process. Some manufacturers boast flexible systems that can accommodate a wide assortment of fabrics and even offer automatic approval for fabrics that have performed successfully on the specific manufacturer's prior testing; others rarely deviate from their standard offerings. Manufacturers realize that specifiers desire greater choice of panel fabrics, and they are constantly evaluating and trying different preapproval processes, alliances with fabric wholesalers, and other innovations.

Obtaining COM approval for panel fabric can be difficult for several reasons. First, many of the systems were designed in the 1960s and

8-96 Panels (freestanding, movable walls that connect to desks and other integrated office furniture) are usually fabric-covered.

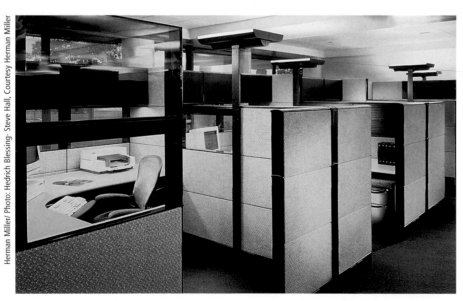

8-97 Panels were originally conceived to circumscribe semiprivate office areas within a larger office.

1970s when far fewer fabric sources actively catered to the contract market and customers rarely thought of using a fabric other than the manufacturer's offering. Consequently, the systems were engineered for application of a particular fabric that worked perfectly within the manufacturer's factory (figures 8-99, 8-100). Today consumers like to have more choices, but these older systems simply cannot accommodate fabrics that are thicker, thinner, stretchier, or more slippery than the fabric the factories are tooled to use. Newer systems have been designed and manufactured with flexibility of fabric application as a criterion, although most remain less flexible than most seating (figure 8-101).

Second, most systems are made by very large manufacturers, and their factories are set up and their minds geared to do what they do well, but to allow little deviation that would decrease efficiency. Most systems furniture goes into large offices of large companies that want to purchase furniture, with economy of scale in mind. Therefore, these companies are drawn to the products of large manufacturers. They may have more limited design possibilities, but the product is well engineered and efficiently manufactured, thus representing an excellent value. (The lower-end manufacturers tend to be most highly automated; hand-processing occurs predominantly with higher-end manufacturers.) The support offered for installation and on-site service by the largest manufacturers is also excellent.

FLAME RETARDANCE

The third factor in COM approval has to do with meeting fire codes: These panels contain wiring that brings electrical accessibility to the

8-98 Panel-systems manufacturers offer panel fabrics that are designed to be upholstered easily on the range of panels that they produce.

work stations throughout an office. The panel fabric itself usually undergoes the tunnel test (ASTM E 84). (As described in chapter 9, most code authorities recommend the unadhered, "loose-laid" version of the tunnel test for panel application.) However, the panels themselves usually must pass the Underwriters' Laboratories test for electrified fixtures to achieve a rating referred to as *UL Listed* (also described in chapter 9). Some manufacturers require that all fabrics undergo UL testing on the actual panel that will be used in in-

stallation. This is expensive and time-consuming; Underwriters' Laboratories is the only agency that can perform the test and its backlog alone strongly discourages the testing, even for the few clients willing to pay the substantial fee to build the specially fabricated test panel and undertake the testing.

Nonetheless, many jobs have COM as panel covering, because tenacious clients and specifiers are willing to undergo the process to achieve a specific aesthetic, or because a flexible system and manufac-

8-99 Panel systems were engineered for application of a particular fabric that work best within the manufacturer's factory. Color choice is the primary aesthetic variation for such fabrics.

8-100 "FR701®" is the oldest panel fabric and still is very popular. Its weight, thickness, content, and color work exceedingly well on the most successful furniture systems.

turer is used, or because the job is smaller and does not require the most rigorous approach to code compliance. In addition, older panels are frequently refurbished and *retrofitted* (recovered with new fabric to accommodate changes in the user's needs or in case of isolated damage or general wear) with COM, in which case the fabric usually must receive a class A rating on the tunnel test (loose laid).

Panel fabrics also can be aftertreated to pass flammability tests; however, the chemical treatments can make them stiff, increase moisture absorption, and change their color. Because of the critical nature of systems-furniture manufacturing, these changes are usually problematic. Furthermore, as noted earlier, the aftertreatment chemicals are considered environmentally negative.

FUNCTION

Since panel fabrics came into popular use, they have been used in unbacked form because some give is necessary to stretch the fabric across the frame of the panel (figures 8-102, 8-103). In recent years, as thinner fabrics of slippery filament yarns have become

8-101 Newer systems have been designed to allow increased flexibility of fabric application.

popular for this purpose (figure 8-104), some manufacturers have begun backing the fabrics or even laminating them to a nonwoven or metal substrate. It is important that the fabric is opaque enough to cover all the material inside the panel, including wiring and insulation material, but it cannot be so dense that it has no give and cannot be pulled and manipulated in application. Also, because panel fabrics are usually used in very large quantities at a time, they need to be relatively low in cost. Consequently, a fabric should be no heavier (and therefore no more expensive) than need be.

Like room walls, panels highlight the slightest imperfection in any fabric, so it is critical that such fabric not be bowed, skewed, or flawed (figure 8-105). From a quality-control perspective, panel application is in some ways even more rigorous than wallcovering. First, the manufacturers themselves insist upon working with "perfect" goods to minimize their fabric headaches. (By comparison, wallcovering installers customarily simply cut out minor flawed lengths as the fabric is applied, as long as the flaws are not inordinately frequent.) Second, while a room easily can be wallpapered with material from one dye lot, one dye lot of fabric may not be enough to cover an entire panel installation. Usually all the panels for an entire building are fabricated simulta-

8-102 Unbacked panel fabrics and crepe weaves allow the necessary stretch for application of the material to the panel.

8-103 This popular panel fabric provides dimensional color and textural effect and is applied easily to most systems.

8-104 Fabrics of slippery filament yarns have become increasingly popular for panels although they present technical application challenges.

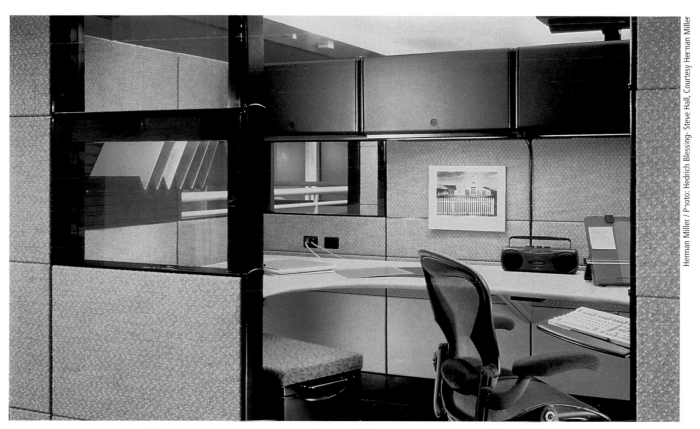

8-105 It is critical that panel fabric not be bowed or skewed, because the rectangular frame of the panel would highlight such a flaw.

neously in the factory, with no regard to which specific pieces will end up within a particular room once installed. Thus, it is critical that all dye lots for a particular systems job be almost identical. The same is true for retrofitted panels: The newly installed material needs to match the older material that remains in the interior. Third, panels "frame" the fabric installed on them. A fabric that is straight on the bolt easily can be applied straight to a wall by an experienced installer, but it can be difficult to align the right angles of the fabric threads to the right-angle edges of the panel (figure 8-106).

Panels covered in soft surfaces offer acoustical absorption, both by preventing sound transmission from one cubicle to another and by reducing the volume level within the entire room. Panels may be fabricated with a various sound-absorbent materials for increased acoustical properties.

8-106 Flawed fabric, or fabric that is not applied straight on the components of this work station, would be highly noticeable.

FIBER CONTENT

Polyester is the most common fiber for panel fabrics because it performs well on flame-retardancy tests, is dimensionally stable after it is stretched, and is relatively low cost. Panel fabrics may include small amounts of other fibers or may feature other flame-resistant fibers such as modacrylic instead of, or blended with, polyester.

8-107 Although plain and textural fabrics are easiest to apply and hide imperfections best, many appropriate abstract patterns are available for panel application.

Because of its low cost, polypropylene is also frequently used for panel application.

DIMENSIONAL STABILITY

Because fabric expands and contracts with moisture changes in the environment, it is critical that for every vertical-application fabric (including panel fabric), fiber and construction have excellent dimensional stability and moisture regain. Wool usually is too expensive for panel fabric, and it sags dramatically in humid environments (although its recovery is excellent). Wool works well in blends for

panel fabric, however. Nylon is inappropriate for panel application because it absorbs so much moisture and its ability to regain its original shape is so poor. Cellulosic fibers (cotton and rayon) do not perform suitably on flammability tests in large contents but are popular as minor elements of polyester blends.

AESTHETICS

The most important consideration in selection of a particular fabric for any use is that it is aesthetically pleasing. Many of the same aesthetic considerations that apply to wallcov-

erings apply to panel applications, except that the fabric does not need to be seamed. Fabrics with strong horizontal or vertical orientation or that feature linear components are likely to show any skewing in fabric manufacturing or application to panels. When several panels are lined up end-to-end, skewing is particularly unattractive, as each runs at a different angle. Fabric for panels need not be a plain texture; many appropriate abstract (nongeometric) patterns are designed to avoid unintentional lines within the pattern (figure 8-107). The scale of patterns also must be considered both with regard to the size of the panel and to the configuration of the panel elements in the particular installation.

As with any end-use, the fabric face and direction should be specified to the installer and processor. As previously noted, panel fabrics must be submitted to the manufacturer for testing and approval before they are specified.

DURABILITY

Panel fabric does not receive the same continuous abrasion as seating fabric, but it is usually tested for abrasion, pilling, crocking, and snagging, especially in areas that are likely to be bumped and pressed by people or furniture. Adequate yarn and seam slippage and tensile and break strength are necessary to withstand the pulling and stretching that are part of the manufacturing process.

In the finer, thinner fabrics that are popular today for panel application, "pulls" may appear from the points where staples are used to secure the fabric to the panel frames. The furniture manufacturers can make recommendations for minimizing these pulls by appropriately selecting materials for specific systems.

Panel fabrics also usually are expected to pass a lightfastness test (receive a class 4 or 5 rating) after 40 (sometimes 60) hours of exposure.

CLEANING AND MAINTENANCE

Regular vacuuming is the recommended routine maintenance for panels. Everyday dust and grime from the atmosphere are the main wear culprits in interior furnishings, even on a vertical plane. As with any other upholstered fabric, only a professional furniture cleaner should undertake additional cleaning.

Floors

Many excellent books have been written on the origin, history, and design of floorcovering, which could be considered an altogether different material from "fabric" when it comes to its use in interiors. Carpets and rugs are actually fabrics, however, and are more similar to other fabrics than they are to hard surface materials (figure 8-108).

Carpets are almost always a tufted material (though they can be woven on a loom in a technique nearly identical to pile fabric weaving, described in chapter 4) and are generally thought of as a "continuous" product, meaning that, like most fabrics, they are produced so that they can be seamed and matched to cover broad expanses (figure 8-109). (Rugs, by contrast, are a "contained" pattern, with edges and a specific outside dimension. It should be noted that *carpet* is also a term used by rug dealers to designate very large handmade rugs, which have nothing to do with machine-made carpet.)

Carpet usually is used wall-to-wall to cover an entire room. In the United States it commonly is produced in 12-foot (about 4-m) wide bolts and

8-108 Floorcovering can define the space and set the tone for the interior.

is called *broadloom*. Bolts can range dramatically in length. In residential application, 90- to 100-foot (about 30-m) bolts are common; in commercial application cuts are made as specified and may be longer or shorter as required. Certain carpet products are 6 feet (about 2 m) wide for manufacturing and installation convenience; for example, a material with a vinyl cushion backing might be too heavy a roll in a 12-foot form. In addition, carpet *tiles*, which are

installed in block arrangement, are available. These tiles are generally highly durable and made for contract use because they can be laid in portions so that a room does not need to be emptied of all occupants for installation. Tiles also offer extra flexibility in accessing the wires under floor systems and in repairing selected areas rather than entire rooms.

As noted earlier, rugs are generally "contained" fabric floorcoverings with definite edges that are part of

Photo: Courtesy Wools of New Zealand

Photo: Judy Juracek

the pattern of the rug (figure 8-110). Rugs may be handmade or machine-woven and may have a pile or flat-woven structure (figure 8-111). Kilim and dhurrie rugs (figures 8-112, 8-113) are flat woven in a weft-faced technique that is identical to traditional tapestry technique. Mats can be woven of almost any material, from natural fibers to those of the vinyl-covered cord shown in figure 8-115.

Braided rugs do not have a pile and are not actually woven. They are made from strips of cloth that are braided together into flat braids. The braided strips then are wound in a spiral from the center and sewn side-to-side to hold the strips in an oval format (figure 8-114). *Rag rugs* are woven on a sturdy cotton warp, and cut strips of finished fabric are used as filling yarn.

Rugs with pile may be tufted like carpet, which is usually machine-made. *Hooked rugs*, which were origi-nally handmade, are one of the simplest forms of tufted rugs; ma-chine-made versions are now quite popular. In this technique a ground fabric of canvas or burlap serves as a foundation. A hook or needle is used to pull loops of heavy yarn or strips of fabric through the ground cloth to form a tight, looped surface pile (fig-ures 8-116, 8-117). So-called orien-tal rugs are usually pile woven by hand in a technique in which the pile is created by tying the filling yarn around the warp as the rug is woven.

8-109 Carpet is produced in bolts but is made so that it can be seamed and matched to cover broad expanses.

8-110 Unlike carpet, rugs are specific sizes. Rug patterns are often designed with a central figure and borders that are contained within the edges.

The dense knots and ground filling obscure the warp, which shows only in the fringe at the two end edges of the rug (figure 8-118). Specific knot configurations traditionally are used to form the pile of the rug; *Ghiordes*, *senna*, and *Spanish knots* are shown in figure 8-119. Contemporary machine-made rugs are often produced in the traditional "oriental" patterns typical of specific areas of the Middle East, sometimes in new color combinations.

FUNCTION

While the main function of carpet or rugs is aesthetic, soft-surfaced floors offer acoustical absorption. In some instances the soft material may require less maintenance than a hard floor, and carpet is integrated with raised floor systems that facilitate critical access to complex wiring within office interiors.

AESTHETICS

The most important consideration in selection of a carpet or rug is that it is aesthetically pleasing. After the walls, the floor is the largest single surface in an interior. A rug's appearance is usually fairly easy to anticipate, and even retail rug suppliers usually allow customers to return rugs for full credit within a few days of purchase so that the rugs can be evaluated in the environment where they will be used.

Carpet must be selected for purchase from a small sample piece and

8-111 In this flat woven striped rug, the fill yarn is the colorful stripe but the warp yarn is visible and creates a pattern of subtle weave effect.

8-112 Kilims are flat-woven rugs in which the fill yarns completely cover the warp yarns.

ABOVE

8-113 Kilim (detail).

RIGHT

8-114 Braided rugs do not have a pile. They are made from strips of cloth that are braided together, and then the braided strips are sewn side-to-side in an oval format.

BELOW

8-115 Rugs can be made of any fibers, including the vinyl-coated cord used to weave these mats.

8-116 Hand-hooked rug of coarse texture.

8-117 Hand-hooked rug of fine texture.

is more difficult to evaluate. This is especially true of patterned carpets, as the human eye perceives patterns differently depending on whether a small piece or large expanse is being viewed. Although carpet manufacturers strive to eliminate potential patterning problems, one motif or color may appear prominent in a memo sample while a different effect dominates a yardage length. In addition, human eyes tend to group motifs as patterns, so in large expanses (especially corridors, for example) patterns that were not visible in a 12-inch (30-cm) square will suddenly become apparent. Fabrics that are subject to this phenomenon cannot be considered flawed; nevertheless, it is wise to evaluate as large a piece as is practical before specifying or selecting a carpet. As is true with any end-use, the scale of carpet pattern must be considered in relation both to the room and to all other furnishings in it (figure 8-120). Although trends change, solid colors are more popular for residential carpet, while small-scale texture and pattern (which disguise soil and wear) are ubiquitous in contract flooring surfaces (figure 8-121). Large-scale patterned carpets are usually confined to hospitality interiors or reception areas where spaces are expansive and

8-118 The fringe along the ends of a rug is the warp yarns, which are usually tied and left loose. (A machine-made fringe is sewn onto some tufted rugs.)

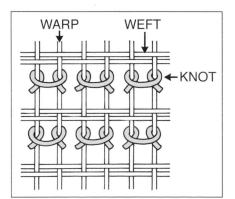
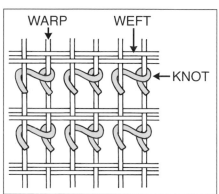
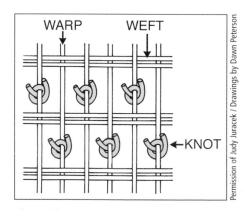

8-119 Left to right, Ghiordes, senna (open on left), and Spanish knots form the pile yarns in traditional hand-knotted rugs.

8-120 The scale of this carpet pattern activates an otherwise austere office space.

8-121 Small-scale texture and pattern are popular for contract installations because they help disguise wear.

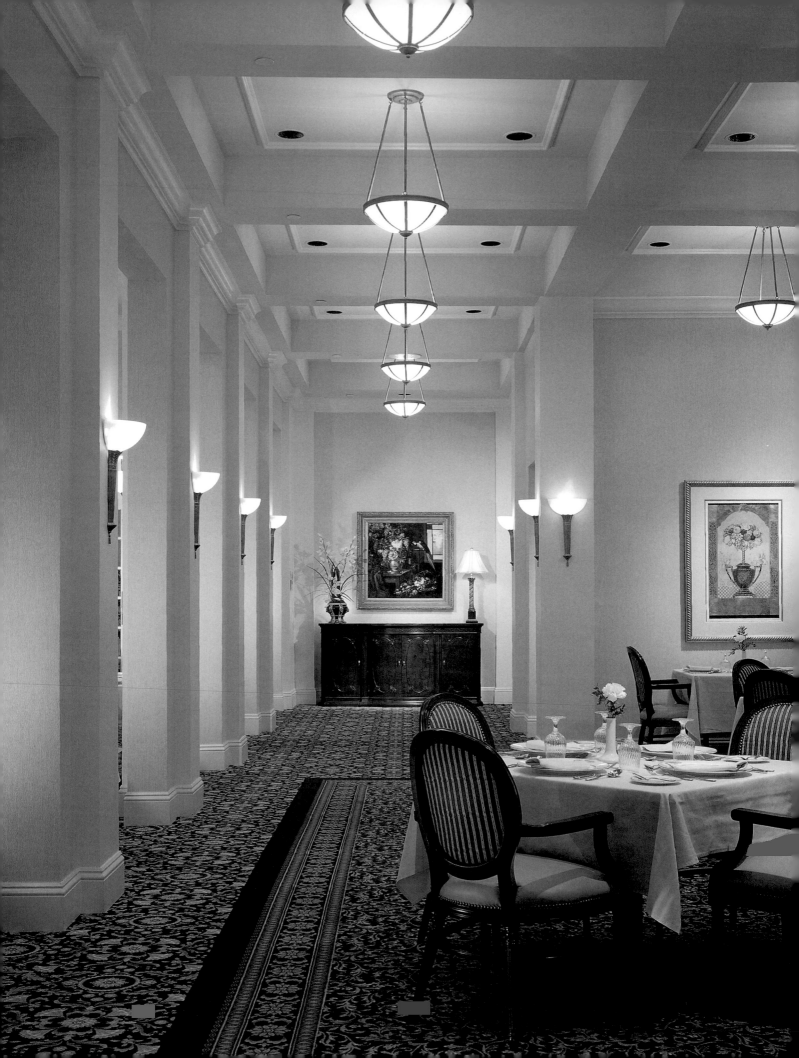

dramatic flooring is an accepted aesthetic (figure 8-122).

Carpet must be seamed unless a room is smaller than the length and width of the bolt of carpet. A good installer handling a quality carpet should achieve minimal visible seams and can offer excellent advice on seam placement. Any specific seaming concerns should be evaluated through sampling in advance of installation, and preferences should be discussed with (and stipulated in written instructions for) the installer in advance. Seams sometimes can be advantageous; for example, they can be placed intentionally to splice different carpeting together to delineate space within an interior (figure 8-123).

CONSTRUCTION, CONTENT, AND BACKING

Wool is perhaps the ideal flooring fiber. It is extremely durable because of its resilience, it naturally repels soiling and is easy to clean, and it accepts dye beautifully (figure 8-124). Cotton is soft underfoot, but its softness limits its durability. Cotton also accepts moisture readily, which creates a propensity to staining. For these same reasons it is ideal for bathroom rugs that need to absorb water, are used only lightly, and need to be machine washable. Flat-woven dhurrie rugs are usually made of cotton. The warp of hand- or machine-made rugs is usually cotton or linen; exceptions include Turkish rugs, which usually have a wool warp, and

OPPOSITE
8-122 In commercial interiors, large-scale patterned carpets are usually confined to reception and dining areas where spaces are expansive and dramatic flooring is an accepted aesthetic.

Systems Furniture: Contrada® by Trendway. Facility: Paradigm Genetics; workplace design team: Nicholas Peele and Debby Ryals Photo: James Anton Koch

8-123 Seams are used intentionally with solid and patterned carpet that are spliced together to delineate space within this office setting. The blocks of bold color also distract the viewer from a linear pattern effect that is evident in a long expanse of the flooring.

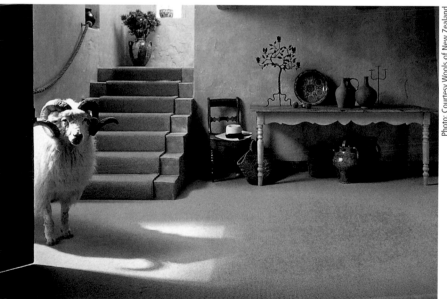

Photo: Courtesy Wools of New Zealand

8-124 Wool is perhaps the ideal carpet fiber because of its durability, resilience, and beauty.

8-125 This looped pile carpet features space-dyed yarns for an all-over multicolored effect.

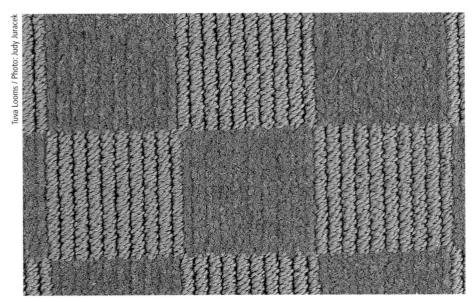

8-126 Areas of cut pile are contrasted with areas of loop pile to create a checkerboard pattern.

8-127 Looped pile carpet is most durable and is therefore popular for contract use.

newer machine-made rugs that may have a synthetic or blended warp yarn. Even if they have multiple types of fiber, handmade pile rugs appear to be 100 percent wool because weft and pile are usually wool and the warp is hardly visible.

Woven carpet, such as *Wilton* and *Axminster* (described below), are usually made of wool but represent a very small segment of the carpet market. Tufted carpet also may be of wool pile, but the vast majority of carpet is nylon. Simply because of its expense, wool fiber is not practical for most commercial applications or many residential uses. Several brands of nylon, which are arguably indistinguishable, are widely used in carpet. The largest producers of carpet nylon are DuPont, BASF, Solutia (formerly Monsanto), and Allied. Antron is a widely used carpet nylon made by DuPont. Some carpet nylon is solution-dyed (dyed by the fiber company before it is extruded into yarn), which limits its color palette but increases its lightfastness. Quality carpet, whether solution-, piece-, or yarn-dyed, will exceed normal lightfastness requirements. (Lightfastness testing is described in chapter 9; actual requirements depend on type and location of installation and the end-user's demands.)

Polypropylene (olefin) is a less expensive alternative to nylon fiber. It is a very durable fiber with low static, but it can be colored only by solution-dyeing. It is also less resilient than nylon and lighter in weight for its bulk than nylon. These two weaknesses cause it to mat down (crush) under high-traffic conditions.

Tufted carpet may be configured of cut or looped pile yarns (figure 8-125), or a combination of both (figure 8-126). As with the weaving techniques described in the section

on pile fabrics (see chapter 4), the supplementary yarns that interlace through the ground fabric to create the pile appearance can be packed more or less tightly together, and the yarns can be long and loose or cropped short. They can be cut to produce a velvetlike hand, or left as continuous loops across the surface. Cut pile can be *sculptured*, or cut in varying heights to create a relief patterned surface. Because cutting the pile weakens the fiber, loop pile is more durable and is consequently more popular for commercial application (figure 8-127). Conversely, cut pile feels softer and is therefore more frequently sought for residential use (figures 8-128, 8-129).

The number of tufts or threads per unit of measurement in the width is known as *pitch*, and in the length as a *row*. This roughly compares to ends and picks (discussed in chapter 4) in woven fabric. Whether handmade oriental or machine-made broadloom, pile density is a sign of quality. The more yarn that is packed into a square inch or centimeter of carpet, and the tighter the twist of the yarn, the more durable the rug or carpet will be. Nonetheless, as with any fabric, the most durable material is not necessary for every use. Density is often a direct trade-off with softness, and the appropriate balance must be found between the two for best results. Again, reputable suppliers, whether retail or wholesale, are best equipped to answer specific questions; carpet manufacturers also have extensive customer service and can be contacted directly for technical support.

Wilton and *Axminster* are machine-woven carpets. Both are made on specialty looms that allow for continuous rolls of carpet with clearer, finer detail than would be possible in tufting (fig-

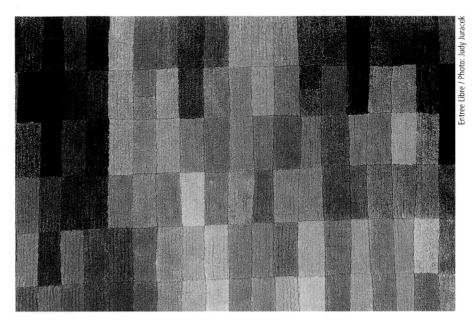

8-128 Wool's dye affinity makes it ideal for carpet. These colors blocks are samples available for custom orders in a cut (wool) pile carpet.

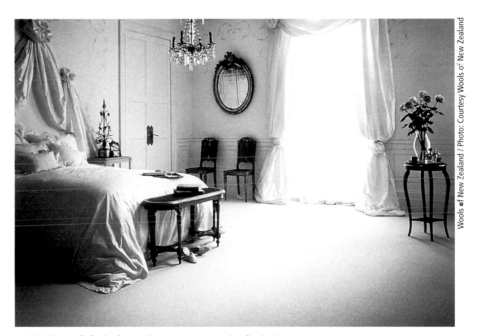

8-129 The soft feel of cut pile carpet is popular for bedrooms.

ure 8-130). In both techniques multiple colors of pile yarn are brought to the surface as needed for the desired effect; in Axminster the hidden, buried portion of the effect yarn is clipped away, while in Wilton it is carried along the back of the carpet. (The techniques are roughly similar to discontinuous and continuous brocade, respectively.) Axminster carpets have a tighter interlacing; the pile

loops of Wilton carpets are known to be sensitive to snagging. Both techniques are expensive, although Wilton is much more so. Axminster offers slightly more color flexibility but is available only as cut pile and requires larger minimums than Wilton, which can be cut or loop pile. Wiltons were traditionally woven 27 inches (70 cm) wide and many still are. Consequently, the seaming required to in-

8-130 The clarity of colors in distinct pattern areas is a characteristic of Wilton and Axminster carpets.

8-131 Sisal rug with bound edges.

stall these carpets is integral to their appearance and considered a signature of this specialty material, although 12-foot- or 13-foot-2-inch (about 4-meter) wide Wiltons are available today. Because of their design flexibility and also because of their price, Wiltons and Axminsters are used primarily in residences and in high-end hospitality installations. Custom developments and colorations of these constructions are common.

Sisal fiber is taken from the leaves of the agave sisalana plant, and is commonly flat woven into rugs and carpet (figures 8-131, 8-132). Similar materials such as coir (from coconut husks), jute (from jute plant stalks), rattan (figure 8-133), and even sea grass and paper are often referred to as "sisal." Fibers of this family are generally difficult to dye and are therefore sold mostly in their natural color. Sisal itself is probably the all-around best-performing fiber within the group: It accepts dye most readily (an indicator that it will also stain most easily), but its balance of softness and resilience makes it comfortable underfoot and also relatively durable. Coir, long used for doormats, is much more prickly and very difficult to dye but is almost indestructible. Jute is much softer but is the least durable of the family.

Sisal-family carpet and other carpets that are woven in continuous lengths are frequently cut to a specific rug size and the edges finished with binding to create a rug. Before the edge is bound, a carpet border may be added to create a more contained appearance. The actual carpet-edge binding was traditionally a narrow-woven fabric similar to a ribbon that was overlapped and bound as an edge. Nonwoven material is now also common binding. Bindings

come in widths from very narrow to several inches (centimeters) wide, and any durable upholstery fabric, including velvet, tapestry, flannel, and leather, can be used. Machine binding is much less expensive than hand application; wider or more patterned material probably adds complexity to the process. Mitered corners are more complicated than lapped bindings; they also cost more but look more finished.

The backing used with a rug or carpet is integral to the performance of the material itself. The greatest wear to any pile fabric comes at the point where the pile yarns are woven into the ground weave, and if the material is not properly cushioned from behind (or below), continual impact to its face will cause the pile yarns to show wear at those points. (As with upholstery or any other use, worn fiber is as likely to become unsightly from pilling, fuzzing, or matting as it is to break.) A reputable supplier can recommend appropriate backing for specific materials and uses. Specific backings are available that impart particular performance features, such as limiting static. Many machine-made rugs (including those of sisal and similar fibers) are sold with integral latex backing that adds stability and may eliminate the need for additional backing or dictate a change in backing requirements.

STATIC GENERATION

Most carpets today are made with an integral antistatic filament that does not affect their appearance. For this reason, and because computers are increasingly well grounded, carpet's tendency to increase static in an interior is no longer a significant issue. Commercial carpet is laboratory-rated (on the AATCC 134 test) to

Baker Furniture / Photo: James Anton Koch

8-132 Sisal rug with bound edges.

Chista / Photo: Judy Juracek

8-133 Rattan, a plant fiber similar to sisal, is often woven into rugs and mats.

8-134 Subtle color changes from exposure to light create a patina in handmade antique rugs that is part of their inherent beauty.

have an electrostatic propensity of less than 3.5 kilovolts. Areas with extreme sensitivity to electronic charges, such as computer laboratories, require particular carpets with specific backings; these carpets can be recommended by quality suppliers.

FLAME RETARDANCE

All carpets must pass ASTM D 2859 "Surface Flammability of Carpets and Rugs" per CPSC (Consumer Product Safety Commission) guidelines. For commercial interiors, more detailed classification of flame retardancy of floorcovering material may be necessary. In most cases, carpet is evaluated by the flooring radiant panel test (ASTM E 684). ASTM E 684 has two classes, and a class 1 rating (minimum .45 watts/cm^2) is often required. Fire safety is a critical issue that must be carefully evaluated by all parties involved; the guidelines discussed here for code compliance are intended as a basic starting point, but issues vary among municipalities, fire marshals, end-users, insurers, and specifiers.

INSTALLATION AND MAINTENANCE

As with most other fabrics, the vast majority of problems that arise with carpet are caused by improper installation. It is highly recommended that a professional installer be used, references be checked, and concerns discussed in advance between consumer, installer, and specifier. An installer with experience working with patterned flooring is critical when any patterned material is to be used.

Appropriate backing is critical to the life of rugs and carpet. Carpet manufacturers and installers can give advice on the best choice for the intended purpose, carpet construction, and material. Handmade and oriental rugs should be placed over a hair or fiber pad with a rubberized surface to keep the rug from moving or wrinkling.

As with other fabrics, carpet should be properly maintained by regular vacuuming. With today's carpet, most stains are removable if treated correctly. Carpet manufacturers provide cleaning instructions with the carpet and can always answer maintenance and performance questions regarding their products. It is important to follow the manufacturer's maintenance instructions, as improperly applied water or solvents may actually set stains. Carpet should be professionally cleaned every few years or as needed, and a professional should be consulted for unusual soiling or specific stains.

In the case of handmade and antique rugs, the patina that develops from light exposure over the life of the rug is part of its inherent beauty (figure 8-134). Nonetheless, it is best to rotate rugs so that the light exposure they receive is as even across their surface as possible. Closing window shades to protect a room from sunlight when the room is not in use is as beneficial for rugs as it is for all other surfaces.

Rugs, like carpets, should be vacuumed regularly and professionally cleaned periodically. They should be vacuumed in the direction of, not against, the nap. Care should be taken to avoid vacuuming the fringe, as this causes the fringe to break down more quickly. In the case of handmade rugs it is especially important to use a reputable cleaner who specializes in oriental rugs, as proper cleaning is essential—many chemical processes remove the rugs' natural oils. Likewise, any necessary repairs should be undertaken professionally.

Because carpets of sisal and sisal-like materials can appear relatively similar but vary dramatically in cost and quality, these carpets should be carefully evaluated for construction, anticipated color change, and smell, all of which can vary with age and humidity changes. Because stains in these fabrics are very difficult to remove, stain-protection finishes are

❖ 240 ❖

recommended and they are best suited for areas where food is not used. Furthermore, true sisal and plant-fiber carpets cannot be successfully seamed and therefore usually are used in wall-to-wall application only when seams can be placed very inconspicuously or when the room is under 13 feet (4 m) in one direction. Wool and synthetic simulations of sisal are probably best when significant seaming or easier cleaning is needed.

Water leakage—whether from houseplants, broken plumbing, or seeping air-conditioner units—is one of the most common causes of damage to rugs and carpet. A wet rug or carpet should be professionally handled immediately.

If a rug or carpet needs to be stored, it should be rolled (clean and moth-proofed) and stored in a dry environment. A rug (or any other fabric) should not be folded or wrapped in plastic for any length of time.

SUSTAINABILITY

Because carpet is used in large quantities, it is perhaps under greater scrutiny for its environmental impact than almost any other interior fabric. As with all other materials, appropriate use and specification are the primary factors in keeping material out of landfills.

Moreover, carpet manufacturers have implemented significant recycling programs in which used carpet is reclaimed and reprocessed in the manufacturers' facilities. A very high percentage (up to 100 percent for some manufacturers) of returned material is reprocessed into other products such as backing material.

Because carpet uses large quantities of fibers that are homogeneous in content, carpet manufacturers are the largest users of many synthetic fibers. These large customers have

8-135 Traditional tapestry wallhanging in a living room.

motivated the fiber and chemical companies to increase their own environmental responsibility. These efforts trickle down to enhance the entire textile community's avenues for lowering fiber consumption and reusing it successfully.

Fabric and Fiber Art

Diverse fabric and fiber materials are created as artwork for purely decorative application. The range—from traditional tapestry wallhangings (fig-

ure 8-135) to baskets to freestanding or ceiling-mounted or wallmounted art—varies very widely in material, size, and appearance (figure 8-136 – 8-140). Artwork exists purely to be enjoyed for its beauty, and art is no exception when it comes to caring for an item in an interior (figure 8-140, 8-141).

DURABILITY, CLEANING, AND MAINTENANCE

Universal principles apply to the care of most art. The most deleterious fac-

OPPOSITE
8-136 "Hands" is a machine appliqué sculptural artwork by Margaret Cusack.

CLOCKWISE FROM TOP LEFT
8-137 Betty Vera's "Memory Garden" is a tapestry woven of cotton and linen.

8-138 "Murgang Sa, Namsan," by Glen Kaufman, is a screen print of silverleaf on silk fabric.

8-139 Sheila Hicks's freestanding sculpture "Compresse II" is made of linen.

OPPOSITE: 8-140 Silk woven panels form this suspended sculpture by Chiaki Maki.

ABOVE: 8-141 "Celebration," by Lenore Tawney, is a linen sculpture.

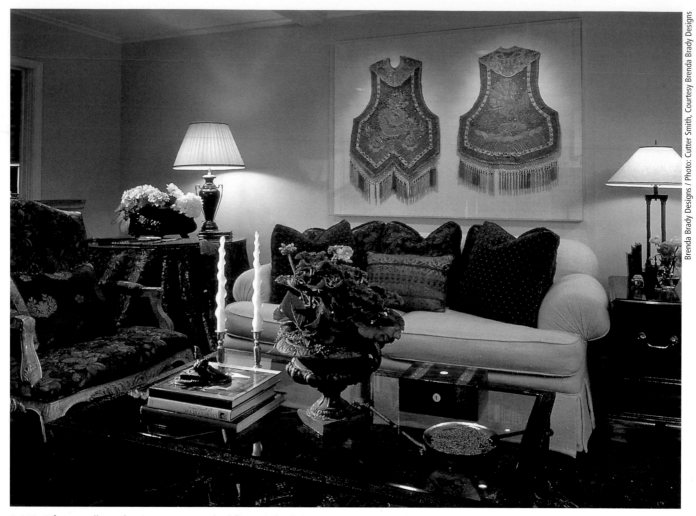

Brenda Brady Designs / Photo: Cutter Smith, Courtesy Brenda Brady Designs

8-142 Often small textile pieces are stretched flat, stitched down onto a neutral cloth background, and mounted in a plexiglass box, as these antique Chinese vests are.

tor for any art work is that fear of its fragility results in its being ignored. Many large fiber sculptures in corporate installations appear less than durable simply because they have never been cleaned or maintained.

Any art, and any fabric, should be kept away from constant light—natural or artificial. If at all possible, fiber-based art should be covered and screens or blinds should be drawn when the room is not in use. In instances where this is impractical, the pieces should be periodically removed from installation and "rested" for periods of time. The longer the rest the better, but even short rests are helpful.

All fabrics need to be cleaned regularly; although too much cleaning creates inordinate wear, too little makes the fabric unsightly and destroys the fiber. Like all fabric, most artwork can be safely cleaned with a vacuum, air gun, or dusting brush. Of course, the smaller the piece, the easier it is to maintain.

Any framing of a fabric should be done by an expert framer so that the art can be properly mounted (stitched —never glued) with appropriate materials, scaled, and protected as necessary (figure 8-142). Wool tapestries have hung on building walls for centuries and can be professionally washed just as handmade wool orien-

tal rugs are washed. Materials of mixed fiber content sometimes require more complex treatment. Baskets of any size or material should be routinely cleaned with a painter's brush and frequently can be wet-cleaned (as long as they are dried quickly with a hairdryer).

First and foremost, galleries, art consultants, and especially artists should provide care instructions when a piece of textile art is sold. These professionals are equipped to recommend appropriate products for specific installations and should be consulted to help assure the end-user's and specifier's satisfaction and beautiful results.

Performance, Testing, and Flaws

Fabric performance is broadly evaluated according to: *durability* (how well a fabric holds up under the wear and tear of fabrication, installation, and use), *colorfastness* (how well it maintains its color over time), and *flammability* (whether it supports a flame when it is exposed to heat or flame). Common sense and a basic understanding of fabric and fiber properties and their relationships are the best guidelines for using fabric. Education, open-mindedness, and support from suppliers are the best tools for predicting a fabric's performance potential. In addition, copious established tests measure fabric attributes and, theoretically, help predict performance features. Most accepted tests for fabric materials are established (and periodically updated) by the American Society for Testing and Materials (known almost exclusively by its acronym, ASTM) and the American Association of Textile Chemists and Colorists (AATCC). ASTM (www. astm.org) is a nonprofit organization that develops standards through a voluntary consensus system of committees composed of producers, engineers, academics, regulatory bodies, and other stakeholders. (ASTM defines a *standard* as a document that has been developed and established within the consensus principles of the organization and that meets the approval requirements of ASTM procedures and regulations.) Individuals from both the textile and chemical communities form the research committees of AATCC (www.aatcc.org), which has developed standard methods of testing and controlling color and shade qualities of textile items. ASTM publishes thousands of guidelines and standards for textile materials;

AATCC lists about two hundred. A tiny percentage of these are commonly used for interior furnishing materials.

Fabric manufacturers run various ASTM and AATCC tests (or other individually developed tests) for their internal use. The test results for fabric used primarily in residential design are not customarily publicized to consumers but may be available upon request. Fabric that is to be used for contract installation customarily is tested by fabric wholesalers and distributors who publish the results so that specifiers and end-users can evaluate the expected performance of individual fabrics.

No fabric—or other material—is perfect. Complicating performance prediction, testing procedures are far from perfect and many are terribly inconsistent. Users always should evaluate a fabric by reviewing all available data rather than by taking a single test result too seriously.

Reputable fabric suppliers are the best source of information for a fabric's appropriate use. It is of primary concern to fabric distributors that end-users be pleased with the performance of their fabrics over a reasonable period of appropriate use, and that specifiers therefore have confidence in sourcing fabrics from them again and again. Thousands of fabrics and fabric constructions have been on the market for many, many years. The best indicator of a fabric's durability is how well the same or similar fabric has performed in a comparable use. Broad categorizations such as "residential" or "contract" are not always helpful; any reputable supplier should be able to give specific guidelines for a particular fabric's intended use, how it is to be maintained, and where it is *not* appropriate.

Residential furniture manufacturers belong to a trade organization called the American Furniture Manufacturers Association (AFMA) (www. afma4u.org), which organizes various interested parties, including textile manufacturers to form a committee known as the Joint Industry Fabric Committee. This committee has agreed to a large body of industry standards that specify and describe all facets of fabric manufacturing and applicability for residential furniture, including appropriate performance testing and relevant ASTM and AATCC standards. These guidelines are commonly accepted by mills and manufacturers in the residential market and are referred to as the "Joint Industry guidelines." Residential material is sometimes labeled as passing Joint Industry Committee standards; users can ask the supplier about fabrics that are not specifically labeled.

Contract fabric suppliers belong to the trade organization Association for Contract Textiles (ACT) (www. contract-textiles.com). ACT has established voluntary performance guidelines so that a fabric that "meets ACT standards" passes all of the tests prescribed for its end use, which include upholstery, drapery, direct-glue wallcovering, and panel and upholstered wall applications. ACT standards are listed in Table 2 in the Appendix.

This chapter identifies most of the major types of tests and the most common specific standards. Specifiers and users do not need to know the exact test methods or required laboratory conditions, just as most of us do not know the exact requirements for passing annual inspection on our cars. We take our car to a certified inspector who runs the tests and tells us if anything needs improvement; similarly, most of the common tests for

fabrics can be performed by any of a number of certified laboratories (figure 9-1), although some ratings must be obtained by a particular lab or municipality. The only task of the specifier is to ensure that the fabric passes the body of tests it is expected to pass for the intended use. If a project requires specific codes, the project manager or client should inform the specifier that all materials must perform to the required standard. Each specific test method is a several-page-long document that can be obtained from testing laboratories, fabric suppliers, or the organizations mentioned previously.

Durability

Durability is probably the most important performance characteristic to an end-user. It is also the most difficult to predict on a quantitative scale, but common sense and a basic knowledge of fabrics will serve users well in their investigation of a material's durability. Ironically, most quality-control experts, even those who deal with the most strenuous fabric uses in our industry, see very few "wear problems" in the field. Users usually tire of fabric or the fabric becomes excessively soiled long before threads begin to break. Furthermore, most untimely upholstery wear is due to installation problems rather than structural weakness in fabric: Wear occurs first at points where chairs bump into tables or other pieces of furniture or because of insufficient padding between the furniture frame and the fabric. All fabric eventually wears out; such failure is not considered "untimely" if the fabric has had an appropriately useful life.

Hand tests that include crushing, creasing, or pulling across the bias (in the diagonal direction) of a fabric

sample to see how it bounces back are excellent tests for resiliency. Gently rubbing a fabric with a forefinger or a pencil eraser is a good indicator of how easily it will fuzz or pill. Rubbing across any loose floats on a fabric should indicate its propensity for snagging. A large sample can even be draped across a seat or cushion and handled in passing over a few days to see if any unusual concerns arise.

It is important to remember that any fabric can be pulled, snagged, and abraded. Furnishing fabrics are not made to be brushed, picked, or pulled with sharp objects, and it is unfair to expect them to pass these tests. Windows are wonderful inventions that enable us to see through walls; the fact that they can be broken when a brick is thrown at them does not mean that they are unsuitable for their purpose.

Fabric manufacturers spend countless hours and dollars altering fabrics and constructions so that they pass "wear tests" and can be stamped with the data that specifiers have been led to believe are important. Many

beautiful, economical, and well-constructed fabrics are removed from marketing plans because they do not pass a wear test. Larger manufacturers and suppliers spend a great deal of money on more extensive testing in order to promote fabrics as being more "marketable" than those of their smaller competitors. Unfortunately, all of the common wear tests are notoriously inconsistent and may shed little light on a fabric's actual usefulness.

ABRASION

The most popular wear-test method for abrasion resistance in upholstery is the Wyzenbeek test, in which horizontal and vertical strips of the fabric are mounted on a machine that oscillates the strips back and forth against a covered roller (figure 9-2). The abradant that covers the roller may be (and was specified in the ASTM standard 4157 as being) a fine mesh wire screen, although the test has been modified to use #10 cotton duck as an abradant, since upholstery fabrics actually are rubbed by

9 1 Textile testing laboratory.

9-2 On the Wyzenbeek machine the blue-gray strips of fabric are the test specimens held in place by the arms that will be lowered to oscillate over the cotton duck–covered cylinder below.

people's clothing, not by wire screen. The results are measured according to how many *double rubs*, or oscillations back and forth on the machine, the test fabric can endure before it shows thread break or "noticeable wear." ACT classifies 30,000 double rubs with a cotton-duck abradant as "heavy duty," which is generally considered appropriate for contract use, although the organization specifies 15,000 double rubs as a "general contract" rating.

Although Wyzenbeek is currently the most widely known abrasion test and most contract specifiers expect contract upholstery to have a rating of 30,000 double rubs, the test itself is so unreliable and its margin of error so great that its competency as a predictor of actual wear is questionable. The test's historically inconsistent results prompted the appropriate ASTM committee to conduct a study in order to calculate the test's "precision and bias." In 2000 ASTM eliminated the standard relating to

Wyzenbeek (4157) because the committee found that the test's margin of error was too great. Because some of the fabric suppliers on the ASTM committee believed it was important to have the most common abrasion test listed, they voted to rewrite the test method as an ASTM "guide" and will rewrite the standard if the test can be redesigned so that appropriate precision and bias data can be gathered. (As an alternative, when criteria cannot be met for an ASTM standard, the "guide" lists "options" but does not recommend a specific course of action.) The last ASTM standard for Wyzenbeek (as originally written for ASTM in 1982) is listed as an ACT standard, with the specific modification of cotton duck as the abradant. Many professionals believe that the inconsistencies highlighted by the ASTM findings have brought the entire test method into question, but since it is so well known and no better test is apparent, it reigns.

The Martindale and Taber methods work similarly to the Wyzenbeek method. With the Martindale test, the test specimens are round, the abradant is worsted wool, and the abrasion is measured in "cycles." Martindale is popular in Europe, and it is thought to yield better results on wool and worse results on cottons than the Wyzenbeek test. Currently less popular than the previous two, the Taber method places a circle of fabric on a platform and exposes it to the rotation of two abrasive wheels.

All abrasion tests usually consider a fabric to have "failed" when thread break occurs, although some testers prefer to evaluate "noticeable wear." Clearly, noticeable wear is not an absolute and the designation varies from tester to tester. Nonetheless, such a "standard" may be more helpful than that based on thread break, as thread break does not necessarily prevent a fabric from being used. For example, in a finely woven fabric with more than one hundred threads per inch, many yarns can break before the fabric looks "worn"; in a coarse weave, on the other hand, one yarn break can unravel into a huge hole. Synthetic yarns, especially filaments, are much more difficult to break than their natural fibers and spun yarns. Fabrics of these materials do well on abrasion tests, and there is little question as to their performance regarding thread breaks. Nonetheless, they often quickly look worn because their static holds soiling and stains and because their fibers lack natural resilience.

The abradant itself causes variations in the test results. Taber and Martindale abradants are more consistent than the material used for Wyzenbeek, as "#10 cotton duck" simply designates a weight of plain-

weave cotton fabric. The cloth itself may vary dramatically in yarn make-up, thread count, and texture. This creates additional variation in a notoriously variable test. How often the abradant is changed on the machine is thought to be another point of inconsistency.

Abrasion tests can also be used to evaluate pilling. Some find these tests unfair as a pilling measurement, because fuzz and pills from the abradant sometimes wear onto the test specimen and make the test material unsightly through no fault of its own. Two other tests specifically measure pilling: the tumble method and the brush method. Tumbling simulates the wear a fabric will undergo through machine drying, but this is an appropriate test only for fabrics that will undergo tumble-drying abuse, such as institutionally installed drapery, bed-covering fabrics, and hospital cubicle curtains. ACT lists the brush pill test in its upholstery standards, even though most manufacturers specifically stipulate that brushes should not be used to clean such fabrics. The Joint Industry's position is that while pilling is a problem, no test in use accurately predicts pilling. In addition, testing experts find the 1-to-5 rating system for these tests quite subjective. Fabrics that do not pill at all or that pill excessively are easy to discern. Those in the middle (classes 2, 3, and 4) should probably be considered one class.

SLIPPAGE

Yarn slippage is usually corrected by the fabric manufacturer before a fabric is marketed. Seam slippage, however, may cause concern in various applications. Therefore, it is important to evaluate this propensity. Labs can conduct such tests, but fabrics also can be examined by hand for signs of slippage. When two pieces of fabric are seamed and then pulled apart, or when a fabric is stretched across a frame and mechanically held in place, the threads of the fabric should stay in the position they are designed to hold and not pull away from the seam or bunch together. Slippage is unsightly and causes increased wear, as the fabric is particularly vulnerable at points where threads are pulled apart.

TENSILE AND BREAK STRENGTH

Important for upholstery and upholstered wall application, tests for tensile and break strength measure the weight that can be exerted to pull fabric apart under pressure before it tears. This is sometimes called a "grab" test. The tests are run for both the warp and fill directions; they can also measure the amount of elongation that occurs before a break. ACT standards name two different specifications for seating and wall applications but these standards apply to the same test process.

COLORFASTNESS

Colorfastness is evaluated according to a fabric's *lightfastness* and *crocking*. Measuring how long a fabric takes to fade by exposing it to a normal light source is impractical, so Fade-Ometer machines were invented to speed up the fading process so that a material or dyestuff's sensitivity to various light sources could be evaluated efficiently. After a sample is exposed to the machine's light source for a specified length of time, the tester compares the original sample and the sample that has been faded by the machine to a *gray scale*. The gray scale is a preestablished, printed gradation showing various shades of gray from lightest to black. The fabric is evaluated on a scale from 1 to 5 according to how many values on the gray scale separate the two samples; 5 indicates no color loss, and 1 indicates severe color loss. Standards for using these machines are established by AATCC because they relate to color-consistency issues. Upholstery fabric is expected to receive a class 4 rating (class 5 is best) after 40 hours of exposure on a Fade-Ometer. Drapery should pass 60 hours, and wallcovering, 40 (ACT standard) or 60 (the practice of many manufacturers). Carpet should withstand 60 to 80 hours.

Two different types of Fade-Ometers currently are in use: the carbon arc and the xenon arc. Joint Industry and ACT standards use them interchangeably, as do many labs. Authorities' opinions differ as to which is more stringent. Xenon is the newer test; it is gaining popularity because it is less time-consuming to run and the equipment is less expensive.

Crocking is measured under both wet and dry conditions; that is, a wet or dry plain cotton cloth is pressed against a test specimen of the fabric (figures 9-3, 9-4). Dry crocking passing results are expected to be superior (class 4 of 5) to wet crocking results (class 3 of 5). For a quick evaluation, such as when comparing fabrics that are likely to be exposed to water in installation, such as seating in a beach house, hand tests can simulate the effects of mechanized tests.

DRAPERY

The durability tests usually run on drapery fabrics are for seam slippage. Crocking may be evaluated; lightfastness is always considered. For any fabric that raises concern, and especially for those not designed and marketed for use as drapery, it is wise

9-3, 9-4 For a crocking test, the fabric test specimens are sandwiched under pressure with undyed material. The amount of color transfered from the test specimen to the undyed material will be observed.

to make up a drapery panel in the intended construction to check for shrinking, elongation, or sagging. The test panel can, of course, also be used for cleaning tests. Any such evaluation must be made with a minimum of 2 or 3 yards (meters) of fabric, and under the same humidity, light, and temperature conditions that will be present in the actual installation.

WALLCOVERING

Wallcoverings are not often tested for abrasion per se but woven fabric wallcoverings are tested for seam slippage, breaking, and tensile strength if they are to be pulled and stretched over a frame in installation. Tests for colorfastness including wet and dry crocking are also important for wallcoverings, as are all of the installation approval tests discussed in the section on wallcoverings in chapter 8.

Flammability

Fire retardance or flame resistance can be measured in several ways in laboratory tests. (Hand tests are inappropriate for determining a fabric's flame resistant properties.) A

specific length of fabric can be set on fire and then clocked to see how long it takes to self-extinguish, or how far the flame has spread after an established number of seconds or how long the "afterglow" remains can be measured. Smoke density can be rated, and the fumes released when the material burns can be evaluated for their toxicity.

ASTM and the National Fire Protection Association (NFPA) (www. nfpa.org) have established flammability tests. These tests are often written into building codes for municipalities, and some governments have created their own variations on these codes for their buildings. The codes may apply to the government buildings in a city (Port Authority of New York and New Jersey, for example), for all commercial buildings (the "City of Boston" code), or to residential buildings (installation of smoke detectors is commonly the most stringent residential requirement).

In addition, corporations may stipulate codes to which all their facilities must comply. Hotel and hospital chains and large corporations, for example, may expect all of their fixtures

to meet the strictest requirements of any locale in which they operate.

Because of the legal issues that arise in the event of a building fire, anyone specifying materials for interiors should be clear about the requirements and, again, look to reputable suppliers for appropriate test data and guidance in appropriate use. Fabric suppliers at all levels strive to make their goods safe and to offer beautiful products that comply with all codes. This should not be taken to mean that fabrics that pass the codes do not burn, nor that all fabrics marketed as F.R. pass all fire codes. Rather, materials are tested according to established test procedures that measure some facet of quantifiable fire-related properties.

The most expensive and onerous flammability test is commonly called the "tunnel test." In this test, established as ASTM E 84, 9 yards of fabric are mounted on a *substrate* (a foundation layer that supports the test material) and inserted into a tunnel; a fire is set inside the tunnel below the substrate. The material is rated according to the amount of flame spread and the smoke density that develops. The score achieved is

compared to a standard wood rating that would have a flame-spread index of 100 over the same distance burned. (The material tested could have a score less than, equal to, or greater than that of the wood.) The material must have a score of below 25 in the flame-spread index portion of the test to receive a class A (or class 1) rating. Most major building codes allow a maximum smoke-developed rating of 450 irrespective of the flame spread index.

Local building-code requirements vary regarding which materials must pass the tunnel test, as well as regarding which substrate should be used in the test. The tunnel test was designed for interior finish materials, which means anything applied to the walls and ceilings (including partitions). It does not apply to upholstery fabrics, but many of the large fabric suppliers run the test for upholstery fabric as a belt-and-suspenders precaution, especially because local fire marshals may erroneously ask for this test. The substrate should be chosen according to how the material will be used, but this is also an area of disagreement among fabric suppliers, furniture manufacturers, and code-compliance experts. Materials adhered to asbestos board, as has been customary for all fabrics for many years, rarely fail the test. More current thinking (and endorsed in ACT standards) is that fabrics intended for wrapped-panel or upholstered-wall application should be tested "unadhered" or "loose laid," usually over an open mesh screen. No version of the tunnel test is an automatic pass; nor is the test extremely difficult to pass. It is expensive and time-consuming to perform.

Floorcoverings are classified as interior floor finish. They have their own test: ASTM E 648, or the Flooring Radiant Panel Test.

Panel fabrics must undergo the "UL" test. Underwriters' Laboratories (www.ul.com) is an independent, nonprofit product-safety–testing and certification organization. Because panel systems are electrified, they must undergo UL testing; some manufacturers insist that each panel configuration be tested separately with any fabric that is intended to be used. If the manufacturer (or an end-user) requires this, a special panel must be built and upholstered with the desired fabric and then submitted to UL and tested under its procedures. This is rarely undertaken except for very large installations because of the expense in building the test panel, the UL backlog and cost, and the unpredictability of the test. Most fabric suppliers take the position that fabrics that pass the ASTM E 84 tunnel test unadhered are appropriate for panel use.

The code requirements for drapery application in commercial interiors are usually more stringent. The difficult NFPA 701, or "vertical test," is usually required. The test is a pass/fail rating. The small-scale or more difficult large-scale version of 701 may be applicable in different instances. The material may be required to pass either version after a specified number of washings or dry cleanings; this is especially critical for material that has been aftertreated for flame retardance.

The "City of Boston" code, a version of the 701 small-scale test, generally is considered to be one of the most difficult to pass. Fabrics that pass the 701 or the Boston code are usually made of fibers that are chemically modified to be flame retardant, such as Avora polyester or modacrylic (figure 9-5). Certain fabrics can be aftertreated to pass these codes, depending upon fiber content,

weight, and weave. Some upholstery fabrics may pass after a flame-retardant backing is applied.

Upholstery codes are generally the least stringent. California (CA) Bulletin 117 is the only ACT standard, and the Joint Industry Committee suggests UFAC, which is a cigarette burn test. Most upholstery fabrics easily pass these tests.

The difficult California (CA) Bulletin 133 test is much more stringent but is required only in limited installations. It is similar to UL testing in that it is designed to test a composite material rather than a fabric sample. CA Bulletin 133 tests the ability for flame to pass through the upholstery fabric and reach the interior foam material, which is usually very flammable and quite toxic when it burns. The test can be passed easily with the use of flame-resistant foam and cushion material, but it is more expensive, harder, and less comfortable than standard foam. To pass this test when standard foam is used, the fabric must be backed with (laminated to) an inflammable barrier material that prevents the fire from passing through to the cushion interior, or the barrier must be separately upholstered and the "decorative" material applied over it.

Flaws and Defects

Fabric manufacturing is an imperfect process, and flaws and defects occur in the course of making fabric. A *flaw* or *defect* is any characteristic of a piece of fabric that is visibly inconsistent with the original sample offered by the supplier and upon which the decision to purchase it was made.

Some flaws that occur in manufacturing can be mended, and this is usually the last step in fabric manufacturing before final inspection (fig-

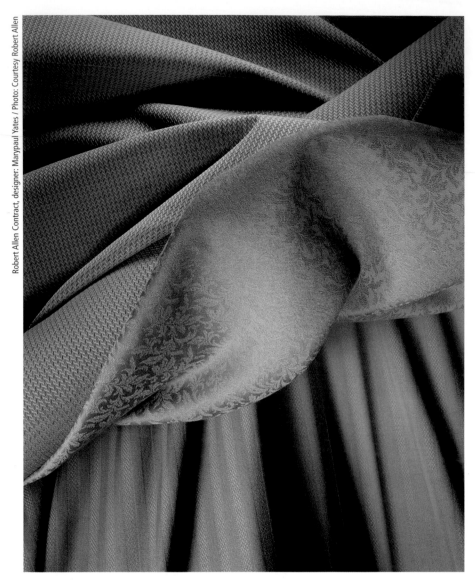

9-5 These fabrics are a blend of worsted wool and modacrylic that, when properly finished, pass the City of Boston fire code.

9-6 Inspectors reviewing finished fabric for flaws before it is shipped from the mill to customers.

ure 9-6). In fabrics that receive finishing processes, certain weaving flaws or yarn inconsistencies may be concealed in the finishing. (Others that were not visible may become evident with finishing. Finishing itself, however, can cause certain kinds of flaws.)

Users of fabric are expected to accept and work around infrequent and small flaws; if defects are continuous, too large, or frequent, the material becomes unusable and is classified as second quality, or *seconds*. The type and quantity of flaws tolerated vary depending upon the market and the type of fabric. Mass production does not necessarily result in fewer flaws than handmade goods, but certain effects may be achievable only in smaller lots or with high yarn inconsistencies, for example. Nonetheless, never before has the market enjoyed a wider range of higher quality products than is available today. There are many reasons for this—including the global economy and ease of transportation—but it is largely due to improved technology that allows equipment to spin and make yarn, weave, knit, dye, and finish with few flaws and excellent lot-to-lot consistency. All fabrics should be evaluated for "consistent inconsistencies." Any slub, nub, crease, streak, or other mark that occurs regularly throughout the supplier's standard for the goods is not a flaw; rather, it is part of the inherent character of the fabric.

Fabric is shipped in *rolls* or *bolts*, which are appropriate quantities of the material for handling by the fabric producer and the user. (The manufactured lot size may be cut into several bolts for ease of handling.) Upholstery and wallcovering fabrics are usually in rolls of about 60 yards (55 m); longer yardage would be very heavy. Lighter-weight fabrics like

drapery can come in larger lengths of 70–80 yards (60–70 m). Wholesalers buy fabric by the bolt and then sell to-the-trade only—to interior designers, architects, fabricators, and end-users—in the exact cut lengths the users require. (Wholesalers may require a minimum purchase from these customers, but usually the minimum is not larger than a yard.)

Within each roll, one defect is allowed per 10 yards of length. Flaws are marked with a brightly colored thread tied into the selvedge at the point where the flaw occurs. Sometimes a manufacturer will ship a roll with more than the allowed number of flaws but will deduct the money due for the length, which is called an *allowance*. Prior approval usually is obtained from the customer before a fabric is shipped with over-the-maximum allowable flaws, even with an allowance.

The most common visual flaw in woven fabrics appears as a horizontal band across the goods and is called a *bar mark* (or *bar, barr,* or *barré*). Bars may be caused by variation in the size, texture, or color of the filling yarn in the flawed area, or by incorrect placement of yarns in that section. A missing filling yarn across the entire or partial width is a *skip pick.*

Streaks in the warp direction are usually *reed marks,* which are caused by a bent or damaged reed (the part of the loom that acts like a comb, holding the warp yarns in place as the filling is inserted; see figure 4-1). Obviously, vertical streaks can also be caused by inconsistencies in yarn size, texture, or color.

Broken warp ends occur during the weaving process but can usually be mended before the fabric leaves the factory. Occasionally, several yarns break, a hole is created, or weaving becomes so inconsistent in the spot

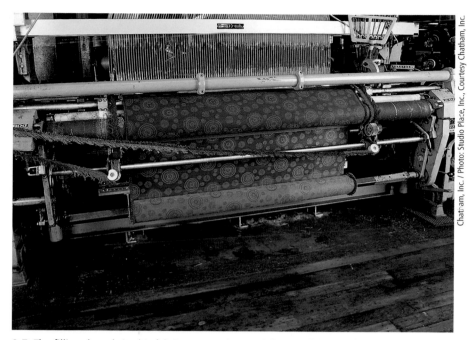

9-7 The filling threads in this fabric are running straight, parallel to the front beam of the loom. If the selvedges are too tight the fabric can actually appear distorted even while it is on the loom.

around the broken end that it cannot be mended and must be tagged.

A vertical yarn that does not interlace according to its normal pattern is called a *warp float,* and a similarly "unwoven" fill yarn is called a *mispick.* Both mispicks and warp floats usually can be mended.

Because yarn is not a continuous material but is also made in lots, most fabrics are woven of yarn with occasional knots. When the knots show up in the fabric, they are usually pushed to the back of the fabric in mending or are untied and darned into the cloth. Designers and consumers often ask if the back of a particular fabric can be used as the face; in these cases it is important to remember that fabrics are inspected only on the face. Extra fabric should be ordered and a careful inspection done for other flaws, especially knots. Heavy yarn in a specific area is called a *slub,* and a *slug* is loose yarn that loops in and out of the fabric. Conspicuous slubs and slugs are usually mended, again by pulling the

loose or defective threads to the back of the cloth.

The filling threads of fabric are also not always perfectly straight across (figure 9-7). In the manufacturing or finishing process, the goods can be distorted so that the filling thread runs diagonally rather than horizontally from the left to the right selvedge. This is called *skewed* or *off-grain* (figure 9-8). Skew is measured by placing a T square across the fabric at a particular filling thread and square with the left selvedge. (The fabric should lie flat with no tension.) Measurement is made along the right selvedge between the T square and the point where the same filling yarn meets that selvedge. The maximum acceptable amount of skew is 1 inch.

Similar to skewing, *bowing* is an arced deviation from the horizontal in which the weft is higher or lower at the center of the goods than it is at the selvedges. Bowing is measured similarly to skewing, and 1/2 inch is the maximum allowable bow.

If bowing or skewing is of concern,

at least three measurements should be taken along the length and then averaged. Poor finishing often causes bowing and skewing, but these flaws often can be corrected by refinishing. Bowing is often caused during weaving, as a variation of the problem called *tight* or *loose selvedges*. Any variation on these horizontal-distortion problems may be correctable in fabrication (especially upholstery), but can be a serious problem if the condition extends several inches (centimeters) in from the selvedges, especially if the pattern is a stripe or

9-8 Skewing occurs when filling threads of fabric do not lie straight across.

9-9 Horizontal distortion in fabric can be a serious problem, because even small geometric effects such as this pattern follow the lines of the furniture silhouette.

has an obvious horizontal pattern (figure 9-9).

To form a roll, or bolt, a manufacturer may roll smaller pieces together. These pieces are not usually shorter than 20 yards (18 m) long, however. Wholesalers stock these bolts of fabric and cut them as they receive orders. Therefore, wholesalers may have the same item in stock in a wide variety of lengths and with certain flaws at any interval. These lengths may be from the same or different dye lots, so it is important to stipulate when ordering yardage from a wholesaler the minimum cut lengths that are acceptable and whether they must be from the same dye lot. Reputable wholesalers will make an effort to cut ordered lengths so that flaws are at inconsequential spots (for example, not exactly in the center of a small cut). Specific information should be furnished on each purchase order so that the wholesaler can accommodate the buyer. For example, a drapery order might be marked "Ten 9-foot panels required. Must be one dye lot." If the fabric is to be used in two different rooms, however, it could be marked "If one dye lot not available, will accept 4 and 6 panels from two lots. Please submit CFAs before shipping."

Most wholesalers will provide *cuttings for approval*, or *CFAs*. This means that the customer asks for a certain quantity to be placed on reserve, usually for about two weeks. The wholesaler sends out a swatch (or swatches) from the actual stock being held for the customer to evaluate. If the color is suitable, the customer calls the wholesaler and gives the go-ahead to ship the order. (It is useless to order a CFA without reserving the yardage, since the stock on hand could be shipped to another customer at any moment and the stock replenished with a different dye lot.)

CFAs are necessary because, just as fabric cannot be made without defects, it cannot be made over and over again in exactly same color! As discussed in the chapter on color application, fabric (or its components) is dyed in lot sizes of 100 yards (meters) or more. Every effort is made to maintain consistency from lot to lot, but each shipment of a particular fabric may vary slightly. No absolute measurement of dye lot variation is possible, but industry agreement on the standard light sources used for evaluation minimizes the variation. At the outset of a given project, a manufacturer and wholesaler will usually come to an understanding regarding tolerance of shade variation, especially if evaluation practices are different from those considered standard within the industry segment.

Dyers usually check colors under a Macbeth SpectraLight (see figure 6-2). Cool-white fluorescent or daylight is the light source chosen by most dyers, but daylight, incandescent, halogen, or some other light source may be specified by particular customers for a given project and for appropriate quantities.

Dirt or grease spots that are evident after finishing are flaws. *Fly* is yarn contamination that is trapped in the fabric during construction, and *burrs* can be part of the yarn. Both can be picked out in mending if they are not too prevalent.

The Fabric Industry

Soon after Samuel Slater had smuggled precious textile-machinery designs from England into America in the late eighteenth century, Eli Whitney invented the cotton gin. Thus began the mechanization and industrialization of the American textile industry. In the first few years of the nineteenth century in Lyon, France, Joseph J. M. Jacquard invented a loom, still in use today and now called by his name, in which the woven pattern is indicated by a set of punched cards and mechanically controlled. The jacquard loom allowed elaborate, intricate patterns to be woven with much less manpower. A few years later, the first practical American power loom was built. Textile mills—where all operations, from the opening of cotton bales to the finishing of the woven cloth, were mechanized and under one roof—came into existence. By 1860 more people were employed in textile mills than in any other American industry.

Today, the processes of textile manufacture are still very much the same as they have always been, although technological advances have increased their speed, efficiency, and cleanliness. Cloth, one of man's basic needs, must be woven or knitted from yarn that is spun from fiber. In contemporary industry these processes are executed by diverse companies. Some textile organizations today own many huge, modern manufacturing plants with efficient and sophisticated machinery, while others have only a few employees and may not manufacture at all. Some American mills that have made very few changes in the past fifty years continue to manufacture fabric.

Textiles are produced in almost every country, in some cases for that country's exclusive consumption but in most cases for export around the world. Some mills abroad are more technologically advanced than American mills, but in many countries fabric is handwoven on simple looms as it was centuries ago.

Designers' Sources

In the United States, most of the companies that call directly on the interior design community to sell fabric by the yard (some of whom are familiar to retail customers) do not actually manufacture fabric at all. These *wholesaler*s, or *jobbers* (as they are known within the trade), buy a wide range of fabric from many sources, initiating the design or color of some the items they purchase and selecting many items that are offered by mills. Brunschwig & Fils, Clarence House, Robert Allen, Schumacher—the showrooms that fill design-center buildings in major American cities and that advertise their fabrics in design magazines are some of these wholesalers. A wholesaler buys fabric from a mill, adopts the fabric into its line, samples it to customers, and continues to resell the same style for many years. The style is often distributed exclusively by a particular wholesaler and is known to the marketplace by that wholesaler's name, regardless of where it is purchased or who originally designed it. By coordinating diversely sourced styles, colors, and constructions, the wholesaler offers a broad and useful range of fabrics presented in an appealing package for designers. While mills are primarily focused on running factories by making fabric, wholesalers have extensive customer service and sales staffs in order to provide effective service to designers and purchasers. The name *wholesaler* or *jobber* derives from their primary commercial function: they buy the fabric in their collections in the larger quantities that mills need to produce and then cut it and resell it to their customers in the smaller cut sizes that are appropriate for interior use on individual sofas, chairs, or drapery treatments. In the press—and even within their own staffs—such companies are occasionally referred to as "mills" in a genuine attempt to simplify and clarify their function; many consumers or designers would recognize the term *mill* as a company that sells fabric, whereas *wholesaler* refers to companies of almost any industry. In fact, mills are the fabric manufacturers that supply these companies. Although mills specialize in fabrics for interiors, they do not advertise or sell directly to designers and consumers. Consequently, their names are largely unfamiliar even to the most experienced designers and workrooms.

American wholesalers tend to specialize in either decorative (residential) or contract (nonresidential) products, although many dedicate large portions of their businesses to serving their secondary market. Most wholesalers specialize in upholstery fabric (or fabric that can be used for upholstery and drapery, wallcovering, or panel applications). Other wholesalers specialize in wallcoverings, although some also have upholstery-fabric lines to complement their offerings.

Wholesalers provide their customers with samples of the fabrics they run in various ways. They may send out samples of their new introductions to their established customers, or their salespeople may call on those designers in their offices and supply only the samples that the customers specifically request. Still other customers may make their own trips

10-1 Small samples called three-by-threes or cuttings serve as reference for color and texture of contract fabrics.

10-2 Fabrics are sampled in stack books and other binders for customers' use.

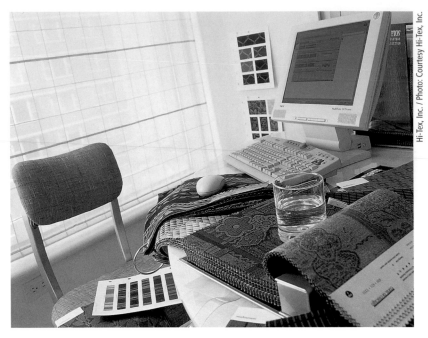

to the showrooms to request only the samples they need. The smallest samples, called *cuttings* (or *three-by-threes* because they are approximately 3 inches square) are usually provided at no charge, but they are so small that they best serve as a quick guide to available colors or as a reminder of the item (figure 10-1). Larger *memo samples* are available upon request, though decorative suppliers charge designers if memos are not returned within thirty days. Contract wholesalers do not customarily charge for memos. Memo samples are usually at least 8 inches by 10 inches (20 by 25 cm), but they may be much larger if size is necessary to see the coloration, effect, or pattern. Fabrics may also be sampled in *stack books* or other binders (figure 10-2); some even feature removable and replaceable insert swatches.

The decorative wholesalers are sometimes known as "uptown" sources because their showrooms are located in the "uptown" section of New York's Manhattan. The "downtown" houses refer to converters and small jobbers that sell to retailers, fabricators, and even the uptown whole-salers rather than to interior designers. Uptown wholesalers that call on interior designers have showrooms in most major cities, but many were originally based in New York.

When a showroom features fabrics credited to a name other than its own, the showroom is acting as a distributor for other wholesale lines. For example, Donghia represents the Rodolph and Pollack lines in some of its showrooms. Brunschwig (an American company) may label fabrics that it distributes from Pierre Frey (a European wholesaler) because Pierre Frey's name is known and commands a following in its own right.

Furniture manufacturers offer standard fabrics to customers as a part of their furniture line, and it is always simplest and the best value to buy (or specify) from within such an offering. Furniture manufacturers buy from the same mills as the wholesalers, and within similar price points both will run similar qualities, although frequently in different patterns or colors. Especially in the middle price ranges, the exact same fabrics are often carried by both a wholesaler and one or more furniture manufacturers. Nonetheless, although some furniture manufacturers offer thousands of choices, many more choices are available through all the wholesalers. If the furniture manufacturer does not have a suitable choice, the wholesalers are an interior designer's next stop. Manufacturers also tend to concentrate their offerings in the lower-to-middle price ranges; wholesalers' offerings usually command middle to higher prices. Furniture manufacturers do not usually sell their fabrics for *cut yardage* (a specific length of fabric that a purchaser sends to another manufacturer or workroom); their distribution applies only to the use of that particular fabric on their own furniture (although as an accomodation, manufacturers may sell extra yardage with purchased furniture for use as a drapery, for example).

This is only the beginning of such overlap and confusion! Especially in the contract and high-end decorative markets, some furniture manufactures have full-fledged fabric wholesaling businesses (Knoll, R. Jones, and Donghia are examples), and although their names are best known

because of their furniture lines, they also function as fabric wholesalers. Some fabric wholesalers manufacture their own furniture (Kravet and Brunschwig, for example). A handful of wholesalers (Scalamandré is one) even own a few looms and actually weave a portion of the fabrics they distribute. Some furniture manufacturers buy from wholesalers rather than mills so that they can buy the fabric in cut yardage lengths as needed and take advantage of the wholesaler's marketing and promotional efforts for the fabric.

Although it is useful and interesting for users to understand that a fabric can follow many paths to reach the market, after all is considered, a textile company is usually labeled by the function for which it is primarily known to its suppliers and customers.

All are motivated to bring the best product to their customers in the most manageable way possible.

Fabric Manufacture

Fabric-manufacturing steps are thoroughly discussed in other chapters. This overview outlines the kinds of companies that usually perform the specific functions that together yield finished fabric.

As previously noted, fabric is usually made from yarn, which is, in turn, made from either natural or man-made fiber. The natural fibers cotton and linen are produced by plants; wool and silk are produced by animals. Man-made synthetic fibers are made by chemical processes; nylon, polyester, and acetate are examples. These fibers are produced by

large chemical companies such as DuPont, Hoechst-Celanese, and BASF. These companies produce no fabric but specialize in the production of certain types of fiber, which they sell to yarn or fabric manufacturers in the raw fiber state or already processed into yarn (figure 10-3).

Yarn producers and *spinners* buy natural, man-made, or synthetic fibers and extrude, spin, or otherwise process them into yarns of different sizes and characters, which fabric manufacturers then weave or knit to produce a fabric. Dixie Yarns and Uniblend are large yarn producers; most company names are unfamiliar to specifiers and consumers.

As noted earlier in this chapter, companies that own the necessary equipment and use it to produce fabric are called *mills*. Mills rarely pro-

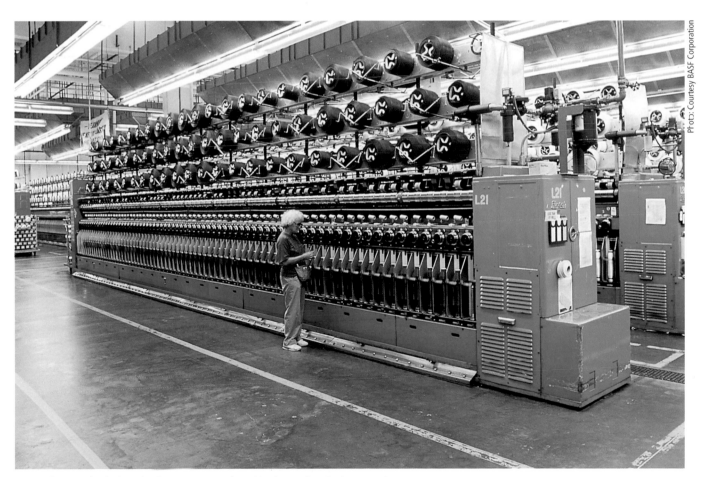

10-3 Fibers and solution-dyed yarns are produced by large chemical companies.

10-4 Crewel embroidery produced in India.

duce fiber but may spin their own yarn, which is woven or knitted to produce a fabric. Most fabrics for interior furnishings (except prints) are constructed of already-dyed yarns; thus, once woven or knitted the yarn-dyed cloth is already colored in a stripe, plaid, multicolor jacquard, or tonal plain fabric. The dyeing of such component yarns is usually handled by the weaver/knitter but is actually done on commission by an independent dye house.

The greige goods used for print bases are often woven by greige mills, larger mills that specialize in such fabrics. The printing is handled by a wholesaler or converter but is actually executed by an independent print plant, most of which do not offer their own lines but provide commission printing to many customers. Piece-dyed wovens may be woven, dyed, and finished in the same mill, or all or some of the processes may be commissioned.

Finishing requires a multitude of processes and a vast assortment of machinery. A vertical mill may handle certain operations, but many finishes, including treatments for stain-repellence and special backings, are applied by commission specialists as required.

Mills that function on more than one of these manufacturing levels— that is, mills that produce yarn, greige goods, and finished fabric— are called *vertical*, or *vertically integrated* operations. The largest and best-known American mills—Burlington, Springs, Milliken—are vertical but primarily produce for the domestics, apparel, and industrial markets. These large mills' main involvement in the interior-furnishings market is the production of greige goods for converters.

Although much smaller than Milliken or Springs, vertical mills like Guilford of Maine are specialists in fabrics for interior furnishings and are prominent suppliers to the contract market. Today these mills handle diverse materials, but their operations grew out of wool manufacturing. Because wool must be finished in a multistep process after it is woven, woolen and worsted mills traditionally handled several steps inside a single factory.

Converters buys greige goods and, according to their own specifications, "convert" them into finished fabric by having them dyed, printed, and finished on commission by a third company. Because a mill owns specific equipment, which must be kept in operation to maintain profitability, it maintains an element of control. Nonetheless, the fact that converters do not own any equipment allows broad flexibility in the types of fabric they can pioneer. Although they may be under contract with their suppliers, if converters have an idea for a new fabric that they believe they can sell, they have the option of finding a new resource to produce the item without compromising their existing converting operation. In this respect, true converters tend to run differently from both mills and wholesalers: Any company that calls on designers and consumers constantly needs to come out with new products, but because converters do not own equip-

ment, they are not restricted to specific manufacturing constraints as are most mills. Most printed fabric is produced by converters. These companies usually fit between mills and wholesalers, though the largest wholesalers convert many of their own fabrics.

Worldwide Textile Sourcing

In any to-the-trade showroom, the fabrics that are labeled with country of origin represent an astonishing range of countries, and a vast percentage are not American-made. (Suppliers can provide country-of-origin information for goods that are not labeled.) There are few American mills compared to the size of the U.S. market, and few new mills have been founded in many decades. Manufacturing has become an unpopular commercial sector that is not favored by our financial markets or tax structure.

Computer technology allows efficient weaving of diverse pattern within existing constructions, which has allowed American jacquard weavers to respond to the desires of interior designers and consumers. Weaving and large-scale fiber production are the centerpieces of contemporary American textile manufacturing. Spinning, yarn twisting, finishing, dyeing, specialty processes, and indeed the manufacturing of textile machinery itself are rare in the American manufacturing landscape.

Although many European mills are quite large and operate with similar structures to the American upholstery mills, Europe maintains a tradition of small manufacturing facilities and a craftsmanlike approach to small-run manufacturing that lends itself to the vast range of simi-

10-5 Silk fabrics woven in Thailand.

lar-but-distinct products marketed for American interiors. American and European weavers use the same kinds of looms (mostly European-produced) and theoretically can produce the same fabrics, but smaller European operations are more willing to run their plants more slowly and dye special colors, run shorter warps, and handle difficult components. This flexibility is not without a cost—lower efficiency means higher prices, and European labor and overhead are usually higher than comparable American costs. For these reasons, and because of the specialty fabrics long produced in specific areas (Scottish wools, Italian prints, and French silks) European decorative and contract fabrics are highly valued in America.

China, Korea, and Japan produce and export large volumes of textiles to the United States. Most of these goods are not the short-run, specialized products favored by the American interiors market, although print bases and certain novelty greige items find their way into interior uses. Countries ranging from India to Thailand to New Zealand and Brazil manufacture and export specialty textiles to the U.S. interior furnishings market. Indian embroi-

10-6 A textile designer edits a design for assignment of weaves in the cloth.

deries (figure 10-4) and Thai silks (figure 10-5) that were once rare and exotic are available from many traditional sources. The suppliers from any country that most readily secure and maintain a loyal American customer base are European-style operations that afford flexibility of color and pattern so that materials can be customized for numerous American wholesalers and distributors while maintaining commercial consistency. American weavers tend to address the broadest segment of the market with fabrics that will make most customers happy most of the time. A few American manufacturers pursue an old-world approach, undertaking niche manufacturing of innovative fabric-making.

The Role of Fabric Designers

Fabrics are largely used to decorate or embellish, whether the object being embellished is a person, a sofa, or a window. Textile design professionals guide the development of desirable appearance and hand in fabrics that are commercially produced (figure 10-6).

The manufacturing facilities of most American textile mills are located in small towns in the North and Southeast. Many are headquartered or have marketing departments in New York City. The design staffs may be located either at the mill itself or in New York City. Most carpet manufacturers' design staffs are at their plants in the Southeast. Although many designers live and work in places other than New York City, the towns where mills are located are usually home to only one mill, so New York is one of the few spots where textile designers for multiple companies are based. The size of the mill's design staff depends on the company's size, but it usually consists of one design director, a design head for each division, and one or more artists and assistants.

The design staffs of the largest wholesalers are quite big. Wholesalers regularly must meet with mills and potential suppliers to familiarize themselves with available cloths, designs, and styles. Because the mills are actually making the samples and strike-offs for many wholesalers and furniture manufacturers, the wholesalers' staffs are busy tracking the samples and motivating the suppliers to prioritize their requests. The designers for wholesalers also work with customers, both to introduce new products to the marketplace and to develop custom patterns and colorations that interior designers want to use for their large or specialized projects.

Wholesalers' design staffs focus on certain priorities: They continually must search the mills to stay abreast of the available materials, cloths, and pricing. They must be ready to adopt the most appropriate goods into their lines and initiate developments that appropriate sources could produce to complement their lines (figure 10-7).

Mill designers focus their efforts differently. Mills are factories that must run constantly and efficiently to be profitable. The designers for mills must generate an ongoing flow of development ideas that will increase the variety of the mill's offerings but work well within the manufacturing structure. Most American mills today produce jacquard wovens, which means that the designers develop or buy artwork for the surface pattern of fabrics, assign or invent weaves that will achieve the desired effects, and specify sample weaving to create trials to see actual samples and colorways of the new designs.

For jacquard designs, artwork is usually scanned into sophisticated computer systems that can handle the once-tedious task of assigning each and every thread crossing in the fabric to a specific weave. These directions often can go directly from the editing stage to the electronic

jacquard head, but several revisions may be necessary for complicated patterns. Although they may not be obvious on a computer screen, unsightly spots where the weaves in a pattern join are often apparent to the eye. The design personnel who handle the computer systems are specialists whose efforts are dedicated to this specific task; thus, they are not usually involved in other design functions (such as deciding which patterns to pursue, developing the overall line, or coloring).

Although the ability to initiate new ideas always depends on how detailed a designer's knowledge of the product is, "technical" knowledge of fabrication is absolutely imperative at the manufacturing level. A wholesaler with an in-depth understanding of textile construction can certainly use such expertise, but many wholesalers who have no ability to develop fabrics from design conception still offer beautiful, well-integrated lines that are assembled by savvy merchants with excellent taste in choosing products from the mill. Some of the small, prestigious wholesalers do not hire designers at all. Most of their lines are styled and assembled by the company owners, for whom putting together the product line was probably the most enjoyable aspect of starting the business.

Fabric companies that produce only prints hire artists to actually paint the designs that will be printed onto the fabric (figures 10-8, 10-9). Most of these converters have at least one stylist or design director to coordinate the entire line development and studio effort, and they may supplement the studio's output with freelance designers who develop painted artwork for various companies. Print design is a specialty unto itself and demands a knowledge dif-

ferent from that required for woven-fabric development.

The textile industry offers rewarding careers for many professionals in spite of its small size. American interior-design and architectural firms number in the tens of thousands; by comparison, interior-furnishing–oriented textile firms with American-based designers barely number in the hundreds. The talent and effort of textile designers are critical to the ongoing development of beautiful, innovative cloths in what is at best a small industry and design specialty.

Custom Services

Although the range of fabrics available today is broader than it has ever been, the demand for custom fabric services is also at a peak. Most wholesalers have personnel available to help customers with these requests; the large contract wholesalers have large staffs dedicated to performing these tasks.

Custom development is far more prevalent for contract application than in residential use because the large quantities of materials that are used in a single installation warrant

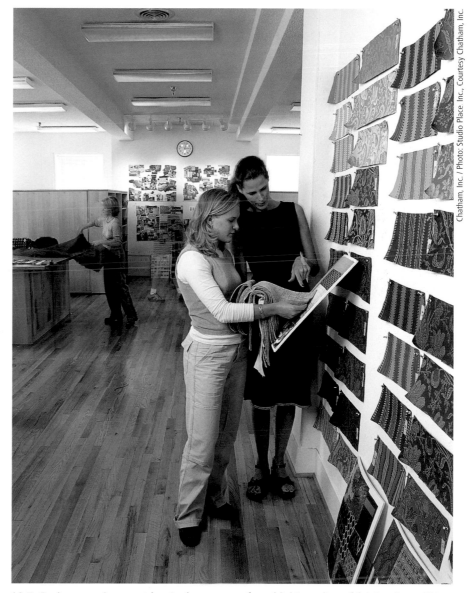

10-7 Designers review swatches in the process of establishing a line of fabrics that will be produced by a mill.

10-8 A print designer paints a design that will later be produced on fabric.

10-9 Designers working in a studio.

wholesalers and converters, especially those that are large suppliers to the hospitality market (where this practice is prevalent), dedicate resources to this undertaking. This practice surely should be discouraged if the integrity of both designers and fabric suppliers is to remain high. Moreover, many fabrics are copyright-protected and the companies that developed the fabrics—and the specifications—frequently take aggressive legal action to protect their investments.

Minimum yardage requirements for a custom development can vary dramatically from fabric to fabric and between resources, although any change from the standard offering rarely is possible for under one piece (approximately 60 yards or 55 meters). The most important allowance to be made in any custom development is for time. Fabric does not grow on trees, and anything special that requires making swatches, adjustments, and countersamples—plus the ordering the yardage itself—takes more time to produce than is required for running items.

Wholesalers sometimes charge for the special trials that are needed for a custom development, especially if they incur a direct cost for the development, but the cost is often refundable against an order for the item developed. Artwork for a print design is much more expensive than a lab dip for a special piece-dye color, for example, and costs vary accordingly. Of course, for very large customers or in certain cases such fees may be waived. While a direct charge may not be incurred, however, custom developments are a labor-intensive aspect of making fabric. The more samples a mill must make proportionate to the yardage it weaves, the more it must charge for

the special sampling and production effort. Most custom fabric development entails special coloration of existing fabrics (figures 10-10, 10-11). Special patterns may be developed for applications that can utilize large quantities of a single cloth, such as prints used in hotel guest rooms and cubicle curtains for hospital rooms. Moreover, most of the Wilton and Axminster rugs produced for either hospitality or residential application

are custom products because Wiltons and Axminsters must be made in small quantities and are quite expensive.

Although it is sometimes legitimate to request the development of a less expensive version of an existing fabric, this particular form of "custom development" frequently results in a barely disguised *knock-off* of a fabric that has already been specified for a large project. Some of the largest

its fabrics. The industry is best served overall by responsible use of these development resources.

Although most wholesalers and mills are well equipped to willingly handle appropriate custom projects, designers who submit well-thought-out, clear, serious requests are much more likely to receive prompt and effective results. Too often requests for customs are cavalier, off-hand queries from designers who have not thought out the project all the way through and who will not actually be able to use the custom result. If the fabric is too expensive or the minimum too high, no custom color will change those given facts. Every request should be stated as accurately as possible and include yardage and timing requirements, desired color, established coordinate fabrics, and codes that the fabric must pass. Although interior designers are not expected to understand the nuances of textile design, common sense should apply. For example, a designer should not submit a fine-lined drawing to be rendered in a coarse texture, or a bold, colorful painting to be interpreted as a two-color damask. These types of poorly thought-out requests at the very least delay trials and at worst (and all too often) lead to unsatisfactory results. Well-articulated, sensible requests yield the quickest and most satisfying results.

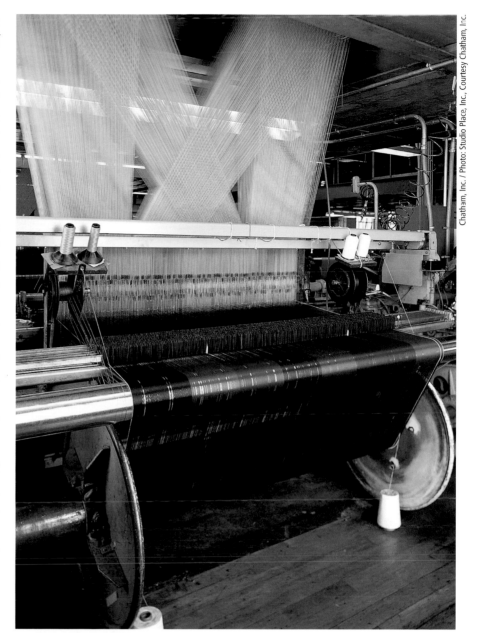

Chatham, Inc. / Photo: Studio Place, Inc., Courtesy Chatham, Inc.

Photo: Ron Sheridan

10-10 This blanket warp on the loom is made up of sections of various warp colors available in the final fabric. These will be crossed with the available filling colors for a particular pattern to show potential colorways for the fabric.

10-11 A strike-off of a roller print being produced. Each individual roller is sequentially loaded onto the machine and its respective color is applied in the time-consuming effort to produce a custom colorway of a print.

Professional Practices

The most successful designers have a sound knowledge of basic fabric facts, relationships, and principles. An open-minded approach and willingness to ask questions go a long way toward circumventing mistakes and problems. Following are some general guidelines that are useful to any designer working with fabric.

Fabric Selection

Choosing appropriate fabrics for a specific interior is critical to achieving the desired effect. Regardless of how the fabric is to be used, its aesthetic features must be the first consideration: If the fabric is not pleasing to look at and touch, how well it holds up and how environmentally sound it is will not really matter! Next, its performance features should be considered in the context of how the fabric will be used. If it is to be used in a commercial interior, applicable building codes must be adhered to. With those considerations in mind, and remembering that any choice involves trade-offs, designers can use a simple checklist of basic fabric properties to help them determine the appropriateness of a fabric. The questions in the following list will help designers determine a fabric's general attributes (each is discussed in detail in appropriate chapters).

• What does the fabric look like? The beginning of an interior coloration or design concept is often a fabric so captivating that an entire room can be planned around it. Other fabrics are necessary as coordinates (called *go-withs* in trade parlance) or as backdrops for other aspects of the room.

• Does it need to be somewhat, moderately, or very durable as an up-

holstery fabric in a light- or heavy-use area? Broad terms like "residential" and "contract" are often meaningless. The family room in a home is subject to the same constant use an office reception area undergoes, whereas an executive's private office receives the same careful use a formal dining room at home does.

• Is drapability required? Some applications, like window treatments or slipcovers, require beautiful drapability, while for tight upholstery or wallcovering applications it is inconsequential or a drawback.

• Is stretchability a disadvantage, as it would be for a drapery, or inconsequential, as for a paper-backed wallcovering? Some stretch is often required for application to ergonomic seating.

• Does the fiber have good "memory" and "recovery" to wrinkling or stretch? This is important in an unconstrained use such as drapery or loose, soft upholstery (and even in tight upholstery); it probably is not in fabric directly glued to foam forms of ergonomic seating. The give of fabric can make upholstering easier as long as the fabric recovers to its original form and does not puddle once it is on furniture.

• What degree of colorfastness is needed? Few fabrics are completely colorfast, but color should not shift quickly or dramatically once the fabric is in use. If the fabric is to be installed in a climate with very strong sunshine, a much higher degree of lightfastness is needed than if the fabric is to be used in a shaded area, for example.

• Will the fabric's use require above-average resistance to wet or dry crocking? Upholstery in a beach or pool house is likely to get wet on occasion, whereas wallcovering will not under normal use.

• Will the fabric be installed in a very humid area or in a climate-controlled building? Certain fibers absorb much moisture from the air, and fibers vary in moisture regain, a fiber's ability to recover its original form on the next dry day.

• Do any unusual building codes apply to the installation? Fabrics that are marketed for contract use meet normal contract specifications. Special materials or treatments may be required for unusual codes or unusual performance expectations.

All of these basic properties can be evaluated within the context of the fabric's basic makeup, which can be determined based on these four questions:

• What is the fabric's structure and construction?
• What is the fiber content and yarn configuration of the fabric?
• How has color been imparted to the fabric?
• Have the fabric's properties been altered through any finishing process or aftertreatment?

It is most important that the designer develop a total impression of all these attributes within the context of application before making a selection. Once the decision is made, the purchase order and specification must be written clearly and appropriately.

Specification and Purchase-Order Writing

In any specification it is critical to stipulate all of the fabric's features that can be put into words so that the purchaser cannot later switch the designer's selection to something that looks similar to save money. All of

the fabric's attributes—its content; yarn type and construction; weave, pattern, and color effect—can be cataloged. Any codes that it must pass, any performance data that relate to it, and any backings or finishes that are a part of it should be enumerated. Details of fabrication should also be clearly spelled out or illustrated, if appropriate. Purchase orders should be made in writing or confirmed in writing if they are verbal. Separate purchase orders for each item are useful and purchase-order (P.O.) numbers are critical for tracing orders.

Purchase orders should, of course, contain the buyer's name, address, phone and fax numbers, and e-mail address. The shipping address should be stipulated, even if it is the same as the buyer's address, and the order should indicate how the shipment should be *marked*, or *sidemarked*—that is, with the name of the job or client prominently marked on the bolt itself and on all paperwork so that it is easy to identify when it is received.

Preferences for methods of shipping should be stipulated. Although very general "urgent" or "rush" requests are meaningless, specific instructions—such as dates by which the order must be shipped or indication that notification be made immediately if the shipment cannot be made by a given date—will be heeded by most suppliers. If more than one item is being ordered, partial shipments will be made unless otherwise stated.

Suppliers may identify fabrics by name, number, or both; all identification should be listed on the order. Color may be identified by number, but even so it is a good idea to list a general descriptive color name to be sure that nothing has been mis-marked. Quantity should be stipulated by number of yards (meters) of fabric; decorative fabric houses accept orders of increments of $1/4$ yard or meter. Unless the order is larger than one piece of the fabric, or if the customer gives specific approval, the supplier should ship the order in a single piece. Specific lengths that are needed (especially for wall or window application) should be enumerated, such as an 80-yard drapery order that requires eight 10-yard panels. With very large orders, stipulation should be made if a single dye lot is needed. If the fabric is for several rooms, different dye lots can be used for each room; in these cases, an enumeration of the quantities required per room is needed.

It is good practice to call and check stock by phone. Fabric items can be placed on reserve for anywhere from three to ten days, depending upon the supplier's policy. This is convenient when numerous items are being ordered from different sources and the job cannot be begun until all or certain items are received, for example. When an item is placed on reserve it is reasonable to request a CFA (cutting for approval) if color is critical or if cuts from different dye lots are in stock and no single lot is enough to fill the order. Once the cutting is approved, a purchase order can be issued for the reserved yardage. Ordering a "cutting from stock" if no yardage is on reserve is pointless, as the stock could be sold at any moment.

When an end-user or other buyer issues the purchase order for an item that was specified by a designer, the specifier's name and company should be given on the purchase order. This makes matters simpler if questions arise; it is also a courtesy to credit the correct fabric salesperson for the order.

Costs and Budgets

Fabric, like any other material, ranges in cost for many reasons. Cotton sheeting produced in large quantities with no variety is less expensive than the shorter-run material that is typically jacquard woven upholstery, for example. More exclusivity and novelty costs more, partly because of inherent materials but largely because of the developing and marketing of such material. A mill that specializes in cotton sheeting, ticking stripes, or basic linen, for example, may rarely need to weave a sample, whereas most of the mills that supply the decorative-upholstery market have large design staffs, extensive computer-aided design hardware, and large sampling resources. These fixed costs must be figured into overhead; consequently, the design cost becomes a part of the fabric cost. Similarly, even within the decorative segment of the market, mills that sell to the broadest portion of the market have greater efficiency and usually better prices than those that weave smaller runs and supply the higher-end (and smaller) market segment. Exclusivity, therefore, increases cost.

Actual cost of raw material is a large portion of actual fabric cost at the manufacturing level. The heavier the fabric, the more expensive its fiber and yarn type, and the more processes a fabric or its components have undergone, the more expensive the fabric. Silk costs more than cotton, mercerized cotton is more expensive than carded cotton, and so on. Nonetheless, because a mill's largest costs are in its factory, people, and equipment, and because every yard woven still requires the same amount of raw material, changing components or quantities may not affect a given mill's selling price substantially.

Cost relative to value may be much more difficult to discern at the interior designer's level than at the mill level. As noted in chapter 10, mills do not sell to designers. Wholesalers exist to service the design community, which they do by making tens of thousands of samples, employing numerous sales and customer-service people, furnishing showrooms, and stocking material and cutting it to the exact small sizes required. All of this support is labor-intensive and necessitates wholesalers' markups. Certain fabrics that are channeled through more than one wholesaler/distributor may reach the designer with additional markups, as new costs are incurred every time a fabric (or any other product) is resold or handled. This is not to say that such costs are inappropriate or that the fabrics are not worth the money. As with all other objects, supply and demand fairly dictate pricepoints. With a sound understanding of the fabric principles set forth in this book, a designer or educated consumer can make an appropriate comparison of quality and ask appropriate questions of suppliers. Two cotton prints may vary dramatically in cost—because one is printed with eight colors and the other with eighteen, for example, or because of their relative availability. Two identical cotton velvets may vary in cost simply because one is handled by a distributor that sells greater volume and therefore has a lower markup. The educated purchaser must carefully compare the relative intrinsic characteristics of fabrics and then decide the premium warranted for special attributes.

No fabric should be considered more valuable simply because it is made overseas. Materials are often made in a specific place because a specific facility produces that cloth. Specialties evolve for many reasons, and the worldwide demand for a cloth may be so limited that no need arises for factories in many locations. But many similar constructions, designs, and colors may be made in other locations, and the relative labor costs, value of currency on the exchange rate, and duties and tariffs will affect the cost of fabrics regardless of their actual intrinsic cost. Furthermore, the farther away a fabric is made, the more it costs to ship it to where it will be used. If two fabrics of similar content and construction are made in two countries, the cost may vary considerably. The domestically produced material should be considered an excellent value rather than an inferior product when it compares favorably to its foreign counterpart.

It is important to compare costs in equivalent terms, by square yard or meter, and of required quantity including waste loss and fabrication cost for a particular project. Cost-per-yard or meter assessments are not necessarily apples-to-apples comparisons: Although most interior-furnishing fabrics are 54 inches (140 cm) wide, many other widths are available. (Cubicle fabrics are usually 72 inches (180 cm) wide and panel fabrics 66 inches (170 cm) wide. Certain drapery fabrics are 48 inches (120 cm) wide; extra-wide goods of up to 108 inches are made, but usually just for sheers. Wallcoverings are frequently 27-inch (70-cm) "split widths." Any number of odd widths occasionally surface.) Similarly, the repeat size and pattern layout on the fabric may make significantly different waste factors (usually for pattern matching) in two fabrics of similar cost per yard. Fabrics may necessitate different installation costs, too, especially in wallcovering or drapery applications. Although it is impossible to perfectly predict, a fabric's expected life should also be considered with regard to its cost. Although more expensive fabric is not guaranteed to last longer, an expensive fabric with a long life may not be more expensive in the long run.

Although the price of two fabrics may be quite different on a per-yard basis, the cost of the fabric is usually a small portion of the finished product. For example, the fabrication of a drapery with all its linings and inner linings is the same regardless of whether it is applied to a cheap or expensive fabric. For example, $60-per-yard fabric is 100 percent more costly than a $30-per-yard fabric, but if the total installed cost of the drapery is $2,000, and twenty yards of fabric are required, the total difference in price for the drapery is $600, or 23 percent more, from $2,600 to $3,200. The difference for a piece of furniture, which may take very few yards of fabric, often is even less significant.

Any budget can absorb luxury costs, even if only in small touches. Because side chairs require so little fabric, they are often an excellent vehicle for a special cloth; tableskirts require only a small amount of fabric but still have a large impact. A spectacular fabric on something as small as a pillow, wall hanging, or other accessory can have a staggering effect on an otherwise ordinary space.

Guidelines and Pitfalls

Even when the best fabricators handle material, certain common pitfalls occur within specific end uses. Although it would be impossible to list every fabric problem, it is helpful to be aware of the most common con-

11-1

change the color, hand, and general appearance of fabrics, so a true evaluation must take these changes into account.

• A fabric is only as good as the workmanship that is used to install, apply, or fabricate it. Even the most beautiful fabric cannot make up for badly executed wall preparation, carpet installation, or upholstery tailoring. The best available installer/ fabricator should always be used.

• Designers often want to use the back of a material as the face for a particular application. This is fine, as long as the designer and end-user realize that the fabric may have flaws on the back that the supplier did not acknowledge, as only the front of the fabric is inspected. Also, abrasion tests for the face of the fabric are not relevant for the back.

• Some of the simplest mistakes arise from designers' (and end-users') inability to stick with their own decisions. Realizing the implementation of an interior project takes many months, and during that time designers are likely to find other interesting materials. Although establishing a successful design concept often involves reworking materials, the best interiors result from a commitment to a well-thought-out, finely executed design solution.

cerns and issues that arise frequently and know how to avoid them.

• Reputable fabric suppliers employ large staffs that are knowledgeable about their products and appropriate application. Likewise, installers and fabricators have experience in handling many materials— and hear the complaints about those that do not perform. Designers are encouraged to ask questions and use their suppliers as valuable resources.

• Fabric appearance changes dramatically in different light conditions and different surroundings. Fabrics need to be viewed in relation to each other, in the actual lighting conditions, and in as large a sample as is practical.

• Whenever possible, mockups and samples that are truly representative of the end product should be evaluated. Any aftertreatments, backings, linings, or other composites

SEATING
(Figure 11-1)

• Mohair plush "crawls" on itself when it is sewn. Therefore, when it is used with a welt or on curves it is almost impossible to sew without puckers. Tightly woven flat fabrics such as silk or cotton taffeta perform similarly, and sheen magnifies the puckers.

• Tightly woven, flat fabrics like taffetas and fine ottomans "pull" at

the stitch marks of seams. These marks show more on tighter upholstery and on curves such as barrelback chairs.

- Velvet of almost any content marks, which means that the pile becomes pressed down in spots where it is even lightly touched. Because an upholsterer must touch fabric to put it on furniture, velvet will never have a pristine surface. Although cotton, linen, and silk velvets are the most expensive and exclusive velvets, they have the highest propensity to mark.

- Mohair plush receives an inordinate share of durability complaints for several reasons. First, like all fabrics, mohair varies greatly in quality. Second, because mohair is considered a high-durability fabric, it is often used without regard to maintenance or upholsterability considerations. If any fabric is not properly padded, upholstered, or maintained, it will not look good in use.

- Chenille fabrics can look very similar and yet vary dramatically in quality. Especially at times when demand for chenille fabrics is high, extra consideration should be given to their construction. If one fabric is much more expensive than another, it is probably (though not absolutely) because the yarns are made very differently. Gently pulling, tugging, and snagging the fabric by hand often can quickly reveal its limitations.

- Pattern placement must be considered and specified on individual furniture frames. Large repeats (27- or 13$\frac{1}{2}$-inch [70- or 35-cm] half-drops) frequently need seams to cover a cushion, even on chairs. Designers must specify the seam placement and which motifs should be centered, and ask the upholsterer about any potential difficulties.

- The majority of fabric-durability problems stem from insufficient in-terior padding on a chair and at impact points such as chair arms that bump into desktops or tabletops. Any unusual wear expectations should be discussed in advance with the suppliers.

WINDOW COVERINGS
(Figure 11-2)

- Especially with sheer fabrics, seams and hems necessarily show through. Placement of seams should be considered, as well as alternative sewing techniques; for example, a fine, scarflike, hem may look better than a deep hem.

- Fabric looks completely different depending on whether the light source comes from the outside (through the back of the fabric) or from inside the room (hitting the face). Thus, interior drapery treatments must be considered both ways. It is critical that the color—and effect—be reviewed with all layers that will be used, including linings and

11-2

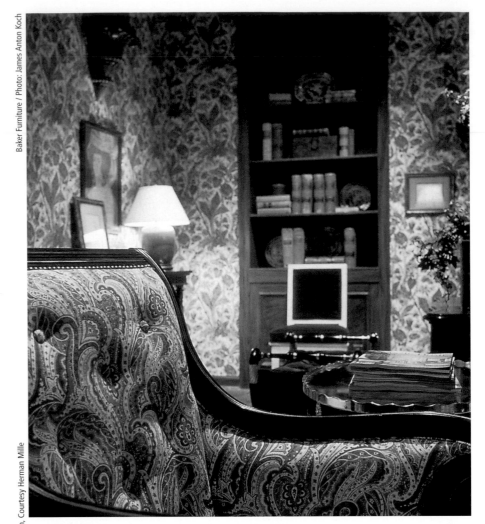

Baker Furniture / Photo: James Anton Koch

inner linings, as the composite color effect is different from that of the face fabric alone.

• Light takes the greatest toll on drapery fabrics, so vulnerabilities must be considered both in terms of materials chosen and fabrication of the treatment itself. Although silk is known as the most light-sensitive fiber, any material will fade or degrade if it is exposed to strong, direct sunlight for a long period of time.

• A sheer fabric that is lined produces a moiré effect. While this can be beautiful, it can also be distracting if it is not intended or desired.

WALLCOVERINGS
(Figure 11-3)

• Unattractive seams in direct-glued wallcoverings are the most common wallcovering complaint. While a good installer can make a huge difference in seaming, wallcoverings have inherent differences in seam characteristics. It is easy to have an installer do a small test panel to show the seam quality before the selection is made.

• For residential installation, pattern matching is considered imperative, but in commercial application, where many plain materials are used, many installers do not match patterns unless they are specifically instructed to do so.

• Wall preparation and installation are the key to an attractive wall. No product will cover the mistakes of a poorly prepared surface; in fact, direct-glued wallcovering often makes irregularities more pronounced.

• When a fabric must be paper- or fabric-backed so that it can be applied to the wall, responsibility for the backing process is a critical issue. It is easy for fabric to become skewed when the backing is applied. A de-

Herman Miller / Photo: Hedrich Blessing- Steve Frykholm, Courtesy Herman Miller

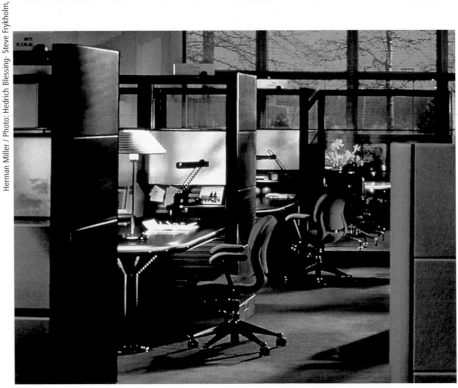

11-4

signer's best protection is to purchase the product in the form in which it will be applied whenever possible. Reputable fabric suppliers offer valuable advice and will often handle necessary processing.

• For wrapped-panel installation (for walls or ceilings) the thinness of many fabrics will allow the "guts" of the panel and any seaming to show through. A test panel should be prepared, and a lining used if necessary.

PANEL FABRICS
(Figure 11-4)

• Panel manufacturers test the fabrics in their own lines for panel suitability and adopt only those that perform superbly on their own panels. Therefore, manufacturers stand behind their own products and rarely experience problems with the fabrics. Specifying a COM fabric for panels can be difficult because manufacturers require extensive testing before specific COM approval is given, and flammability testing by UL is usually required by the manufacturer and the end-user. Time and budget must be allowed for UL and manufacturer's approval of any COM consideration.

• Panel fabrics that have potential problems usually are not approved by office-furniture manufacturers. However, fabric sagging (especially for wool-content fabrics) can still occur for approved fabrics because of changing humidity conditions in an installation.

FLOORCOVERINGS
(Figure 11-5)

• A large expanse of any pattern will look different from a small swatch. This is an especially significant concern for floorcoverings because they often cover large,

11-5

uninterrupted spaces. Different motifs, lines, and scale may become apparent in this application.

• Seaming placement and character are primary concerns in carpet installation. Preferences should be stipulated to installers, and installers should be consulted in advance about limitations and concerns.

• Choosing an inappropriate backing for carpet and installing carpet poorly are the most serious floorcovering problems. Reputable suppliers will recommend appropriate backing. Installers' references should be

checked and examples of their work should be evaluated. When possible, use an installer with experience in handling similar products.

CUSTOM DEVELOPMENTS

• The most important allowance to be made in any custom development is for time. Anything special that requires making swatches, adjustments, and countersamples (plus the ordering of the yardage itself) takes more time than is required for running items.

Baker Furniture / Photo: James Anton Koch

• The more samples a mill must make proportionate to the yardage it weaves, the more it must charge for its fabrics. The industry is best served by responsible use of these development resources.

• Too often requests for customs are cavalier, offhand queries from designers who have not thought the project all the way through and who will not actually be able to use the custom result. If the fabric is too expensive or the minimum too high, no custom color will change those facts.

• Every request regarding yardage and timing requirements, desired color, established coordinate fabrics, and codes that fabric must pass should be stated as accurately as possible. Well-articulated, sensible requests yield the quickest and most satisfying results.

• Custom yardage cannot be produced to a precise length requirement. Therefore, custom orders must stipulate a minimum required and a maximum allowed yardage. At least a 10 percent overage from the minimum requirement is industry standard and must be accepted.

• When custom colors need to be dyed, the target to be matched must be appropriate for the material to be used. Dyers are professional color matchers who do an excellent job, but they are not mind readers. A solid-color fabric cannot be matched to a stippled laminate or to a stone, for example. In these cases, the dyer must decide which part of the target to match. If the dyer's choice is different from the choice the designer would have made, neither will be pleased with the result. A dyer will achieve the designer's desired result if the request is clear.

Furnishing fabric is a critical interior element that pleases the eye and provides physical comfort to the occupants. When fabric is properly selected and applied, it meets the aesthetic and functional needs of both the designers and users of the space. This book is intended to simplify the selection process, but all reputable suppliers are equipped to provide recommendations if a particular use or fabric raises any questions with regard to appropriateness. In order for this advice to be most useful, specifiers or users should ask questions that are as specific as possible. They especially should ask how the fabric has performed in similar uses; it is also helpful to ask which uses should be avoided. Established fabricators (upholsterers, drapery workrooms, carpet or wallcovering installers) also may have experience with comparable products, and their recommendations can be invaluable. Established fabric houses can recommend appropriate choices for specific or unusual building codes that the architectural or interior-design firm determines are necessary.

Appendix

Category	Generic Name	Brand Name (Non-F.R.)	F.R. Brand Name	Fiber Class	Origin	Forms Available	Positive Features	Negative Features	Primary Uses in Interiors
Natural Man-mades	**Rayon**	Avril	Linsing	cellulosic	wood pulp, cotton waste fiber	filament, spun, viscose, cuprammonium, high wet modulus	drape, luster, accepts dye, blends well	poor dimensional stability, especially when wet	used in blends to lend luster, used as accent yarn. Never for panels
	Acetate		cannot be treated	modified cellulosic	wood pulp	filament	low-cost, light resistant, dimensionally stable, high luster	poor abrasion, not many yarn fabrications	drapery lining, drapery warp yarns
	Latex		cannot be treated	mineral, elastomeric	rubber	filament	stretch	does not blend well	elastic bands, backing
	Glass	none	Fiberglas, Fiber Glass	mineral	glass	filament, spun, nonwoven	does not burn	undyeable, environmental concerns	fireproof barrier liner in upholstery and bedding
Sythetic Man-mades	**Polyester**	Dacron, Fortrel, Trevira	Avora F.R., Trevira F.R. & C.S., Visa	synthetic	petro-chemical	filament, spun,	light resistant, dimensionally stable, wrinkle resistant	collects static, pilling	all
	Nylon	Antron, BASF, Cordura	aftertreatment only (Nomex and Kevlar, sometimes considered FR nylon, are a similar yet distinct fiber called Aramid)	synthetic	petro-chemical	filament, spun	strong, versatile	collects static, pills	upholstery, intimate blend with wool, not appropriate for vertical application
	Acrylic/ Modacrylic	Acrylic: Orlon, Acrilan	Modacrylic: SEF, Kanekalon	synthetic	petro-chemical	filament, spun	resembles wool, F.R. forms available	collects static, pills	F.R. upholstery, F.R. blends, wool substitute
	Olefin (polypropy-lene)	Herculon, Nouvelle, American (formerly Amoco)	cannot be treated	synthetic	petro-chemical	filament, (spun not common)	non-absorbent, stain- and mildew-resistant	color limited, cannot be treated for flame resistance	high-volume and commercial markets, upholstery, wallcovering
	Spandex	Lycra	cannot be treated	elasto-metric	polyurethane	filament	good stretch recovery, strong	damaged by bleach, heat, time	blends for stretch apparel, some upholstery

Table 1-a: Fiber Properties chart: Man-made Fibers

Category	Name	Fiber Class	Origin	Forms Available	Flame Retardancy	Postive Features	Negative Features	Primary Uses in Interiors
Cellulosic	Cotton	cellulosic	cotton plant	spun, staple, carded, combed, mercerized	after-treatment only	versatility, light- and abrasion-resistant, releases soil	absorbs moisture	all
	Linen	bast	flax plant	line-linen, tow-spun, wet-spun, dry-spun	no	luster, cool hand	brittle, wrinkle-prone, low resilience	wallcovering, print groundcloth
	Sisal	bast	plant	spun	no	sturdy	color fades	floorcovering
	Jute	bast	plant	spun	no	inexpensive	color fades	carpet backing, burlap wrappings
	Hemp	bast	plant	spun	no	sturdy	color fades	floorcovering
	Ramie	bast	plant	spun	no	soft hand, silky luster	low abrasion resistance	small content in blends for upholstery and drapery
	Raffia	bast	plant	strand	no	sturdy	not flexible	floorcovering, filling in upholstery and wallcovering
	Bamboo	bast	plant	stalk	no	sturdy	not flexible	window blinds, screens
	Tatami (Sea grass)	bast	sea grass plant	spun	no	sturdy	not flexible	floorcoverings
	Cane	bast	plant	stalk	no	sturdy	not flexible	window blinds, screens
	Rattan	bast	plant	stalk	no	sturdy	not flexible	window blinds, screens
Protein	Wool	animal	sheep fleece	worsted, felt, woolen, reclaimed	Zirpro after-treatment	lofty, abrasion-, wrinkle-, and soil-resistant, dye affinity	can be scratchy	all
	Mohair	animal	angora goat fleece	spun	no	silky appearance, soft hand	high cost	upholstery especially plush
	Cashmere	animal	Kashmir goat fleece	spun	no	soft and fine	high cost, delicate	accent pieces, wool blends.
	Alpaca	animal	alpaca fleece	spun	no	soft and fine	high cost, delicate	accent pieces, wool blends. Usually used in natural colors
	Angora	animal	rabbit fleece	spun	no	soft and fine	high cost, very delicate	luxury blend with wool
	Camel's hair	animal	camel fleece	spun	no	soft and fine	high cost, delicate, low dye affinity	accent pieces, wool blends. Usually used in natural colors
	Vicuna	animal	vicuna's fleece	spun	no	soft and fine	high cost, delicate	luxury blend with wool
	Horsehair	animal	horse's tail	strand	no	beautifully smooth; very durable	high cost, narrow widths	historically used as stuffing and upholstery fabric. Rare, staple of traditional upholstery. Used in natural colors
	Silk	animal	silkworm's cocoons	spun, tussuh, tram, doupioni	no	elegant sheen, rich luster, vibrant colors, high tensile strength	high cost, sensitive to light, fading	luxury upholstery, drapery, wallcovering. Blended with synthetics

Table 1-b: Fiber Properties Chart: Natural Fibers

	Upholstery	Panel and Upholstered Walls	Direct Glue Wallcovering	Drapery
Abrasion	**Wyzenbeek** ASTM D4157-82 30,000 double rubs: heavy duty 15,000 double rubs: general contract **Martindale** ASTM D4966 40000 double rubs heavy duty			
Physical Properties	**Seam Slippage** ASTM D3597-D434-75 25lbs minimum warp & weft **Breaking Strength** ASTM D3597-D1682-64 (1975) 50lbs minimum warp & weft **Brush Pill** ASTM D3511 3-4 minimum	**Seam Slipppage** ASTM D3597-D434-75 25lbs minimum warp & weft **Breaking strength** ASTM D1682-64 Grab Method 35lbs minimum warp & weft		**Seam Slippage** ASTM D3597-D434-75 if fabric is>6oz/square yard 25 lbs minimum warp & weft if fabric is<6oz/square yard 15 lbs minimum warp & weft
Flammability	CA Bulletin 117	ASTM E 84 Unadhered (NFPA 701 small scale more difficult)	ASTM E 84 Adhered	NFPA 701 Small Scale
Colorfastness	**Colorfast to light** AATCC 16A-1974 or AATCC 16E-1976 Class 4 minimum at 40 hours **Colorfast to wet crocking** AATCC 8-1988 Class 3 minimum **Colorfast to dry crocking** AATCC 8-1988 Class 4 minimum	**Colorfast to light** AATCC 16A-1974 or AATCC 16E-1976 Class 4 minimum at 40 hours **Colorfast to wet & dry crocking** AATCC 8-1974 Class 3 minimum	**Colorfast to light** AATCC 16A-1974 or AATCC 16E-1976 Class 4 minimum at 40 hours **Colorfast to wet & dry crocking** AATCC 8-1974 Class 3 minimum	**Colorfast to light** AATCC 16A-1974 or ASTM D3691-AATCC 16E-1976 Class 4 minimum at 60 hours **Colorfast to wet & dry crocking** ASTM D3691 AATCC 8-1988 (Solids) ASTM D3691 AATCC 116-1988 (Prints) Class 3 minimum

Table 2. ACT Performance Guidelines*

* These guidelines are developed by the Association for Contract Textiles (ACT). The standards are not always written by ACT in the same forms that ASTM and AATCC proscribe, and they are periodically revised and restated by ACT. Any inquiries can be directed to ACT's headquarters listed in "Trade Organizations" (page 305).

Glossary

abaca A long fiber derived from the abaca plant, used for matting and ropes.

acetate Man-made cellulose-based fiber used for fabric of the same name. Saponified rayon is reverted from acetate through a chemical process so that it looks like rayon but dyes like acetate.

acrylic Man-made, resin-based fiber used for fabrics and carpets. Properties include a soft hand, the ability to be easily washed and dyed, thermoplasticity, and resistance to wrinkles and deterioration from exposure to sunlight.

aftertreatment Any process that a fabric undergoes after it is produced, usually to impart a performance feature such as stain repellence or fire retardance.

air-entangled See *texturized.*

air-texturized See *texturized.*

alleyways Unintentional lines formed by negative spaces (spaces vacant of motifs) in a pattern design.

all-over layout A design that, within one repeat unit, has irregularly occurring motifs connected in some way.

aniline dye An organic dye derived from coal tar or petroleum chemicals.

animal fibers Fibers that are harvested from animal fur, hair, and cocoon materials. All are protein-based. Wool, mohair, and silk are examples.

antique satin A fabric that on the face shows yarn slubs in the filling and is satin on the reverse side. The intended effect is that of a silk from the seventeenth or eighteenth century. Generally used for drapery. It may be made from a variety of fibers.

Antron Registered trademark owned by DuPont for nylon fiber. Popular in interior furnishings in carpet.

appliqué A separate piece of material that is sewn or bonded to an area of a base fabric.

asbestos A mineral fiber. It is inherently fireproof and was widely used for theater curtains and industrial uses.

ASTM American Society for Testing and Materials, a nonprofit organization that provides a voluntary consensus system for developing standards through committees composed of producers, engineers, academics, regulatory bodies, and other stakeholders.

ASTM guide A compendium of information or series of options set forth by the appropriate ASTM committee that does not recommend a specific course of action.

ASTM standard A document that has been developed and established within the consensus principles of ASTM and that meets the approval requirements of ASTM procedures and regulations.

Aubusson (1) Carpet. A machine-made uncut loop pile carpet made to imitate the hand-made tapestries and carpets of that name. (2) Tapestry (or rug). A tapestry-woven textile, originally made in the French town of Aubusson.

Austrian shade A window shade with closely spaced stitched vertical shirring, or made with seersucker or other crinkled-stripe fabric that has a shirred effect. Like balloon and Roman shades, it is pulled up on vertical cords from the bottom. Also called *Austrian pouf* or *Austrian valance.* See also *balloon shade, Roman shade.*

Avora Registered trademark owned by Hoechst-Celanese for polyester fiber, popular in interior furnishings in its F.R. (flame-resistant) form. Formerly marketed as Trevira F.R. and Trevira C.S.

Axminster A woven, cut-pile carpet made on a loom that allows for a wide range of pile heights and colors. The technique is attributed to a factory in Axminster, England, although the specialty loom that produces it was invented in New York.

balance (said of pattern) A design with no line-ups, alleyways, or holes is said to be "in balance."

balanced fabric A textile constructed with warp and filling yarns of equal weight, woven with an equal number of picks and ends per area.

balanced stripe A layout of stripes that is symmetrical relative to one stripe at the center of the configuration.

balloon shade A window shade that draws up from the bottom on cords into soft, full scallops. Also called *cloud* or *poufed shades.* See *Austrian shade, Roman shade.*

bark cloth A nonwoven material derived from tree bark, which is soaked and then beaten into a coarse fabric.

bark crepe A variation of crepe fabrics that are woven to resemble the texture of tree bark.

barrier In upholstered furniture and bedding, a fireproof or waterproof material that is an interlining between the cushion material and the outside cover. It prevents flame or moisture from an outside source from reaching the cushion material.

BASF Registered trademark owned by BASF popular in interior furnishings in carpet and upholstery fabric for solution-dyed nylon fiber.

basket weave A variation of plain weave in which two or more yarns are woven together in both warp and filling directions.

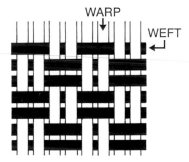

G-1 Basket weave

bast fibers Fibers derived by a retting process from the inner bark, husks, and other parts of plants such as hemp, jute, and sisal.

batik A wax-resist dye process in which the design is drawn in wax directly on the fabric. See also *resist printing.*

batiste A fine, sheer, lightweight plain weave in cotton, silk, wool, linen, or appropriate synthetic. Named for Jean Batiste, a French weaver.

batting Fluffed fibers of wool, cotton, kapock, polyester, or other appropriate material formed into sheets and used as padding between layers of fabric to form a compound material.

bayadere Originally a plain woven fabric with brightly contrasting horizontal stripes originally based on an Indian fabric. The term now refers to any horizontal pattern layout.

beetling A finishing technique that passes damp material between a metal cylinder and mallets. This increases luster and gives a harder surface to the fabric.

bendé effect A halftone-like appearance of shading in one color, produced in screen printing by the dense or sparse spacing of dots of the desired color.

berber yarn A thick, originally hand-spun, natural-color yarn with very little twist.

bird's eye A shaft or dobby weave consisting of a dot surrounded by a diamond.

blanket (1) A bed covering. (2) A term used in the textile industry for a sample piece of yarn-dyed fabric woven with sections of different warp colors crossed with different filling colors so that the various color choices available in the style can be viewed in one fabric.

blend A yarn or fabric that has been made from two or more types of fibers. Called an *intimate blend* when the fibers are mixed in the same yarn, and a *mixture* when yarns of distinct fibers are woven or knitted into a cloth.

blister cloth Fabric with a pebbled surface that has been achieved by a variety of techniques. Examples are crepe weave; weaving the cloth from a combination of yarns that shrink and yarns that do not and then finishing with a process to cause shrinkage; chemically causing areas on the fabric to react; varying the tension during the weaving.

block printing A process in which blocks carved with a pattern are used to print a design.

blotch A background area of a fabric design printed in the same way the motifs are printed. Fabrics so printed are said to be *blotch printed*.

bobbinet A lightweight hexagonal net fabric used for drapery sheers and theatrical backdrops.

bobbin lace Handmade lace made by a technique that outlines the pattern on a cushion (or pillow) with straight pins; the thread is then worked around the pins. Also called *pillow lace*.

bonded fabric A fabric with an applied backing substance. Usually this backing increases the structural integrity of the fabric. See also *laminate*.

botanical A design showing entire plant forms (roots, stems, etc.) rendered as in a botanical illustration.

bouclé An irregular loopy yarn made by twisting heavier, pretwisted threads around a fine core yarn.

bowing A characteristic arced horizontal deviation across a fabric causing the center of the weft to be higher or lower than each selvedge. Considered a flaw when the deviation is more than $1/2$ inch (1.2 cm).

braid (1) A narrow fabric constructed by diagonally intertwining sets of yarns. It may be flat or round. (2) Any narrow fabric used for trimming.

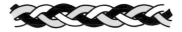

G-2 Braid

braided rug A rug made from strips of fabric that are braided together, wound into a spiral, and stitched into a mat that is round or oval.

broadcloth Originally, fabric that is woven on a loom wider than 27 inches (70 cm). Typically used to describe a fine plain weave cloth of spun yarn, usually cotton, silk, or synthetic.

broad goods Fabric that is wider than 18 inches (46 cm).

broadloom Woven and tufted carpets 12 feet (3.6 m) or wider.

brocade (from French "to sew") (1) A compound weave in which a supplementary weft is inlaid into a base fabric during the weaving process to yield the appearance of embroidered motifs. (When supplementary warp is used, the fabric is lisère.) In sections where the supplementary yarn is not visible on the face, it may float on the back of the fabric between the areas where it is woven, called *continuous brocade*. (See figure G-3.) In *discontinuous brocade*, the supplementary yarn is only woven into the patterned areas. (See figure G-4.) A supplementary yarn may be removed without affecting the base fabric. (2) Fabric constructed with a brocade weave.

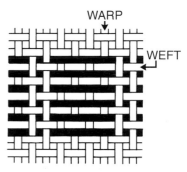

G-3 Continuous brocade

G-4 Discontinuous brocade

brocatelle A fabric with a high-relief motif created with a stuffer pick (traditionally a coarse linen yarn). The motif, often in satin, is created with a supplementary warp in a color that contrasts with the ground. Originally an imitation of Italian tooled leather, in which the background is pressed and the figures embossed.

broché A clipped brocade, usually silk, with a floral design. See also *clipped*, *cutwork*.

brushed fabric Woven and knitted fabrics that have been napped, resulting in a soft, pilelike hand.

buckram A coarse, open, plain woven, heavily sized fabric used for stiffening.

bulk A yarn or fabric's appearance of fullness with respect to its weight.

bullion fringe (1) Fringe made from silk or rayon twisted yarn 2 to 24 inches (5–60 cm) long and used as upholstery and drapery trim. (2) Fringe made from metallic thread that is tightly coiled around a flexible cord.

burlap A plain woven fabric made with jute yarn. Originally made for utilitarian purposes such as sacks, it is often dyed for decorative use.

burn-out print A fabric made of cellulosic and synthetic fibers, on which an acid is applied in certain areas to dissolve the cellulosic fibers and leave part of the fabric translucent.

calendering A finishing process that applies heat and pressure to fabric (usually cotton or linen) resulting in effects such as a luster, glaze, moiré, or embossed print.

candlewick Fabric with a muslin base through which thick yarn (similar to that used for candlewicks) is pulled and left looped or cut to give a tufted effect. This technique is used for what are commonly called chenille bedspreads.

canvas A heavy, stiff, closely woven fabric, usually made of carded cotton or linen yarn. The heavier version is called *duck*, but the terms are often used interchangeably. Canvas does not have a finish.

carding The preliminary process in spun yarn manufacture in which impurities and very short fiber pieces are removed and the remaining fibers are separated and smoothed into a thin web of condensed material.

carpet (1) A variety of fiber-based floorcoverings that are manufactured in continuous lengths. (2) A sixteenth- or seventeenth-century term for table coverings. (3) A term often used interchangeably with *rug* (especially a very large rug) to refer to pile-woven floorcoverings. See also *rug*.

casement A fabric in which yarns are spaced far enough apart to create openings through which light passes. Used for curtains and other window treatments.

cashmere Soft, fine, silky wool fiber from the underbellies and throat areas of goats that are raised in the Kashmir region of India and Pakistan.

cationic Fiber polymers that have been modified chemically to take a different dye class from the standard polymer. Cationic nylon and cationic polyester are most common.

challis A sheer, lightly napped, plain-woven fabric usually of fine wool or rayon.

check (1) A pattern of squares on a fabric. It may be woven or printed and is usually two or three colors. In a *true check*, the warp and filling are the same layout. (2) Fabric with a check pattern.

cheesecloth A very loosely woven, plain-woven cotton fabric. The yard width is called tobacco cloth. Used for curtains, costumes, and cleaning cloths.

chenille (1) A yarn that has a pile. It is made by closely packing a small number of filling yarns and then slicing between the groups along a warp line. (2) Fabric woven from chenille yarn.

chenille bedspread A spread made of a tufted fabric called *candlewick*. Usually no chenille yarn is actually used. See also *candlewick*, *tufted*.

chenille embroidery Embroidery with chenille yarn, usually executed on velvet.

chenille rug or **carpet** A machine-made pile carpet made from chenille yarn.

chevron See *herringbone*.

China silk A plain woven, lightweight silk with irregular yarns. The term now applies to machine-made silk made to resemble the original fabric that was hand-woven in China.

chiné A warp-printed cloth, usually in a French floral motif. See also *warp print*.

chinoiserie Any western interpretation of an oriental design.

chintz A glazed (calendered) plain-woven cotton that may be solid colored, printed with floral designs or stripes, or embossed. First imported to Europe from India in the seventeenth century.

chintz print A floral pattern, usually large-scale, with strong, vibrant colors and a glazed finish.

ciré A glossy finish originally done on satin. It may be achieved by applying wax (or similar substances) and then hot calendering, or by applying heat to heat-sensitive fabric.

class of dye Category of a particular type of dyestuff because of its affinity for a particular fiber or fibers. Fiber-reactive dyes, for example, are a class that will bond with cellulosic fibers.

client The individual or firm that hires an interior designer or architect to select materials, including fabrics, for an interior. A client may be passively or actively involved in the selection process. See also *end-user*, *consumer*.

clipped An effect achieved by cutting away the floating portions of supplementary yarns so that the remaining loose-cut edges are used as a part of the design. Motifs are usually isolated on a ground. Dotted Swiss and clip-spot are examples.

cloth The term is applied to wovens, knits, felt, and other fiber-based, pliable materials and usually does not include plastic films, rugs, carpets, or most paper. See also *fabric*, *textile*.

coated fabric Fabric that has been finished by the application of a varnish, oil, vinyl, polymer, or similar material. Examples are oilcloth and Naugahyde.

coir The fiber derived from coconut husks. The fiber is used for brushes, but it also can be made into a yarn.

color combinations See *colorways*.

colorfastness The dyed fiber, yarn, or fabric's degree of resistance to the color-damaging influences of light, abrasion, water, or atmospheric impurities.

colorways The range of colors available for a specific fabric. Also called *color combinations*.

combing In worsted and some cotton yarn manufacture, a process subsequent to carding that separates the choicest, most desirable fibers and arranges them in parallel order before they are spun.

compound fabric A fabric woven with multiple sets of warp or filling yarns.

construction (of fabric) A description of a specific woven or knitted fabric using only the content, sizes, and density of the warp and filling yarns

in the cloth and irrespective of pattern weave.

consumer An individual who makes decisions about and directly purchases materials (including fabric) for an interior, without the advice of an interior designer or architect. See also *client, end-user.*

contemporary A fabric design featuring simple, extremely stylized motifs.

contract The market that supplies fabric (and furniture) for commercial (nonresidential) interiors such as offices, hotels, hospitals, and schools.

conversational A design using pictures of recognizable objects as motifs. Sometimes used interchangeably with *figurative,* although *figurative* is a broader term for any such motif, while conversationals usually depict more casual, everyday items.

converter A company that buys unfinished fabric, has it printed, dyed, or finished on a commission basis, and sells the finished product to the customer; also, the person working for a textile company who handles the flow of goods between these processes. The process is called *conversion.*

coordinates Designs developed to be used together.

cord Heavy groups of yarns that are twisted together into a rope and used as a decorative trim in place of welt on upholstered furniture or pillows.

corded fabric Fabric with a vertical ribbed effect. Those in the warp direction are *cords,* and those in the filling direction are *rep.*

Cordura Registered trademark owned by DuPont for filament-form nylon fiber.

corduroy A filling-pile fabric with a vertical cut-pile wale.

cotton A fiber derived from the fruit of the cotton plant and that is used to make yarn. Various fibers are classified according to length, strength, and geographical origin.

couching An embroidery technique in which thread is laid on the surface of fabric and attached with very fine, inconspicuous stitches.

count The number of warp and filling yarns per square increment of measure. The number of warp ends is given first when referring to fabric count.

counterpane A bedcovering made of multiple layers. A quilt is a counterpane.

course One widthwise row of stitches (loops) in knitted fabric.

cramming A weaving technique in which a greater number of yarns per inch or centimeter than is used in other parts of the fabric are forced into a specific area.

crepe A fabric of crinkled appearance usually as a result of the weave, yarn type and finishing techniques.

crewelwork Embroidery done with crewel yarn, a loosely twisted worsted wool, on a linen or cotton ground.

crocking Transfer of colorant material from the surface of a dyed or printed fabric onto another surface by rubbing.

crochet A type of needlework resulting from interlocking loops made with a hooked needle.

cross-stitch An embroidery stitch that crosses one stitch over another at a 90 degree angle, making an X shape.

crushed pile Pile fabrics that are exposed to heat, moisture, crushing, calendering, and heat setting in the finishing process to flatten areas of the pile.

Crypton A registered trademark of Hi-Tex, Inc. for a range of materials that are water-repellent and breathable.

cubicle curtain The unlined curtains used as room dividers in hospital rooms or other medical facilities. Fabrics for this purpose are usually woven 72 inches (180 cm) wide because they were originally railroaded. They are intended to be viewed from both sides and are usually of flame-retardant synthetic composition.

cuprammonium rayon See *rayon.*

cut pile See *pile.*

cutting A small swatch of an individual fabric mounted on a card, supplied by fabric companies to interior designers for reference and selection purposes. Usually about 3 by 3 inches in size, and often called a *three-by-three.*

cutwork (1) A type of appliqué and embroidery in which areas of the ground fabric are removed and the edges of the remaining cloth are edged with embroidery. Also called

open work. The term was later applied to needle lace on a woven ground. (2) Fabric in which the floats formed by supplementary yarns have been clipped away on the back of the fabric.

damask (1) Originally, a rich silk fabric of woven floral designs made in China and introduced to Europe through Damascus, from which it derived its name. (2) A construction that produces a reversible fabric in which areas of high and low luster (satin and sateen) are contrasted to create the figure and ground. (3) Fabric that features a lustrous satin surface and has a symmetrical layout. (Vase, leaf, and plant motifs are typical of traditional damask woven goods.) Usually woven in damask construction but may be printed or otherwise produced to achieve the effect. Also called *framed damask.*

decating A finishing process that applies heat, steam, and pressure to wool fabrics. Similar to calendering of cotton or linen fabrics.

decorative The portion of the textile market that supplies fabric for upholstery, drapery, and wallcovering, usually through interior designers, to be used in homes; included in the home furnishing or residential market.

degradé Voided velvet.

degumming The process of removing the sericin (gum) from silk.

denier The mass in grams of 9,000 meters of a fiber, filament or yarn. Higher denier indicates heavier material.

denim Heavy twill of carded cotton woven with dyed warp yarn and white filling yarns. See also *twill.*

dhurrie An Indian carpet woven with no pile from heavy cotton yarn. Patterns are formed by colored filling yarns.

dimensional stability The degree to which a fiber, yarn, or fabric retains its shape and size after having been subjected to wear, maintenance, and environmental factors.

directional A design in which all motifs or the finish are oriented in one direction, so that the design or the fabric surface looks correct only when viewed from one direction.

discharge printing An expensive multi-step printing method in which the ground cloth is dyed a solid color, desired areas are bleached out, and the bleached "discharged" areas are simultaneously printed with another color.

discontinuous brocade See *brocade*.

dobby (1) An attachment to a loom used to facilitate the weaving of small geometric patterns. (2) The fabrics produced on a dobby loom. (3) Woven fabrics featuring a small, all-over, geometric pattern.

documentary A design derived from a specific style or fabric. The original from which the design is derived is called the *document*.

domestics Fabrics designed and produced for sheeting, towels, blankets, and other bed, bath, or kitchen textile products.

dotted Swiss A sheer, traditionally cotton fabric with a pattern of raised dots that may be produced by weaving, embroidering, or flocking.

double cloth Fabric that results from weaving two layers of cloth simultaneously on the same loom. Double sets of warp and filling yarns are joined together at regular points by reversing the sets of warp or filling yarn, which allows clarity in isolated color. See figure G-5.

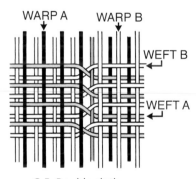

G-5 Double cloth

doupioni Silk yarns drawn from a cocoon that has been formed by two worms producing strands simultaneously or drawn from two cocoons. The yarn is uneven, irregular, and larger than regular filaments. Plain weave *shantung* cloth made from the yarn is sometimes called doupioni.

drape A term used to describe how a fabric hangs.

drawn work A type of needlework in which threads in a fabric are pulled aside, according to a design, and stitched together with a variety of decorative stitches with various types and colors of thread.

dry printing Pigment printing.

duck A very durable, plain-woven fabric, usually made of cotton or linen. It is available in a variety of weights. Heavier than canvas, though the terms are often used interchangeably. "Number 10 cotton duck" is popularly specified as the abradant material to be used in performing the Wyzenbeek abrasion test.

dye Colorants that chemically interact with fibers. They may be natural or synthetic and often require various processes or mordants to fix the color to the fiber. See also *piece-dyed, solution-dyed, stock-dyed, yarn-dyed*.

elastomer A material that has the ability to stretch to several times its length when pulled and to recover to its original length upon release.

embossing A finishing process in which fabric is calendered, usually with hot, engraved rollers, resulting in a dimensional design. In order for this process to be permanent, the fabric must be thermoplastic. Velvet and leather are commonly embossed.

embroidery The decoration of fabric with needleworked stitches, including cross-stitch and crewelwork.

end An individual warp yarn.

end and end Fabric woven with every other warp yarn alternating between colors or types of yarn.

end-user The individual or firm that inhabits or uses an interior for which materials (including fabric) were selected by an interior designer or architect. The end-user may not have been involved in making the selections. See also *client, consumer*.

engineered pattern A design in which the entire, completely self-contained pattern is used for one object such as a towel, scarf, or rug.

epinglé A fabric with short, uncut looped pile.

ergonomic seating Chairs that are specifically designed for maximum comfort and functionality during long-term use by office workers. Ergonomic chairs are usually sculptural in character and require that fabric tightly fit the molded cushions. Fabric is often applied through vacuum forming and gluing processes.

Essera Registered trademark owned by American Fiber (formerly Amoco) for polypropylene fiber.

eyelet embroidery A needlework technique in which small areas are cut or burned out from a base fabric according to a design. The cut edges are surrounded by embroidery stitches. See also *burn-out, schiffli*.

fabric A more inclusive term than *cloth* for textiles, plastic films, rugs and carpets, wire mesh, and other similar materials.

face The side of the fabric designed to be the front.

faille A soft, plain woven, rep cloth with horizontal, crossgrain texture made with a fine, densely sett warp and a heavier filling. Often silklike, it has a luster, crushes easily, and is used for moiré. (*Ottoman* has a similar ribbed effect, but is stiffer and heavier.)

fall-on (trap) An effect achieved by printing one color over a different one to yield a third color. Because they are difficult to control and predict, fall-ons are not commonly used.

fastness The property of dyed fabric to retain color when exposed to sunlight, water, and other elements.

felt A nonwoven fabric made from loose natural or man-made fibers that are formed into a sheet by means of moisture and pressure. Cellulose and some synthetic fibers require a bonding agent.

festoon A fixed curtain at the top of a window or door. It hangs from two points and is draped in a variety of styles. Also called *swag*.

fiber The chemically distinct primary unit of material, whether natural or synthetic, used for the manufacturing of fabric. Fibers are spun into yarn for weaving or knitting or formed into fabric by a nonwoven process.

Fiberglas Registered trademark owned by Owens-Corning Fiberglas Company for glass fiber.

figured weave A fabric that has a woven pattern or design.

filament A continuous form of fiber. Silk and hair are natural filaments.

Man-made filaments are produced by extruding solutions and other processes. Filaments are used in their entirety, manipulated, or chopped up into staple fibers that are spun into yarns. Unmanipulated, synthetic filament is called *continuous filament*.

filling The set of yarn elements in a woven fabric that run horizontally or from selvedge to selvedge, crossing and interlacing with the warp. Also called *weft* or *woof*. See figure 4-1.

fill-faced fabric Fabric that has a greater number of picks than ends on the face, or in which the picks are heavier than the ends, causing the filling to dominate.

film A man-made fabric manufactured directly from chemical solutions without yarn. Vinyl for upholstery or for wallcovering is a film.

finishes Processes applied to constructed, dyed fabric that give it its final appearance or add performance features. Examples are backing, beetling, calendering, embossing, napping, stain repelling, washing, and waterproofing.

fishnet A diagonally knotted net.

fit See *registration*.

flamestitch An irregular chevron pattern similar to a stylized flame. It may be woven or printed.

flannel A light- to medium-weight plain or twill woven that is fulled and usually napped, resulting in a fabric with a soft, brushed hand.

fleeced A fabric, usually knit construction, that is heavily napped.

float The passage of a yarn over another yarn before it interlaces in the weaving process.

flocking Applying an adhesive to certain areas of a fabric, then dusting the fabric with fine, loose fibers that adhere to the adhesive. Also called *flock printing*.

flock printing See *flocking*.

floss silk Silk yarn that is barely twisted and used for embroidery. Also called *embroidery floss*.

Fortuny print Originally, hand-printed fabrics designed by Mariano Fortuny, typically featuring a darker or mottled batiklike ground overprinted with metallic or lighter color to achieve the pattern. The patterns are reminiscent of those found in traditional Italian brocades and damasks. Mechanical print techniques imitate the original style.

foulard (1) A small-scale pattern in which all motifs are repeated directly above, below, and next to each other (e.g., polka dots); also called a *set* pattern or a *tailored* pattern. (2) The lightweight silk, rayon, cotton, or wool fabric characterized by its twill weave that is traditionally printed with these designs, originally for scarves and neckties.

framed damask See *damask*.

friezé, friezette Antiquated terms. See *frisé*.

frisé A woven pile with short, uncut loops. Patterns may be created by loops of different heights, the arrangement of the loops, or shearing the loops at various heights. The fabric is made from wool, mohair, or appropriate synthetic, and used for upholstery.

fulling A finishing process used on wool or protein fiber in which the fabric is shrunk by exposure to moisture, agitation, and soap. The resulting fabric has more bulk and resilience.

fusing A joining process that uses heat or chemicals to seam appropriate materials.

gabardine A fine twill woven fabric made from worsted yarn. It is durable, drapes, is densely sett, and has a hard twist, a slight luster, and a smooth hand.

gauge The measure of thickness of plastics and similar fabrics. Also, the measuring unit for knitting stitches. The higher the number, the thinner the sheet and the finer the knit.

gauze A plain weave, usually cotton fabric loosely woven from thin yarn.

Ghiordes knot Turkish knot. See *knots, carpet*, figure G-7.

gimp (1) A narrow, flat-woven braid used for upholstery trimming (often used instead of welt). (2) A core wrapped with silk, plastic, or metal.

gingham (1) A plain woven, lightweight fabric that is solid or woven in yarn-dyed checks. (2) The two-color checks of equal-size blocks typical of gingham.

glass fiber A generic fiber category in which the manufactured fiber-forming substance is glass.

glazing A finishing process in which fabric is treated with a substance such as wax, shellac, or resin and often is calendered, producing a polished surface. See also *chintz*.

Gobelin (1) A hand-woven tapestry from the Paris factory of the name. (2) The technique of weaving with discontinuous weft, creating a reversible design that dates to the sixteenth century.

grass cloth A wallcovering made with widely spaced warp threads and heavy bast fibers in the filling.

graufrage Embossed or stamped velvet or leather. Heated metal cylinders etched with the design apply the pattern.

gravure printing See *rotogravure printing*.

gray goods See *greige goods*.

greige goods (**gray** or **grey goods**) Fabric that has been woven but has not been wet- or dry-processed in any way. Also called *loomstate*.

grille The bars spanning the open spaces between areas in lace.

grosgrain A faille woven in a narrow width, made from silk or synthetic fiber with a similar luster and a cotton filling. Often used for ribbons.

gros-point, petit-point Embroidery made on a coarse canvas where the stitches are put at the intersections of the weave so the canvas is completely covered. In gros-point, stitches are twelve to eighteen per inch (4 to 7 per cm); petit-point is eighteen or more stitches per inch (8 per cm). Loop-pile woven fabrics are sometimes called gros-point because they resemble these stitched effects.

ground A textile surface, either dyed or undyed, onto which motifs are printed or another material is worked, such as in embroidery or tufting.

gum (1) The sericin emitted by a silkworm along with the silk filament to form the cocoon. (2) A group of natural, water-soluble substances used as adhesives, sizes, and glazes in the finishing of fabrics.

habutai (**habutae**) Japanese term for a lightweight, plain-woven silk fabric.

haircloth A stiff plain woven made from cotton and horsehair.

halftone Gradual shading from light to dark in one color, using only one roller or screen to achieve the effect.

hand (1) The way a fabric feels when handled; in England and in older usage *handle* is used instead of *hand*. (2) The "style" of an artist's design. *Tight hand* indicates a very fine, detailed rendering; *loose hand*, a freer, more stylized way of drawing.

hand-blocked Term describing fabric that has been printed by hand using the process of block printing. See also *block printing*.

handkerchief linen A calendered plain woven cotton or linen. The finish ranges from soft and matte to stiff with a luster. Also called *cambric*.

hand-spun Yarn that is twisted on a hand-operated spinning wheel. It is more irregular than machine-spun yarn.

handwoven Fabric that is made on a manually operated loom. Also called *handloomed*.

harlequin Any large diamond pattern often made in bright colors.

harris tweed A hand-woven plain or twill fabric made from homespun and hand-dyed wool yarn from the Scottish Hebrides Islands.

head-end An initial production sample of a woven fabric, usually less than a yard (meter) long, to be evaluated before further production is begun.

healthcare The portion of the interior furnishings market that includes design of and supplies materials for hospitals, nursing homes, doctor's offices, and other medical facilities.

heather A wool yarn or fabric that is a blend of a variety of tones and colors. The fibers are dyed before the yarn is spun. Sometimes simulated in synthetics. Also called *stock-dyed*.

heat setting A heat process applied to synthetic materials (or treated natural materials) that stabilizes the material, or forces it to retain a desired shape or effect.

heat-transfer printing Process of first printing a design on paper with printing inks containing dyes, then applying the paper with heat and pressure to fabric, which transfers the dyes. Possible only on certain synthetics, the technique offers infinite color and shading possibilities.

hemp A long (up to 8 feet or 2.5 meters), strong bast fiber retted from the hemp plant. Extremely resistant to rotting when exposed to water.

Herculon Registered trademark owned by Hercules for polypropylene fiber.

herringbone A twill fabric formed by bands of twill lines of alternating directions. See also *twill*.

high-tenacity rayon See *rayon*.

high-wet-modulus rayon See *rayon*.

holes Uneven gaps between motifs in a pattern design.

homespun A plain-woven fabric loosely woven from irregular, slubby yarn. May have an uneven texture. Originally, fabric that was handwoven from handspun yarn.

honeycomb See *waffle weave*.

hooked rug A rug made by pulling yarn or strips of fabric through a canvas or burlap ground with a hooked tool so that it forms loops on the face.

hopsack A coarse, plain woven fabric, sometimes a basket weave, constructed from burlap or similar fabric used for sacking.

horsehair (1) Long, lustrous hair obtained from the tail of a horse. (2) The stiff, smooth fabric that is woven from the fiber. See also *haircloth*. (3) The short hair fibers obtained from the horse's mane, used as stuffing material in period upholstered furniture.

hospitality The segment of the interior-furnishings market that includes design of and supplies materials for hotels, motels, restaurants, and similar facililties.

houndstooth A check pattern with pointed ends created by alternating blocks of light and dark yarn in both warp and fill directions in a twill weave.

ikat The Indonesian term for warp- or weft-resist dyeing. See also *warp-* or *weft-resist dyeing*, *kasuri*.

illusion A lightweight, fine tulle or net.

imberline stripe A damask with a multicolor warp stripe.

Impressa Registered trademark owned by American Fiber (formerly Amoco) for polypropylene fiber.

indienne Printed (or jacquard woven) designs that are French interpretations of early Indian prints. They are similar to Jacobeans but feature more exotic motifs rendered in a lighter, more finely detailed style.

indigo A blue-black vegetable dye.

interlacing The crossing over and under of warp and filling yarns to construct a woven fabric.

itajime Japanese resist-dye technique that uses engraved wood panels under pressure as the resist device. Also called *clamp-board resist*.

jabot An element of a window treatment that is a vertical hanging piece of fabric that comes to a point. Usually used in conjunction with a swag.

Jacobean Printed or jacquard-woven designs that are derived from popular embroidered furnishing fabrics of the Jacobean and late Elizabethan eras. Characterized by heavy ornament of German and Flemish origin, usually made up of branches and other arborescent forms accented by floral motifs, arranged in a meander layout.

jacquard A mechanism for a loom (also the fabric it produced) invented by Joseph J. M. Jacquard in 1801–1804. The jacquard machine, positioned above the loom, holds a set of punched cards that instruct the loom to weave the pattern according to the punched holes that correspond with threads to be lifted. Complicated patterns can be woven efficiently by jacquard weaving.

jaspé Yarn twisted of two different colors in the ply. Also called *marl*.

jersey A single knit that is all knit stitches on the face so it has a smooth surface and no distinct rib. The process is called *jersey stitch*.

jobber A textile company that buys a finished product and resells the fabric, usually in smaller quantities, to another customer. The term is commonly used to refer to the companies that call on and supply interior designers, decorators, and architects. Also called *wholesalers*.

jute A long (3- to 15-foot [1- to 5-

meter] bast fiber obtained by retting and used for twine and textiles. It deteriorates when exposed to moisture.

juvenile A design to be used for children's furnishings, clothing, linen, dishes, etc.

kapok A resilient, moisture-resistant fiber from the seed pods of the kapok tree used for stuffing pillows, mattresses, and life preservers.

kasuri Japanese term for warp- or weft-resist dying. See also *warp-* or *weft-resist dying, ikat.*

katazome A Japanese term for paste-resist stencil dyeing.

Kevlar Registered trademark owned by the DuPont Company for aramid fiber, which is considered flameproof.

khaki (1) A light-brown or olive-drab color. (2) A fabric dyed one of the shades of khaki, usually made of cotton.

kilim A tapestry-woven textile often used for rugs. Also *khilim* and *kelim*.

knit A fabric that has a continuous interlocking loop construction using a single yarn. This results in a fabric with some degree of elasticity. See figure G-6.

be open on the left or the right. See figures G-7–G-10.

knotted lace A fabric made by joining yarn with a series of knots, usually in some design. Examples are tatting and macramé.

knotted pile A technique of creating a pile fabric or carpet by hand tying yarns into the base fabric around the warp yarns. A variety of knots are used. See also *knots.*

lace A fabric constructed by twisting, knotting, or intertwining threads to create an open fabric. Unlike embroidery, no ground fabric is used. Lace is hand- or machine-made by a variety of techniques, producing many different types. Most variations can be categorized according to the construction. See also *schiffli.*

lamb's wool Wool clipped from sheep less than eight months old.

lamé (1) A flat fabric woven with metallic yarn so that it reflects light like metal does. (2) A warp-knit fabric that is bonded with a metallic coating layer.

laminate A fabric composed of two or more layers of woven or nonwoven

cloth joined by some adhesive process.

lampas Fabric woven with filling yarns of contrasting colors that surface in specific areas of the pattern as in a brocade, but none of the yarns are supplementary. When the fill color is not required on the face, it is woven inconspicuously on the back of the fabric.

lappet A plain woven that has extra warp threads applied to mechanically create the effect of a small embroidered pattern.

latex Dispersions of natural or synthetic rubber in water. May be extruded into yarn or used as a finish to coat fabric. Latex coatings are popular as backings for small, machine-made rugs.

lawn A sheer plain woven, usually cotton or linen, that is constructed in a way that gives it more body than a gauze or voile. It may be stiffly finished, like organdy. Also called *batiste.*

layout The plan for a textile design, showing the arrangement of motifs, irrespective of exact rendering or color.

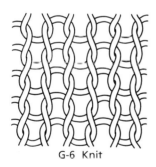

G-6 Knit

knock-off A design produced by one company copying a successful design of another company. The knock-off is usually less expensive than the original, and takes business away from the original. *Knock off* as a verb refers to the act of copying.

knots (1) A tied joining. (2) The means by which each yarn is held in place in knotted pile carpets or fabric. The yarns are wrapped around the warp and held in place by the weft. Three basic types of knots are: the Ghiordes (Turkish), Spanish, and senna (Persian). The senna knot may

G-7 Ghiordes knot

G-8 Spanish knot

G-9 Senna (Persian) knot
open on left

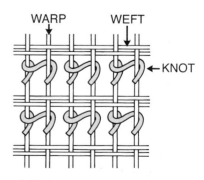

G-10 Senna (Persian) knot
open on right

leno weave A variation of plain weave in which pairs of warp threads are alternately twisted between each insertion of filling yarn. The technique stabilizes yarns in an open construction.

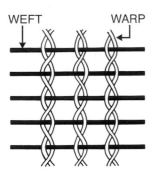

G-11 Leno weave

lightfastness The degree of resistance that dyed fabric or fiber has to the color-destroying influences of light.

line The group of products sold by one company and released to show to the market at one time. Also called a *range* or *collection*.

linen A bast fiber from the flax plant.

line-ups Unintentional lines formed by motifs in a design.

lisère A warp brocade fabric usually with a heavy, corded pattern on a figured ground.

loden (1) A heavy woolen fabric used for coating that is naturally water-resistant because the inherent oil has not been fully removed from the wool fiber. (2) The green color typical of loden fabric.

loft The springiness and resilience of a yarn or fabric to its bulk when squeezed.

looped pile See *pile*.

lustering A finishing process applied to yarn or fabric to produce a sheen. Processes mainly involve friction but may use heat or pressure. Synthetics are also often *delustered*.

Lycra Registered trademark owned by DuPont for spandex, an elastomeric polyurethane fiber.

macaroon An item of trim that is made from the same fabric as the piece to which it is applied. The fabric is made into a tube and then is shaped into a rosette, coil, or other contained shape.

Macbeth SpectraLight A small chamber made to isolate an object under lighting conditions free from outside influence. It can be set for a variety of specified lighting conditions.

madder A vegetable dye that produces a red color. It was one of the earliest permanent colorants.

madras Originally a hand-woven cotton imported from Madras, India, in woven plaids, checks, and stripes in which the yarn was dyed with vegetable dyes. U.S. trade regulations prohibit the term's being used to describe fabrics not actually from Madras, so it is also used as an adjective (rather than a proper noun) to describe a wide range of woven cottons, often of bright colors, that fade easily.

madras gauze A lightweight fabric (used for casements) with a leno foundation and patterns formed by a heavier supplementary filling that is woven into the motif areas and cut away at the edge of the motifs so that it does not appear in the ground areas. Originally from Madras, India, now woven primarily in Scotland and Italy.

malimo A technique in which a nonwoven base material is topstitched in various designs.

man-made fiber A general term for fibers that are either chemically processed from natural materials or are developed as new chemical compounds.

market (1) A segment of the textile industry that handles fabric for a particular end-use, such as the apparel market, decorative market, or contract market. (2) A segment of the textile industry that sells fabric of a particular price range, such as a middle market or high-end market. (3) The time or year when a particular segment of the industry introduces new product lines, usually once or twice a year for a particular segment of the industry.

Marquésa Lana Registered trademark owned by American Fiber (formerly Amoco) for polypropylene fiber.

marquisette A leno-woven, netlike fabric that may be plain or patterned and is used for curtains. See also *leno*.

matelassé A double cloth with a quilted or padded texture resulting from stuffer yarns inserted between layers. Usually jacquard woven in solid or near-solid colors.

melton A heavy (usually woven with a double warp or filling) woolen flannel that has been fulled but not napped.

memo (memo sample) A sample of an individual fabric that is supplied by fabric companies to interior designers for reference and selection purposes. Usually about 10 inches (25 cm) square, but may be much larger if necessary to see overall color, repeat, or effect. In decorative trade, designers are charged for memos if they are not returned. Contract suppliers usually do not charge for memos.

memory The ability of a material to retain its finished shape and character when stretched or manipulated.

mercerization A chemical process applied to cotton yarn or fabric that permanently increases the luster and receptivity to dye by immersing it in caustic soda under tension. Invented by John Mercer, in England, in 1844.

mesh A fabric that has regular openings between the yarns. It may be constructed by any appropriate method.

metallic printing A form of dry, or pigment, printing in which a metal powder or other reflective material combined with a binder is applied to the fabric's surface.

metallic thread or **yarn** A thin strip of metal or synthetic film that looks like metal used as yarn. This film is usually supported with another yarn through twisting before it is used in weaving.

microfiber An extremely fine synthetic yarn (with a count of one denier or less) used in woven and knitted fabrics. The minute yarn size allows for a lightweight high-density fabric with a range of properties, including wind- and waterproofness, and that allows moisture vapors to escape through it, has a soft hand, and has the ability to maintain temperature, wash easily, and drape well.

mill A company that owns and uses the equipment necessary to produce fabric.

mineral fibers Fibers that can be

processed into yarn and/or fabric that are derived from minerals. They include asbestos, glass, and rubber.

mock leno A variation of plain weave in which yarns group together in both directions to produce a fabric with open spaces resembling a leno, but without the twisting of warp yarns.

modal British term for high-wet-modulus rayon fiber. See also *rayon*.

mohair A long fiber from the hair of the angora goat that is spun into a soft, lustrous yarn. Commonly used as the pile fiber in mohair plush.

moiré (1) A calendering process with engraved rollers that results in a rippled surface resembling watermarks. (2) The visual effect of the process. It may also include fabric that has been printed to imitate the calendered effect or fabric that naturally crushes into the effect, like faille.

moisture regain The ability of a material to retain its finished shape and character when it comes in contact with moisture in the atmosphere.

moleskin A satin-weave fabric tightly woven with a very short nap for a suede finish. Originally of cotton; today, similar fabrics are made from microfibers.

monk's cloth A heavy, usually cotton, fabric constructed in a loose basket weave.

monofilament A filament (usually man-made) made from single extruded units.

moquette Short pile upholstery fabrics made from wool, mohair, or similar stiff fiber. They may be cut or looped pile or a patterned combination. Also called *moquette velvet*.

mordant A chemical used to set dyes. It may be applied during different stages of the manufacturing process depending on the dye, fabric, yarn, or desired effect.

motif The basic element that is repeated in a pattern or that forms the theme of a design.

multifilament A fiber yarn composed of many fine filaments. See also *monofilament*.

muslin A wide range of plain woven cotton fabrics. May be sheer or heavy, bleached or naturally colored.

Mylar Registered trademark owned by DuPont for plastic slit film that is highly reflective and appears to be metallic.

nailhead Tacks made of brass or other metal that hold fabric to an upholstery frame as a decorative accent; called *nailhead trim*. The nailheads may be round or other shapes and may be arranged in straight lines or in patterns such as swags or scallops.

napping A finishing process in which the fabric is passed through abrasive rollers that disturb its surface. The fabric has a soft hand and a suedelike appearance.

narrow goods Fabric that is woven no more than 27 inches (70 cm) wide, which was once the maximum size of commercial looms. It is an indication of the age of antique fabrics or specialty techniques that have not been modernized.

natural dyes Dyes that are derived from animals, vegetables, or minerals, such as cochineal, indigo, madder, and aniline. These colors are usually simulated with synthetic dyes today.

natural fibers Fibers derived from animals, vegetables, or minerals that can be spun into yarn.

needlepoint A type of needlework in which a yarn is pulled through the spaces between the warp and filling of a loose woven base fabric to create a design.

needlepunched A process of joining a web of fibers by a mechanical method used in making nonwoven fabrics, in enhancing the stability of other fabrics, and for decorative effects.

needle tapestry A type of needlework done on a canvas base. Made to imitate a woven tapestry.

net An open fabric usually made by knotting yarns, threads, or rope in a square pattern.

noils Short fibers that are byproducts of yarn production. They are spun into rough and novelty yarns or used as padding.

Nomex Registered trademark owned by DuPont for aramid fiber, which is considered flameproof.

nonwoven fabric A fabric that is constructed by joining the fibers or fila-

ments by means of adhesives, pressure, or heat.

novelty yarn A yarn manufactured with a unique texture or other non-standard qualities. Examples are bouclé, chenille, and ratiné.

nub A clot of fiber on a yarn. Considered a flaw when excessive or unexpected in limited areas.

nylon A man-made synthetic fiber. It is strong and durable, exhibits high static and pilling, and has low moisture regain.

ogee A layout featuring onion-shaped designs.

oil cloth A waterproof fabric made by coating a base fabric (which may be napped) with a compound of oil, clay filler, and binders.

olefin Polypropylene fiber.

ombre A stripe composed of distinct bands of color closely related in hue, value, or intensity and placed in graded order from lightest to darkest or dullest to brightest.

open work See *cutwork*.

organdy A sheer cotton fabric that is a closely woven plain weave and has a crisp finish.

organza A rayon, silk, or nylon fabric resembling organdy.

organzine A heavy, plied filament silk yarn usually used as warp, and the plain taffeta fabrics that are woven from the yarn.

Orlon A registered trademark owned by DuPont for acrylic fiber.

ottoman A heavy plain-woven fabric with a prominent horizontal rib resulting from a heavier-weight filling yarn. Usually heavier, stiffer, and with less sheen than faille.

overprint A print process in which the design is printed onto dyed or patterned fabric.

overshot A woven effect created by filling floats in a brocade technique to achieve simple, geometric patterns.

oxford A fine cotton plain-woven fabric that employs a basket weave or similar variation, often using a white filling and yarn-dyed warp.

paisley A traditional Asian pattern of intricately drawn and decorated tear drop shapes usually in rich colors. Originally produced in India and found on painted and printed fabric,

and on woven cashmere shawls. Imitations of the oriental shawls were first woven in Paisley, Scotland.

panels The movable walls that define and separate spaces in an office interior; *panel fabrics* are engineered to cover them. Called *systems* or *systems furniture* as a category.

panné velvet A pile fabric that has been calendered in one direction, creating high luster. It is lightweight, drapes well, and is made from silk or a synthetic with similar properties.

pashmina From the Persian *pashm*, the word for cashmere fiber. Fabrics marketed as pashmina tend to be a lightweight, fine construction and may be blended with silk. See also *cashmere*.

paste-resist dyeing A resist-dye process in which the resist is starch paste. See also *resist dyeing, katazome*.

patchwork A technique in which pieces of cloth are stitched together, making one unit with no ground cloth. The pieces are typically small and of different colors or types of fabric.

pattern A design for decorating a surface composed of a number of elements arranged in a regular, continuous, or formal manner.

peau de soie A satin-woven silk or similar synthetic with a cross-rib and with a slight luster.

pelmet A fabric-covered, shaped valance.

percale A plain-woven cotton using fine carded or combed yarn and having a high thread count.

Persian knot Senna knot. See *knots*, figures G-9 and G-10.

petit-point See *gros-point*.

pick One individual filling yarn. See *filling*.

piece A bolt of fabric of the length usually manufactured and conveniently stored and handled.

piece-dyed Fabric dyed in piece, or bolt, form, usually in a solid color, after it has been constructed.

pigment An opaque colorant that does not chemically bond to the fiber as dye does. A chemical binder or binding process is necessary to adhere the color.

pigment printing (*dry printing*) Applying color to dry cloth using pigment and a chemical binder. The

effect of this method is that the color appears to sit on the surface of the cloth.

pile A looped yarn on the surface of a fabric. It may be cut or uncut and is produced by a variety of techniques that include: (1) Yarns knotted through a base fabric. (2) A set of yarns woven over wires and through a base fabric. The wires are slipped out to form a loop, or have a cutting edge that when raised, results in cut pile. See figure G-12. (3) A set of yarns woven through a double cloth. The yarns are sliced, resulting in two pieces of cut-pile fabric. See figure G-13.

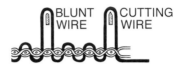

G-12 Loop pile–woven fabric

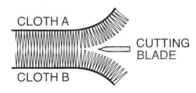

G-13 Cut pile double cloth

pilling The tendency of a fabric, usually synthetic, to form little fuzzy balls in reaction to abrasion. Considered a defect when excessive.

piqué A woven fabric with raised areas created with heavy stuffer picks. It may also have small geometric surface designs. When the design is a vertical cord, it is called *bedford cord*.

plaid A woven design formed by warp and filling yarn of different colors crossing at perpendiculars. In a *true plaid*, the warp and filling are the same layout. A plaid may be simulated through printing. See also *tartan*.

plain weave One of the three basic weaves, in which a filling yarn crosses over a warp yarn and then under the next warp yarn. Each row alternates the "over" and "under" warp yarns. Many variations are possible as a result, both of the character of yarns used and of variations within the weave. Among the fabrics woven in a plain weave are: gingham, calico, muslin, tapestry. See figure G-14.

plaiting A construction formed by interlacing one or more elements. Not applied to most woven fabrics, the term usually refers to braids, mats, and baskets.

plangi Indonesian term for a resist-dyeing technique that employs binding, wrapping, folding, or a combination of these processes before dyeing.

pleat Folds in a fabric fixed by a process of stitching or heat.

plissé (1) Originally, a cotton fabric treated with caustic soda in a way that shrinks the fabric where the caustic soda is applied. The result is pleated effect. (2) Any fine, lightweight, pleated fabric.

plush A velvet with long pile. Usually constructed in mohair or wool.

ply (1) The single yarn element that is twisted into a plied yarn or cord. (2) The individual layer of fabric in a product composed of multiple layers.

polished cotton Cotton fabrics characterized by a sheen resulting from a finishing process or satin weave.

polka dot A round dot that forms a surface pattern.

polyester A man-made fiber that is high-strength, washable, and abrasion-resistant but subject to pilling, collecting static electricity, and staining.

polypropylene A man-made fiber that is bulky but lightweight, can only be solution-dyed, and has a low melting temperature, which allows for texturing of the yarn (which can be heat set). The term is interchangeable with *olefin* with regard to fiber.

polyurethane See *urethane*.

pongee Plain-woven silk fabric produced from uncultivated silk, characteristically with slubs, irregularities,

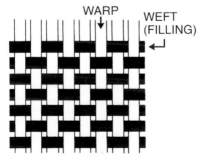

G-14 Plain weave

and in a varied natural color. Also called *tussah*.

poplin Plain-woven cotton fabric with fine horizontal ribs resulting from a heavier-weight filling yarn and more picks than ends.

portiére A curtain that hangs behind a door.

Portuguese Printed fabrics that simulate fabrics which were block-printed in England during the mid-nineteenth century for export to Portugal. Often features brightly colored figured stripes with vases and vignettes.

print Fabric that has been colored by a printing process.

printing The production of patterns or motifs on a fabric by applying a coloring agent to the fabric surface in specific areas. See also *block print, discharge printing, resist printing, roller printing, rotary printing, screen printing*.

Provençal prints Country French textile designs derived from eighteenth-century woodblock prints, usually small-scale floral or geometric patterns in rich, sunny colors and in set layout.

quality Term that refers to fabric as defined by its construction but not by its weave, design, pattern. Two fabrics that use the same size and content yarn, with the same number of ends and picks, and with the same finish are said to be of the same *quality*, although they could be completely different patterns.

quilt (1) A product made by stitching through two layers of fabric that enclose a layer of padding. (2) To stitch through these layers, usually in a pattern.

raffia A long fiber usually less than an inch (2.5 cm) wide harvested from the raffia palm. The fiber is traditionally used to make mats and baskets, but it is sometimes woven.

rag rug A woven rug with a cotton warp and a filling made from cut strips of finished fabric.

railroad To turn a fabric sideways when upholstering on furniture so that the filling yarns run vertically.

raised embroidery Needlework that creates a pattern by covering padding with a satin stitch.

ramie A cellulosic fiber made from the bark of a ramie plant. It is soft with low abrasion resistance but is blended with other fibers for use in upholstery and wallcovering.

ratiné An irregular, loopy yarn made by twisting heavier, pretwisted threads around a fine core yarn. Ratiné is less loopy and more zigzagged than bouclé.

raw The unprocessed state of a fiber.

raw silk Silk that has not been completely degummed and is stiff.

rayon A man-made fiber processed from cellulose that is easily dyed and lustrous. Used alone or as a blend, the yarn is used in a variety of fabrics with a soft hand and that drape well. *Viscose* rayon has been processed into liquid and then extruded into filament and is rayon's most popular form. *Cuprammonium* rayon is extruded through a copper solution. *Saponified* rayon is reverted from actetate. *High-wet-modulus* rayon and *high-tenacity* rayon are physically modified fiber forms that yield greater stability in the material.

recovery The ability of a fabric to return to its original shape after compressing, bending, exposure to heat or moisture, or other deformation. Also called *resilience*.

registration Exact alignment of all rollers or screens in order to print all motifs onto the fabric in correct relation to one another. Also called *fit*.

rep A fabric with a horizontal rib effect characterized by closely spaced warp yarns with ribs or cords in the filling. A slub yarn may be used in the filling for texture.

repeat One standard design unit containing a specific arrangement of motifs that is repeated across the width and along the length of a fabric. The horizontal repeat size of a design must divide evenly into the width of the fabric to be printed or woven.

resilience See *recovery*.

resin A synthetic finishing material applied to fabric to give stability or a specific luster or hand.

resist dyeing A process in which selected yarns or parts of the fabric are dyed, while others are treated in a manner that prevents the acceptance

of dye. When the resist substance is removed, some effect or design is achieved. The fabric may be overdyed for additional effects. See also *batik, ikat, itajime, kasuri, katazome, paste-resist dyeing, roketsuzome, tie-dyeing, tritik, wax-resist dyeing, warp-* or *weft-resist dyeing*.

resist printing A process parallel to resist dyeing in which the resist is applied by means of a printing technique.

rib A straight, raised structural ridge repeated across the length, width or on the diagonal of a fabric.

ribbon Narrow woven fabric used as trimming.

rib weave A plain weave that produces a rib by combining different weights of warp and filling yarns or by varying tension of the warp. See also *rib*.

roketsuzome A Japanese term for wax-resist dyeing.

roller printing A printing process in which engraved copper rollers apply the design to fabric as it passes around a metal cylinder. In limited use today, except with heat-transfer printing paper, called *rotogravure printing*.

Roman shade A window covering that lies flat when extended and pulls up in accordion pleats. Like Austrian shades and balloon shades, it is raised up on vertical cords from the bottom.

rotary printing A printing process in which cylindrical "screens" made of aluminum mesh are masked in certain areas, and dye is applied from the inside of the screen through the unmasked areas onto the fabric. Also called *rotary screen printing*.

rotogravure printing The roller-printing process used to print patterns with dyes onto heat-transfer printing paper that is later transferred to fabric through sublimation.

rows (1) The average number of pile yarns per inch (centimeter) on the warp of carpet. (2) The stitches in knitting or crocheting that run from one side of the goods to the other.

rug A floorcovering of a specific size and design. It may be of any structure, including woven or tufted, or made from nonwoven materials such as felt or animal skins.

sailcloth Originally a cotton duck used for construction of boat sails, the term now also refers to a wide group of strong medium- or heavy-weight, plain-woven fabrics of cotton, synthetics, or a blend.

sateen (1) A filling-faced satin weave. See figure G-15. (2) Cotton fabric used for prints.

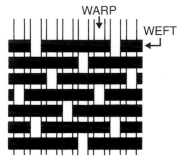

G-15 Sateen weave

satin A smooth, warp-faced fabric that is a product of the satin weave.

satin weave One of the three basic weaves, which produces a smooth surface by floating warp yarns over multiple picks (warped-faced), or floating filling yarns over multiple ends (filling-faced sateen). The points of intersection of warp and filling are as widely spaced as possible.

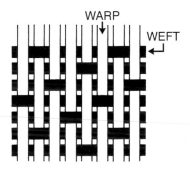

G-16 Satin weave

Savonnerie French factory-made rugs knotted in an oriental style but with rococo designs.

schiffli A machine method used to manufacture lace and embroidered fabric.

Scotchgard A registered trademark of the 3M Company for a stain-repellent finish that was phased out in 2000 because of concerns that a compound produced in the manufacturing process persists in the body and the environment.

screen printing A printing process in which dye is forced through unmasked areas of a silk or nylon screen stretched on a wooden frame. The process can be accomplished by hand, or more commonly through automation. See also *rotary printing*.

scrim Lightweight, loose, plain woven cotton or linen. Also called *gauze*. In very wide widths, called *sharkstooth scrim* or *theatrical gauze*.

sculptured The effect of raised and depressed areas of a carpet surface, a design created by cutting the pile shorter in certain areas than in others.

sea grass A plant that grows in or around water that has fibers used for plaiting, braiding, knotting, and weaving. Also known as *aquatic grass*, *rush*, and *aquatic rush*.

seam The line created where two pieces of fabric are joined together by sewing or adhesive. Sewn seams may be *plain*, *topstitched*, or *double topstitched*. *Double topstitched* is also called *baseball* or *saddle* seam.

seersucker A woven fabric, usually cotton or blend, with a permanent crinkled stripe in the warp direction produced by alternating groups of warp yarns, fibers, and weaves that shrink differently.

SEF (Self-Extinguishing Fiber) Registered trademark owned by Solutia (formerly Monsanto) for modacrylic fiber.

selvedge (selvage) The long, finished edges of a bolt of fabric that run parallel to the warp. The filling yarns are caught by these end yarns, and they usually are a stronger yarn than the rest of the warp.

senna knot Persian knot. See *knots*, figures G-9 and G-10.

serge A regular twill fabric woven in many weights, from a variety of yarns (cotton, silk, wool, synthetics) with a prominent diagonal rib.

sericulture The raising of silkworms and the production of silk.

sericin See *gum*.

sett Number of yarns or threads per inch (or centimeter) in the warp and their specific arrangement in the reed of the loom.

shade See *Austrian shade*, *balloon shade*, *Roman shade*.

shantung Plain-woven silk, originally made from uncultivated silk on handlooms in Shantung, China. The fabric originally was made of tussah but today usually is made of doupioni yarns.

sheen The lustrousness of a fabric or yarn. Considered a positive characteristic. *Shine* or *shininess* is considered a negative description.

sheer (1) Lightweight, translucent fabric made from a variety of fibers in a variety of weaves. (2) Translucent curtains hung adjacent to glass windows, often behind other drapery.

shibori Japanese term for resist-dyeing technique that employs binding, wrapping, folding, stitching, or a combination of these processes before dyeing.

shot fabric Fabric woven with fine warp and filling yarns (usually silk or similar synthetic) that reflect light differently, resulting in an iridescent effect. Also called *iridescent taffeta* or *shadow silk*.

sign cloth A medium-weight plain weave with the face filled with starch, clay, or a variety of plastics or vinyls. Used for banners and outdoor signs.

silk (1) A protein fiber harvested from the cocoons of silkworms. The raw silk filament is stiff from the gum (sericin) that holds the cocoon together. The gum is removed by boiling. The cleaned filament is fine, supple, lustrous, and exceptionally strong. Silk is naturally in filament form as extruded by silkworms. (2) Thread or fabric made from silk.

sisal A long, durable, and flexible fiber from the leaves of the sisal plant. It ranges in color from light beige to yellow to olive and is used for twine, cord, mats, and carpets.

sizing Substances applied to yarn or as a finishing to fabric that add smoothness, stiffness, luster, weight, or other surface qualities.

skewed A characteristic horizontal deviation across a fabric in which a filling yarn runs diagonally instead of horizontally across the fabric. Considered a flaw when the deviation is more than 1 inch (2.5 cm).

slippage The propensity of yarns that make up a fabric to slip or slide apart,

leaving open spaces in the fabric. Slippage that occurs where two pieces are seamed together is *seam slippage.*

slit tapestry See *tapestry.*

slub A thick twist or heavier part of a length of yarn, considered a flaw when excessive or unexpected in limited areas.

slub yarn A novelty yarn with alternating thick and thin areas spun into the yarn.

solution-dyed Synthetic fiber that has been dyed while still in the solution state before being extruded into filaments.

soutache A round braid, usually with a herringbone pattern, used for trimming.

space-dyeing A technique for dyeing yarn in which a single length of yarn is printed or injected with different colors at irregular intervals, producing a random variegated effect.

spandex An elastomeric fiber composed primarily of polyurethane.

Spanish knot See *knots,* figure G-8.

specifier The person or firm (usually an interior designer or facilities planner) that chooses the fabrics and other furnishings to be bought by a different party (such as an installer, fabricator, or end-user) for a specific interior project.

spinning The mechanical process of making yarn from staple fiber.

spun-bond A nonwoven process for producing fabric by randomly joining extruded synthetic filaments. During the process, the filaments twist and loop, forming an irregular net.

staple Natural fiber or cut lengths from filaments that is spun into yarn. See also *fiber, filament.*

stencil printing A technique that applies a design by means of cutting out a motif in paper, plastic, or other appropriate material, laying this stencil on the surface to be printed, and applying ink or paint through the open area of the stencil.

stock-dyed Staple fiber that has been dyed and then blended into a yarn, creating a heathered effect.

stretch yarn Yarn that has been manufactured to have a permanent stretch and recovery. It often contains elas-

tomeric fiber or may have a high twist.

striae or **strié** A stripe that changes subtly in color and/or texture throughout the fabric, usually creating an all-over effect.

strike-off The initial production trial made of a printed fabric so that accuracy of color and design may be verified before full production begins.

strike through The unwanted tendency of adhesive or other liquid that is applied to the back of a fabric to seep through to the face.

structure A description of a specific woven or knitted fabric using the details of the yarn interlacings and interloopings in the cloth—that is, weave or stitch, irrespective of fiber content, pattern, or design.

stuffer An extra yarn or thread that runs between the back and front of the fabric used to give weight or bulk or to give relief to a pattern. See also *brocatelle, matelassé,* and *piqué.*

stylist The person employed by a textile company to direct and coordinate the development of the company's product line.

sublimation Chemical process that causes color to be applied to cloth, used in heat-transfer process. Printed paper is heated, causing the dye on its surface to bond with the fabric placed over it, without need for dye paste.

suedecloth Woven or knitted fabric that has been finished with a short nap to give a hand that is similar to leather suede.

supplementary yarn (weft) A yarn that may be removed without affecting the base fabric. See also *brocade.*

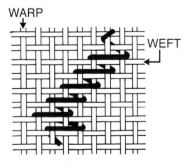

G-17 Supplementary yarn

swatch A small sample of fabric.

swivel weave A mechanical technique that produces novelty fabric that ap-

pears to have been embroidered. A loom attachment applies a separate, supplementary yarn to the ground fabric without the necessity of floats between the motifs.

synthetic Fibers made from chemicals that were never fibrous in form. Man-made synthetics are developed by chemists; natural man-made fibers occur in nature but are manipulated into a filament form by man.

systems furniture, open office system See *panels.*

tabby Fabrics made with a plain weave.

tabby weave Plain weave.

taffeta A very fine-sett plain-woven fabric usually made of silk, mercerized cotton, or similar synthetic, with a smooth face and usually a luster.

taffeta weave Plain weave.

tapestry (1) A hand-woven textile in which the design is created by discontinuous filling yarns worked over the specific area. When the next filling color is woven, it must be joined to the adjacent area by a variety of interlocking methods including: slit, interlocking, dovetail, and eccentric. (2) The weaves used in these hand-woven fabrics. See figures G-18, G-19, G-20, G-21 on page 294. (3) A jacquard fabric that is tightly woven, weft-faced, with multiple warps and fillings, and often in patterns and textures reminiscent of hand-woven tapestry.

tartan A plaid worsted twill or plain weave with individual patterns historically representing different Scottish clans. Usually symmetrical, true plaids. Modern usage of the term refers to a variety of balanced, woven plaids in many different yarns and colorations that are reminiscent of the originals. See also *plaid.*

tattersall A large overcheck, usually in two colors over a solid ground.

Teflon A registered trademark of DuPont for stain-repellent finish.

tensile strength The resistance of a yarn to breakage when stretched.

tentering A finishing technique in which fabric is stretched to a desired size and then heat-set.

terry cloth A looped warp pile fabric woven with the pile on both sides. It is usually cotton or an absorbent synthetic.

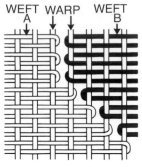

G-18 Slit tapestry

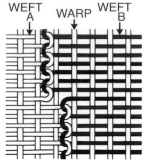

G-19 Interlocking tapestry

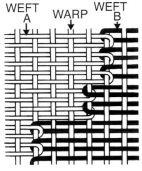

G-20 Dovetailed tapestry

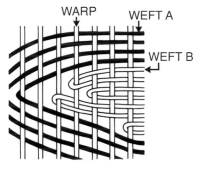

G-21 Eccentric tapestry

textile A woven fabric.

texture The general description of a fiber, yarn, or fabric in terms of the overall effect achieved through its structure, appearance, or hand.

textures Textiles that are woven with surface variations as a result of different yarns or loom techniques. These tactile variations are in the hand, character, and relief, but are not motif patterns.

texturized Filament yarn that has been processed in a way that roughens its smooth appearance and yields a more spun-like character. Also called *air-texturized*, *air-entangled*.

thermoplastic The characteristic of a material to soften when exposed to heat and reharden when cooled.

thermoset The characteristic of a material to harden irreversibly when heated.

thread (1) A thin, flexible cord, often plied, twisted, and finished, that is used for sewing and needlework. (2) Synonymous with *yarn* when used to refer to yarns in woven goods, as in "threads per inch."

thread count Measure of cloth density and fineness indicated by enumerat-

ing first the number of warp ends per inch (or centimeter), then the number of filling picks per inch (or centimeter).

ticking (1) Any tightly woven textile of any structure or pattern used for the outside of bed mattresses. (2) Coarse, two-color stripes traditionally used to cover matresses. A blue-and-white striped twill is the most common.

tie-dyeing A process in which areas of fabric are stitched, wrapped, folded, bound, or tied before the material is dyed. Those tied areas resist the dye, and shapes are produced when the ties are removed. The fabric may be overdyed. This technique also may be applied to the yarns before weaving. See also *ikat*, *kasuri*, *plangi*, *tritik*, and *warp-* or *weft-resist dyeing*.

toile de Jouy A style of printed linen, cotton, or silk fabric characterized by floral designs and genre scenes, printed in a single color on a light ground, usually finely drawn in the style of an engraving. The French town of Jouy was the site of the first well-known western factory to produce these copper-engraved prints that originated in

India for the European market. Commonly abbreviated to *toile*.

toile de Nantes A less common style of toile than toile de Jouy, from a rival production center, featuring cruder motifs and stripe layouts with "twisted" motifs. Floral (rather than scenic) motifs are typical.

tossed layout A fabric-design type in which motifs do not recur at regular intervals within one repeat unit.

Trace F.R. Registered trademark owned by American Fiber (formerly Amoco) for flame-resistant polypropylene fiber.

tram silk A low-twist, plied silk yarn formed by combining two or three single strands, generally used as filling.

transitional A stylized fabric design for home furnishings, usually showing some recognizable naturalistic motifs, considered to be usable with a variety of design themes rather than with one particular historical period.

trapunto A quilting technique of outlining the area of a design with stitching and then stuffing the defined areas to produce a raised design.

Trevira Registered trademark owned by Hoechst-Celanese for polyester fiber. Popular in interior furnishings in its F.R. (flame-resistant) form (called Trevira F.R. or Trevira C.S.). It is currently marketed as Avora.

tricot A durable warp-knitted fabric with vertical wales on the face. It is usually made of acetate, nylon, or rayon.

tritik Indonesian resist-dye technique that employs a drawn-up stitch technique as the resist method. It allows for intricate designs. Also called *stitch resist*. See also *resist dyeing*, *tie-dyeing*.

trompe l'œil Patterns designed to produce the illusion of absent architectural features or to show realistically rendered objects.

true check A plaid (or check) composed of a warp and a filling stripe that are identical. Also called *true design*, *true plaid*.

tuft A yarn or strip of pliable material pulled through a finished base fabric so that either both ends of the material are on the face of the fabric or a

group of long loops are formed. The tufts may be tied or fastened (as in the case of a quilt) to hold the padding layer in place, used purely as a decorative technique, or secured with a backing (as in a tufted carpet). See also *tufted*.

tufted (1) Carpet produced by a tufting machine, not a loom. The tufts are secured to the base by a backing of latex or similar material. (2) Fabric in which tufts are used to form lines or designs. This may be done by hand or by a mechanized process. See also *candlewick*, *chenille bedspread*. (3) In upholstery, a stitch taken through the entire thickness of the sofa back, from the face fabric through all cushioning material and attached to the frame. The stitch is covered with a button that is normally covered in fabric that may match or contrast with the main fabric. The buttons may be arranged in diamonds (*diamond tufting*) or squares (*biscuit tufting*).

Turkish knot Ghiordes knot. See *knots*, figure G-7.

tussah A coarse, light-brown silk yarn or fabric made from cocoons of uncultivated silkworms. The fabric is also called *pongee*.

tweed Named for the Tweed River in Scotland, where such fabrics were first woven, a broad group of woolen fabrics and yarns. The yarn is often multicolored or the fabric may be woven from several colors of yarns, in plain or twill weaves. The hand ranges from rough to soft, but varieties are distinguished by a speckled nubby quality derived from the yarn. Some specific tweeds are Harris and Donegal, named for the areas where they originated.

twill damask A fabric in which combinations of warp- and fill-face twill mix to create an intentional pattern.

twill weave One of the three basic weaves in which the filling yarns pass over one or more and under one or more warp yarns in offset progression to create the appearance of diagonal lines. Denim is a ubiquitous twill cloth. Some variations of the weave are herringbone and bird's eye. See figure G-22.

twist The number of turns about its axis per unit of length of yarn or other textile strand. Direction of twist is indicated by S or Z. If the yarn spirals are parallel to the middle portion of the Z it is a "Z-twist," and vice versa. S-twist is most common; Z-twist is a specialty affect.

Tyvek Registered trademark owned by DuPont for spun-bonded fabric of olefin fiber.

unbleached Cotton fabric or yarn that is left in its natural color, which is a distinctive cream.

union cloth A plain weave cloth made of warp of one fiber (most often cotton) and fill of a different fiber (usually wool or linen). Called *cotton/wool* or *cotton/linen union*, respectively, and used as a greige cloth for piece-dyeing or printing.

urethane A group of synthetic chemical compounds used to produce a wide variety of foam materials that range from soft foam used for furniture cushions to rigid and brittle materials. Also called *polyurethane*.

valance A rectangular border usually used at the top of a window. It may also refer to a bed canopy or similar decorative use.

vegetable dyes Dyes such as madder or indigo that are derived from botanical sources. See also *natural dyes*.

velour (1) A general term for velvet, plush, and velour. (2) A pile fabric constructed in a plain or satin weave, usually cotton, with a dense, short-cut pile that lies in one direction. (3) A napped knitted or flocked fabric made to imitate velvet.

velvet A warp-pile fabric that is constructed as double cloth (two sets of warp and filling yarns) with a fifth yarn set forming the pile. While still

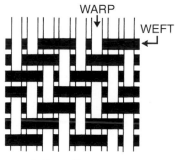

G-22 Twill weave

on the loom, the fabrics are cut apart by a lateral cutting knife. See figure G-13.

velveteen A filling-pile fabric constructed similarly to velvet, usually in cotton.

vertical integration A term describing textile companies that perform operations on more than one manufacturing level, for example, a company that spins yarn, weaves, dyes, and finishes fabric.

vinyl A nonwoven water-repellent film that may be used alone or laminated to a backing fabric.

virgin wool In the U.S., new wool that is made into yarns and fabrics for the first time. Outside the U.S. it refers only to the wool from the first shearing of a sheep or lamb never before shorn.

viscose rayon See *rayon*.

voided velvet A fabric in which the pattern is created by pile areas (motif) contrasted against nonpile (ground) areas. This can be achieved through either a burn-out process that eliminates the pile in the unwanted areas or through isolating the pile areas in the weaving process (similar to discontinuous brocade).

voile A transparent, sheer, plain-woven fabric with a low thread count. It is made from a variety of fibers and has a crisp hand.

waffle weave A group of fabrics woven on a dobby loom that have dimensional, square ridges forming a wafflelike texture. Also called *honeycomb*.

wale (1) The pile cord in corduroy. (2) One lengthwise row of stitches (loops) in knitted fabric.

warp The set of yarn elements running lengthwise on a loom and in woven fabrics on the bolt. It is in place before the weft or filling yarns are woven over and under it. Individual warp yarns are called *ends*. See figure 4-1.

warp dyeing A process in which the warp is dyed before the fabric is woven. See also *warp-resist dyeing*.

warp-faced Fabric that has a greater number of ends than picks on the face or in which the ends are heavier than the picks, causing the warp to dominate.

warp print A process in which the warp yarns are printed before the fabric is woven. The filling yarns usually remain solid. During the weaving, the warp yarns shift slightly resulting in a slightly blurred pattern. See also *chiné*.

warp- or **weft-resist dyeing** A dye technique in which the warp or weft or both are resist-dyed before the cloth is woven. See also *ikat*, *kasuri*, *resist dyeing*.

washi Handmade Japanese paper. Used since ancient times, it is manufactured in many thicknesses, may be laminated, and is used as decorative structures and wallcovering.

wax-resist dyeing A resist-dye process that uses hot wax as the resist. See also *batik*, *hot-wax printing*, *resist dyeing*, *roketsuzome*.

weave The process of interlacing two sets of yarns (warp and filling) at right angles to form a fabric. The basic weaves are plain, twill, and satin, and others are based on these.

weft See *filling*.

welt The fabric-wrapped cord used where fabric meets the wood frame of many upholstered sofas and chairs. May match or contrast with the main fabric. In *double welt*, two parallel cords are used. Welt is also used at seams of cushions. *Flange welt* uses the fabric wrap without the cord filler.

wet-out A finishing process that involves wetting fabric without agitation and then drying it.

wet-printing Coloring fabric with dyes rather than pigments by a printing method.

Wilton A woven, cut- or looped-pile carpet made on a loom that allows for a wide range of pile heights and colors. Wiltons are often woven and in narrow (27-inch [70 cm]) widths. The effect yarn is run inconspicuously on the back when not appearing on the face. See also *Axminster*.

woof See *filling*.

wool Fiber derived from the fleece of sheep. The fiber is resilient and may be blended with natural or man-made fibers.

woolen Yarn spun from wool fibers that are shorter and more crimped than those used for worsted yarn, and the fabric woven from that yarn. Tweed and flannel are woolen fabrics. See also *worsted*.

worsted Yarn spun from combed, long wool fibers, and the fabric woven from that yarn. It has a smoother, finer, more even character than woolen yarn. Gabardine and serge are worsted fabrics.

yarn A strand made from spun fibers or continuous filament that is used in weaving and knitting.

yarn-dyed Fabric that is made from yarn that is dyed before the fabric is constructed.

yuzenzome A Japanese dyeing technique using rice paste applied in fine lines as a resist with subsequent direct dyeing with brushes. The result is a style of elaborate pictorial design that is often combined with metal-leaf application and/or embroidery.

Sources

American Fibers and Yarn Company
P.O. Box 66
Greenville, SC 29602-0066
(800) 925-0668

American Silk Mills Corporation
41 Madison Avenue
New York, NY 10010-2202
(212) 213-1919

Arc-Com Fabrics, Inc.
33 Ramland South
Orangeburg, NY 10962
(800) 223-5466

Aubergine Interiors
30 Ezekills Hollow
Sag Harbor, NY 11963
(631) 725-7404

Backhausen & Son Gesmb.H
Kartner Strabe 33
A-1010 Wein (Vienna)
AUSTRIA

Baker Furniture
1661 Monroe Avenue NW
Grand Rapids, MI 49505
(616) 361-3324

Barbara Ross Interior Design
226 East 54th Street
New York, NY 10022

BASF Corporation
1675 Broadway, 35th Floor
New York, NY 10019
(212) 408-9700

Bernhardt Textiles
P.O. Box 740
Lenoir, NC 28645
(212) 888-3232

Blumenthal
99 Railroad Street
Canaan, CT 06818
(860) 824-8000

Braemore, a Division of P/Kaufman, Inc.
2 Park Avenue
New York, NY 10016
(212) 292-3286

Brenda Brady Designs
4145 Travis Suite 102
Dallas, TX 75204
(214) 528-6294

browngrotta arts
276 Ridgefield Road
Wilton, CT 06897
(203) 834-0623

Brunschwig & Fils
979 Third Avenue
New York, NY 10022-1234
(212) 838-7878

carletonV
979 Third Avenue
New York, NY 10022
(212) 355-4525

Carnegie
110 North Centre Avenue
Rockville Centre, NY 11570
(516) 678-6770

Chatham
An Interface Company
304 E. Main Street
Elkin, NC 28621
(336) 835-2211

Chista
537 Greenwich Street
New York, NY 10013
(212) 924-5754

Churchville Fabrics
1215 Unity Street
Philadelphia, PA 19124
(212) 535-4917

Clarence House
211 East 58th Street
New York, NY 10022
(212) 752-2890

Color Association of the United States (CAUS)
315 West 39th Street, Studio 507
New York, NY 10018
(212) 372-8600

Country Curtains
Main Street, Department 5158
Stockbridge, MA 01262
(413) 243-1474

Craftex Mills, Inc.
P.O. Box 3017
Blue Bell, PA 19422-0795
(610) 941-1212

Hi-Tex, Inc.
32813 Middlebelt Road
Farmington Hills, MI 48334
(248) 855-6000

Culpepper, McAuliffe & Meaders Inc.
3300 Northeast Expressway
Atlanta, GA 30341
(770) 676-7600

Margaret Cusack
124 Hoyt Street
Brooklyn, NY 11217-2215

Daniel C. Duross Ltd. at Ruth Caplan Ltd.
232 East 59th Street, 3rd Floor
New York, NY 10022
(212) 826-3756

Designer's Guild for Osborne & Little, Inc.
90 Commerce Road
Stamford, CT 06902
(203) 359-1500

Doblin Fabrics
2 Park Avenue, Suite 1606
New York, NY 10016
(212) 578-1233

Donghia
485 Broadway
New York, NY 10013-2607
(212) 925-2777

DuPont (E. I. DuPont de Nemours and Company)
Wilmington, DE 80840
(800) 441-7515

Duralee Fabrics
150 West 25th Street, 10th floor
New York, NY 10001
(516) 273-8800

Entrée Libre
110 Wooster Street
New York, NY 10012
(212) 431-5279

Erika Brunson Custom Line
903 Wesbourne Drive
Los Angeles, CA 90069
(310) 652-0010

Fantagraph
One Knollcrest Drive
Cincinnati, OH 45237
(513) 761-9255

Teri Figliuzzi
315 Riverside Drive
New York, NY 10025

Fonthill, Ltd.
979 Third Avenue
New York, NY 10022
(212) 755-6700

Freundorfer Gallery at the Kitano
66 Park Avenue
New York, NY 10016
(212) 885-7130

GA Peach Designs
185 East 85th Street, 20F
New York, NY 10028
(212) 722-2405

Gessner
10 Park Avenue, Suite 20S
New York, NY 10016
(212) 696-9338

Govmark
96 D Allen Boulevard
Farmingdale, NY 11735
(516) 293-8944

Greeff
79 Madison Avenue
New York, NY 10016
(212) 213-7989

GretagMacbeth LLC
617 Little Britain Road
New Britain, NY 12553

Grey Watkins
979 Third Avenue
New York, NY 10022
(212) 755-6700

Guilford of Maine
An Interface Company
5300 Corporate Grove Drive, Suite 200
Grand Rapids, MI 49512
(800) 544-0200

Haworth, Inc.
One Haworth Center
Holland, MI 49423-9570
(616) 393-3000

Herman Miller, Inc.
855 East Main Avenue
Zeeland, MI 49464-0302
(616) 857-2554

Hi-Tex, Inc.
32813 Middlebelt Road
Farmington Hills, MI 48334
(248) 855-6000

Hytex Industries
58 York Avenue
Randolph, MA 02368

Intek
An Interface Company
300 Taylor Street
Aberdeen, NC 28315
(910) 944-4300

Interface Flooring Systems
1503 Orchard Hill Road
LaGrange, GA 30241
(800) 336-0225

Jay Yang Partners
132 West 22 Street, 10th
 Floor
New York, NY 10011
(212) 206-9012

Glen Kaufman
Department of Art
University of Georgia
Athens, GA 30602
(706) 542-1660

Kirk Brummel
979 Third Avenue
New York, NY 10022
(212) 755-6700

Knoll
105 Wooster Street
New York, NY 10012
(212) 343-4000

Koroseal
3875 Embassy Parkway
Fairlawn, OH 44333
(330) 668-7675

Carol I. Kover
59 West 12 Street
New York, NY 10011

Lee Jofa
201 Central Avenue South
Bethpage, NY 11714
(516) 752-7600

Lx Rossi
71 Williams Avenue
San Francisco, CA 94124
(415) 671-1144

Maharam
251 Park Avenue South
New York, NY 10010
(212) 995-0115

Manuel Canovas
136 East 57th Street
New York, NY 10022
(212) 213-6522

**Maverick Group, a division
 of Yates Weisgal Inc.**
185 East 85th Street, 20F
New York, NY 10028
(212) 722-2405

Merida Meridian, Inc.
643 Summer Street
Boston, MA 02210
(617) 464-5400

Momentum Textiles
17801 Fitch Street
Irvine, CA 92614
(800) 366-6839

Morris & Co.
979 Third Avenue, 4th Floor
New York, NY 10022-1234
(212) 319-7220

NUNO Corporation
Axis Bldg, B1F Minato-KU
Roppongi, Tokyo
106-0032, JAPAN
011-81-3-3582-7997

Panache Designs
8445 Melrose Avenue
Los Angeles, CA 90069
(323) 651-3700

Paradigm Genetics
P.O. Box 14523
Research Triangle Park, NC
 27709
(919) 425-2930

Perkins & Will
1 Park Avenue, 19th Floor
New York, NY 10016

Pollack
150 Varick Street
New York, NY 10013
(212) 627-7766

R. Jones and Associates
P.0. Box 560705
Dallas, TX 75356
(214) 951-0091

Randolph & Hein
2222 Palou Avenue
San Francisco, CA 94124
(310) 855-1222

Robert Allen Fabrics
55 Cabbott Boulevard
Mansfield, MA 02048
(800) 531-1110

**Robert Noble Ltd./Replin
 Fabrics**
March Street Mills
Peebles EH45 8ER
SCOTLAND, UK
011-44-1721-720-146

Rodolph Incorporated
999 West Spain Street
Sonoma, CA 95476
(707) 935-0316

Scalamandré
37-24 24th Street
Long Island City, NY 11101
(212) 980-3888

**Schumacher, a division of F.
 Schumacher and Co.**
79 Madison Avenue
New York, NY 10016
(800) 523-1200

Ron Sheridan
Stelmar Trading Corp
1359 Broadway
New York, NY 10018
(212) 695-4399

Sina Pearson Textiles
150 Varick Street
New York, NY 10013
(212) 366-1146

Steelcase
P.O. Box 1967
Grand Rapids, MI 49501-
 1967
(616) 698-4222

**StretchWall Installations,
 Inc.**
42-03 35th Street
Long Island City, NY 11101
(718) 729-2020

Stylex
Box 5038
Delanco, NJ 08075
(856) 461-5600

Sunbury
460 Broome Street
New York, NY 10013
(212) 925-4600

Swiss Net Company Ltd.
CH9540
Meunchwilen TG
SWITZERLAND
011-41-71-969-3232

Travers & Company
979 Third Avenue
New York, NY 10022
(212) 888-7900

Trendway
13467 Quincy Street
P.O. Box 9016
Holland, MI 49422
(800) 968-5344

Tunnell Handel & Assoc.
1133 Broadway, Suite 1609
New York, NY 10010-7902
(212) 645-9026

P. C. Turczyn
113 Carroll Street
Brooklyn, NY 11231
(718) 852-2321

Tuva Looms
636 Broadway, Room 1200
New York, NY 10012
(212) 598-1021

Betty Vera
41 Union Square #521
New York, NY 10003

Ray Wenzel
P.O. Box 31
New York, NY 10276

Carol Westfall
208-17 West Shearwater
 Court
Jersey City, NJ 07305

Wools of New Zealand
700 Galleria Parkway, Suite
 300
Atlanta, GA 30339-5943

Xamax Industries, Inc.
63 Silvermine Road
Seymour, CT 06483

Illustration Details

Many of the fabrics and furniture illustrated in this book are currently produced. When known, the sources are listed in the captions that accompany the photographs, and the names of the items are detailed on the following pages. Most suppliers listed sell to the trade only; some sell retail. A few sources listed do not supply designers directly but do refer inquires to a trade source. Names and addresses for all those credited are listed in the sources section on pages 297–298.

For unique products, or when sources are unavailable, the captions offer what is known about the material, such as its fiber content, technique, and date and country of origin.

Copyright notices and the names of individual designers appear with images at the request of the specific source. The reader should assume that all images featured are the property of their source or their producer and may not be reproduced without permission.

American Fibers and Yarns Company
3-3 Polypropylene extrusion through a spinneret
3-5 Polypropylene texturized yarns
3-36 Polypropylene pelletized resin and color concentrate
6-9 Polypropylene pelletized resin

Aubergine Interiors
5-45 Living room interior
8-67 Bedroom interior

Baker Furniture, designer: Marypaul Yates
1-10 "Newberry"
3-25 "Kyoto," "Salem," and "Hamburg"
4-26 "Conamaragh"
4-78 "Penzance"

BASF Corporation
3-4 Solution-dyed yarns are wound onto packages at BASF's plant in Anderson, SC
3-33 "Monet's Garden" by Sina Pearson Textiles made of Zeftron 200R; BASF carpet made of Zeftron 2000R. Both BASF solution-dyed nylon
6-6 Packages of solution-dyed carpet yarns wait for shipment
6-10 At BASF's plant in Anderson, SC, vats of pigment for solution dyeing
9-2 Wyzenbeek test
9-3 Crocking test—laying out the fabric
9-4 Crocking test—sandwiching the fabric
10-3 Solution-dyed upholstery yarn draw twisting in Anderson, SC, plant.

Bernhardt Textiles
1-4 "Clarity"
3-31 "Sky Lark," designer: Teri Figliuzzi
4-38 "Earthquake," designer: Marypaul Yates
4-47 "Button," designer: Jennifer Eno
4-54 "Earth Works," designer: Marypaul Yates
5-32 "Baby Walker," designer: Jennifer Eno
6-4 "Suzanne's Stripe," designer: Suzanne Tick
10-1 "Chendail"

Blumenthal
8-68 "Aerial," "Superior Stripe," and "Diagonal Stride"
8-71 "Madagascar"
8-72 "Superior Stripe" (with reverse side)
8-74 "Tanaka Grassland"
8-76 "Tuscan Wall"
8-82 "Tatami"
8-91 "Intaglio"
8-92 "Industrial Jute" and "Industrial Chic"
8-93 "Industrial Jute"
8-94 "Enigma"
8-95 "Enigma"

Brenda Brady Designs
8-142 Interior featuring Chinese vests

browngrotta arts
8-139 Sheila Hicks: "Compresse II" (linen, 1967), photo ©Tom Grotta 1995, Courtesy browngrotta arts
8-140 Chiaki Maki: Large Silk Akina Devider (Malda and Doupioni, silk natural anar and red chandon dye, 1998), photo ©Tom Grotta 2000, Courtesy browngrotta arts
8-141 Lenore Tawney : "Celebration" (linen, 1973–74), photo ©Tom Grotta 2000, Courtesy browngrotta arts

Brunschwig & Fils
3-19 Fabric: "Suchet Horsehair Medallion"; chair: "Directoire Sidechair "
4-68 "Ivy Madras Lace"
4-70 "Lindsey's Garden Liseré"
4-71 "Boxwood Woven Figure"
4-72 "Les Kaftans"
4-75 "Sconset Quilted Floral" (reverse side)
4-77 "Lockwood Figured Plaid"
4-98 "Adirondack Patchwork"
5-12 "Abigail Figured Woven"
5-13 "Rivere Enchantee Cotton Print"
5-14 "La Portugaise Glazed Chintz"
5-15 "Sconset Quilted Floral"
5-19 "Bromley Hall Toile"
5-36 "Comtesse D'Artois Silk Warp Taffetas"
5-37 "Comtesse D'Artois Printed Warp"
5-43 "Benoa Cotton Print"
6-25 "Tropical Hermitage Glazed Chintz"
6-39 "Vezelay Cotton Print"
6-40 "Out of Africa Cotton Print"
6-50 "Sevenoaks Cotton and Linen Print"
6-60 "Chesterfield Cotton Print"
6-61 "Shishi Cotton Print"
8-25 Fabric: "Suchet Horsehair Medallion"; chair: "Directoire Side Chair"

Alva Lee Bryan
4-93 Hand-embroidered crewel, American, mid-twentieth century, wool/linen

Carnegie
8-35 "Xorel Chair"
8-37 "Triton Stretch"
8-75 "Palazzo," Création Baumann for Carnegie
8-86 "Xorel™ Two"
8-87 "Xorel™ Two"
8-88 "Xorel™ Two"
8-89 "Xorel™," Classic Xorel™ patterns "Strie," "Nexus," and "Meteor"
9-9 "The Twist"

Charlene Page Kaufman Textile Study Collection, Lamar Dodd School of Art, University of Georgia
5-42 Detail of yukata, shibori (stitch- and bound-resist-dyed), indigo dye on cotton
6-48 Fragment, Java?, nineteenth century?, wax-resist (batik) on cotton
6-51 Detail of naga-juban (under kimono), itajime shibori (clamp-board–resist dyed), chemical dye on silk
6-52 detail of yukata, shibori (stitch- and bound-resist-dyed), indigo dye on cotton

Chatham, Inc.
6-13 Jet dyeing
9-1 Textile testing laboratory
9-7, 10-10 Sample weaving on a loom

Chista
8-133 Woven mat, Borneo, rattan

Clarence House
5-8 "Parvoon"
5-9 "L'Herbier"
5-11 "Nicotiana"
5-16 "Ali Baba"
5-17 "Mongolia"
5-21 "Le Navigateur," toile, circa 1800
5-24 "La Conteuse"
5-25 "Coromandel"
5-26 "Staffordshire"
5-28 "Bibliotheque"
5-34 "Feuilles D'Automne"
5-48 "Palazzo Strozzi"
5-49 "Tsarevich"
5-53 Floral, original document, Collection of Clarence House
5-54 "Floral," print on cotton
5-56 "Topkapi"

Culpepper, McAuliffe and Meaders Inc., Atlanta GA
1-11 Carlisle Palm Beach Care Facility
1-17 Doubletree Hotel in Tampa
8-122 Carlisle Palm Beach Care Facility

Margaret Cusack
8-136 "Hands" hangs in the J. Willard Marriott Continuing Education Center on the campus of the Culinary Institute of America in Hyde Park, New York

Daniel C. Duross Ltd. at Ruth Caplan Ltd.
7-6 Pillow with Gaufrage Deerskin "Renaissance"

Designer unknown
1-8 Handblock printed cotton, India, late 20th century
4-88 Hooked rug, American, wool/ cotton
4-89 Hooked rug, American, wool/ cotton
4-92 Hand-embroidered cross-stitch, American, mid-twentieth century, cotton/linen
4-106 Bark cloth, African, twentieth century
6-37 Handblocked print, India, late twentieth century, cotton
6-54 Ikat (warp), Indonesia
6-55 Double ikat, Indonesia
8-115 Matting, woven, vinyl-covered cord

Designer's Guild for Osborne & Little, Inc.
10-4 "Jalaja" (discontinued)

Doblin
5-10 "Cumbria"

Donghia
4-5 "Block Island Arm Chair"
4-21 "Brenta Stripe"
9-8 "Brenta Stripe"

DuPont Fibers
3-34 "Pachinko"
4-44 "Wool-Dura"

Duralee Fabrics
designer: P. C. Turczyn
5-1 "Nobuko" and "Haiku" from the "Haiku Collection"
5-33 "Gingko" from the "Haiku Collection"
5-47 "Lotus Land" from the "Haiku Collection"
6-26 "Haiku" from the "Haiku Collection"

Entree Libre
8-128 Color weave for colors available for custom orders for Marcel Zelman-ovitch. 100% wool, Tibetan.

Erika Brunson Custom Line
4-96 "Princess Armchair "

Fantagraph
Decorative Healthcare Textiles by Fantagraph
4-111 Sunrise, Cincinnati, OH. Ice cream parlour/eating area. Printed drapery and woven Crypton. Draperies manufactured by Fantagraph.
8-62 Fantagraph, Cincinnati, OH. Manufacturing workroom. 72-inch printed, woven cubicle with mesh attached.
8-64 Sunrise, Cincinnati, OH. Bath/ whirlpool using solid and printed drapery. Draperies manufactured by Fantagraph.

Fonthill
4-99 "Chatsworth Chintz"; handblocked cotton chintz fabric (quilted as special sample) (N 092)

Greeff
designer: P. C. Turczyn
5-60 "Bukhara"

GretagMacbeth
6-2 GretagMacbeth SpectraLight™III

Grey Watkins
4-27 "La Poterie"

Guilford of Maine
8-98 Panel fabrics
8-100 "FR701®"
8-107 Panel fabric

Haworth Inc.
Courtesy of Haworth Inc.
8-106 Panels, "Enhanced Premise"; work surface, "if"; side table and storage, "if"; overhead storage, "One Touch"; worktools, "Jump Stuff"; seating, "S-Con"

Herman Miller
1-15 "Ethospace" Interiors, red "Equa" chairs
4-102 "Aeron" chair
8-34 "Ethospace" call center
8-97 "Ethospace" work stations
8-99 "Action Office Series," "Equa" seating
8-101 "Passage" Product line, Arc Screen: "Comet Harvest Moon"
8-105 "Ethospace" Interiors (stackable frames), "Meridian" files and "Aeron" seating
8-120 "Aeron" side chair, "Passage Free Standing Furniture Office Environment line"; fabric: "Ribbons Rhythm"

8-121 "Passage" product line, "Ribbons Rhythm" fabric
11-4 "Ethospace" Interiors, "Equa" seating

Sheila Hicks
8-139 "Compresse II" (linen, 1967), photo ©Tom Grotta 1995, Courtesy browngrotta arts

Hi-Tex, Inc.
7-15 "Crypton™"
7-16 "Crypton™"
10-2 House of Crypton™

Hytex Industries, designer: Kathleen Tunnell
8-70 "Reflections/Expressions" Wallcovering fabrics

Intek
8-103 "Galaxy"

Jay Yang Partners
5-5 "Dundee"

Glen Kaufman
8-138 "Murgang Sa, Namsan," screen print, silverleaf on silk

Kirk Brummel
8-24 "Amalfi" (Helen Wainwright)
8-52 "Compeigne" (Helen Wainwright)

Knoll
Courtesy Knoll
4-90 "RPM" chair

Koroseal
8-80 "Esquire"
8-81 "Chimayó"

Lee Jofa-Groundworks
8-38 "With Curves"
8-49 "Leno Square"

Lx Rossi
4-85 "Pairoli" chair
7-13 "Como" chair

Maharam
8-73 "Tek-Wall™" (with reverse side)
8-85 "Tek-Wall™"

Chiaki Maki
8-140 Large Silk Akina Devider (Malda and Duopioni, silk natural anar and red chandon dye, 1998), photo ©Tom Grotta 2000, Courtesy browngrotta arts

Manuel Canovas
5-22 "Les Indiennes"
6-14 "Brantome"

Merida Meridian, Inc.
4-6 Unnamed prototype, black and natural 100% paper.
4-7 "Panama" prototype, reversible weave. 50% wool, 50% paper.
4-11 "Tatami, Light Stripe." 100% paper.

Momentum Textiles
8-63 "Bamboo Fields"
8-65 "Glorietta" and "Hacienda"
8-66 "Ballyhoo," "Hoopla," and "Hullabaloo"

Morris & Co.
5-7 "Golden Lily"

Nuno Corporation
6-18 "Cloud Chamber," designer: Keiji Otani
6-20 "Mercury," technique development: Keiji Otani; surface design: Reiko Sudo
7-7 "Crystal Pleats," designer: Reiko Sudo

Panache Designs
4-69 "Copenhagen" Dining Armchair
7-14 "Normandie" Club Chair

Paradigm Genetics
8-123 "Systems" furniture: "Contrada®" by Trendway. Facility: Paradigm Genetics; workplace design team: Nicholas Peele and Debby Ryals.

Perkins & Will
1-3 Reception area, New York Presbyterian Hospital, pediatric cardiology
7-17 Patient area, New York Presbyterian Hospital, pediatric cardiology

Pollack
1-5 "Butti" and "Butti Stripe"
3-20 "Thai Texture"
3-40 "Jet Stream"
3-42 "Shadow Play"
3-48 "Reverie"
4-34 "Chinoiserie" (face)
4-35 "Chinoiserie" (reverse side)
4-50 "Rhythm," "Jazz," and "Tap Dance"
4-91 "Techno"
4-103 "Vinery Finery"
5-3 "Festoon"
5-4 "Mayfair," "Gazebo," and "Maypole"
5-20 "Animal Magnetism," "Animal Instincts," and "Animal Desires"
5-29 "Solitaire," "Chinese Checkers," and "Tiddlywinks"
5-35 "Chiaroscuro"
8-39 "Skyline"
8-40 "Net Worth," "Techno," and "Knit Wit"
8-50 "Zephyr"

R. Jones & Assoc.
3-8 Fabric: "Diamond Desert," designer: Marypaul Yates; sofa: "Deco Series"
3-29 "Harvest," designer: Marypaul Yates
4-20 "Diamond Desert," designer: Marypaul Yates
5-46 Fabric: "Frontier," designer: Marypaul Yates; chair: "Alexi Series," designer: Dennis Christiansen
8-4 Sofa: "Uptown," designer: Dennis Christiansen
8-6 Fabric: "Diva"; chair: "Charleston Series"
8-11 Sofa: "Adolfo Series"
8-13 Sofa: "Elan" Lounge
8-14 "Bentley" lounge chair
8-18 COM form
8-23 Fabric: "Diva"; sofa: "Charleston Series"
8-29 Fabric: "Rainforest", designer: MaryPaul Yates; chair: "Adolfo Series"

Randolph & Hein
7-12 Fabric: "Staccato"; chair: "Cantrall"

Robert Allen Contract, designer: Marypaul Yates
3-35 "California Sojourn" Collection
4-46 "Painter's Palette" Collection
5-2 "Painter's Palette" Collection
6-16 "Fast Track" Collection
9-5 "California Sojourn" Collection

Robert Noble Ltd/Replin Fabrics
3-39 J5497 0201 (Marl yarns in damask quality)

Rodolph Incorporated
3-12 "Calypso"
3-22 "Castille,"
designer: Marypaul Yates
3-32 "Garland Stripe"
4-23 "Arielle,"
designer: Marypaul Yates
4-32 "Castille,"
designer: Marypaul Yates
4-33 "Nonpariel,"
designer: Marypaul Yates
4-60 "Ribbet" (face)
4-61 "Ribbet" (reverse side)
5-6 "Solid Start"
5-18 "Ribbet" and "Gecko"
6-45 "Illusions"
7-5 "New Pizzazz"
8-60 "Heir Apparent,"
designer: Marypaul Yates
10-5 "Imperial Plaid,"
designer: Marypaul Yates

Scalamandré
4-73 "Giardino Esotico"

Scalamandré Archives
4-56 Pattern 93.46.
Metallic, silk
6-47 W Genoa,
seventeenth century, voided
cut/looped velvet

Schumacher, a division of F. Schumacher & Co.
6-42 "Gilet"

Sina Pearson Textiles
3-33 "Monet's Garden" by
Sina Pearson Textiles made
of Zeftron 200R, BASF
solution dyed nylon (shown
with BASF carpet made of
Zeftron 2000R)

Steelcase, Inc.
8-96 95S0722

Stylex, Inc.
2-4 Chair: "Bounce"
8-5 Chair: "Swing"
8-7 Chair: "Swing"

Sunbury
5-41 62083
5-61 59261

Swiss Net Company Ltd.
3-30 961532
4-64 466/76A Pro 415

Lenore Tawney
8-141 "Celebration" (linen,
1973–74), photo ©Tom
Grotta 2000, Courtesy
browngrotta arts

Trendway
8-123 Systems furniture:
"Contrada®" by Trendway.
Facility: Paradigm Genetics;
workplace design team:
Nicholas Peele and Debby
Ryals.

P.C. Turczyn
6-49 "Nandini"

Tuva Looms
8-126 "Satin Block"
8-127 "Glen Plaid"

Betty Vera
8-137 "Memory Garden"
(installation view), The
Kitano, New York

Ray Wenzel
1-7 "Magic Mountains"
5-30 "Dreamland"

Carol Westfall
4-2 "Back To Basics"

Wools of New Zealand
8-109 "Decorwool"
8-124 "1996 Decorwool"

Xamax
4-105 Industrial surface veil
fabric, spunbonded polyester

Photographers

Chuck Choi Photography
204 Berkely Place
Brooklyn, NY 11217
(917) 678-5825

Guy Gurney
P.O. Box 7206
Wilton, CT 06897
(203) 761-1021

Judy Juracek
43 Kent Hill Lane
Wilton, CT 06897
(203) 761-0081

James Anton Koch
Koch Studio, Inc.
109 South West Point Avenue
High Point, NC 27260-7252
(910) 887-6677

Maryanne Solensky Photography
187 Montclair Avenue
Montclair, NJ 07042

Mikio Sekita
79 Leonard Street
New York, NY 10013
(212) 925-6717

Bibliography

Albeck, Pat. *Printed Textiles.*, Vol. 5 of *Oxford Paperback Handbooks for Artists*. New York: Oxford University Press, 1969.

Albers, Josef. *The Interaction of Color*. New Haven: Yale University Press, 1971.

Alster, Norm, and William Echikson. "Are Old PCs Poisoning Us?" *Business Week*, 12 June 2000, 78–80.

American Society for Testing and Materials. *The Handbook of Standardization*. Conshohockon, Penn.: American Society for Testing and Materials, 1999.

——. *ASTM Annual Book of Standards 2000*. Section 7, *Textiles*, Volume 7.02. Conshohocken, Penn.: American Society for Testing and Materials, 2000.

Amoco Chemicals. *Chemical Reactions*. Vol. 16. Greenville, N.C.: Amoco Chemicals, 1997.

Barker, A. F. *An Introduction to the Study of Textile Design*. New York: E. P. Dutton and Co., 1903.

BASF Corporation. *BASF Performance Certification*. N.P. : BASF Corporation, 1995.

Billcliffe, Roger. *Mackintosh Textiles Designs*. New York: Taplinger Publishing Co., 1982.

Birren, Faber. *Principles of Color*. N.p.: Schiffer Publishing Co., 1987.

Blum, Herman. *The Loom Has a Brain*. Rev. ed. Philadelphia: Craftex Mills, Inc., of Penna., 1973.

Bonda, Penny. "Mainstreaming Green." *EnvironDesign Journal*. Northbrook, Ill.: L.C. Clark Publishing Co., spring 1999.

Braddock, Sarah E., and Marie O'Mahony. *Techno Textiles*. New York: Thames and Hudson, 1998.

Bury, Hester. *A Choice of Design, 1850–1980*. London: Warner and Sons, 1981.

Busch, Jennifer Theile. "A Finer Rendition." *Contract Design*, September 2000, 54.

Carmichael, Linton, and Price. *Callaway Textile Dictionary*. LaGrange, Georgia: Callaway Mills, 1947.

Corragio, Ida. "Finished Business." *Contract Design*, February 1997, 62.

Custom Laminations, Inc. *Custom Laminations, Inc: Enhancement Services Catalog*. Paterson, N.J.: Custom Laminations, Inc., 1997.

Dan River, Inc. *Dictionary of Textile Terms*. 14th ed. New York: Dan River, Inc., 1992.

Daubs, James. "Laying it Down." *Contract Design*, July 1998, 68.

Editors of American Fabrics Magazine. *Encyclopedia of Textiles*. Englewood Cliffs, N.J.: Prentice-Hall, 1980.

Emery, Irene. *The Primary Structure of Fabrics*. Washington, D.C.: The Textile Museum, 1966.

Fannin, Allen A. *Handloom Weaving Technology*. New York: Design Books, 1998.

Fitterman, Tobe Jane. "Wall Coverings: Practical Information for Perfect Design Solutions." *Interiors and Sources*, April 2000, 102–105.

Gentille, Terry A. *Printed Textiles*. Englewood Cliffs, N.J.: Prentice Hall, Inc., 1982.

Goven, Carol, and Marty Gurian. "Fabrics for Your Health." *Contract Design*, November 1998, 68.

Greene, Fayal. *The Couch Book*. New York: Hearst Books, 1993.

Grimble, Ian. *Scottish Clans and Tartans*. New York: Crown Publishing, 1986.

Grosicki, Z. J. *Watson's Advanced Textile Design*. 4th ed. London: Butterworth and Co., 1977.

Hardingham, Martin. *The Fabric Catalog*. New York: Pocket Books, 1978.

Harris, Jennifer. *Textiles 5,000 Years*. New York: Harry N. Abrams, 1993.

Hittinger, Joe. "Designing 'Green.'" *Interiors and Sources*, May 1991.

Johnston, Meda Parker, and Glen Kaufman. *Design on Fabrics*. New York: Van Nostrand Reinhold Co., 1981.

Joseph, Marjory L. *Introductory Textile Science*. 6th ed. Orlando: Harcourt Brace College Publishing, 1993.

Joyce, Carol. *Designing for Printed Textiles*. Englewood Cliffs, N.J.: Prentice-Hall, 1982.

——. *Textile Design*. New York: Watson-Guptill Publications, 1993.

Juracek, Judy. *Surfaces*. New York: W. W. Norton & Company, 1996.

——. *Soft Surfaces*. New York: W. W. Norton & Company, 1999.

Justema, William. *The Pleasures of Pattern*. New York: Reinhold Book Corp., 1968.

———. *Pattern.* Boston: New York Graphic Society, 1976.

Kirby, Mary. *Designing on the Loom.* Tarzana, Calif.: Studio Publications, 1955.

Kolander, Cheryl. *A Silk Worker's Notebook.* Rev. ed. Loveland, Colo.: Interweave Press, 1985.

Larsen, Jack Lenor. *Material Wealth: Living with Luxurious Fabrics.* New York: Abbeville Press, 1989.

Larsen, Jack Lenor, and Jeanne Weeks. *Fabrics for Interiors.* New York: Van Nostrand Reinhold Co., 1975.

Licking, Ellen. "Turning Blue Jeans Green." *Business Week,* 30 November 1998, 99.

Linton, George E. *The Modern Textile Dictionary.* Plainfield, N.J.: Textile Book Service, 1973.

Loecke, John. "Got it Covered." *American Homestyle and Gardening,* July/August 1999, 32.

Louder than Words. Ventura, Calif.: Patagonia, 1998.

Lubell, Cecil. *United States and Canada.* Vol. 1 of *Textile Collections of the World.* New York: Van Nostrand Reinhold Co., 1976.

———. *United Kingdom and Ireland.* Vol. 2 of *Textile Collections of the World.* New York: Van Nostrand Reinhold Co., 1976.

———. *France.* Vol. 3 of *Textile Collections of the World.* New York: Van Nostrand Reinhold Co., 1976.

Lyle, Dorothy Siegert. *Modern Textiles.* New York: John Wiley and Sons, 1976.

Mara, Tim. *The Thames and Hudson Manual of Screen Printing.* New York: Thames and Hudson, 1979.

Parry, Linda. *William Morris Textiles.* New York: Viking Press, 1983.

Raimondi, Julie A. "Backing Away." *Contract Design,* February 1999, 32.

Rossbach, Ed. *The Art of Paisley.* New York: Van Nostrand Reinhold Co., 1975.

Safire, William. "*On Language: Pashmina.*" *New York Times* Magazine, 16 January 2000, 41.

Springs Industries, Inc. *UlrasuedeHP.* New York: Springs Industries, Inc., n.d.

Storey, Joyce. *The Thames and Hudson Manual of Textile Printing.* New York: Thames and Hudson, 1974.

———. *The Thames and Hudson Manual of Dyes and Fabrics.* New York: Thames and Hudson, 1992.

StretchWall Products, Inc. *The StretchWall™ System.* Long Island City, N.Y.: StretchWall Products, Inc., BuyLine 1057.

"Textile Solutions." *Contract Design,* June 1997, 18.

"Textile Solutions." *Contract Design,* July 1997, 16.

"Textile Solutions." *Contract Design,* August 1997, 18.

"Textile Solutions." *Contract Design,* September 1997, 28.

"Textile Solutions." *Contract Design,* October 1997, 28.

"Textile Solutions." *Contract Design,* November 1997, 12.

Truppin, Andrea. "William McDonough, 1999 Designer of the Year." *Interiors,* January 1999, 95.

"Twice Told Tale: Renaissance of Horsehair Fabrics." *Veranda,* January/February 2000, 50–51.

Walch, Margaret. *Color Source Book.* New York: Charles Scribners's Sons, 1979.

Watson, W. *Textile Design and Colour.* London: Longmans Green and Co., 1947.

———. *Advanced Textile Design and Colour.* London: Longmans Green and Co., 1947.

Wingate, Dr. Isabel B. *Fairchild's Dictionary of Textiles.* 6th ed. New York: Fairchild Publications, 1979.

———. *Textile Fabrics and Their Selection.* 8th ed. Englewood Cliffs, N.J.: Prentice-Hall, 1984.

Yaeger, Jan. *Textiles for Residential and Commercial Interiors,* New York: Harper and Row, Publishers, 1988.

Yates, Marypaul. *Textiles: A Handbook for Designers.* Rev. ed. New York: W. W. Norton & Company, 1996.

Yee, Roger. "Seamless." *Contract Design,* February 1999, 34.

Trade Organizations

AATCC
American Association of Textile
Chemists and Colorists
One Davis Drive
P.O. Box 12215
Research Triangle Park, NC 27709-
2215
Phone 919-549-8141
Fax 919-549-8933
www.aatcc.org
E-mail to info@aatcc.org.

ACT
Association for Contract Textiles
P.O. Box 101981
Ft. Worth, TX 76185
Phone: 817-924-8048
http://www.contract-textiles.com/

AFMA
American Fiber Manufacturers Asso-
ciation
1150 17th Street, N.W., Suite 310
Washington, D.C. 20036.
Phone 202-296-6508
Fax 202-296-3052
http://www.fibersource.com/afma/
afma.htm

AFMA
American Furniture Manufacturers
Association
P.O. Box HP-7
High Point, NC 27261
Phone: (336) 884-5000
Fax: (336) 884-5303
http://www.afma4u.org/

ASTM
American Society for Testing and
Materials
100 Barr Harbor Drive
P.O. Box C700
West Conshohocken, PA 19428-2959
610-832-9500
http://www.astm.org/

ATMA
American Textile Manufacturers
Association
111 Park Place
Falls Church, VA 22046-4513
Phone (703) 538-1789
Fax (703) 241-5603
http://www.atmanet.org/

ATM
American Textile Manufacturers
Institute
1130 Connecticut Avenue, NW, Suite
1200
Washington, DC 20036-3954
Phone: 202-862-0500
Fax: 202-862-0570/0537
http://www.atmi.org/

CPSC
U.S. Consumer Product Safety
Commission
Washington, D.C. 20207-0001
Tel. (301) 504-0990
Fax (301) 504-0124 and (301) 504-
0025
E-mail: info@cpsc.gov
http://cpsc.gov/about/contact.html

DFA
Decorative Fabrics Association
Contact: Rosecrans Baldwin
Bergamo Fabrics, Inc.
7 West 22nd Street, 2nd Floor
New York, New York 10010
Tel (212) 462.1010
Fax (212) 462.1080
E-mail: crans@bergamofabrics.com

GSA
Government Services Administration
800 F Street, NW
Washington, DC 20405
(202) 501-1231
http://www.gsa.gov/

ISO
International Organization for Stan-
dardization
1, rue de Varembé, Case postale 56
CH-1211 Geneva, 20 Switzerland
Phone: 41 22 749 01 11
Telefax: 41 22 733 34 30
Email: central@iso.ch
http://www.iso.ch/

Joint Industry Fabric Standards and
Guidelines Committee
Contact: American Furniture Manu-
facturers Association

NADFD
National Association of Decorative
Fabric Distributors
3008 Millwood Avenue
Columbia, South Carolina 29205
Phone: 800-445-8629
Fax: 803-765-0860
E-Mail info@nadfd.com
http://www.nadfd.com/

NFPA
National Fire Protection Association
1 Batterymarch Park
P.O. Box 9101
Quincy, MA 02269-9101
Phone: (617) 770-3000
Fax: (617) 770-0700
http://www.nfpa.org/

UL
Underwriter's Laboratories
Corporate Headquarters
333 Pfingsten Road
Northbrook, IL 60062-2096
Telephone: 847-272-8800
Fax: 847-272-8129
E-mail: northbrook@us.ul.com
http://www.ul.com/

Index